AMERICAN PAINTING

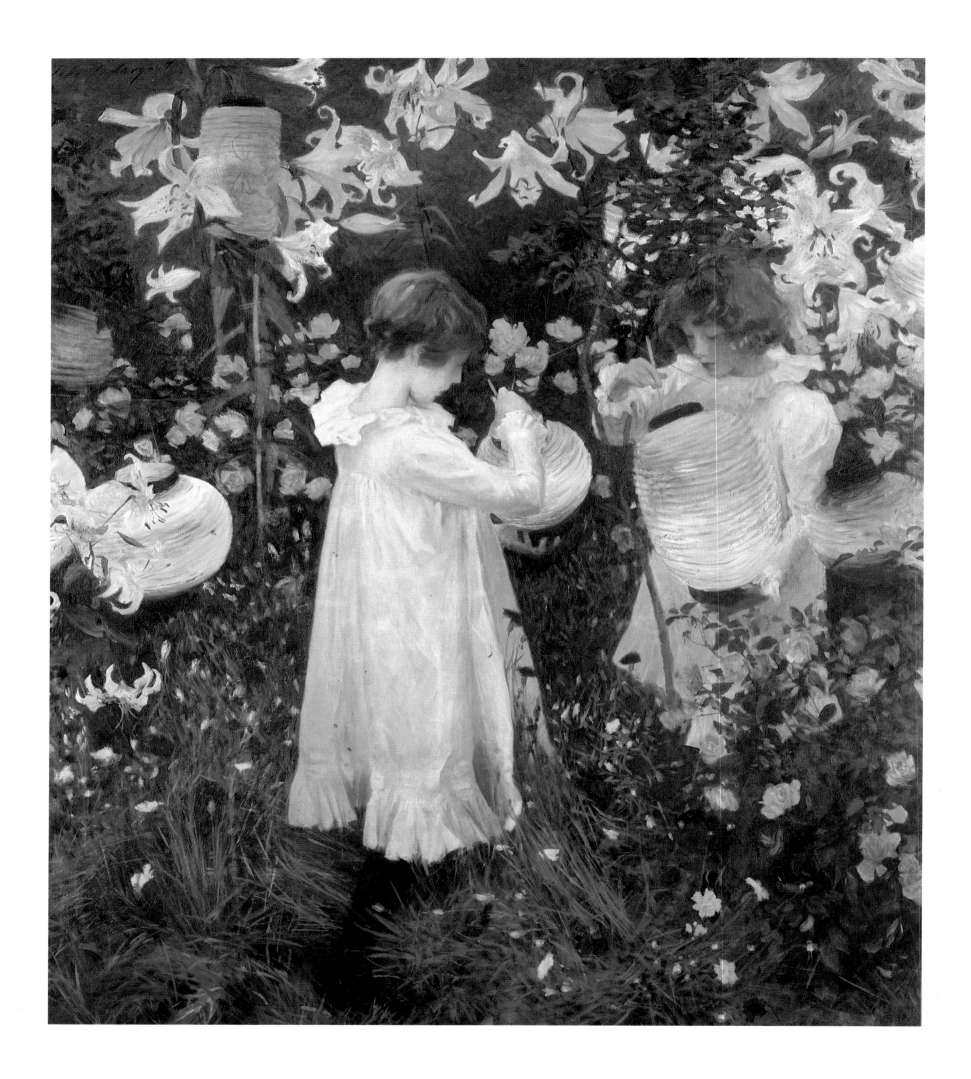

DONALD GODDARD

AMERICAN PAINTING

Introduction by ROBERT ROSENBLUM

Hugh Lauter Levin Associates, Inc.
Distributed by Macmillan Publishing Company, New York

Published by The Reader's Digest Association, Inc.,
with permission of Hugh Lauter Levin Associates, Inc.

Copyright © 1990, Hugh Lauter Levin Associates, Inc.

Design by Nai Chang

Editorial production by Harkavy Publishing Service, New York

Photo research by Catherine Stofko

Typeset by U.S. Lithograph, typographers, New York

Printed in Italy by Milanostampa S.p.A.

ISBN 0-88363-590-9

Jacket illustration:

Edward Hopper
 The Lighthouse at Two Lights. 1929
 Oil on canvas. 29½ × 43¼"
 The Metropolitan Museum of Art, New York City
 Hugo Kastor Fund

Frontispiece:

John Singer Sargent
 Carnation, Lily, Lily, Rose. 1885–1886
 Oil on canvas. 68½ × 60½"
 Tate Gallery, London
 Photograph courtesy of Art Resource, New York
 N1615

Contents

PREFACE

Selection is a hedge against chaos. It might be a way of manipulating history, of attempting in the evolutionary sense to ensure "the survival of some individuals or organisms" at the expense of others. In any case, it is always a form of expression, whether against, with, or across the grain. No matter how inclusive or authoritative, any book on art involves selection and leaves out much—for clarity and identity, one hopes, rather than for consensus.

The motives of selection in this book are tied as little as possible to the banners of movements and groups and more to converging themes of visual perception and conception, of intellectual interest and emotional response, all of which also have, obviously, historical dimensions. There is merit in considering Thomas Eakins and Mary Cassatt together, as there might also have been merit in juxtaposing, for instance, Jasper Johns and Gregory Gillespie. There are many possibilities, many fascinating links in American painting, but the point here has been to expose correspondences, rather than influences or preponderances, over a long and fascinating history. It is the power of the images that ultimately counts. Others would do it in different ways.

The term "American" here means the European-derived tradition of the past three hundred fifty years in what is now the United States. Ours has been an immigrant nation since its first settlements, and many American painters were not born here. Conversely, many American painters were or are expatriates in other lands. John Singer Sargent, who was born in Italy and died in England, never lived in the United States. Whistler, Cassatt, Man Ray, Cy Twombly, and Joan Mitchell, among others, went abroad young and stayed away. The reverse is true of Willem de Kooning, Arshile Gorky, Arakawa, Komar and Melamid, and many others. Still, their presence and influence is felt as American artists. It is not a matter of acceptance or adaptation but of our polyglot history.

The term "painting" is also expanded beyond "color painted on a flat surface." It would be impossible to understand or even recognize painting since Cubism if collage and other accretions and variations were eliminated. A master of illusion and allusion, Joseph Cornell did very little painting, but his work might also be problematic in a book on sculpture. Art is no longer strictly classifiable in traditional terms, and crossovers are often more interesting than the old, rigid categories.

American Painting is in part a collaboration between myself and other editors and writers. The copyediting talents of Julie Smith and the editorial production skills of Michael Harkavy, Alan Gold, Lisa Jenio, and Dale Ramsey of Harkavy Publishing Service were indispensable in meeting some very difficult deadlines. The other writers—Barbara Cavaliere, Gail Stavitsky, Harry L. Wagner, and Ann-Sargent Wooster—were tapped for selected chapters for which their knowledge of a given school or artist was a welcome resource. Their contributions are identified by the placement of their initials at the conclusion of the chapters in question, and I thank them heartily for their assistance.

Donald Goddard
New York City
May 1990

JOHN PETO (b. 1854, Philadelphia– d. 1907, New York City)

Ordinary Objects in the Artist's Creative Mind. 1887 Oil on canvas. 56 × 33″ Shelburne Museum, Shelburne, Vt.

INTRODUCTION

What was once a burning question in the 1930s and '40s—"What is American about American art?"—is not asked or answered very often in these days of airport internationalism, when McDonald's can open in Moscow, maple syrup can turn up on the breakfast table of a hotel in Kyoto, and another Disneyland is scheduled to open northeast of Paris. That old question, in fact, seems to have had to do with the cultural inferiority complexes of the Roosevelt era, when it was clear to almost everybody that the best art of the century was coming from across the Atlantic and landing at the Museum of Modern Art and that the native product, if obviously not the equal of Matisse, Picasso, and Mondrian, might be defended by claiming that it had distinctive qualities that could only be found on these shores and that ought to be cherished and preserved against the aesthetic onslaught from alien territories. But with what was to be called in the title of Irving Sandler's important study of Abstract Expressionism "The Triumph of American Painting," it became equally clear that American artists in the post-Roosevelt era had miraculously emerged as the torchbearers of not only the best and most inventive of modern art, but also of an art that was universal in character, an art so surprisingly cosmic in scope that issues of nationalism seemed piddling. Not only had the once uneven competition between European and American art apparently and unexpectedly been won by the 1950s, but it had been won on so grandiosely abstract a level that the search for an American identity seemed an embarrassing memory of a parochial past.

Nevertheless, that heroic myth, in which a provincial grass-roots patriotism is conquered by a language of international breadth that can be understood around the planet, is, like most myths, both true and false. If it is true that the pictorial worlds of Pollock or Still seemed to leap from American earth to timeless nature and emotions, it is also true that when such paintings were first seen in Europe in the 1950s, foreign critics often commented upon what they felt were peculiarly American qualities—a more expansive sense of scale consonant with the vastness of the American continent; a toughness and crudity of paint handling that spoke of traditions less suave and hedonistic than those familiar to French painting; a rejection, either through intention or incompetence, of the more harmonious compositional conventions common to European painting. Although it was and still is difficult to articulate intuitions about why we feel that something, whether it be an oil painting, the taste of butter, or the cut of a suit, belongs to one country and not another, such efforts to characterize these responses suggest that the question of national character is a very real one. In fact, just in terms of ordinary experience, even in these days of non-stop tourism with internationalized hotels, fast-food chains, and shopping centers, we know that when we cross a border from one country to another, our antennae are alert to exactly those differences that would distinguish, say, Belgium from Holland or Spain from Portugal. Even in North America, who has not crossed the Canadian border without discerning that something, however subtle, has changed? And though we would be very hard put to define that change in words an outsider might understand, we would still know the experience to be true. But however distinctive, the smallest, not to mention the largest of nations still belong to communities of international experience, sharing a broad range of space–time coordinates we might lump together under the vague rubric of Western culture.

So it is that the story of more than three centuries of American painting can be read in varying ways. We may concentrate on the American accent of the individual voices or

we may try to hear each voice in the context of an international chorus whose whole is more than the sum of the parts. Characteristically, American museums, at least when dealing with art before 1945, tend to segregate American art from its European counterparts, keeping it to its own galleries, curators, and publications. Europe is elsewhere when we visit, say, the Whitney Museum of American Art in New York, the National Museum of American Art in Washington, the Terra Museum of American Art in Chicago, or the Butler Institute of American Art in Youngstown, Ohio; and if we go to the Oakland Museum, we may even think that California has its own radiant tradition as many light years away from New York as it is from Paris or London. But there are also other ways of shuffling this familiar deck. For example, at the Spencer Museum in the University of Kansas, American art is completely integrated with its European siblings, so that what emerges is less the particular flavor of the American tradition but a United Nations history of Western art in which American artists join forces with their transatlantic colleagues in the experience of living in, say, 1790 or 1840 or 1890.

Such an approach, in keeping with today's world of jet travel, tends to narrow rather than to widen the Atlantic Ocean, making American achievements belong more to a communal rather than a local history. A telling case in point here concerns the two painters who are generally considered the founding fathers of the American tradition in painting: John Singleton Copley and Benjamin West, both born, conveniently for this venerable genealogical table, in the same year, 1738. As for Copley, it has long been a convention to divide the course of his life and art into two sharply divided, even antagonistic, parts. Act I took place in Colonial America, concluding in 1774, two years before the Revolution, when he sailed from New England to Old England, never to return to his birthplace again; Act II took place in the center of the Anglo-American empire, London, where Copley lived out his long life as a flourishing artist in the middle of a sophisticated art world. Those who would nurture the values of America versus those of Europe tend to make a case for the probity and the superiority of the portraits Copley painted in Boston, often implying that in London, his art was gradually diluted and, by implication, corrupted by association with standards foreign to his roots. Indeed, some early writers on American painting even infer that an act of aesthetic as well as patriotic treason was involved in Copley's switch of allegiance. But this simple parable is far more complex, and demands international angles of vision. When Copley's 1765 portrait of his half-brother Henry Pelham, *Boy with a Squirrel*, was sent to London from Boston for exhibition at the Society of Artists in 1766, it became not only the first American painting to be seen in Europe, but a painting that some British artists thought to be a work by one of their own up-and-coming masters, Joseph Wright of Derby, Copley's almost exact contemporary. Wright of Derby's portraits, usually ignored by Americanists seeking for the pure American truth in Copley, are in fact in every way comparable to Copley's, look-alikes that also reflect a tough new mid–eighteenth century breed of well-heeled and hard-working sitters and their wives and children, a social type that grew rapidly in the Midlands as in the Colonies and that wanted the material facts of their lives to be painted as if they could be touched, grasped, and bought. Both Copley and Wright of Derby can be seen as brilliant provincial painters in a new Anglo-American world of commerce and industry, standing in similar relationships to the more artificial and tradition-bound styles of the capital which, as in Sir Joshua Reynolds's portraits, were generally more suitable to dyed-in-the-wool aristocrats than to the growing new world of self-made men and women. Moreover, Copley's tough, foursquare Bostonian portraits, with their hard-edged polished tables and sharp-focus still lifes, may even find affinities on the Continent. Many of David's own portraits of friends and family, painted both before and after the Revolution, reveal a like insistence on the palpable facts of faces, clothing, and things, unpolluted by arty conventions that falsified the truth of the material world. Seen in such lights, Copley's archetypal Americanism in his Bostonian portraits can also be interpreted as one more manifestation of a new international style that mirrored deep social changes on the eve of revolutions that were both gradual and sudden.

But Copley's pictorial output in London is no less blurry when it comes to national classifications. Because *Watson and the Shark* has always been considered a textbook

classic of American painting, one tends to forget that its hero and patron, Brook Watson, was, after all, a Londoner who commissioned the picture for a London audience at the Royal Academy exhibition of 1778. And the success of this reportorial canvas, with its news-camera clarity of horrific detail, would be amplified by Copley in the next decade with his fancier account of the on-the-spot drama of another Englishman, Major Francis Peirson, giving his life for his country on the island of Jersey. But if these paintings are steeped in British history and culture, they also have American reverberations. *Watson and the Shark* has been convincingly interpreted as, among other things, a contemporary allegory of American independence; and Major Peirson's more rhetorical agonies provided the formula for many American history painters, especially John Trumbull, who would patriotically document the wars of independence for posterity.

As for West, although he, too, is worshipped as an American ancestral figure, it should be recalled that he got out of the colonies even earlier and, in artistic terms, far more prematurely than Copley, sailing in 1760 from Philadelphia to Livorno before settling in 1763 in what he called "the mother country." A resident of London for the remaining fifty-seven years of his life, West loomed so large in the British art establishment that he could not only paint the king and queen, his devoted patrons, but could become, after Reynolds's death in 1792, the president of the Royal Academy itself. It would be hard to be more British. On the other hand, even if his ambitions could quickly rise to the classical mythologies or Biblical ghost stories that were growingly fashionable in the British milieu of the 1760s and '70s, he shrewdly hawked the wares of his American origin, recording exotic Indians and faraway North American battles, features prominent in his famous *Death of General Wolfe*, which probably had as much issue in Britain and in the circle of David as it did among West's own American students. And as for Indians, even if they seemed to be one of West's trademarks and selling points, they were also painted, after all, by Wright of Derby, not to mention many other British and French artists of the period. Indeed, such international exchanges of North American Indian lore continued well into the nineteenth century, when, for example, George Catlin's "Indian Gallery," with its portraits of Indians and wild-west hunting scenes, was displayed to the London of Queen Victoria and the Paris of King Louis-Philippe.

Again and again, what might be viewed as something singularly American often turns out to be part of an international network. Gilbert Stuart's picture of a young Scotsman, William Grant, on ice skates, a surprising portrait inspired by an adventure both artist and sitter had had on the thin and melting ice of the Serpentine in Hyde Park, may seem like a one-shot image of daring candor that only an unpretentious Yankee would have the audacity to exhibit at the Royal Academy in 1782; but in fact, there are at least two other late–eighteenth century portraits of gentlemen on ice skates—one by the Scotsman Sir Henry Raeburn, the other by the Frenchman Pierre Delafontaine— which, together with Stuart's, would compose a beguiling international trio.

Even "Luminism," that American style and viewpoint most often singled out as offering an authentic and unique contribution to nineteenth-century painting, though it was only baptized in 1954, a century after it flourished, is better served when seen as part of a phenomenon familiar to many North European landscape painters. To be sure, the eerie, all-engulfing light that dominates the silent, unpopulated landscapes of Martin Johnson Heade or Fitz Hugh Lane may evoke peculiarly American myths and experiences of an awesomely vast, primeval terrain in which something akin to God casts immaterial rays upon a land of blessed purity and innocence; but such a vision of what has been called "natural supernaturalism" can be found in many earlier European masters, whether as famous as Friedrich and Turner or as up-and-coming in reputation as the Danes Christen Købke and Christoffer Eckersberg, all artists whose comparably "Luminist" visions have begun to work their way into more sophisticated recent studies of American landscape painting.

In many cases, beginning with Copley and West, the practice of declaring artists American because they were born in America might well be challenged. Although Whistler has become an icon of American culture, he, in fact, left the States for Europe in 1855, at the age of twenty-one, and, like West, only became a mature painter

within a foreign context. In looking at his *Symphony in White No. 2: Little White Girl*, we might well forget his New England roots, for here it is the tale of two cosmopolitan cities, London and Paris, that counts. Shown in London in 1864, at the Royal Academy exhibition, it absorbs not only the literary aestheticism of both Swinburne and Gautier, but visual references to both Millais and Ingres. And if we had to locate the painting in a friendly group, it would probably be happiest in the company of works by Whistler's own British and French acquaintances and contemporaries: Rossetti, Degas, Manet, Fantin-Latour. Even more to the point of American birthplaces not making American artists, there is the case of Mary Cassatt, who left her native Pennsylvania for Europe in 1866 at the age of twenty-two and, despite a few short visits to the States, took firm roots in Paris. Not only did she exhibit at the Salon in the early 1870s with Manet, but was an integral part of the Impressionist group exhibitions from 1879 to 1886, where she shared the walls with her close friend Degas and such other French masters as Renoir, Monet, and Gauguin. But she could also send her pictures back home for public display, so that, for example, *At the Opera* of 1879 was first shown in New York, in 1881, at the Society of Artists, where it stuck out as a precocious example of an unfamiliar new style of split-second, candid observation in which women could play worldly rather than domestic roles.

In the same expatriate category, there is John Singer Sargent, whose confusing national identity made it possible for him to have, within recent memory, retrospective exhibitions at both the National Portrait Gallery in London and the Whitney Museum of American Art in New York. To thicken this international stew, Sargent, who was actually born abroad, in Florence, though of American parents, traveled widely on the Continent; studied with a French master, Carolus-Duran; exhibited in, among other art capitals, New York, Paris, Brussels, London; frequented and painted the international jet-set of his day, who might be found anywhere from Majorca to Blenheim Palace. And if he was grand enough to paint the Duke of Marlborough's family, he was also esteemed enough in democratic America to be commissioned to do murals for the Boston Public Library. Yet if we would understand his art, we would do far better not to look to America, but to an international style of around 1900, whose pictorial and social luxuries were also reflected in the equally cosmopolitan work of artists like the Italian Giovanni Boldini, the Spaniard Joaquín Sorolla, the Frenchman Jacques-Emile Blanche, and the Swede Anders Zorn.

Still, even granting the obvious internationalism of so many artists who hold firm places in American biographical dictionaries, there is always the nagging question of whether their art does not somehow disclose a distinctively American inflection that would single it out from a multi-national crowd. The question is relatively easy to answer in the case of such American classics as Winslow Homer and Thomas Eakins. Both of them had experienced art in Paris—Homer on a ten-month visit in 1866–67, when he showed at the Paris World's Fair; and Eakins, in a more sustained and influential way, since he studied there between 1866 and 1869 with Jean-Léon Gérôme and Léon Bonnat, two masters whose imprint can often be discerned in his work. In the case of Homer, paintings like *Breezing Up* and *Northeaster* might strike even Europeans as quintessentially American images of the salt-sprayed rigors of the North Atlantic coast, but other paintings of his beg revealing comparisons with their European counterparts. For example, his 1869 view of the salubrious beach resort at Long Branch, New Jersey (which, for chic, had been dubbed "the American Boulogne") instantly recalls, in its tonic breeze and glare, the Channel coast scenes of vacationers painted by Monet and Boudin in the same decade. But, this said, we also intuit a very different mood in which even such a scene of overt pleasure and camaraderie reveals a bare and lonely emotional skeleton. The two fashion-plate ladies in the foreground, each with a parasol, are aligned in tandem, but appear as strangely isolated from each other as the lone male figure on the cabin porch surrounded by drying linens; and the relationship of these figures to this place on the American continent which juts out into the immensity of the ocean is almost that of intruders upon a still uninviting and unpopulated land. It is an experience that runs counter to the French sense of layered social history in a territory that has long

been inhabited and civilized. Moreover, the white intensity of the sunlight, rather than pulverizing and fusing figures and landscape, produces quite the opposite effect, starching clothing, hardening earth and grass, clarifying simple architectural shapes pitted against the rawness of nature. Looked at from an American rather than a European angle of vision, the feeling here is less akin to Monet than it is to Edward Hopper, whose figures, whether in city or country, similarly seem to intrude upon a bleak environment of blanching light and primitive geometric order.

As for Eakins, this dour mood of lonely human presences in an environment that reaches out to nowhere is equally apparent, especially in the company of French parallels. His 1873 painting of the Biglin Brothers in a scull on the Schuylkill River reveals in unexpected ways Eakins's training with Gérôme, who constructed many exotic boating scenes on the Nile with the same perspectival precision and photographic detail that characterize the quasi-scientific approach of Eakins to the facts of the seen world. But the American painter has turned these Orientalist travelogues into a scene of inwardness and solemnity in which each of the two scullers, brothers though they are, seems alone and in which the river and the far bank suggest such vast expanses of water and land that the few people we see recall early settlers on unfamiliar soil. Inevitably, Eakins's boating scenes echo the many French paintings of the 1870s and '80s that depict sportily dressed men and women rowing on the Seine; but here, too, the Parisian mood of cheerful, breezy conviviality on a bustling waterway underlines the austere silence of Eakins's American view. No less telling is Eakins's *Concert Singer* in which, despite the obvious clues that this is a live performance before a conductor and an audience, we feel that the contralto, Miss Weda Cook, is totally alone, lost in a dark and empty space and absorbed in the private reverie inspired by the aria she sings from Mendelssohn's *Elijah*. It is tempting to discern in this mood and image something that speaks with an unmistakably American voice of a kind that became almost a trademark in Andrew Wyeth's *Christina's World*.

Still, such black-and-white distinctions between America and Europe can always be turned into shades of gray, especially when one recalls, while thinking of Eakins, how the psychological ambience of meditation and withdrawal, often prompted by music, gradually permeated later nineteenth-century European painting as well, a stop on the way to that universal domain of frail, visionary fantasies most conveniently categorized as Symbolism. Americans, too, contributed to this ubiquitous world of twilight reverie that cast an eerie spell over Western art at the turn of the century; and it has recently become clearer that what used to be thought of as a weird cluster of downright eccentric American artists that kept popping up as the century drew to a close—Elihu Vedder, Ralph Blakelock, Arthur Davies, Louis Eilshemius, Thomas Dewing and, above all, Albert Pinkham Ryder—could be put in this pan-European melting pot. All these artists looked so far inward that the visible, palpable world was gradually replaced by wispy dreams of longing and fevered imagination, frequently inspired, as in the more empirical approach of Eakins, by music, whether the long-ago sounds of a lute in a painting by Dewing or the surging new sounds of Wagner's Ring Cycle in a painting by Ryder. It was the kind of search that could lead eventually to the mysteries of pure chromatic abstraction, a goal theoretically justified by analogies with music and one attained in Paris on the eve of the First World War by what was again an international community of artists that, in addition to the Czech Kupka and the Frenchman Delaunay, included two Americans, Stanton Macdonald-Wright and Morgan Russell, who, in the name of Synchromism, would also try to hear the music of the spheres as generated by their fantasies of free-floating prismatic color.

But such adventures into the most daring reaches of modernism, often learned directly at their European sources, could also be translated into a self-consciously American idiom by the choice of specifically American icons of modernity. Whether the New York subway's rush hour, as evoked by Max Weber, or New York's answer to the Eiffel Tower, the Brooklyn Bridge, as praised again and again in works by John Marin and Joseph Stella, it was New York's urban themes that often inspired a Machine Age dynamism which asserted how the most vital energies of the new century were to be

found on new American soil. Small wonder that two French masters of mechanical fantasy, Duchamp and Picabia, thrived in New York and, for once, helped to form on the American rather than the European side of the Atlantic a cosmopolitan group of artists that could set on fire the wildest imaginations of Americans like Man Ray or John Covert.

Such alliances preview the accelerating speed of transatlantic dialogues in our own century, when we may often think that the world has become a space–time blur in which the non-stop traffic of art and people instantly homogenizes everything in collections, publications, and exhibitions that can mix David Salle and Anselm Kiefer, Jennifer Bartlett and Francesco Clemente. Indeed, so international has art become in the late twentieth century that many admirers of, say, Jasper Johns or Andy Warhol hardly notice that the choice of the American flag or a Campbell's soup can is as willfully American a subject as was, say, Grant Wood's choice of the Daughters of the American Revolution or Albert Bierstadt's of the Rocky Mountains. Contemporary sophistication, in fact, tends to ignore the old-fashioned question with which we began, "What is American about American art?" Yet Americans belong not only to the world, but to their own singular traditions and experiences. When we look at a painting by Rothko, we may well be reminded of many European masters, from Turner to the late Monet, but we also sense indigenous roots whose ancestry might take us not only to the realm of American Luminism but to such oddball visions of American eternity as provided in Elihu Vedder's *Memory*. And when we look at Eric Fischl's *The Old Man's Boat and the Old Man's Dog*, even though the painting finds its home in an international collection of contemporary art in London, we would be hard put to understand it without recalling the marine paintings of Winslow Homer in which the dramas of American nature and American passions are played against each other. Like American people, American art lives both at home and abroad.

Robert Rosenblum
Professor of Fine Arts
New York University

I. In the Beginning

Europeans came to the New World with little artistic baggage, or interest. Native American cultures barely influenced the newcomers, so oddly costumed and awkwardly settled on the Florida coast, the southwestern desert, the pestilent riverbanks of Virginia, and the rocky soil of New England. Even such extravagant expressions as the great Aztec city of Tenochtitlán, in Mexico, were treated with disdain, as places to be swept away and ultimately supplanted. Colonial aspirations varied, but they did not include, to any effective degree, the desire or ability to adopt what were considered heathen ideas and customs, even in those few, such as William Penn and the Quakers, who admired Native Americans and their means of social organization.

In fact, Indian art forms were hardly recognized until the early nineteenth century and little respected until well into the twentieth. Yet there were convergences, even as Native American nations were being moved west and annihilated. Emerson, Thoreau, Cooper, and the landscape painters of that era were close in spirit to Indian expressions of universalism and reverence for nature. Despite the destruction of Indian culture itself, the familiar cycle of conquest and absorption by the conquered seems to recur. It is ironic, and telling, that in the latter half of this century much American art looks more like the adornments of everyday Indian life than like high art in the Western tradition.

But the forms of colonial art were strictly European, reduced to essentials. In New Spain—New Mexico, Arizona, and then California—art was almost exclusively religious. Paintings and sculptures made for the church-fortresses there are stark, fervent renderings of Biblical scenes and saint-intercessors. The English settlers were equally austere and practical, but from an entirely different point of view. As Protestants and Puritans, they scorned religious art. As Englishmen, they espoused an art devoted primarily to portraiture.

Art, however, was the least of their interests for a hundred years or more. About two hundred fifty thousand people lived in the colonies from Maine to the Carolinas by 1700, but the major towns of Boston, New York, and Charleston were hardly flourishing centers of culture. There were other, more pressing things to do, and only slight support for what seemed marginal activities. Domestic architecture, meetinghouses, furniture, utensils, and farm tools were necessities; paintings and sculptures were not.

As far as we know, there were no full-time artists until well into the eighteenth century. A limner, or painter of portraits, made his living painting houses, signs, carriages, and coats of arms or in some other line of work entirely. There was little demand for any subject other than portraiture, and the limner was simply the craftsman who carried out the task. Art played a role in colonial life, but one that was almost totally prescribed by the patron's need for recognition or commemoration.

Certain formulas were followed more or less faithfully, and repeatedly. Artists depended on prints of English and European paintings to determine how and in what kinds of setting subjects should be posed. Stylistically, American artists were far behind. The few paintings we have from the seventeenth century, such as *Mrs. Elizabeth Freake*

and Her Daughter Mary, draw on the conventions of sixteenth-century Elizabethan portraiture, with its emphasis on flat patterns of volume and space. More contemporary styles were introduced in time by artists such as John Smibert, who came to the colonies with academic training. At a distance from Europe, American artists struggled with the grandness, spatial fluidity, and realism of the baroque and rococo styles. Generally, it was understood by patrons that not much should be expected in this regard: that colonials would be inherently inferior until they had the opportunity to be trained in the Old World, the mother culture. And this would not happen until 1760 and later.

But it is precisely this cultural deprivation that gave Early American art its character, initiating a pattern of difference between the Old and New Worlds that continues today. Settlers in the New World were, in a sense, starting over again, at the beginning, whether they were escaping religious persecution, pursuing commercial interests, or avoiding jail. Their art, such as it was, focused almost entirely on individual human presences, on the people engaged in the colonial enterprise. There was nothing else. It was an exercise in self-definition and self-creation, a means of establishing identity, of promoting familiar customs and beliefs in what was thought of as an alien or primeval environment. Artists and patrons alike were unwilling or unable to venture beyond the narrow compass of the self.

Yet this procession of simple, narcissistic images powerfully evokes the world in which these people lived. They are endowed, for one thing, with an extraordinary cheerfulness. Everyone smiles. Little disturbs the pleasant and contented demeanor of young mothers, children, ship's captains, merchants, ministers, and statesmen. While acknowledging death in skull and poem, even Thomas Smith exudes quiet strength and confidence rather than despair or contemplative reverie. This might reflect the artist's desire to flatter, even when the subject is himself, or an untutored inability to render any expression other than the "archaic smile" (a standard, quite serene smile that does not attempt to capture the particular look of the individual depicted).

There are exceptions, however, that seem to indicate other instincts or motives. Gustavus Hesselius's *Tishcohan* portrays a grave and world-weary Delaware Indian. And John Smibert, in a painting otherwise full of lively and uplifting interaction, has shown himself, at the far left, looking out at the viewer rather seriously, and even questioningly. In a sense, both the Indian Tishcohan, whose people gave up their land under a purchase agreement with the colony of Pennsylvania, and the artist Smibert were outsiders. They were detached from the optimism that permeated, for instance, the nearly successful plan of George Berkeley, the prominent Anglican bishop at the right in Smibert's painting, to establish a college in Bermuda where "There shall be sung another golden Age, / The rise of Empire and the Arts, / The Good and Great, inspiring epic Rage, / The wisest Heads and noblest Hearts." Some artists were capable, in other words, of seeing beneath the cheerful exterior.

But the purpose of American art was to validate, rather than to speculate or glorify,

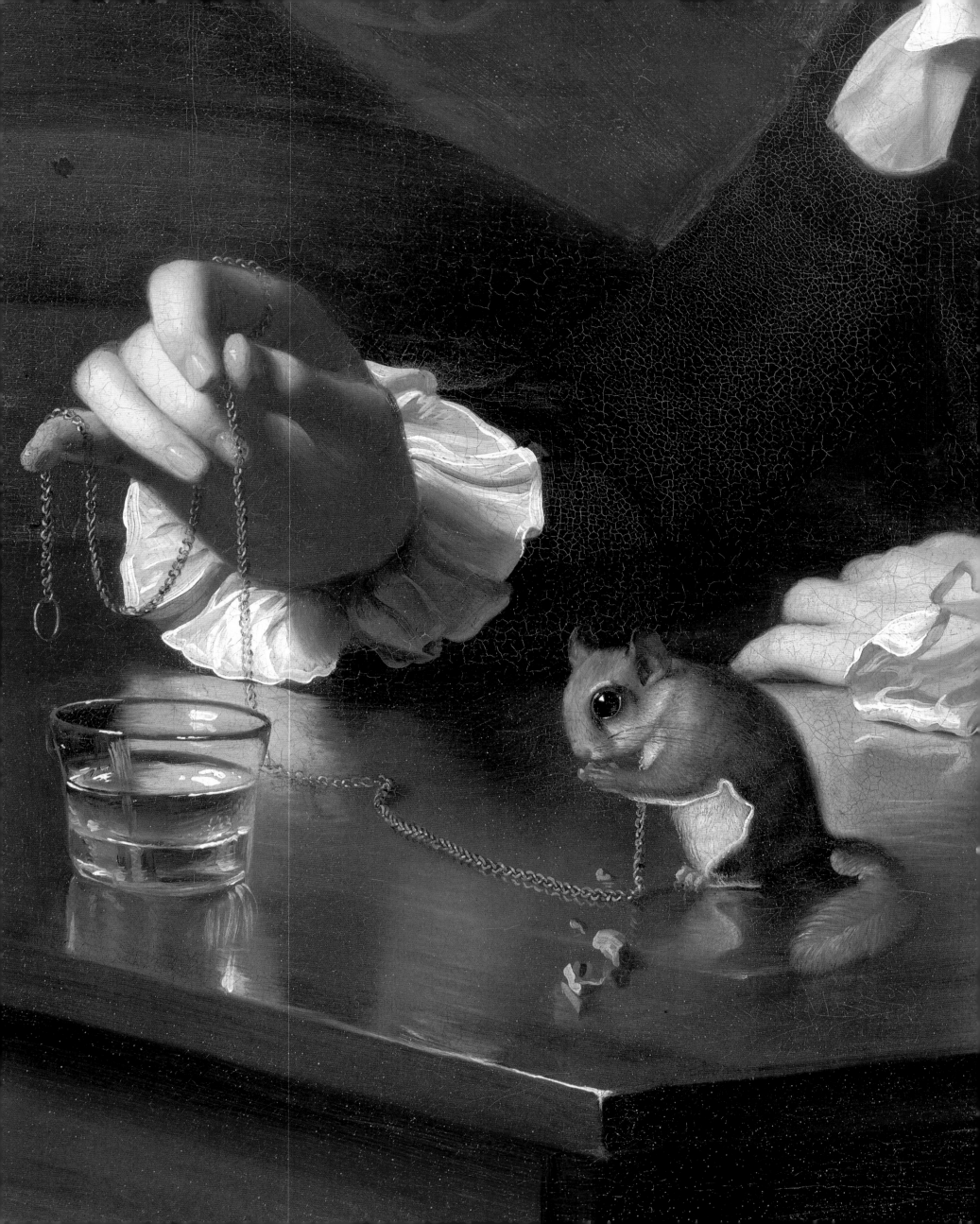

in contrast with much European portraiture. People are what they possess or what they do, and this insistence on a material, practical identity is what gives the best colonial images their charm and authority. Elizabeth Freake and her daughter, forever bound together as mother and child, are defined by the pervasive and delicately rendered textures of fabrics, laces, embroidery, and ribbon. The clothing itself becomes a personification. In Captain Smith's self-portrait, there is no mistaking his penchant for the sea, whereas a comparable portrait in Europe might imply the subject's distance from or superiority to his profession. There is also a frank acknowledgment, and acceptance, of death.

In the work of John Singleton Copley, who at the age of twenty-one was already the dominant artist in Boston, material presence takes on an almost preternatural quality. He was able, with an unparalleled skill acquired from his own intensive observations and his study of prints made by other artists, to overcome the puerile timidity of most colonial painting, and to embrace the endless diversity of visual experience. His greatest paintings glow with the perfect illusion of three-dimensional volumes and reflective surfaces, yet it is the character and spirit of his figures that dominate. The Royall sisters are engulfed in an expanse of satin that takes up more than half the picture, but their gaze and youthful sensuality are what ultimately capture our attention.

Simple but subtle correspondences bring Copley's figures into focus. Mrs. Ezekial Goldthwait caresses the fruit as though it were the very essence of her own round and comfortable being. Samuel Adams is aroused to forthright anger about the Boston Massacre by the documents in front of him. These are not just attributes or props; they are embodiments of character, action, and idea. Copley's *Boy with a Squirrel*, a portrait of his half-brother, Henry Pelham, is entered through a sliver of light along the table's projecting corner, which leads through the eye of the squirrel, along the chain, across the hand, and up to the expectant profile of the boy, who looks away and out of the picture. The painting is brought to life by the tiny figure of the squirrel, and even more precisely by the light in the squirrel's eye. Copley's ability to locate underlying forces brings to mind the later writings of Emerson and his disciples in transcendentalism. In any case, it is a magical performance, and one that amazed Sir Joshua Reynolds, Benjamin West, and others when this work of an untrained colonial was exhibited in London in 1766, preparing the way for Copley's later emigration to England.

Fittingly, the last great colonial American portrait was completed by Charles Willson Peale in August of 1776, in the city where the Declaration of Independence had been accepted by the Second Continental Congress on July 4th. Peale had begun the painting in 1772 as a portrait of his daughter Margaret, who had died of smallpox that year. Four years later, he added the figure of his wife Rachel weeping over the small, prostrate figure. In this unusual image, portraiture reaches a climax of expression it had formerly denied. It is the final and most intense manifestation of this particular form of art, which had begun with another mother and child, Elizabeth Freake and her daughter Mary. The colonial child is laid to rest in a paroxysm of grief. A new, post-Revolutionary age of society and art is about to dawn.

JOHN SINGLETON COPLEY

Henry Pelham (Boy with a Squirrel) (Detail). 1765
Oil on canvas.
Museum of Fine Arts, Boston
Gift of the Artist's Great Granddaughter
(See page 25 for full image.)

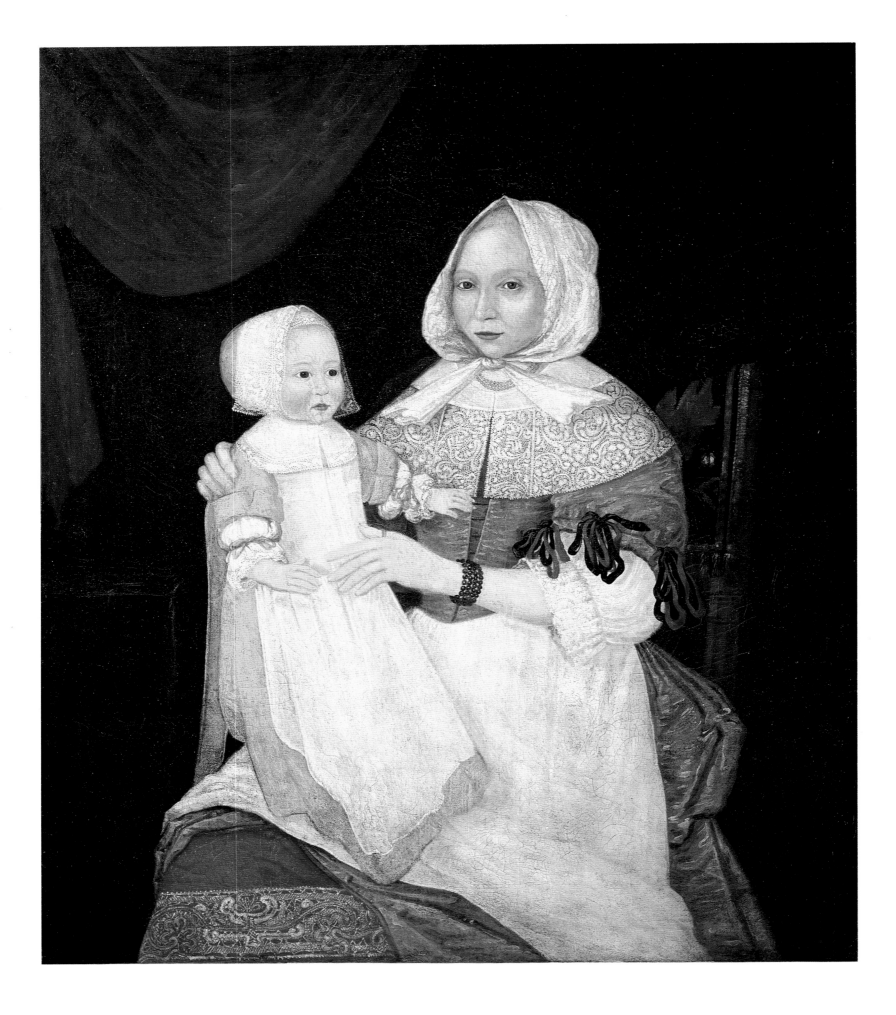

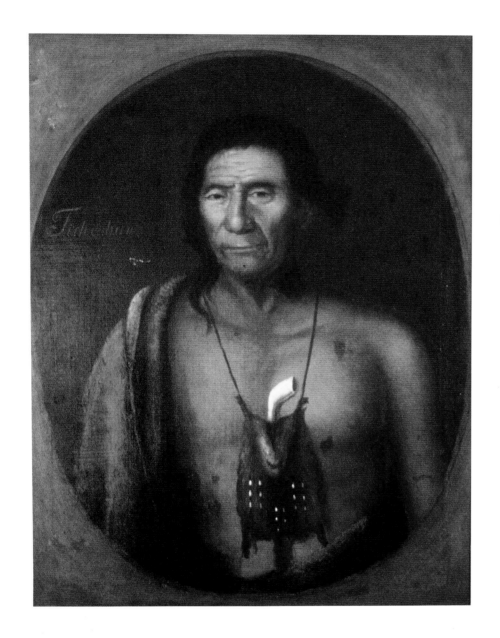

GUSTAVUS HESSELIUS (b. 1682, Falum, Sweden–d. 1755, Philadelphia)

Tishcohan. 1735
Oil on canvas. 33 × 25″
Historical Society of Pennsylvania, Philadelphia

CAPTAIN THOMAS SMITH (active 1670–1691, Boston)

Self-Portrait. 1670–1679
Oil on canvas. 24½ × 23¾″
Worcester Art Museum, Worcester, Mass.

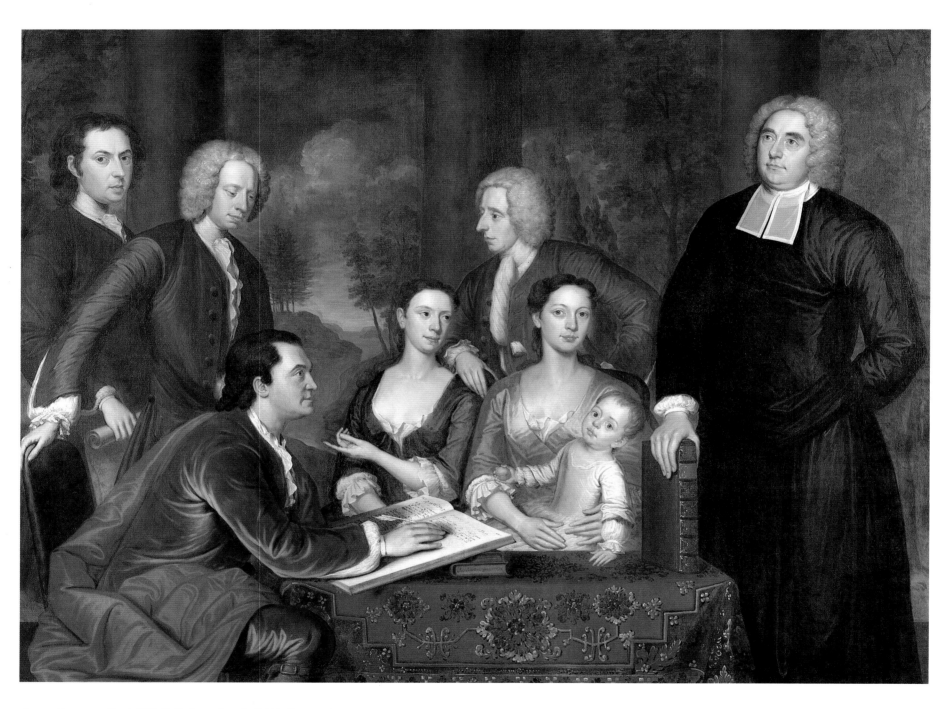

JOHN SMIBERT (b. 1688, Edinburgh–d. 1751, Boston)

The Bermuda Group—Dean George Berkeley and His Family. 1729
Oil on canvas. 69½×93″
Yale University Art Gallery, New Haven, Conn.
Gift of Isaac Lothrop of Plymouth, Mass.

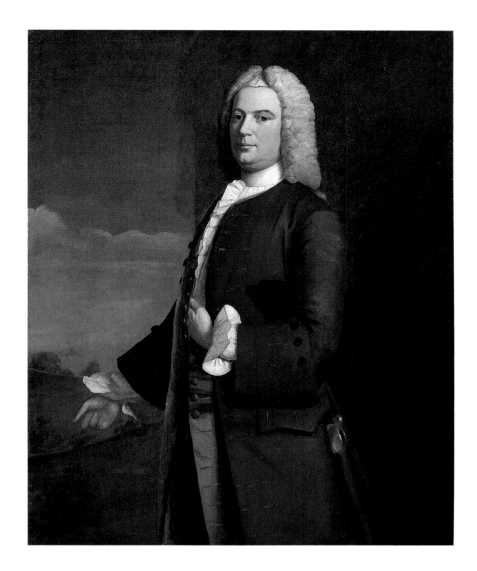

ROBERT FEKE (b. ca. 1708, Oyster Bay, N.Y.–d. ca. 1751, Bermuda)

Tench Francis. 1690?–1758
Oil on canvas. 49 × 39″
The Metropolitan Museum of Art, New York City
DeWitt Jesup Fund

JOHN SINGLETON COPLEY (b. 1738, Boston–d. 1815, London)

Mary and Elizabeth Royall. ca. 1758
Oil on canvas. 57½ × 48″
Museum of Fine Arts, Boston
Julia Knight Fox Fund

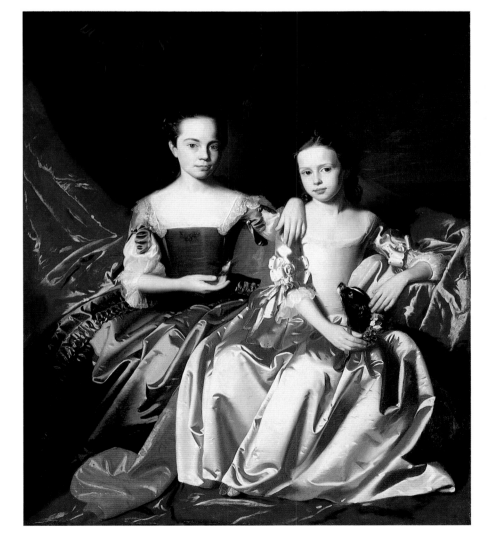

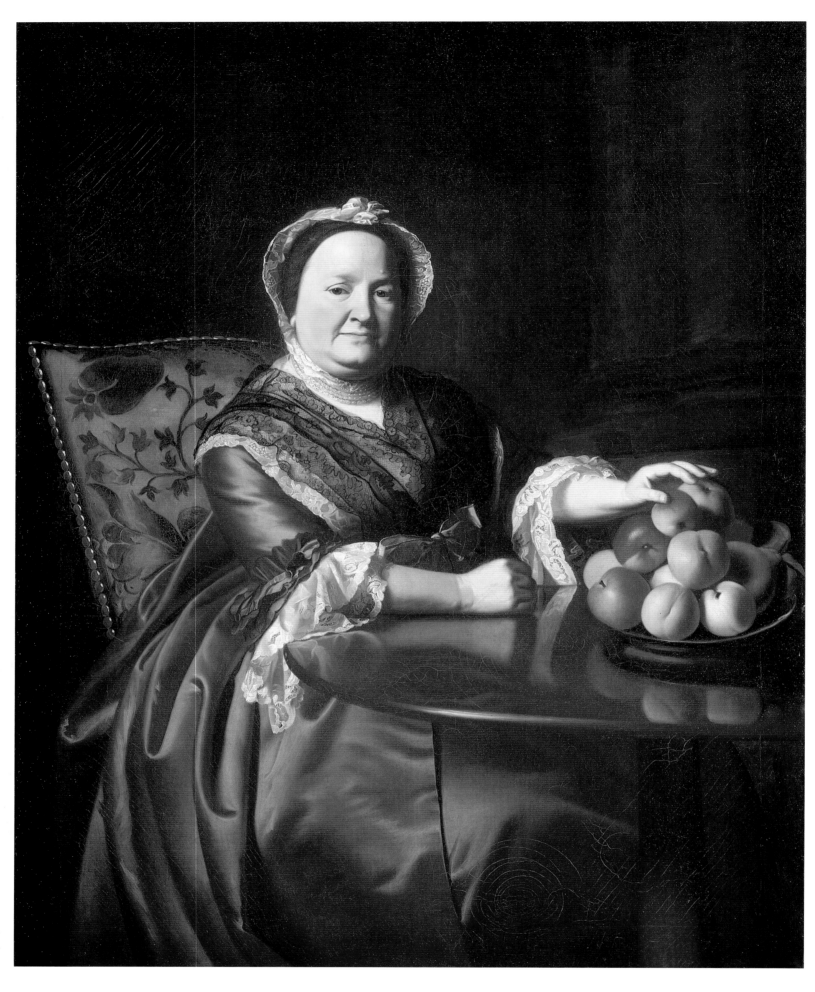

John Singleton Copley

Mrs. Ezekial Goldthwait. 1771
Oil on canvas. 50⅜ × 40¼″
Museum of Fine Arts, Boston
Bequest of John T. Bowen in memory of Eliza M. Bowen

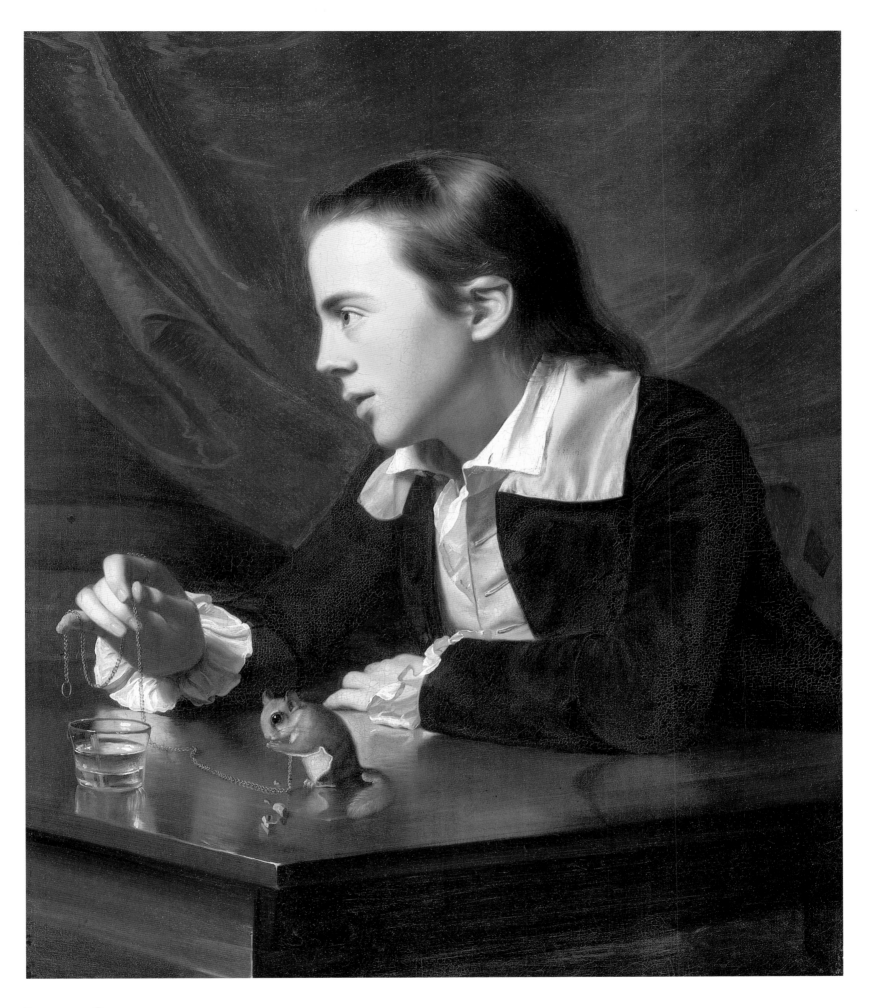

JOHN SINGLETON COPLEY

Henry Pelham (Boy with a Squirrel). 1765
Oil on canvas. 30¼ × 25″
Museum of Fine Arts, Boston
Gift of the Artist's Great Granddaughter

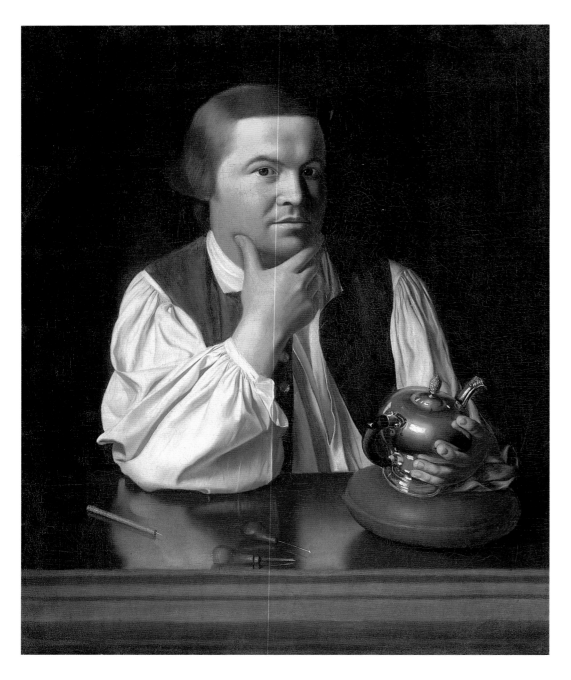

John Singleton Copley

Paul Revere. 1768–1770
Oil on canvas. 35 × 28½″
Museum of Fine Arts, Boston
Gift of Joseph W., William B.,
and Edward H.R. Revere

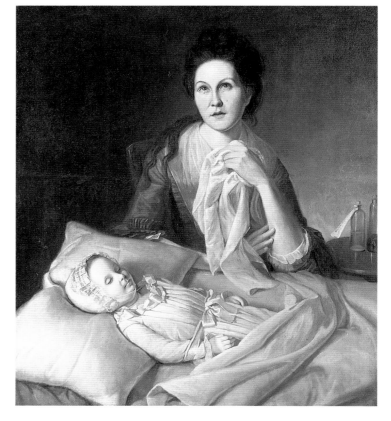

Charles Willson Peale (b. 1741, Queen Anne's
County, Md.–d. 1827, Philadelphia)

Rachel Weeping. 1772–1776
Oil on canvas. 37⅛ × 32¼″
Philadelphia Museum of Art, Philadelphia
Given by the Barra Foundation, Inc.

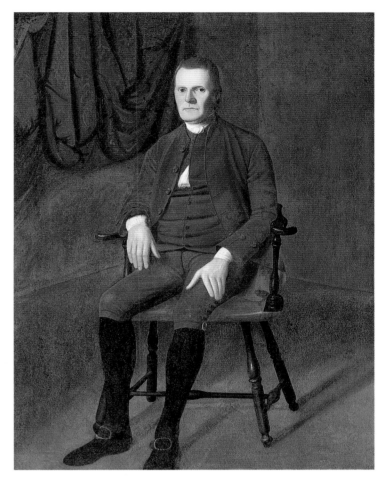

John Singleton Copley

Samuel Adams. ca. 1772
Oil on canvas. 50 × 40¼"
Museum of Fine Arts, Boston
Deposited by the City of Boston

Ralph Earl (b. 1721, Worcester County,
 Mass.–d. 1801, Bolton, Conn.)

Roger Sherman. ca. 1775
Oil on canvas. 64⅞ × 49⅝"
Yale University Art Gallery, New Haven, Conn.
Gift of Roger Sherman White

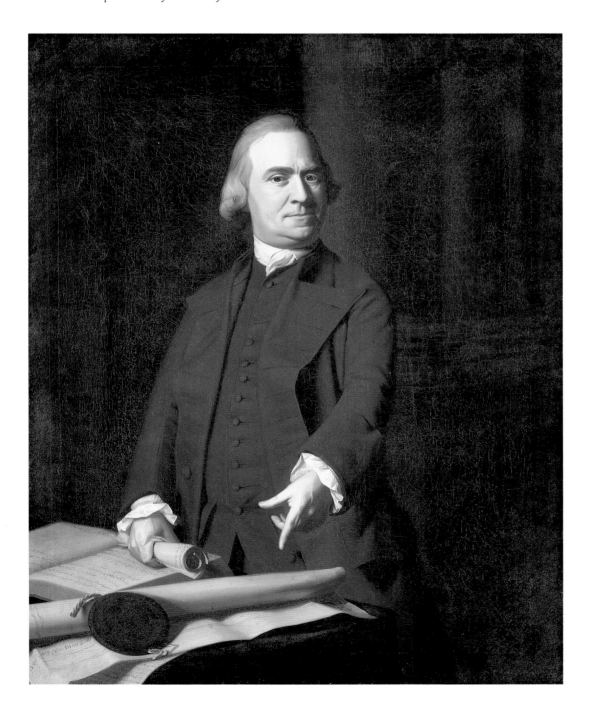

2. THE AMERICAN SCHOOL

Ironically, the influences that shaped American painting during and after the War of Independence were primarily English. But the principal vehicle of training and inspiration, Benjamin West, was American. Born near Philadelphia in 1738, West used his youthful success as a portraitist in Philadelphia and New York to gain backing for a trip in 1759 to Italy, where he was immediately lionized. He moved to England in 1763, was appointed history painter to King George III in 1772, and succeeded Sir Joshua Reynolds as president of the Royal Academy in 1792: all this despite his presumed sympathy with the cause of independence.

Beginning with scenes that reflect his neoclassical training in Rome, the most beautiful of which is *Venus Lamenting the Death of Adonis*, West took on styles and themes of increasing grandeur, culminating in three immense religious cycles, two of which, for Windsor Castle and Fonthill Abbey, were never finished. Through his enormous pictorial ambition, and even because of its often evident absurdity, he opened many new avenues for American and English painting beyond the realm of portraiture, a genre that West avoided as much as he could. Meanwhile, visiting American artists also learned from the leading English painters of the day, including Joshua Reynolds, Thomas Gainsborough, and Thomas Lawrence.

A steady stream of young American artists worked in West's London studio. Between Matthew Platt, in 1764, and Samuel F. B. Morse, in 1811, were Charles Willson Peale, Gilbert Stuart, Ralph Earl, John Trumbull, Washington Allston, Rembrandt Peale, and Thomas Sully: practically the entire pantheon of prominent American artists of the period. One exception, John Vanderlyn, studied and worked in France for long periods with the kind of support he would not receive later in his own country.

These reverse pilgrims of art represented the political spectrum. Peale, who had been in London from 1767 to 1769, served twice in the American militia. Stuart sailed from Boston in 1775, at the height of the early fighting, apparently uninterested in either side. Earl was accused of spying for the Crown in Connecticut. And Trumbull, whose father was the governor of Connecticut, was an officer in the Continental Army. Copley valiantly but unsuccessfully mediated for the colonial merchants prior to the Boston Tea Party and finally, in 1774, fulfilled a long-standing vow to West by sailing for England, where he remained for the rest of his life.

The times were dramatic, and West, for his aristocratic audience, offered an appropriately theatrical style, transfiguring the sensual classicism of *Venus Lamenting the Death of Adonis* into the darkly mystical romanticism of *Saul and the Witch of Endor*. In whatever mode, West created costume dramas in which all of the action and *dramatis personae* are compressed into a shallow foreground stage. The background serves as a larger tableau of historic moment. *The Death of General Wolfe* is a mise-en-scène of expressive rhetorical devices—the composition modeled on the deposition of Christ, the dramatic smoke of war echoed by an unfurled flag, the decorated Indian representing a strange new world, the grieving soldier pointing to the battle in the background—and West even took the daring step of garbing his figures in contemporary rather than classical dress, thus placing modern and ancient history on the same august plane.

ABROAD

In London, American artists took to this theatricality with great enthusiasm. *Watson and the Shark*, Copley's first history painting, places the horrific event agonizingly close to the viewer, with the action coursing upward to the figure of the black man at the apex of the compositional triangle. Copley's *The Death of Major Peirson* and Trumbull's *The Death of General Montgomery* carry West's dramaturgy to even greater heights of formal complication and, in Trumbull's case, of bravura brushwork and lighting effects. Influenced by Gainsborough and Romney, Gilbert Stuart, on his way to becoming, briefly, one of Great Britain's most sought-after portraitists (and debtors, being rather too well known for his drinking and gambling), evolved a spontaneous style that is exemplified by the nonchalant confidence portrayed in *The Skater*, which apparently owes its unorthodox setting to the complaint of William Grant, the subject, that they might better be skating than sitting in Stuart's cold studio. Washington Allston spent much of his second stay in England painting enormous religious works, such as the thirteen-by-ten-foot *The Dead Man Restored to Life by Touching the Bones of the Prophet Elisha*, following the example of West's late work.

The promise of all this activity and talent dissipated when these artists returned home to the new American republic. In fact, there would be little support for such ambitious aesthetic ideals until well into the 1830s and 1840s, so that those who believed in them—Trumbull, Vanderlyn, Allston, Morse, and others—were to become bitterly disappointed. The alternative, in the meantime, was still the portrait.

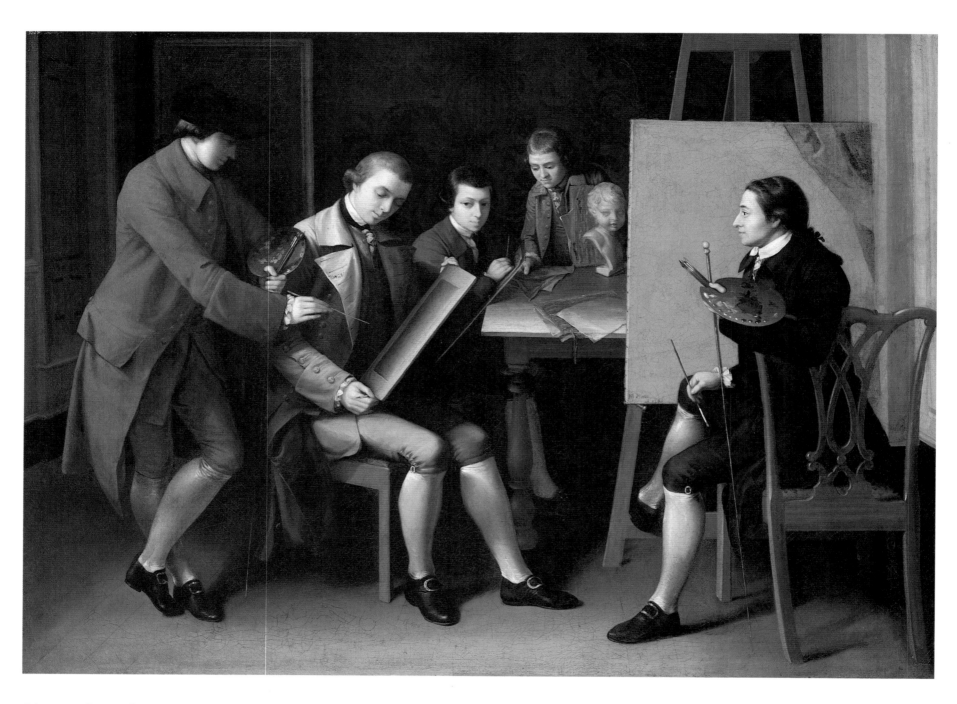

MATTHEW PRATT (b. 1734, Philadelphia–d. 1805, Philadelphia)

The American School. 1765
Oil on canvas. 36 × 50¼"
The Metropolitan Museum of Art, New York City
Gift of Samuel P. Avery

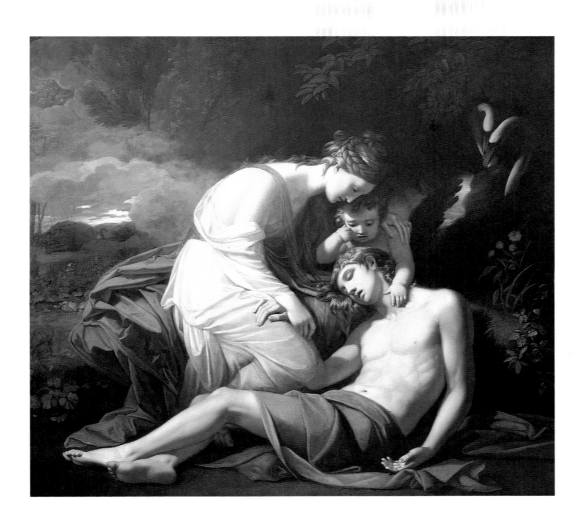

BENJAMIN WEST (b. 1738, Springfield, Pa.–
d. 1820, London)

Venus Lamenting the Death of Adonis.
1768; retouched 1819
Oil on canvas. 64 × 69½″
Carnegie Museum of Art, Pittsburgh

BENJAMIN WEST

The Death of General Wolfe. 1770
Oil on canvas. 60½ × 84″
National Gallery of Canada, Ottawa
Transfer from the Canadian
War Memorials, 1921
(Gift of the 2nd Duke of Westminster,
Eaton Hall, Cheshire, 1918)

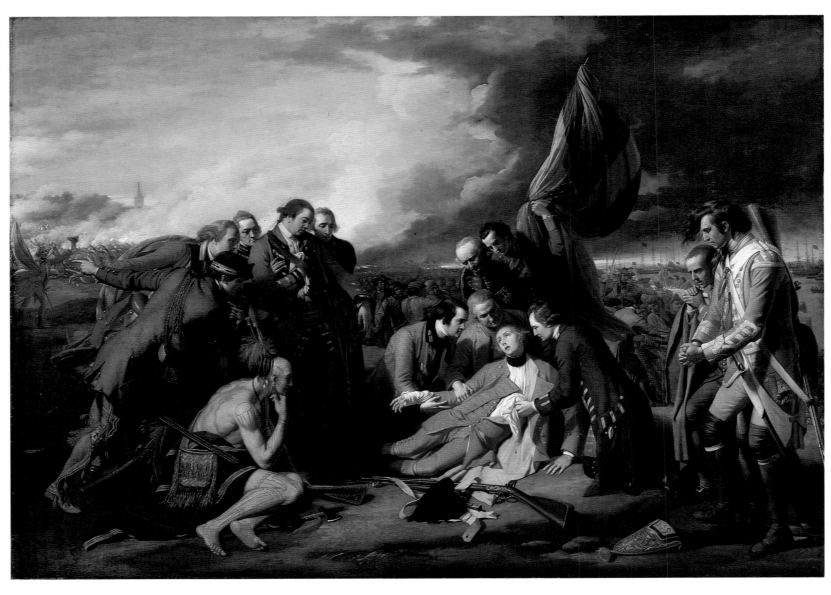

31

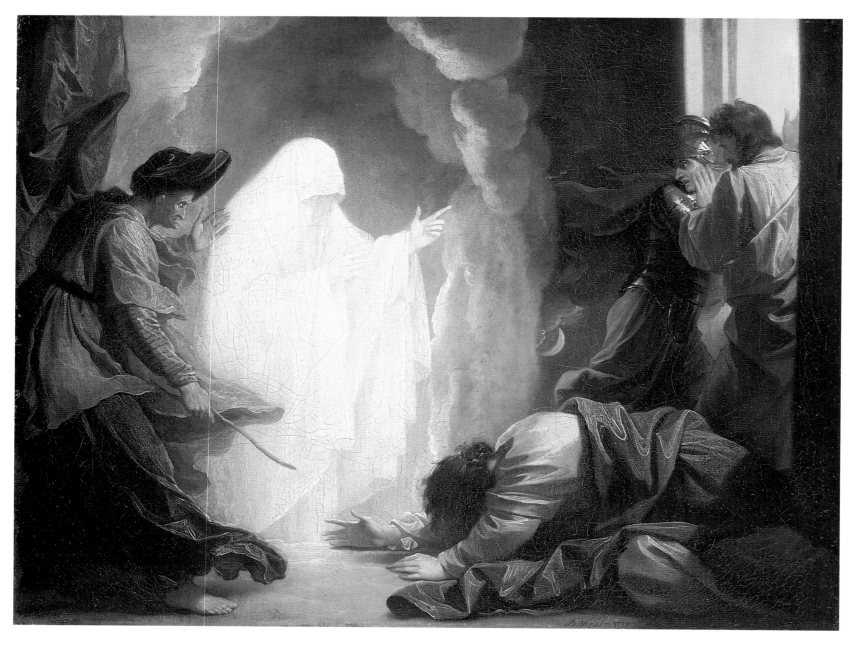

BENJAMIN WEST

Saul and the Witch of Endor. 1777
Oil on canvas. 19¹⁵⁄₁₆ × 25¾″
Wadsworth Atheneum, Hartford, Conn.
Bequest of Mrs. Clara Hinton Gould

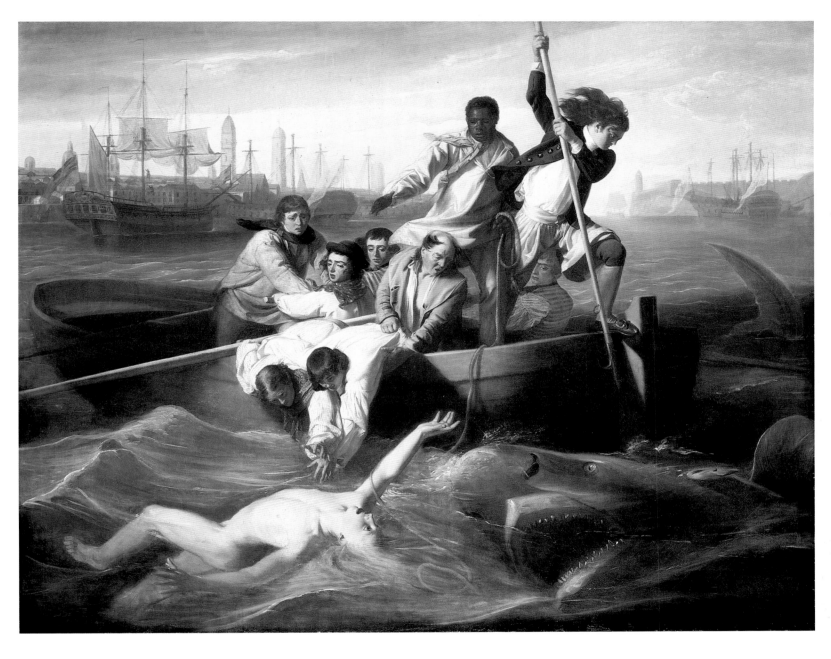

JOHN SINGLETON COPLEY

Watson and the Shark. 1778
Oil on canvas. 71¾ × 90½″
National Gallery of Art, Washington, D.C.
Ferdinand Lammot Belin Fund

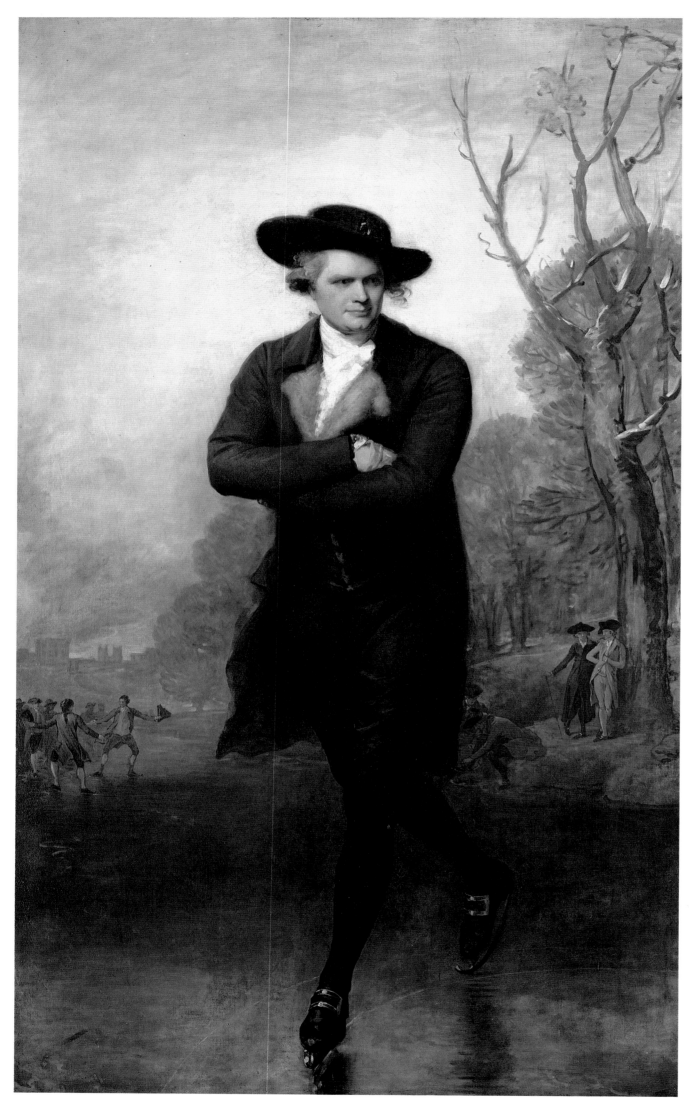

GILBERT STUART (b. 1755, North
Kingston, R.I.–d. 1828, Boston)

*The Skater (Portrait of
William Grant)*. 1782
Oil on canvas. 96⅝ × 58⅛″
National Gallery of Art,
Washington, D.C.
Andrew W. Mellon Collection

OPPOSITE, TOP:

JOHN SINGLETON COPLEY

The Death of Major Peirson. 1783
Oil on canvas. 99 × 144″
Tate Gallery, London

OPPOSITE, BOTTOM:

JOHN TRUMBULL (b. 1756, Lebanon, Conn.–
d. 1843, New York City)

*The Death of General Montgomery
in the Attack on Quebec*. 1786
Oil on canvas. 24⅝ × 37″
Yale University Art Gallery,
New Haven, Conn.

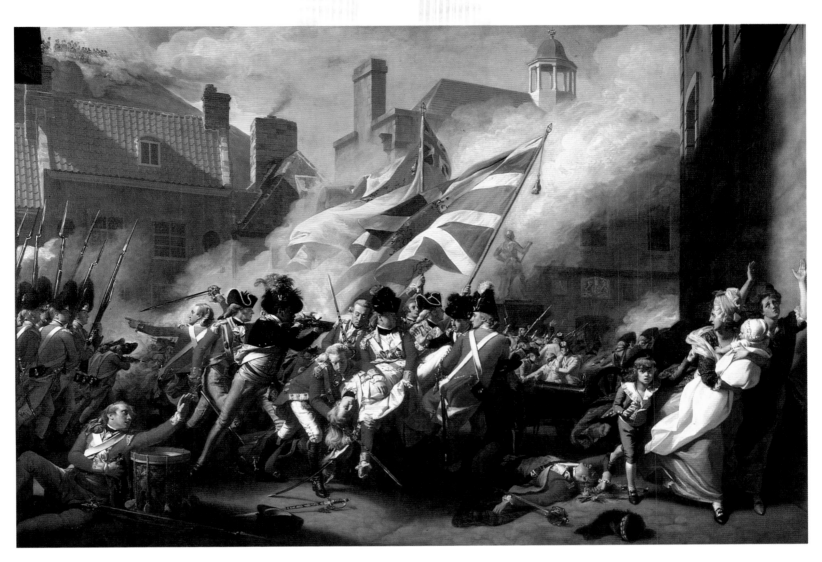

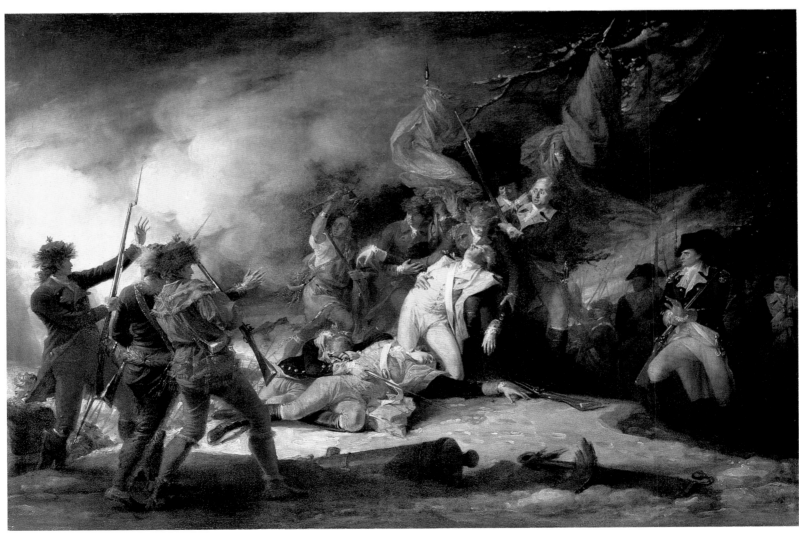

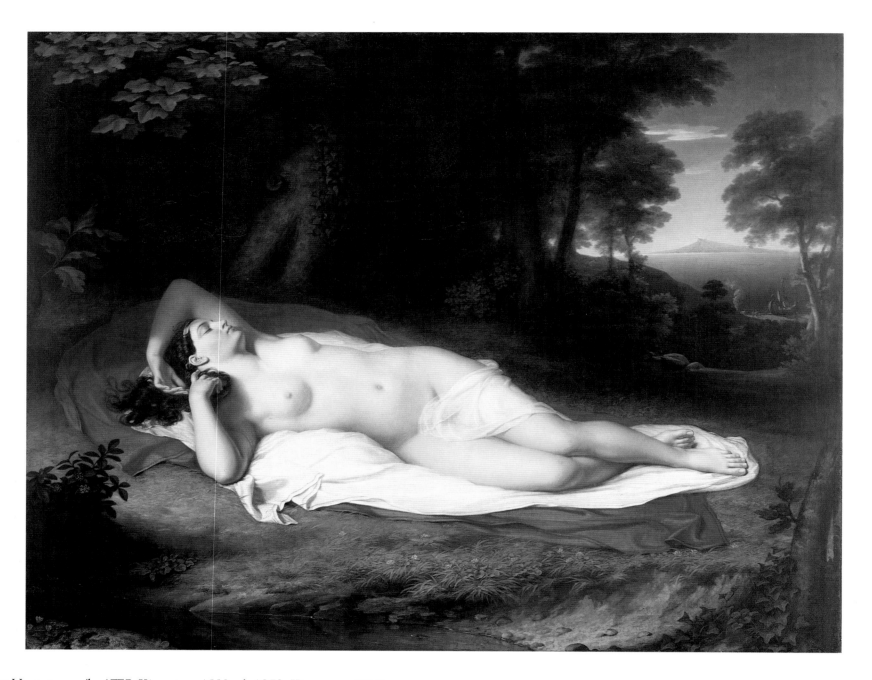

JOHN VANDERLYN (b. 1775, Kingston, N.Y.–d. 1852, Kingston, N.Y.)

Ariadne Asleep on the Island of Naxos. 1809–1814
Oil on canvas. 68½ × 87″
Pennsylvania Academy of the Fine Arts, Philadelphia
Joseph and Sarah Harrison Collection

WASHINGTON ALLSTON (b. 1779, Waccamaw, S.C.–
d. 1843, Cambridgeport, Mass.)

*The Dead Man Restored to Life by Touching
the Bones of the Prophet Elisha*. 1811–1813
Oil on canvas. 156 × 122″
Pennsylvania Academy of the Fine Arts, Philadelphia

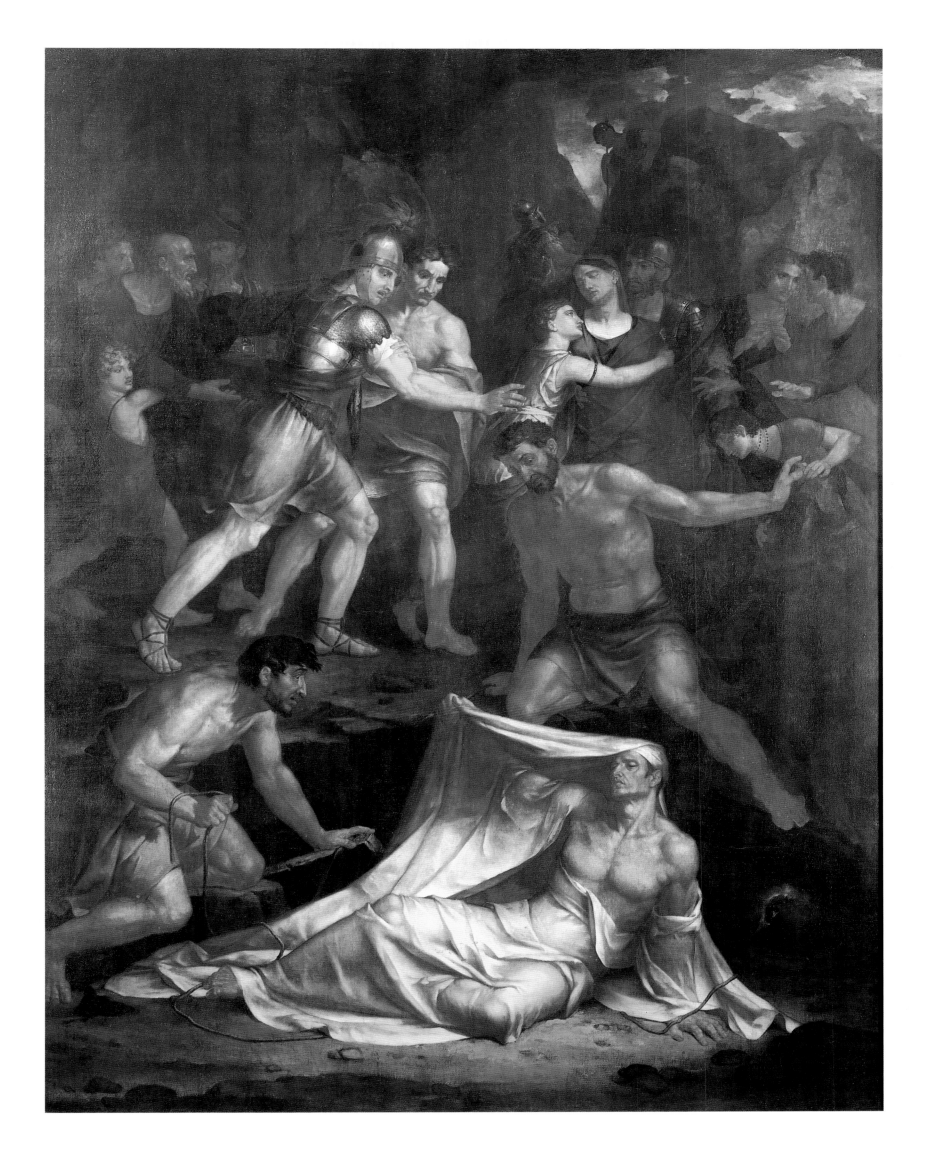

3. Portraits of the New

The birth of a nation did not mean the immediate birth of a new art. Nor was the nation much commemorated by the art that did exist during its first forty years. John Trumbull's ambition in American history painting began during his years in England and France with oil sketches for *The Declaration of Independence*, *The Surrender at Yorktown*, and other subjects (1786–97), all of which are more neoclassically moderate than his earlier battle scenes. But it was not until 1817 that he was commissioned by the federal government to paint monumental versions of these scenes for the new Capitol rotunda. Another twenty years passed before John Vanderlyn was commissioned to paint *The Landing of Columbus* for the rotunda. Samuel Morse had been rejected for the project after years of preparation: a bitter disappointment that ended his painting career.

What all of them did do was paint portraits, despite their loftier aspirations, alongside those who never looked beyond portraiture, such as Gilbert Stuart, Thomas Sully, and John Neagle. Portraiture was the principal medium for celebrating the Revolution, or, rather, the Founding Fathers, most especially George Washington. Charles Willson Peale, who actually served under Washington, painted him from life first and most: before, during, and after the war, fourteen times in all. Rembrandt Peale, accompanying his father, painted a portrait of Washington in 1795 that he then replicated sixty-five times. And Stuart practically mass-produced Washington portraits, turning out at least 114 of them based on three different life versions of 1795–96, including the Vaughn portrait.

It is perhaps curious that a nation conceived in liberty and equality should indulge in what later revolutionaries might call a cult of personality. But focusing on the individuals whose ideals defined the Revolution, rather than glorifying events or manufacturing a program of visual myths, as West and Copley were doing in England, is also disarmingly honest and true to the tradition, indigenous by then, of portraiture and its intense concern with identity.

In a sense, Stuart's portraits were the purest in the genre so far. With no setting or props, and seldom more than waist-length, they concentrate on immediacy in expression of the sitter's personality and of the painter's medium. This directness, which relies on a rapid and almost impressionistic application of paint, is most extreme in the unfinished *Mrs. Perez Morton*, depicting a poet, a member of Washington society who had written in praise of an earlier Stuart portrait of her. Her poem and the painter's response to it are joined in mutual spontaneity.

In his fresh and lively way, Stuart was the first to import the British manner to America, but he was certainly not the last. For a while this new sophistication and painterly skill represented the only distinctive change in postwar art. Portraits remained preeminent, but sophistication replaced untutored awkwardness. Just in time, men could now be shown in command of their surroundings and women could be idealized and classically sentimentalized, as Thomas Sully, taught by Stuart, West, and the fashionable British portrait painter Thomas Lawrence, was wont to do throughout his long, prolific career in Philadelphia.

Copley's pictorial precision gave way to a more flattering and flamboyant theatricality, at its strongest in a painting such as *Pat Lyon at the Forge*, by Sully's student and

REPUBLIC

son-in-law John Neagle. It is the perfect image of a self-made man who, confident in his current success (as a hydraulic engineer), shows himself at his earlier, humbler profession. The painting also gives Neagle the opportunity to remind people of the Philadelphia jail in which Lyon was unjustly held as a young man.

But emphasis on the practical business of portraiture did not entirely dim the hopes of art. Charles Willson Peale continued to create oddly affecting paintings, though his time was increasingly devoted to science and to running his museum of art and natural history in Philadelphia. *The Staircase Group* is an exercise in illusionism that Peale completed by placing a real stair in front of the painted ones. As illusion, the work extols the possibilities of art itself, and it does so in the persons of Peale's own sons, Raphaelle and Titian, his artist-heirs.

For Peale, art was an all-encompassing enterprise that included his family and a wide range of intellectual pursuits. In a country with a limited tradition in art, the museum was for him the locus and symbol of this enterprise, the place where all is revealed by drawing back the curtain. There is something of that faith as well as in Morse's *Gallery of the Louvre*, which heroically and charmingly presents his choice of Europe's great paintings, and perhaps his hopes for the future of American art. Both men struggled valiantly to sustain this larger vision. Both had science to fall back on.

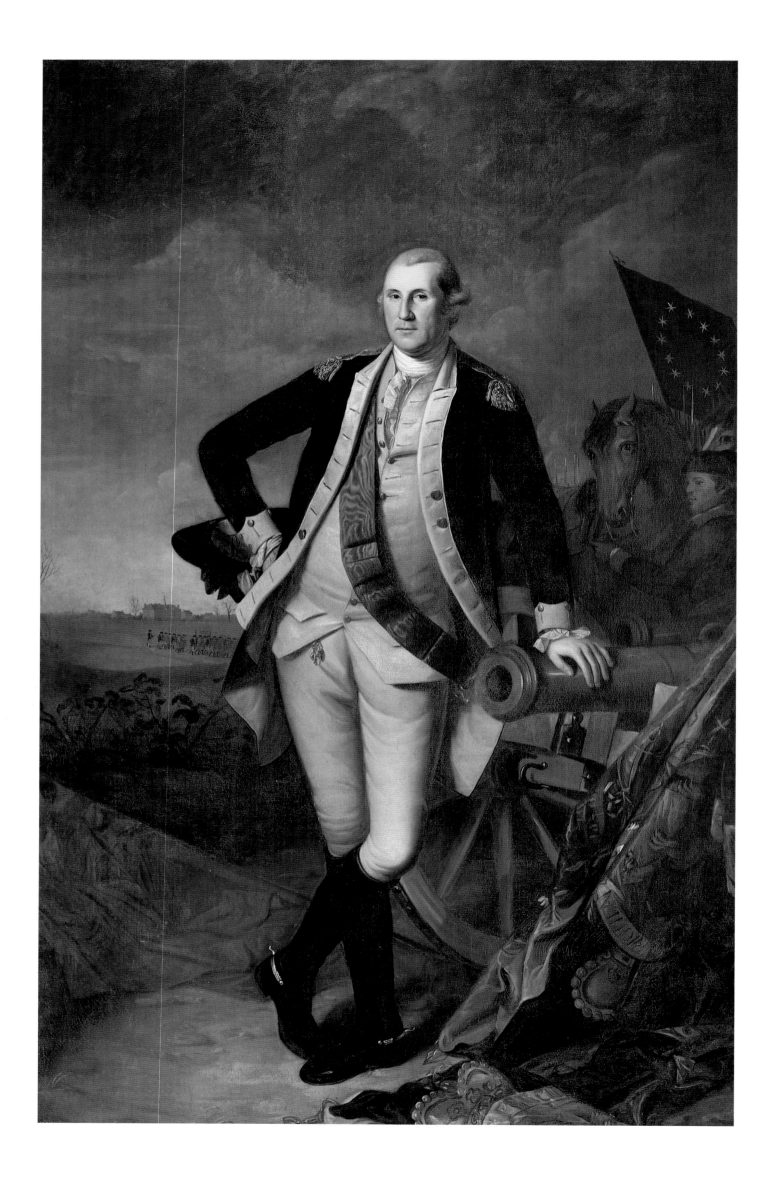

OPPOSITE:

CHARLES WILLSON PEALE

George Washington at Princeton. 1779
Oil on canvas. 93 × 58½″
Pennsylvania Academy of the
Fine Arts, Philadelphia
Gift of Maria McKean Allen and Phebe
Warren Downes through the
bequest of their mother, Elizabeth
Wharton McKean

CHARLES WILLSON PEALE

The Staircase Group. 1795
Oil on canvas. 89 × 39½″
Philadelphia Museum of Art, Philadelphia
George W. Elkins Collection

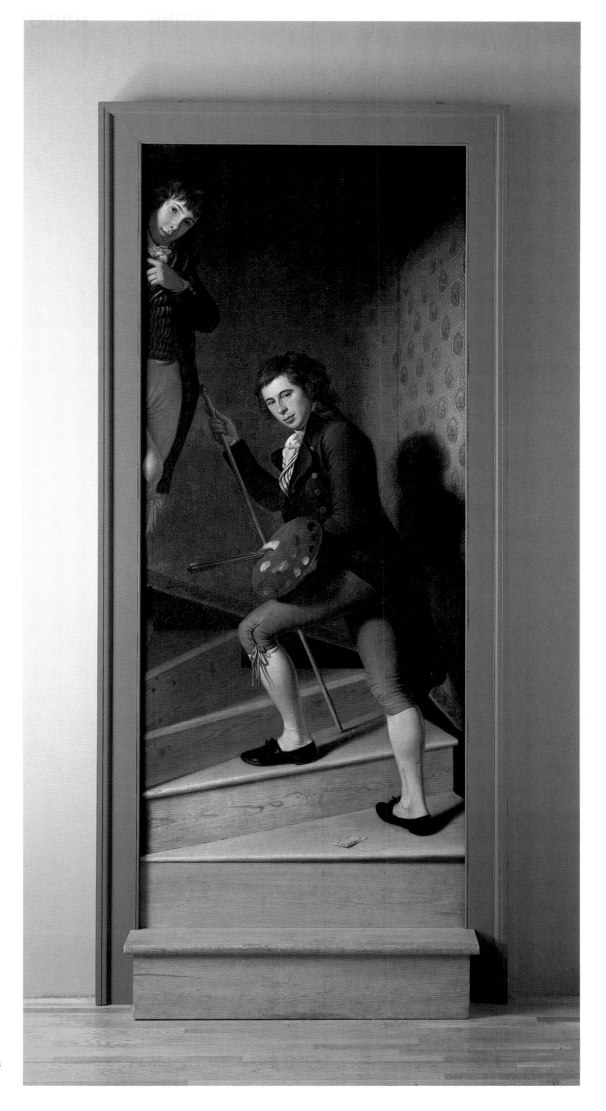

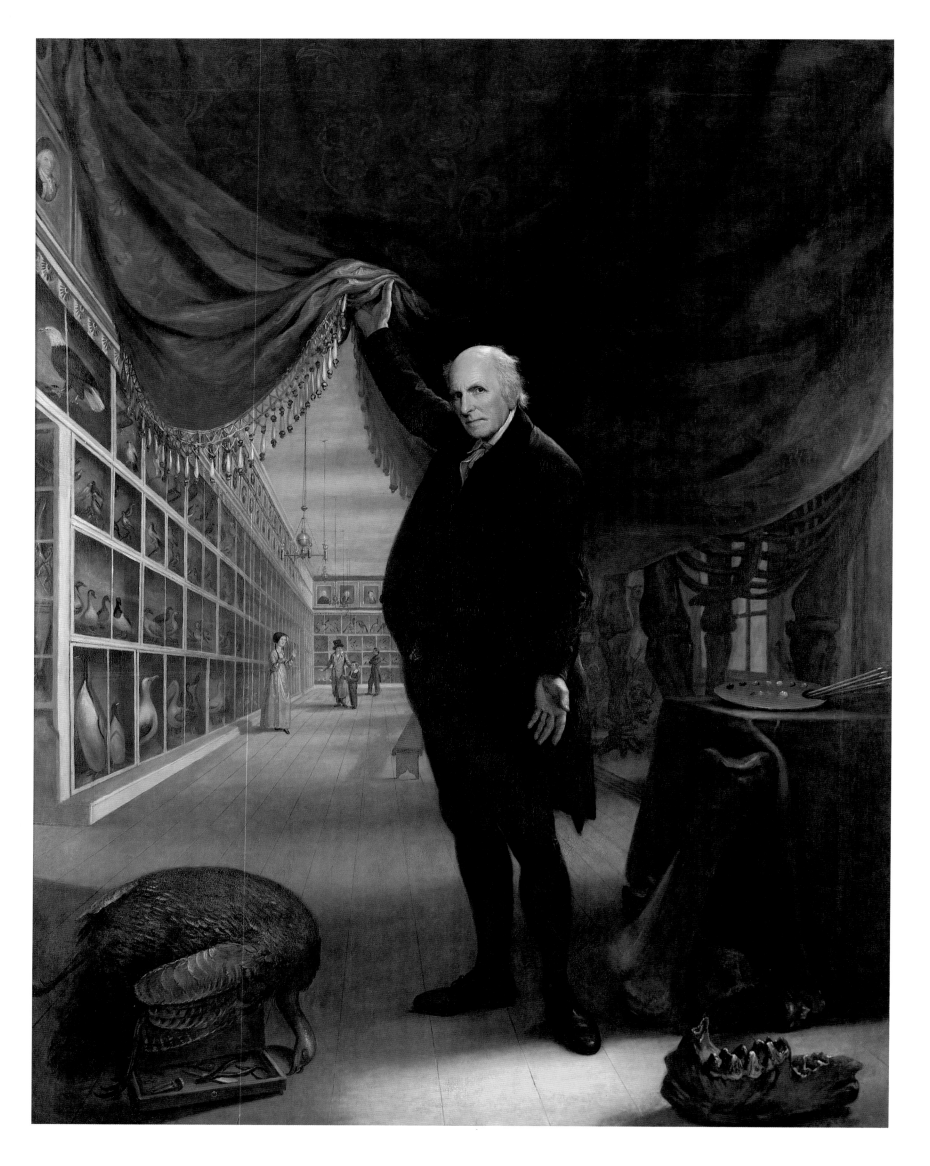

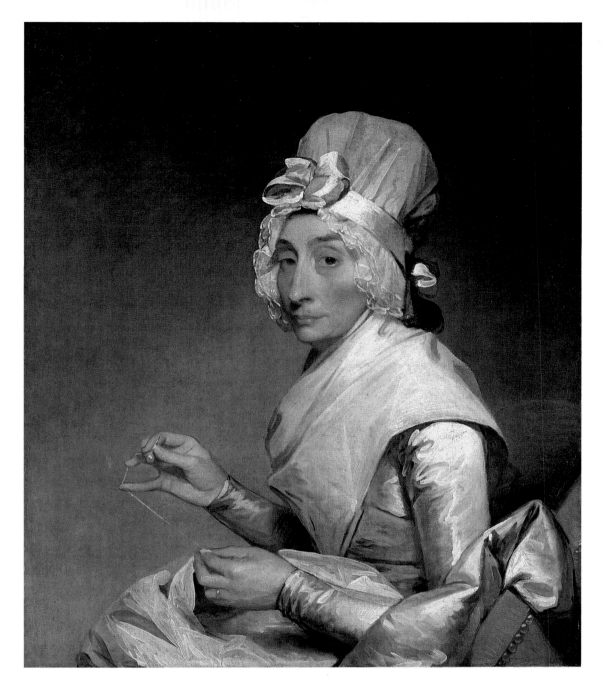

GILBERT STUART

Mrs. Richard Yates. 1793–1794
Oil on canvas. 30¼ × 25"
National Gallery of Art, Washington, D.C.
Andrew W. Mellon Collection

CHARLES WILLSON PEALE

The Artist in His Museum. 1822
Oil on canvas. 103¾ × 79⅞"
Pennsylvania Academy of the Fine Arts, Philadelphia
Joseph and Sarah Harrison Collection

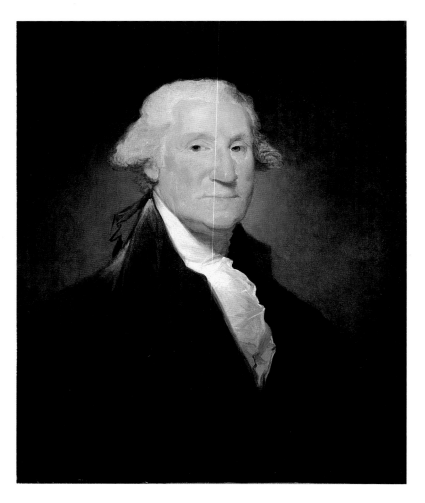

GILBERT STUART

 George Washington (Vaughn portrait). 1795
Oil on canvas. 29 × 23¾"
National Gallery of Art, Washington, D.C.
Andrew W. Mellon Collection

GILBERT STUART

 Mrs. Perez Morton (Sarah Wentworth Apthorp). 1759–1846
Oil on canvas. 29⅛ × 24⅛"
Worcester Art Museum, Worcester, Mass.
Gift of the Grandchildren of Joseph Tuckerman

REMBRANDT PEALE (b. 1778, Bucks County, Pa.–d. 1860, Philadelphia)

 Rubens Peale with a Geranium. 1801
Oil on canvas. 28¼ × 24"
National Gallery of Art, Washington, D.C.
Patrons' Permanent Fund

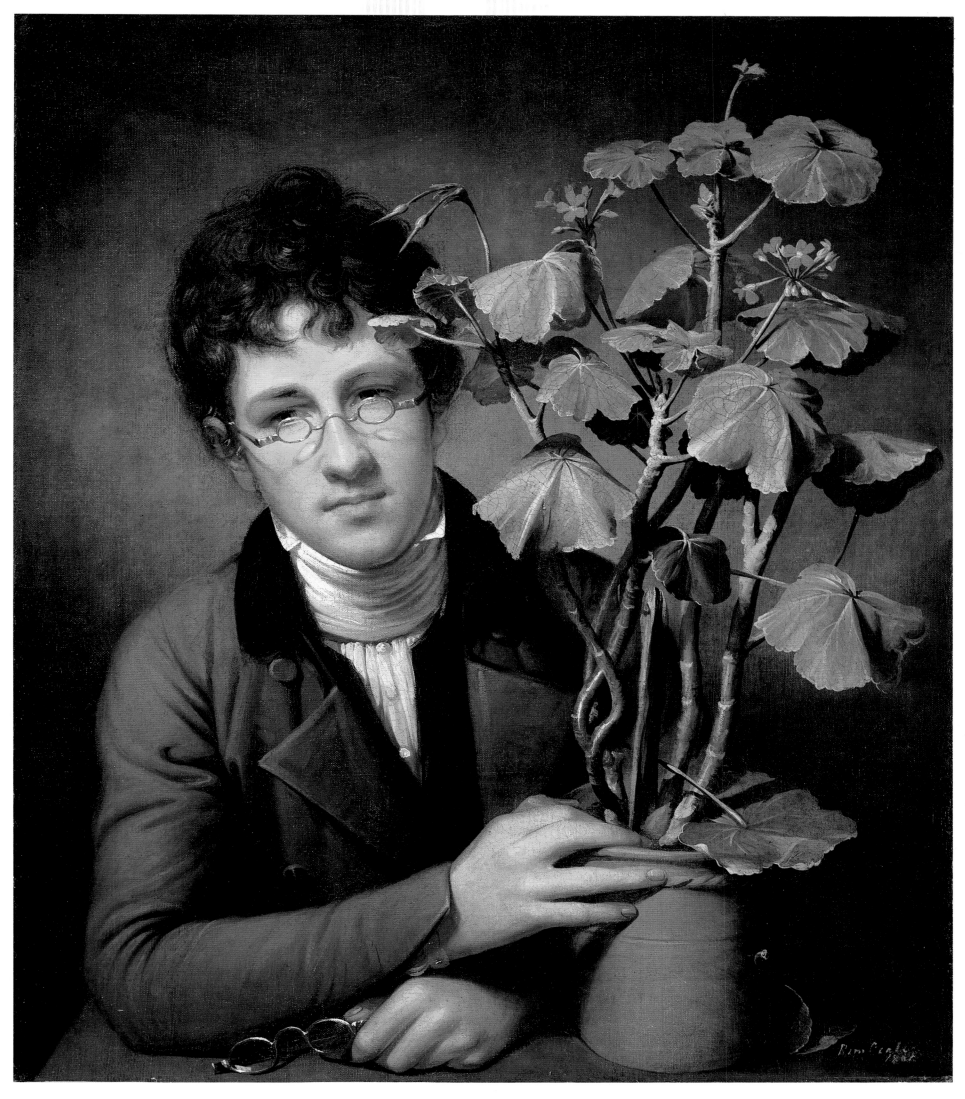

THOMAS SULLY (b. 1783, Horncastle,
England–d. 1872, Philadelphia)

The Sicard-David Children. 1826
Oil on canvas. 34¼ × 44¼"
National Gallery of Art, Washington, D.C.
Chester Dale Collection

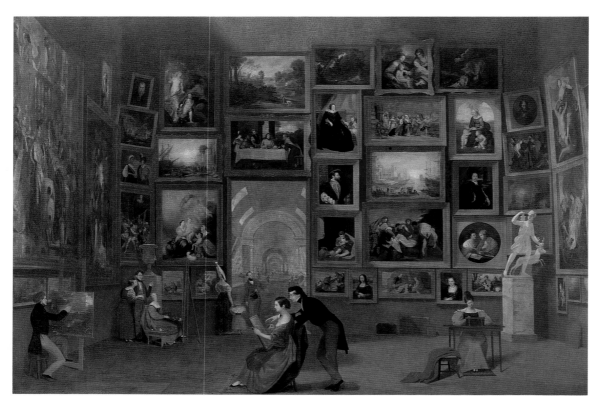

SAMUEL F. B. MORSE (b. 1791, Charlestown,
Mass.–d. 1872, New York City)

Gallery of the Louvre. 1831–1833
Oil on canvas. 73¾ × 108"
Terra Museum of American Art, Chicago
Daniel J. Terra Collection

JOHN NEAGLE (b. 1796, Boston–
d. 1865, Philadelphia)

Pat Lyon at the Forge. 1826–1827
Oil on canvas. 93 × 68"
Museum of Fine Arts, Boston
Herman and Zoe Oliver Sherman Fund

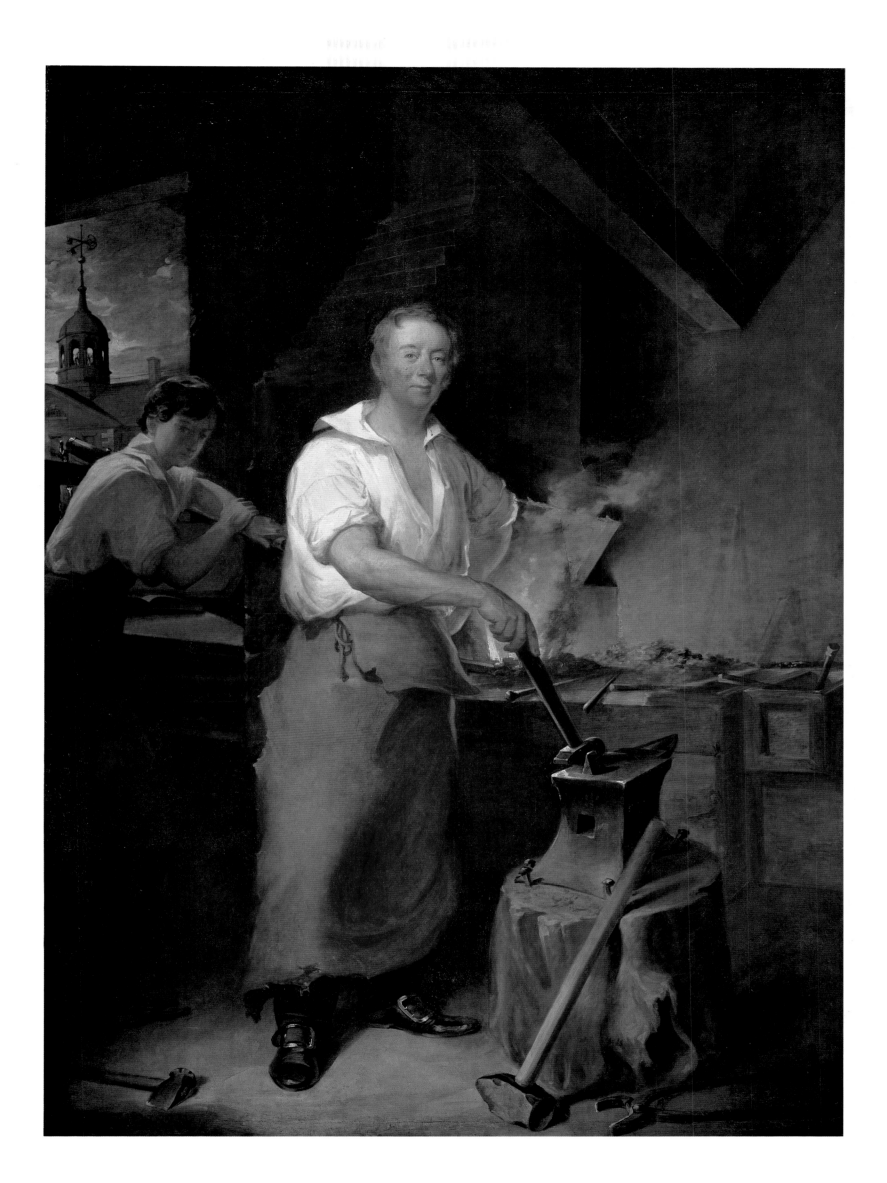

4. THE VOYAGE OF LIFE: COLE
LANDSCAPE

Complementing colonial American portraits were topographical prints: representations of the land. They measured the progress of settlement from Boston to Savannah in the seventeenth and eighteenth centuries. But it was not until after the War of Independence that landscape became an art form with a meaning beyond documentation.

Enthusiasm for landscape followed from the very fact of independence: the emergence of a new nation with its own identity, freed from colonial laws and customs. As a separate and established people, Americans could now contemplate their domain philosophically as well as practically and commercially. In the first forty years, as settlers spread out across the wilderness, interest in the land and its wonders, such as Niagara Falls, accelerated. What eventually appeared was the first distinctive and coherent school of American painting—the Hudson River school—and the beginnings of a landscape movement that was to evolve and change through the rest of the century.

The landscapists accomplished what the frustrated painters of historical, classical, and religious themes could not: the acceptance of an art more portentous than portraiture. Some of the impetus, of course, came from those who had been trained abroad in the grand manner and immersed in the high drama of Romanticism. Though history painting remained for Washington Allston the highest category of art (in keeping with the academic line of West and Reynolds), he found nature, in its vastness and wonder, a fitting theater for the expression of universal emotion. In *Moonlit Landscape*, that emotion is almost literally portrayed, with the moon as the central and single source of light animating the landscape plane by plane: from mountains to trees to bridge to foreground figures and their shadows. The world and its creatures are held in suspension by light that struggles against the darkness.

Allston's landscapes are not real places; they are poetic constructions that evoke an idea of nature and humankind outside of time. But most of the landscapes painted in the United States during the first thirty years of the nineteenth century are of real places—waterfalls, rivers, and forests, country estates and farms, cities and towns. Like portraits, they achieve a likeness, and that is their purpose, with occasional homage paid to the sublimity or drama of some natural phenomenon. This real American landscape, or wilderness, was ultimately perceived as the equivalent of Allston's timeless landscape: as a natural paradise or Garden of Eden. It was this perception, particularly in the work of Thomas Cole, that served as the ideological foundation for the Hudson River painters.

Cole's love of the wilderness developed during the brief time he spent as a young man in Ohio and western Pennsylvania, where his family had moved from England. Discovered by John Trumbull and Asher Durand in New York in 1825, Cole was almost immediately hailed as an American genius. From the very beginning he achieved a merging of the actual and the epic, a realization of landscape as the site of all creative

AND THE PRIMORDIAL

and mythical forces, and of the journey from birth to death. Among his early works were *The Garden of Eden, Saint John in the Wilderness, Scene from "The Last of the Mohicans"* (after James Fenimore Cooper's novel), and *The Subsiding of the Waters of the Deluge*. At the same time, he painted scenes derived from his many sketching expeditions in the Adirondacks, the White Mountains, and the Catskills, where he settled in 1832.

Cole knew both the Old World and the New World, and he spent much of his life exploring both—from the precipitous wall of wilderness in *Falls of the Kaaterskill*, with its remnant Indian figure, to the exquisitely modulated *View of Florence from San Miniato*. He encompassed all human history in "The Course of the Empire" and all of individual human life in "The Voyage of Life." Both these series of paintings were immensely popular in Cole's day, and their mass distribution in engravings made him a national figure. In these and most of his other works, his vantage point remained elevated and distant, as though he could not otherwise embrace enough of the world.

Many later landscapists adopted the same lofty point of view, though with less inclination to mythologize. With his detailed studies of rocks and trees, and his truth-to-nature approach, Durand was often to be found at ground level. Sanford Gifford and John Kensett, like Fitz Hugh Lane and Martin Johnson Heade, were obsessed with light as an atmospheric and poetic medium. And George Inness, turning from the effects of progress (note the railroad in *Lackawanna Valley*) on the real landscape, aspired to an evanescent "expression of feelings" that belongs with developments later in the century. The "heroic" landscape of Cole would return, and then in a different form, only when artists such as Frederick Church and Albert Bierstadt moved south and west.

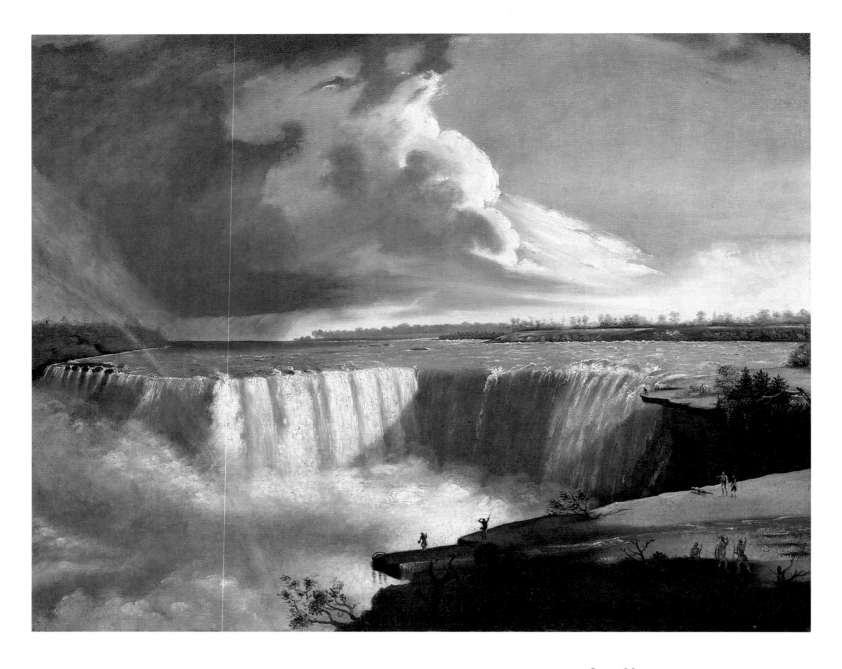

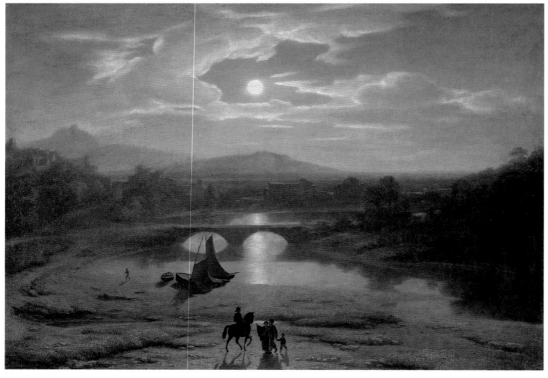

John Vanderlyn

Niagara Falls from Table Rock.
ca. 1801–1802
Oil on canvas. 23½ × 29½"
Museum of Fine Arts, Boston
M. and M. Karolik Collection

Washington Allston

Moonlit Landscape. 1819
Oil on canvas. 24 × 35"
Museum of Fine Arts, Boston
Gift of William Sturgis Bigelow

OPPOSITE:

Asher Durand (b. 1796, Maplewood, N.J.–
d. 1886, Maplewood, N.J.)

The Beeches. 1845
Oil on canvas. 60⅜ × 48⅛"
The Metropolitan Museum
of Art, New York City
Bequest of Maria DeWitt Jesup,
from the collection of her husband,
Morris K. Jesup

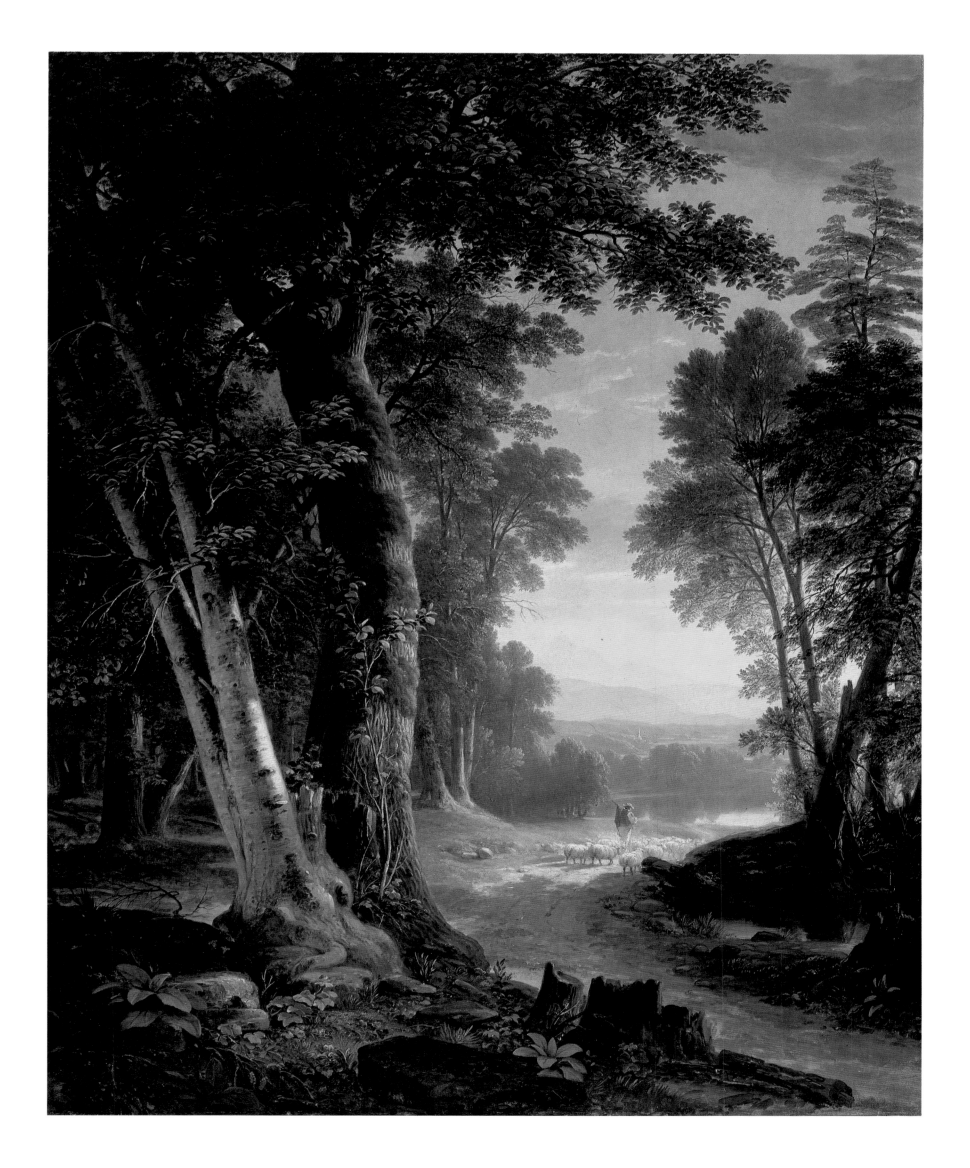

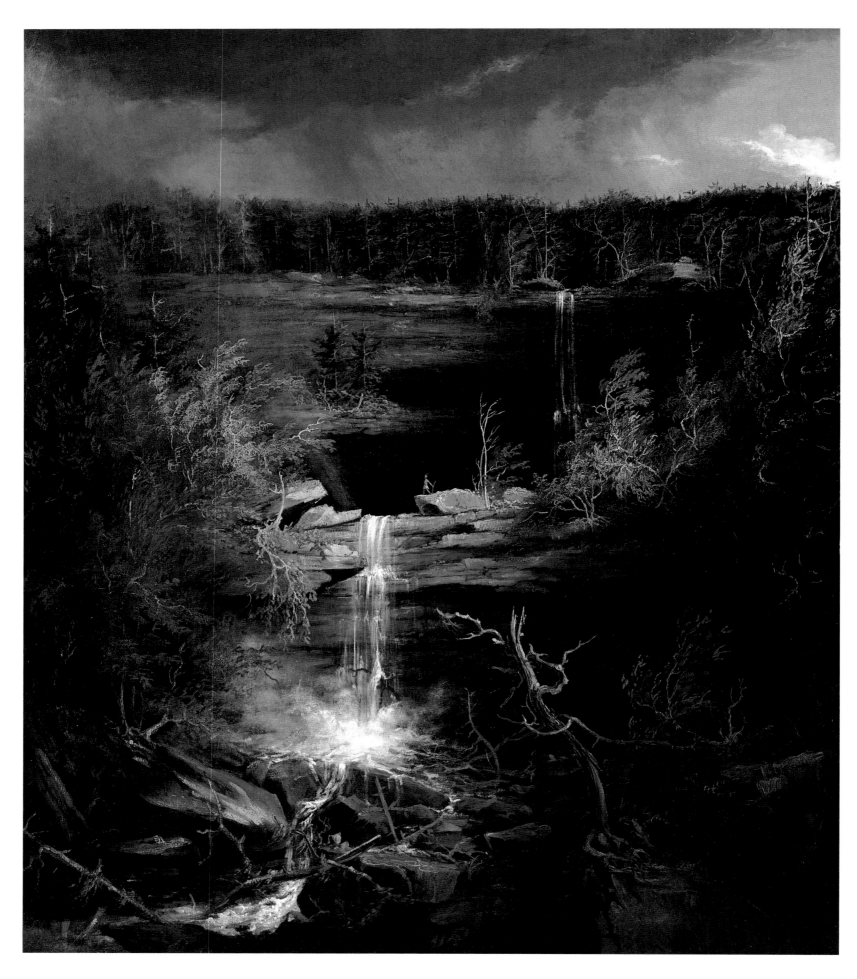

THOMAS COLE (b. 1801, Bolton-le-Moor, England–
 d. 1848, Catskill, N.Y.)

Falls of the Kaaterskill. 1826
Oil on canvas. 43 × 36″
The Warner Collection of the Gulf
 States Paper Company, Tuscaloosa, Ala.

ASHER DURAND

Study from Nature:
Rocks and Trees. ca. 1856
Oil on canvas. 17 × 21½″
The New-York Historical Society,
New York City

THOMAS COLE

The Course of the Empire: Consummation. 1835–1836
Oil on canvas. 51¼ × 76″
The New-York Historical Society, New York City

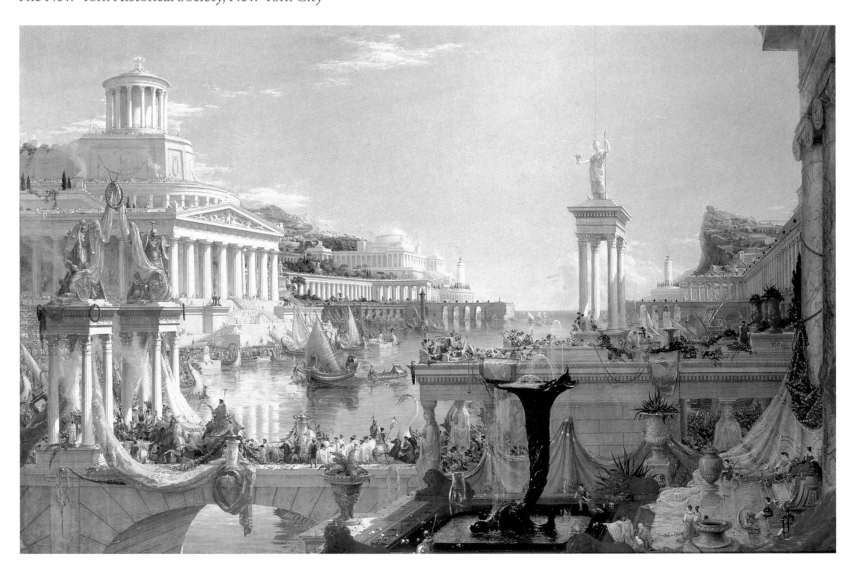

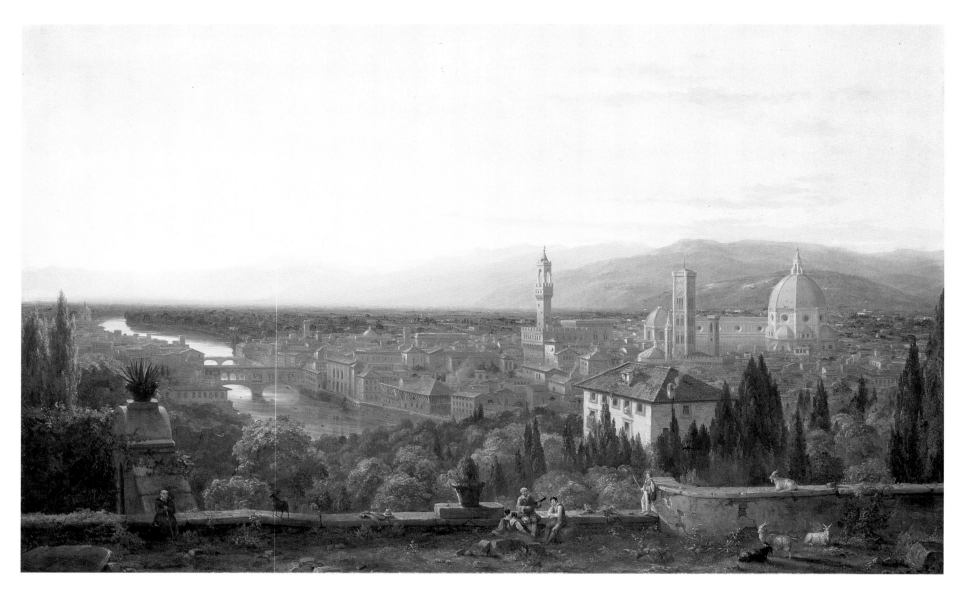

Thomas Cole

View of Florence from San Miniato. 1837
Oil on canvas. 39 × 63⅛″
Cleveland Museum of Art, Cleveland
Mr. and Mrs. William H. Marlatt Fund

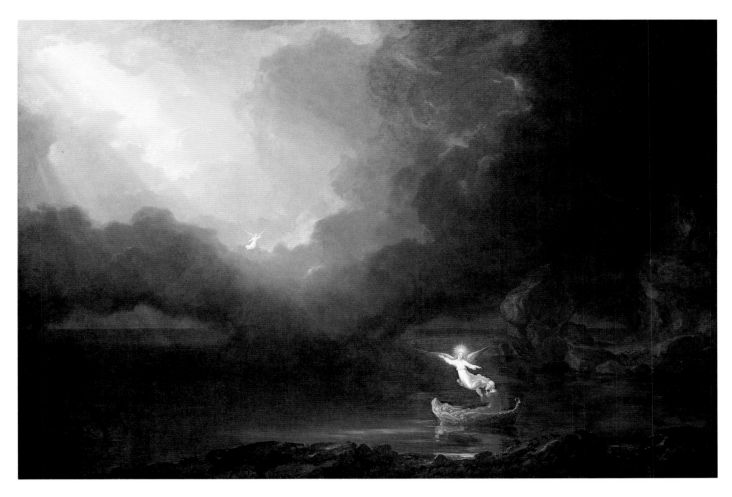

Thomas Cole

The Voyage of Life: Old Age. 1842
Oil on canvas. 52½ × 77¼″
National Gallery of Art, Washington, D.C.
Ailsa Mellon Bruce Fund

Thomas Cole

Genesee Scenery. 1847
Oil on canvas. 51 × 39½″
Museum of Art, Rhode Island
School of Design, Providence
Jesse Metcalf Fund

GEORGE INNESS (b. 1825, Newburgh, N.Y.–
d. 1894, Bridge-of-Allan, Scotland)

The Lackawanna Valley. 1855
Oil on canvas. 33⅞ × 50¼″
National Gallery of Art,
Washington, D.C.
Gift of Mrs. Huttleston Rogers

5. NATURALISTS AND

Emerging at about the same time as Cole, in the 1820s, were several artists who were just as relentless in exploring the American countryside. They were largely self-taught and operated outside the art establishment. Their objectives were more practical, but they were no less passionate about the art through which they promulgated their ideas and observations. In a very focused, even obsessive way, they were dedicated to ideals of brotherhood, humanity, and ecology that still occasionally inspire American art.

John James Audubon was determined to portray all the species of birds in North America, in their natural habitats, and he went to great lengths to do so. From his backwoods treks through Pennsylvania and much of the Northeast, the Ohio and Mississippi Valleys, the Carolinas and Florida, the Missouri and Yellowstone River valleys, he ultimately emerged with watercolors of 489 species. Over a twelve-year span in Scotland and England, Audubon then had the original art translated into oversized color engravings that were published as three portfolios, titled *The Birds of America*, between 1827 and 1838.

The effort and expense were enormous, but Audubon managed to realize his original vision by enrolling an impressive roster of distinguished subscribers in Europe and the United States, despite bitter running battles with competing members of the ornithology and art establishments. It is an unusual and stunning achievement, one that exalts animal life as no other artist had done before him. Exquisitely lifelike in movement and detail, the birds completely dominate their space, dwarfing the landscape and any signs of human settlement that appear. They seem to possess the land, though Audubon certainly understood how precarious their hold was, in the face of the human advance.

Audubon also understood the plight of Native Americans and even reproached George Catlin for romanticizing them. But Catlin, while not as successful in his lifetime, was no less committed to his subject. Between 1832 and 1836 he made several trips into the western territories, where there were still indigenous tribes. Between 1852 and 1860 he made extraordinary tours of South and Central America, and of the west coast of North America up to Alaska. Like Audubon with his birds, he was intent on recording every tribe in North America.

Though Catlin's limitations would have obscured him if he had followed a conventional career (judging from his early portraits, in Philadelphia and New York), he was able, in his direct and summary manner, to capture the spirit of Indian life and of individual people. In its sketchiness and repetitiveness, his work seems more authentic than the detailed renderings by other Indian chroniclers. Recognizing the terrible fate of Native Americans, Catlin remained their sympathetic advocate through a lifetime of touring the United States and Europe with his "Indian Gallery" of art and artifacts, which was finally accepted by the Smithsonian Institution only after his death.

Edward Hicks and Erastus Field stayed in the East—Pennsylvania and Massachusetts, respectively—though Hicks did make a grueling pilgrimage to Niagara Falls and Canada in 1819. Both were rural artists in the colonial tradition: Hicks a carriage and sign painter (and famous Quaker preacher), Field an itinerant portrait painter. Both were

PREACHERS

deeply religious and opposed to slavery; both produced idealized visions of American society. They captured, perhaps, what Trumbull's and Cole's more sophisticated structures could not.

Almost everything in Hicks' paintings is derived from Biblical prints or from works by West, Trumbull, Sully, and others. His work is a selective compendium of Christian and Early American images. *Noah's Ark* comes from a print published by Nathaniel Currier. His best-known subject, of which he did about fifty paintings, usually combines a shorthand version of West's *William Penn's Treaty with the Indians* and an interpretation of Isaiah's Old Testament vision of the Peaceable Kingdom. Using the American landscape as a medium, often with landmarks such as Niagara Falls or the Natural Bridge in Virginia, Hicks projects his allegory of an ideal society into the foreground, separate from the historical event in the background. It is like John the Baptist's announcement of the coming of Christ, and reveals a similar faith.

Field's vision did not take hold until the 1860s, inspired, perhaps, by the divisions leading to the Civil War, and including once again *The Garden of Eden*, that primordial image of American wholeness. After the war, Field created his magnum opus, the *Historical Monument of the American Republic*, a nine-by-thirteen-foot painting in which American history is detailed in reliefs and inscriptions covering a fantastic ten-towered structure. It is a vision that outdoes even Cole's *The Consummation of Empire*, but one that is meant to withstand the erosions of time and human folly.

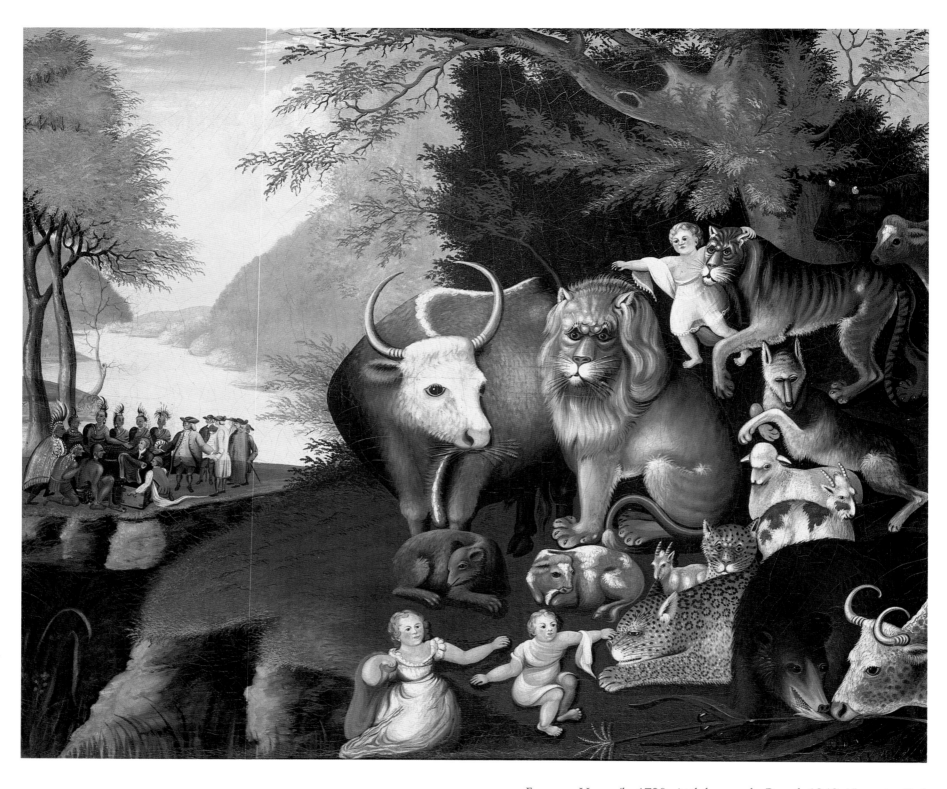

EDWARD HICKS (b. 1780, Attleborough, Pa.–d. 1849, Newton, Pa.)

Peaceable Kingdom. ca. 1834
Oil on canvas. 30 × 35½″
National Gallery of Art, Washington, D.C.
Gift of Edgar William and Bernice Chrysler Garbisch

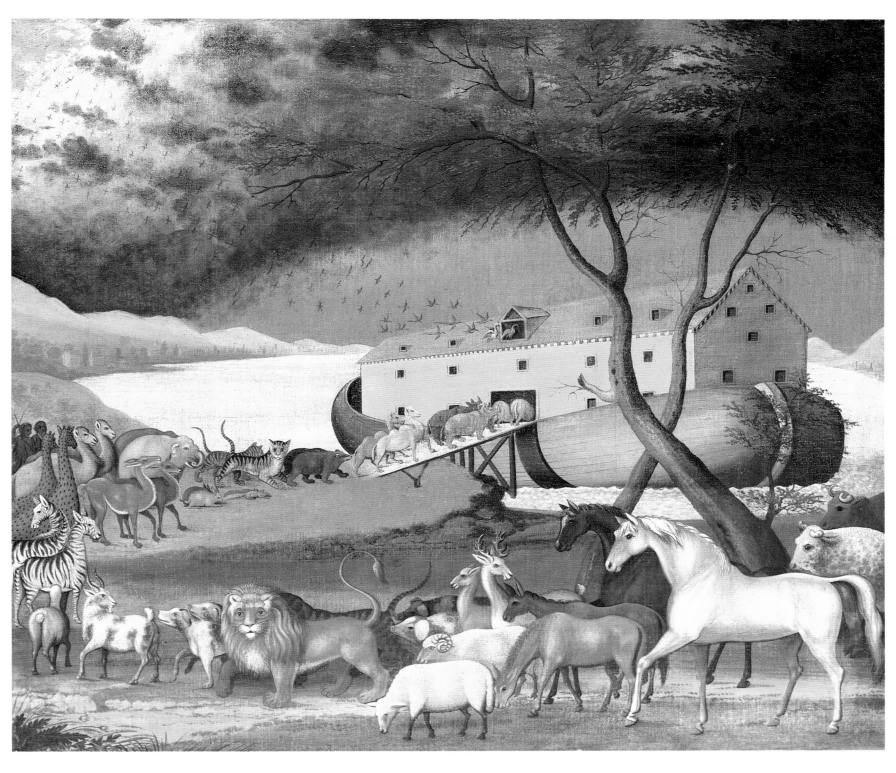

EDWARD HICKS

Noah's Ark. 1846
Oil on canvas. 26½ × 30½″
Philadelphia Museum of Art, Philadelphia
Bequest of Lisa Norris Elkins

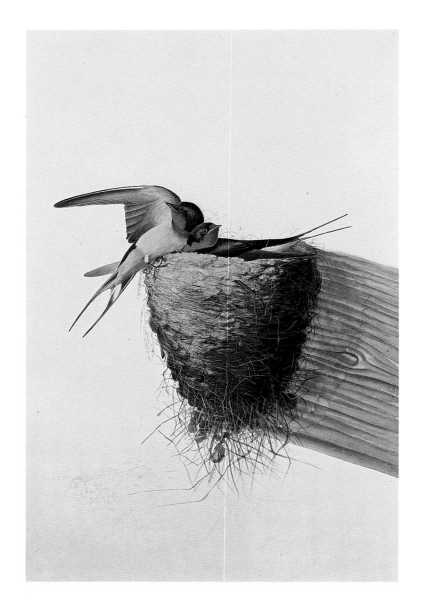

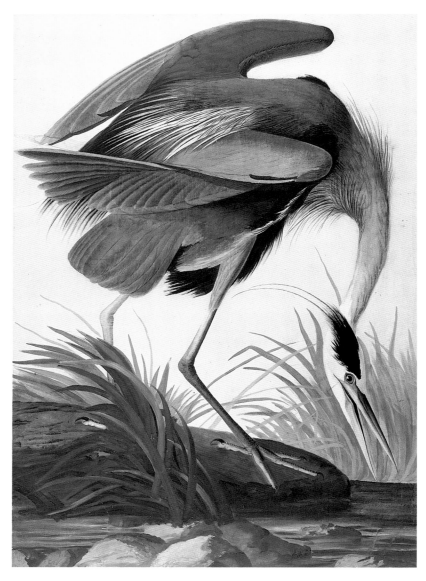

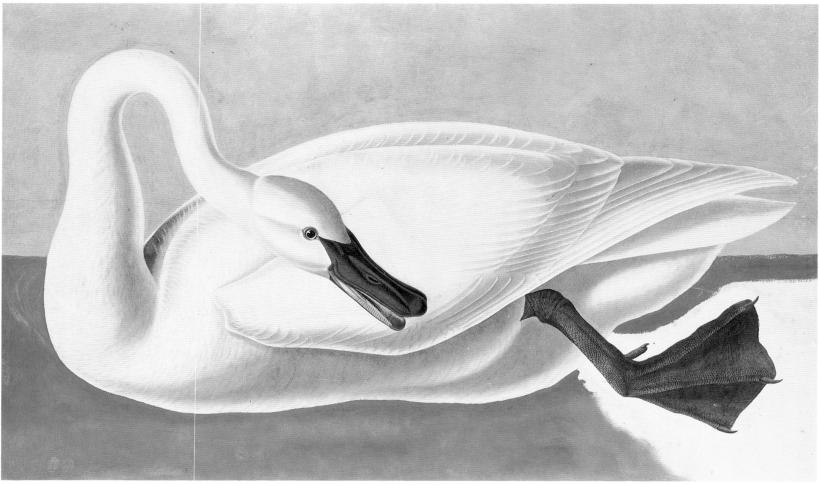

John James Audubon

Barn Swallow. 1832
Watercolor on paper. 20¾ × 13½″
The New-York Historical Society,
New York City

John James Audubon

Great Blue Heron. 1821
Watercolor on paper. 36 × 25¼″
The New-York Historical Society,
New York City

John James Audubon (b. 1785, Les Cayes,
Haiti–d. 1851, New York City)

Trumpeter Swan. ca. 1836–1837
Watercolor on paper. 23 × 37⅝″
The New-York Historical Society,
New York City

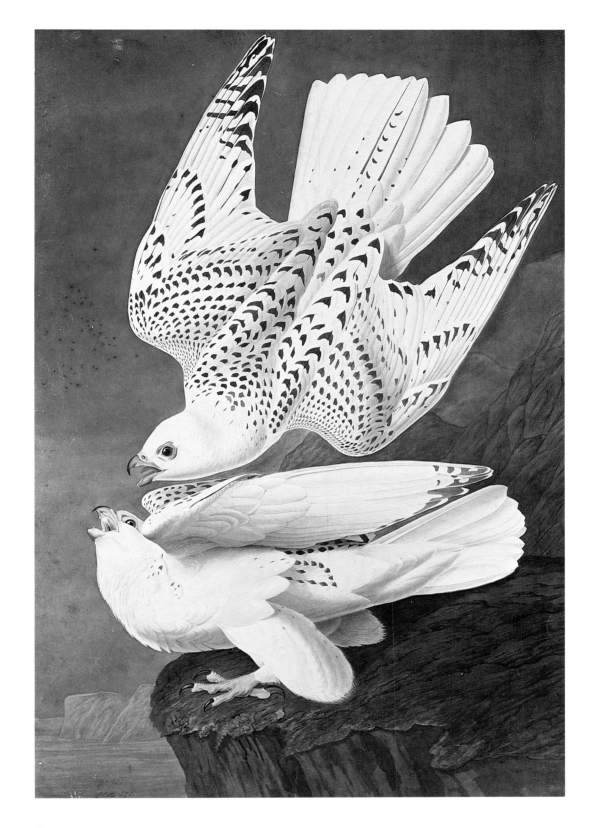

John James Audubon

Gyrfalcon. ca. 1835–1836
Watercolor on paper. 38¼ × 25½″
The New-York Historical Society, New York City

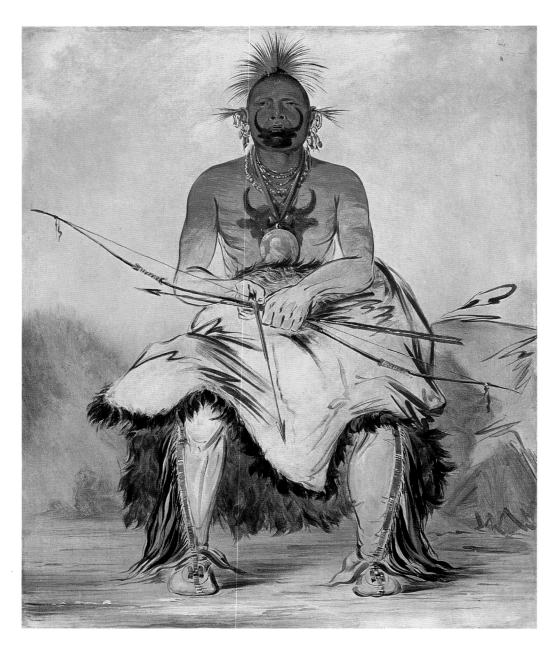

GEORGE CATLIN (b. 1796, Wilkes-Barre, Pa.–d. 1872, Jersey City, N.J.)

Buffalo Bull—A Grand Pawnee Warrior. 1832
Oil on canvas, mounted on aluminum. 29 × 24″
National Museum of American Art, Smithsonian Institution, Washington, D.C.
Gift of Mrs. Joseph Harrison, Jr.

GEORGE CATLIN

Buffalo Bulls Fighting in Running Season, Upper Missouri. 1837–1839
Oil on canvas. 24 × 129″
National Museum of American Art, Washington, D.C.
Gift of Mrs. Joseph Harrison, Jr.

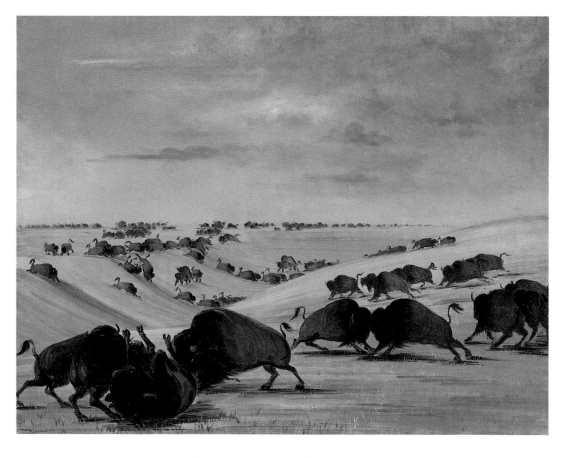

ERASTUS FIELD (b. 1805, Leverett, Mass.—d. 1900, Sunderland, Mass.)

The Garden of Eden. 1865
Oil on canvas. 35 × 41½″
Shelburne Museum, Shelburne, Vt.

6. LUMINISM

Around 1850, a certain kind of light began to appear in the work of widely disparate artists, from Gloucester, Massachusetts, to St. Louis, Missouri. It is an expectant light that fills the air with silence and promises revelation, a quality that suggests kinship with the revelatory philosophy of transcendentalism. The reasons for its manifestation in painting are not clear. A comparable movement had started earlier in Scandinavia and Germany but probably had little influence on Americans. And there was neither much notice of luminism as a trend nor much contact among the artists involved; the term "luminism" was applied only later.

A drama of light had, in fact, been more pronounced in American painting since Copley than in other national schools. Copley's play of light, shadow, and reflection sets up a bold interaction between primary and secondary perceptions. Allston's landscapes, and even some of his figural paintings, seem to glow from within. And Cole's usage ranges from highly theatrical representations of godhead in "The Voyage of Life" to serene views of Florence and of lakes stunned by light. Thus Cole would be a model both for the fireworks of Church and Bierstadt and for the quietistic reveries of Fitz Hugh Lane and Martin Johnson Heade.

Lane and Heade—and perhaps John Kensett and George Caleb Bingham in his early river paintings—are the purest exemplars of luminism, partly because their subject matter called for it. The United States was, after all, a maritime nation, founded by sailors and dependent on shipping. A large proportion of its inhabitants, then as now, lived in great port cities and smaller villages along its coast. After several decades of obsession with the interior and its wilderness, a number of artists turned to the coast and its less obviously varied but equally potent scenery; its joining of sky, sea, and land in a structure suffused with light. The subject has fascinated painters well into the twentieth century.

The paragon for any landscapist was the seventeenth-century French painter Claude Lorrain, who was no less instructive for marine painters. His port scenes, with sunset and sunrise skies blending effortlessly into water, epitomize the contemplative mode. Lane, Heade, and others also probably looked to the more mundane light-filled shipping scenes of seventeenth century Holland and to the delicate eighteenth-century port scenes of Claude-Joseph Vernet.

It is perhaps not surprising, then, that Lane and Heade stress balance and precision, even when the mood or the weather suggest turmoil or tragedy. They continue an elegiac tradition, but in an intensified, compact form. The paintings are distillations of time, space, light, shape, color, and composition, reducing wide panoramas, beyond the eye's real scope, to crystalline miniatures that require close attention to detail by the artist and the viewer. Everything is perfectly realized—water, rocks, sand, ships, clouds, figures—and perfectly placed between foreground and horizon.

For Lane, who spent years as an engraver of maritime scenes and lived practically his entire life in the coastal town of Gloucester, the view is almost always outward, to the ships and the sea. Light seems to expand into the sky and to dematerialize images. Heade, who studied briefly with Edward Hicks and then in Europe, focuses inward,

from the sea toward the land in the case of the marsh scenes from Massachusetts to Florida he painted throughout his life. Misty, dark, or stormy skies force the view forward, as do barriers created by rocks and by left and right diagonals aiming out of the picture. Heade's inward focus led him to the rain forests of South America—the source of life—and to tropical flora and fauna—orchids and hummingbirds—which he continued to paint after his return. The hummingbirds, which he called "the gems of Brazil," are fitting miniature symbols of Heade's search for perfect natural beauty.

Both John Kensett and Sanford Gifford knew Heade, but their attachments were to the Hudson River School and to a somewhat different approach to light and landscape. In the tradition of Cole and Durand, their work is based on close observation and on the idea that nature itself is sublime and picturesque.

Kensett, who concentrated on coastal scenery during the last fifteen years of his life, used light as a unifying force; it seems to suffuse everything equally. The forms of land, sea, and sky became increasingly simplified in his later work, and he achieved a subtle range of color and light effects within a very narrow compass. One of his last works simply juxtaposes an orange sky and rippled sea, joined at the horizon.

Light as an overwhelming presence, as a veil through which the world is seen, reaches its climax in a number of works by Sanford Gifford after 1860. In *October in the Catskills*, a reworking of an earlier painting, Gifford adopts the epic Hudson River point of view, high above the land; now it has become a pure emanation of light, a ghostlike remembrance of time past.

FITZ HUGH LANE (b. 1804, Gloucester, Mass.–d. 1865, Gloucester, Mass.)

Boston Harbor. 1850–1855
Oil on canvas. 26¼ × 32″
Museum of Fine Arts, Boston, Mass.
M. and M. Karolik Collection, by exchange

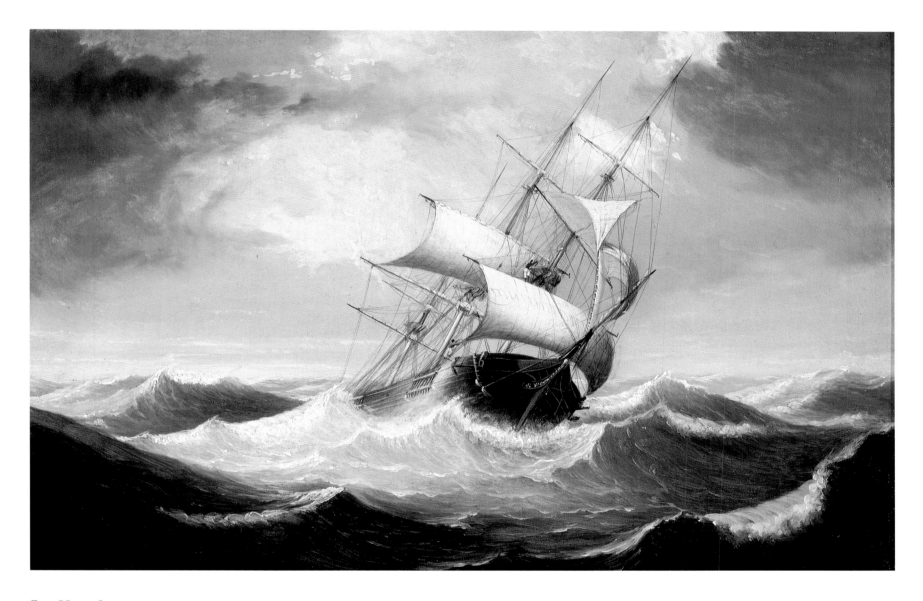

FITZ HUGH LANE

Three-Master in Rough Sea. 1856
Oil on canvas. 10½ × 15¾"
Cape Ann Historical Association, Gloucester, Mass.
Gift of Caroline W. Trask

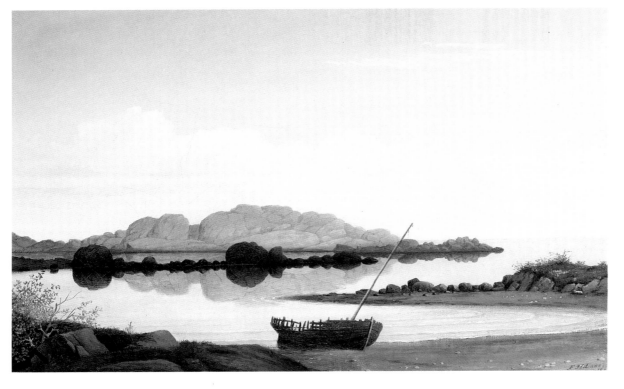

FITZ HUGH LANE

Brace's Rock, Brace's Cove. 1864
Oil on canvas. 10 × 15″
Terra Museum of American
Art, Chicago
Daniel J. Terra Collection

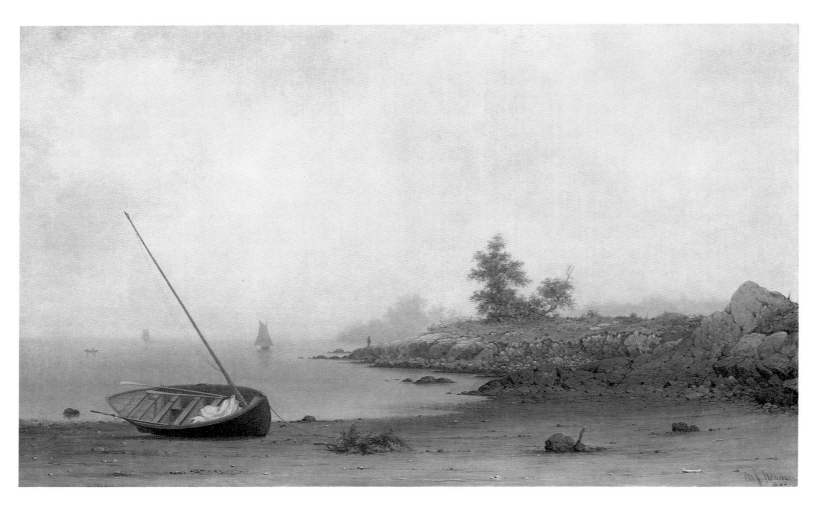

MARTIN JOHNSON HEADE
(b. 1819, Lumberville, Pa.–
d. 1904, St. Augustine, Fla.)

The Stranded Boat. 1863.
Oil on canvas. 22¾ × 36½″
Museum of Fine Arts, Boston
M. and M. Karolik Collection

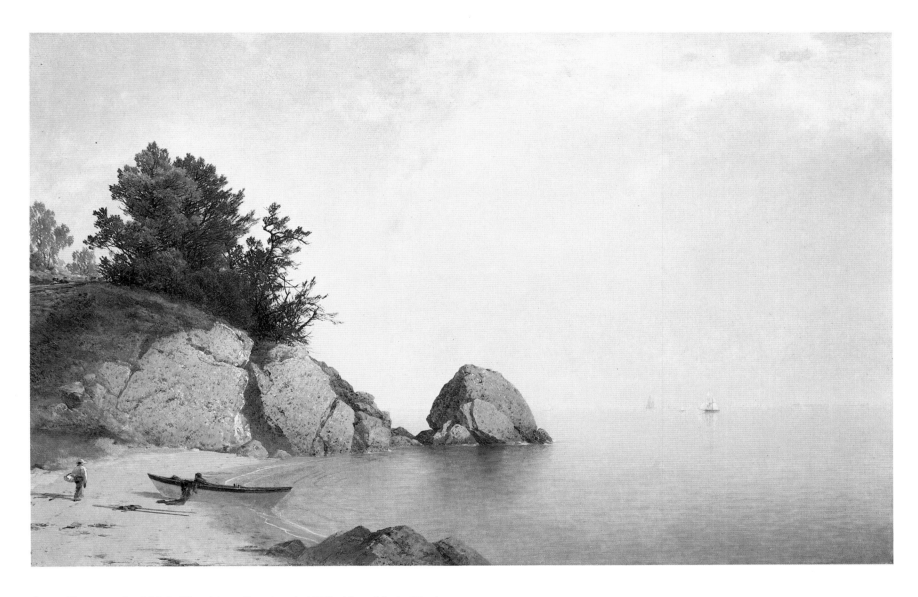

JOHN KENSETT (b. 1816, Cheshire, Conn.–d. 1872, New York City)

Beach at Beverly. ca. 1869–1872
Oil on canvas. 22 × 34″
National Gallery of Art, Washington, D.C.
Gift of Frederick Sturges, Jr.

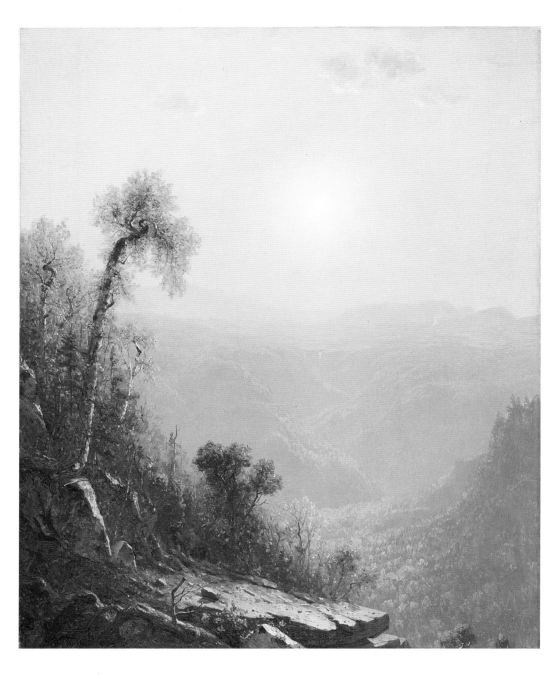

SANFORD GIFFORD (b. 1823, Greenfield, N.Y.–
d. 1880, New York City)

October in the Catskills. 1880
Oil on canvas. 36⅜ × 29⅜″
Los Angeles County Museum of Art, Los Angeles
Gift of Mr. and Mrs. Charles C. Shoemaker,
Mr. and Mrs. J. Douglas Pardee and
Mr. and Mrs. John McGreevey

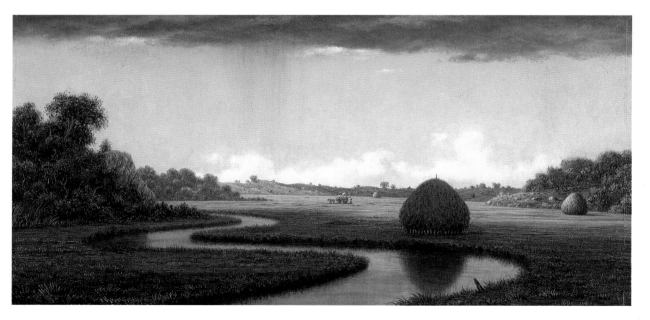

MARTIN JOHNSON HEADE

Newburyport Marshes: Passing Storm. ca. 1865
Oil on canvas. 15 × 30″
Bowdoin College Museum of Art, Brunswick, Me.

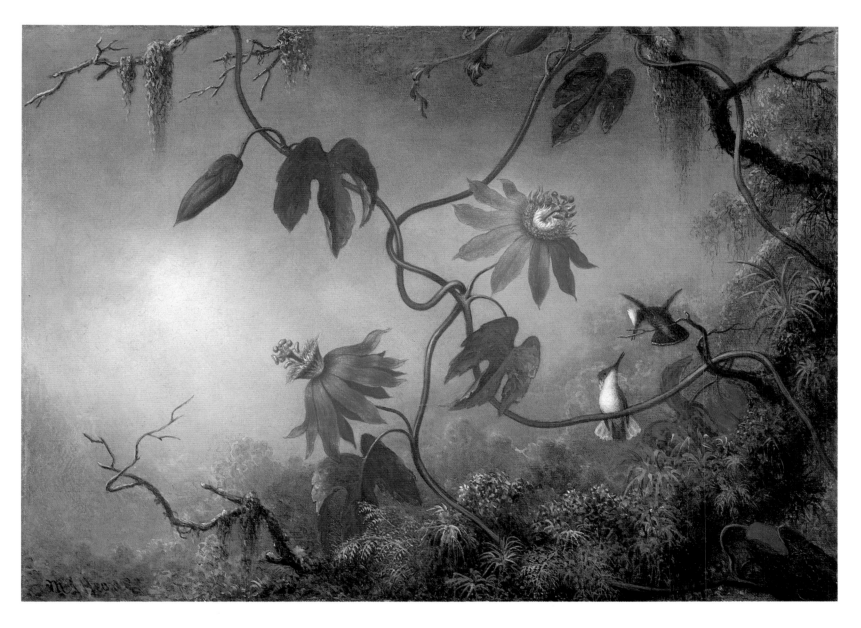

MARTIN JOHNSON HEADE

Passion Flowers and Hummingbirds. ca. 1865
Oil on canvas. 15½ × 21½″
Museum of Fine Arts, Boston
Gift of Maxim Karolik for the Karolik Collection of American Paintings

7. THE HEART OF THE ANDES:

Heade's trip to South America in 1863 was inspired by his good friend Frederick Edwin Church, who was by that time the country's most celebrated artist. Cole's favorite pupil, Church had already staged a remarkable series of public exhibitions. Several of his huge paintings, including *Niagara*, *Heart of the Andes*, and *Cotopaxi*, sold for enormous prices and toured, one by one, several major cities in the United States and Great Britain. For a ten-year period he was the most acclaimed and successful artist in the English-speaking world.

Church had traveled to Colombia and Ecuador in 1853 and 1857. By defeating Mexico in 1848, the United States had expanded its territory to include what is now New Mexico, Arizona, California, Nevada, and Colorado. The ensuing westward migrations were complemented by the frenzy of the gold rush to California. People trekked across the country by land, but they also got there by sailing to Central America, clambering across land to the Pacific, and sailing north to San Francisco. On Church's second trip, he was able to cross Panama on an American-owned railroad, which by 1859 would net six million dollars. Even as he explored one Andean mountain after another, the United States was inexorably extending its territory, interests, and influence both west and south.

Church himself was gobbling up the world. Even more voracious than his teacher, he drew and sketched in oil everything in his path—trees, rocks, flowers, mountains, clouds, waterfalls, icebergs—as he toured the Hemispheres, from the Catskills to Connecticut, Maine, South America, Labrador, Jamaica, Europe, and the Near East, and finally back to the Hudson, where he built a house in 1872 that gave him henceforth a spectacular view. He was the great cataloguer, a synthesizer of science and art who was determined to encompass everything in God's creation, from the tiniest plant and finest geological distinction to the most breathtaking sweep of molten land and sky.

Church might have appreciated the sweep and ambition of Jackson Pollock's work in the 1940s, and his statement "I am nature." The two painters' similarities also include a contradiction that is perhaps characteristic of American art. A bold projection of ego, evident in the size of the paintings and the distinctive, signature style of each artist, is attended by a loss of the same ego in oceanic spaces that have no stable reference points. The desire is to be overwhelmed by the subject, to go through the window created by art, thus assuming a theological function for art itself.

No less theological is Albert Bierstadt, who was born in Germany, returned there for artistic training at the Düsseldorf Academy, and then, from his first trip west, in 1859, became the quintessential artist of America's expansion to the Pacific. Lander's Peak, in the Rockies, and the Sierra Nevada, in California, are seen with the same kind of spiritual exaltation as Church's southern and eastern landmarks. They rise like the walls of great Gothic cathedrals into realms of light where the deity seems to reside. Some paintings, such as *Shore of the Turquoise Sea*, have a lurid grace that repeats nature's most garish and outrageous moments.

But whereas Church, despite his theatricality, ultimately offers a rather impersonal overview, Bierstadt insists on the pathos of living things and on connections between

JOURNEYS TO THE INTERIOR

the viewer and the landscape. The prospect is generally upward from near ground level rather than downward from high above it. We are immediately introduced to an extended and detailed genre scene of Indian life or to an alert stand of deer and waterfowl that seems to invest the entire landscape with life. In later works, such as *Shore of the Turquoise Sea* and *Last of the Buffalo*, the central trope is often a tragic one. One the most compelling images of the period, *Wreck of the "Ancon" in Loring Bay, Alaska*, distills the sense of juncture between overwhelming nature and human fate, the elemental sky and sea intersected by the tilted wreck.

Awesome orchestrations of weather and geology continued in the work of Thomas Moran, who devoted himself to portrayals of the western wilderness after his first trip to the Yellowstone River, in 1871. Deeply influenced by J. M. W. Turner, whose work he had studied on two trips to England, Moran was determined to capture the way things look, including the effects of atmosphere and light on color and form. When people, usually Indians, appear, it is as part of an over-all maelstrom of color and space that suggests their identification with the landscape's miasmic origins. Moran represents the end of the Hudson River tradition, still painting nature with religious zeal, but also for its own sake, as spectacular scenery. What began as moral philosophy in Thomas Cole ended as aesthetic tourism in Thomas Moran. Moran also stands at the beginning of the conservationist movement in the American West. His first painting of Yellowstone, for instance, was instrumental in the creation there of the first U.S. national park.

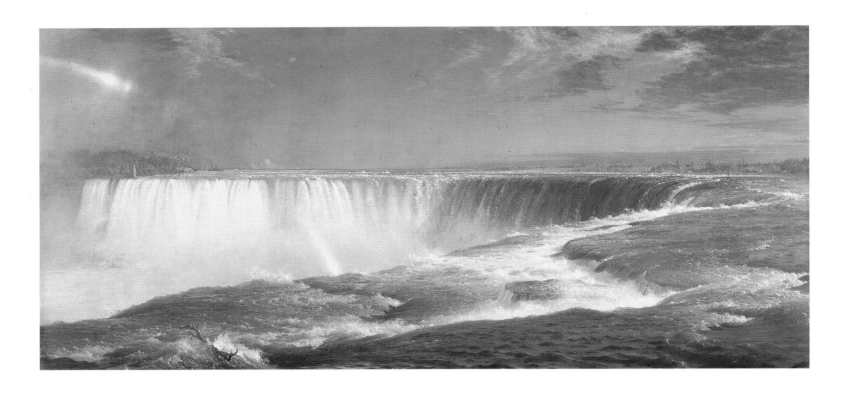

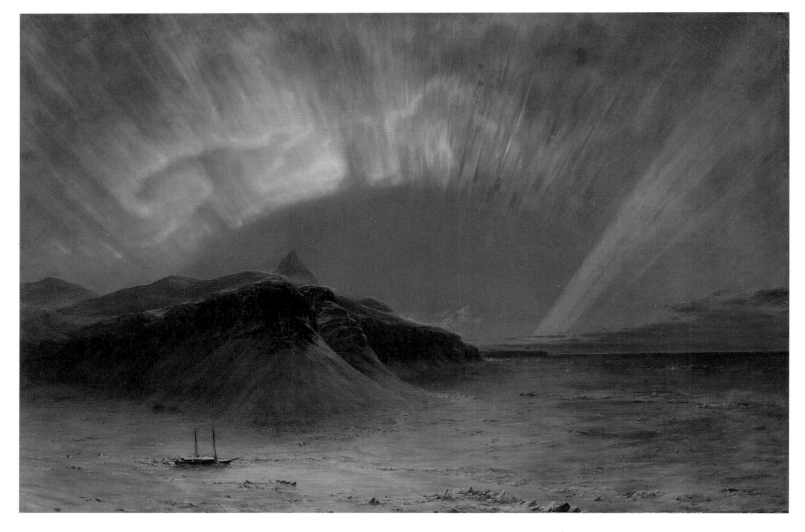

FREDERICK EDWIN CHURCH

Aurora Borealis. 1865
Oil on canvas. 56⅛ × 83½″
National Museum of American Art,
Smithsonian Institution,
Washington, D.C.
Gift of Eleanor Blodgett

FREDERICK EDWIN CHURCH (b. 1826, Hartford,
 Conn.–d. 1900, New York City)

Niagara. 1857
Oil on canvas. 42¼ × 90½″
Corcoran Gallery of Art, Washington, D.C.

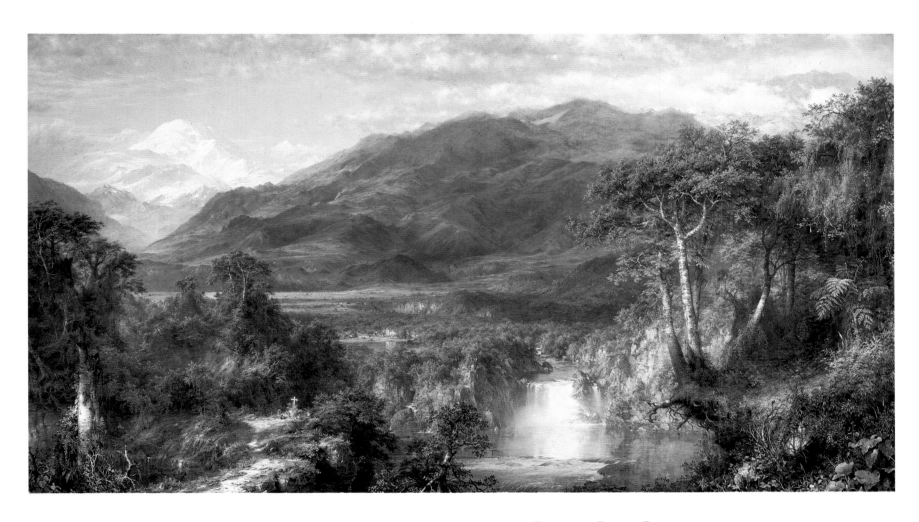

FREDERICK EDWIN CHURCH

The Heart of the Andes. 1859
Oil on canvas. 66⅛ × 119¼″
The Metropolitan Museum of Art, New York City
Bequest of Margaret E. Dows

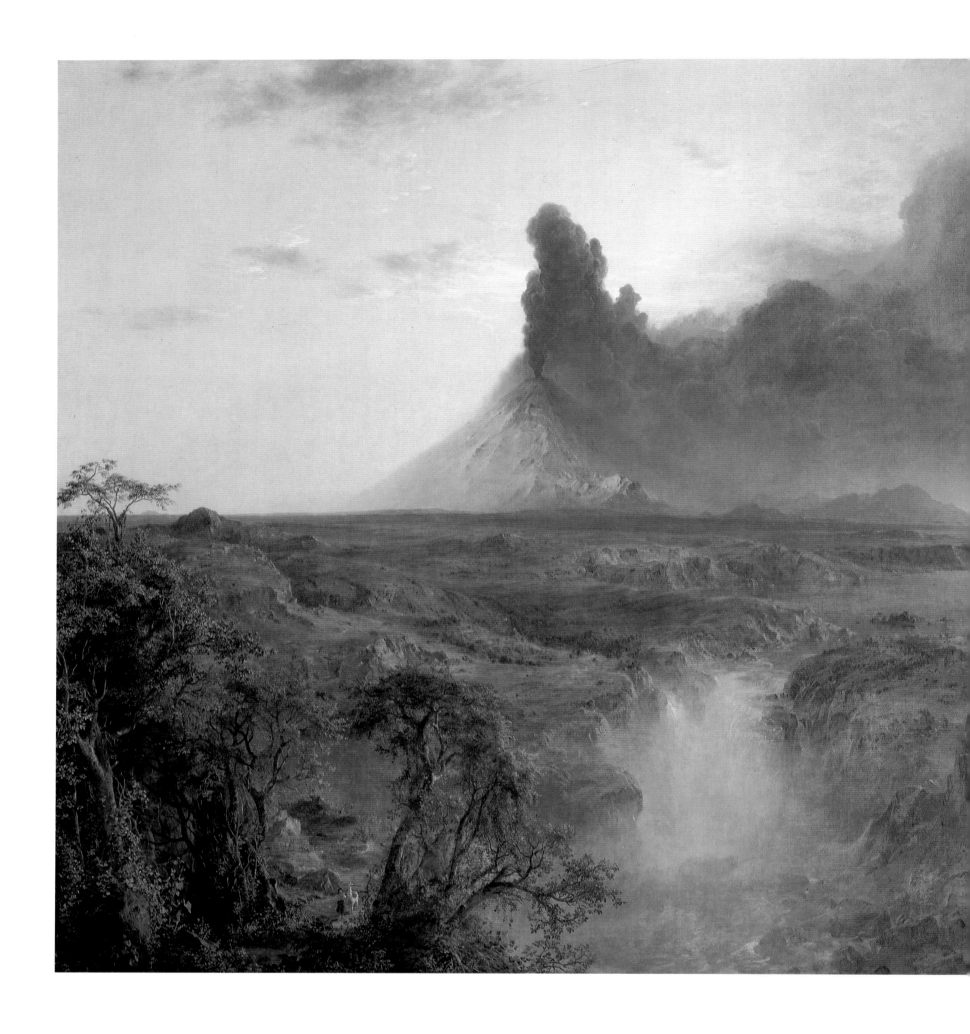

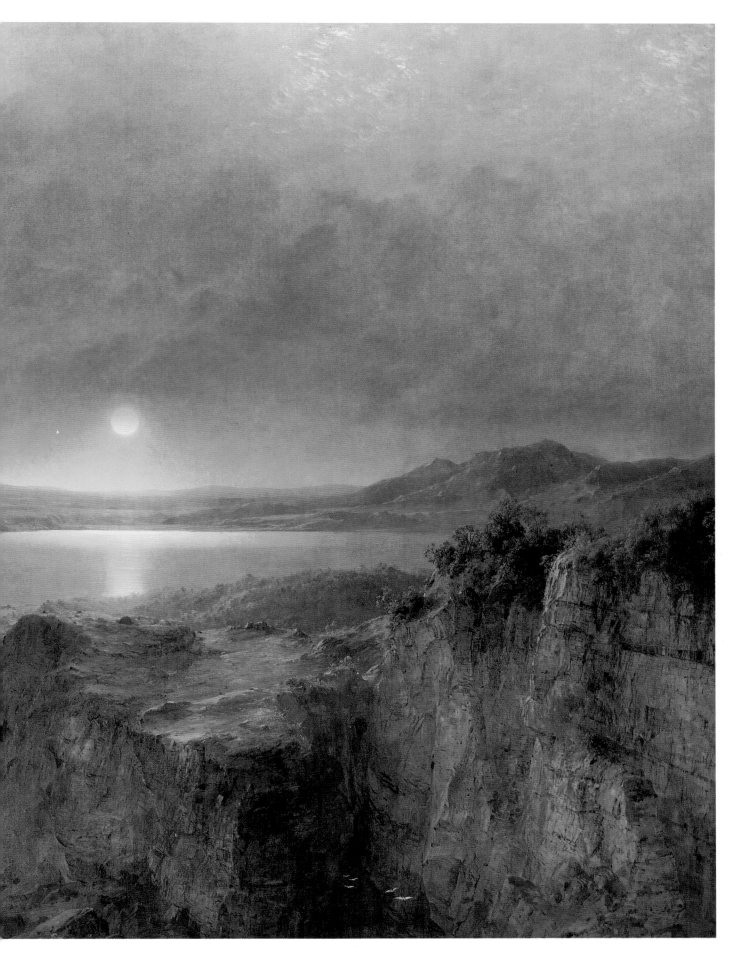

FREDERICK EDWIN CHURCH

Cotopaxi. 1862
Oil on canvas. 48 × 85″
Detroit Institute of Arts, Detroit
Founders Society Purchase with
funds from Mr. and Mrs.
Richard Manoogian,
Robert H. Tannahill
Foundation Fund

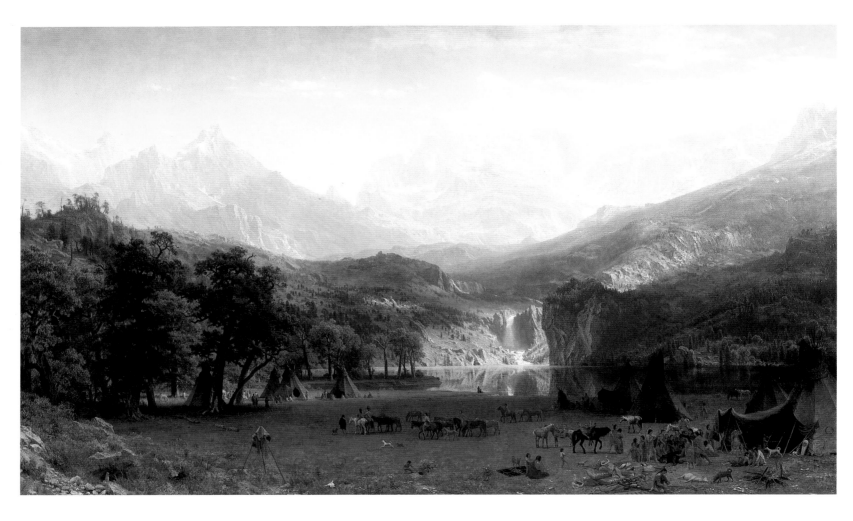

ALBERT BIERSTADT (b. 1830, Solingen, Germany–d. 1902, New York City)

The Rocky Mountains, Lander's Peak. 1863
Oil on canvas. 73½ × 120¾"
The Metropolitan Museum of Art, New York City
Rogers Fund

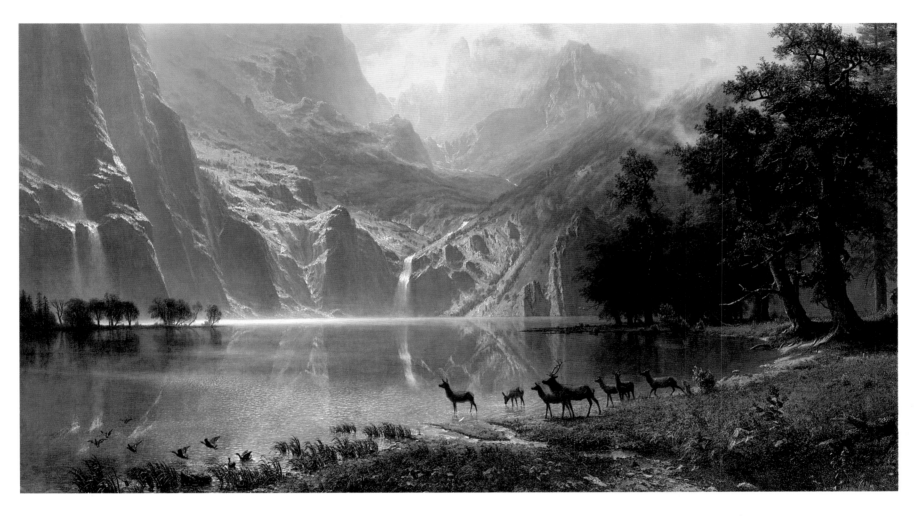

ALBERT BIERSTADT

Among the Sierra Nevada Mountains, California (Detail). 1868
Oil on canvas. 72 × 120″
National Museum of American Art,
Smithsonian Institution, Washington, D.C.
Bequest of Helen Huntington Hull

Albert Bierstadt

Wreck of the Ancon *in Loring Bay, Alaska*. 1889
Oil on paper, mounted on panel. 14 × 19¾″
Museum of Fine Arts, Boston, Mass.
Gift of Mrs. Maxim Karolik for the Karolik Collection of
American Paintings, 1815–1865, 1947

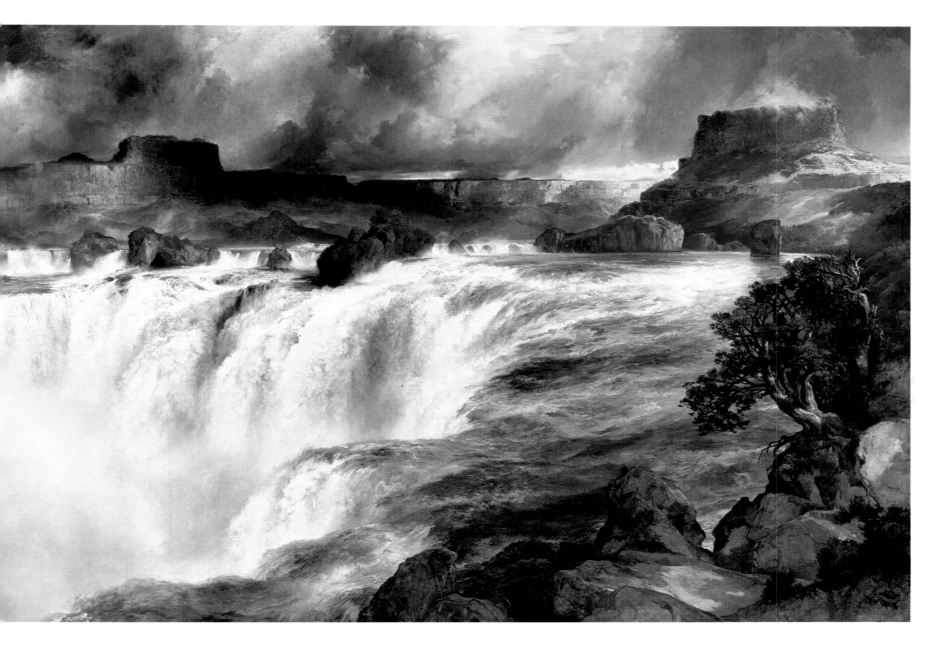

THOMAS MORAN (b. 1837, Bolton, England–d. 1926, Santa Barbara, Calif.)

Shoshone Falls on the Snake River. 1900
Oil on canvas. 71 × 132"
Thomas Gilcrease Institute, Tulsa

8. CLASSICISM, GEOMETRY,

Subject matter in American painting developed by accretion: first came portraiture, then history, then landscape. Scenes of everyday life, or genre, though not without precedence, appeared for good in the 1830s, and in genre, interestingly, the other three modes of representation converged. These early genre paintings often were, in other words, portraits of recognizable individuals (specific or generalized), in distinctively American landscapes, arranged in figural groupings that might be likened, for instance, to the foreground tableau of West's *The Death of General Wolfe*.

Genre came of age partly because the general public was ready for it. The pre–Civil War works of William Sidney Mount, George Caleb Bingham, James Clonney, William Ranney, and James Fitzwilliam Tait reached thousands of people through prints produced by the American Art-Union and Currier & Ives, among others. Though connected with the English popular tradition that began with William Hogarth, this movement was distinctively American. It provided the first real affirmation of American life in the age of Jacksonian democracy and territorial expansion. The parameters of daily life and the American character could now be asserted and defined, from the eastern farmlands to the frontier across the Mississippi.

Anecdotal realism was understood in classical terms by the artists, particularly Mount and Bingham. Each received some formal training. Mount at the National Academy of Design, in New York, Bingham at the Pennsylvania Academy of Fine Arts, in Philadelphia, during a brief trip from St. Louis. But the range of their self-education, from prints and books, was extensive. Mount was well acquainted with and widely admired by the art establishment in New York, including Thomas Cole, from an early age. Less secure in St. Louis, Bingham also depended on New York patronage, which eventually disappeared. His distinctive works were done during a ten-year period, between 1845 and 1855. They are infused with his knowledge of the frontier and its blossoming political scene, in which he was deeply engaged himself.

Treating the ordinary as timeless, Mount and Bingham based their paintings on underlying principles of mathematical perspective and composition. Mount kept a "perspective" notebook in which he worked out a variety of complicated spatial constructions and relationships among three-dimensional bodies on the two-dimensional picture plane. In his painting *Dance of the Haymakers*, for instance, with its seeming informality, every object, every architectural member and human gesture is part of an over-all structural fabric. Even the stray strands of straw on the ground are visual paths. Mount creates an almost endless series of pictures within the picture—for instance, the large rectangles of the door and the barn interior, the triangle formed in the lower-right-hand corner by the door's crossbar, and the larger triangle bounded by the violin and the knife on the platter—which overlap and are woven together by vertical, horizontal, and diagonal movements through space.

Bingham's mathematics are equally rigorous, though more dependent on dominant shapes, such as the pyramidal grouping of figures in *The Jolly Flatboatmen*. This is perhaps appropriate in a landscape ruled by the flat and converging reaches of the great Mississippi, Missouri, and Ohio Rivers, whereas Mount's guiding motif was the modest farm archi-

AND GENRE

tecture of Long Island. For both artists, music is a recurring theme, an analogue of their interest in mathematical, structural, and societal concordances. In depicting sound, these luminist masters of silence also recognize painting's limitations in relation to nature.

The classicism of Mount, Bingham, and the younger Charles Wimar is based on the rudimentary forms of farm and frontier life: wooden rafts, flatboats, barns, tools, fences, musical instruments, trees, clouds, and a very prominent ground plane upon which everything is constructed. The entire perspective system of Bingham's *Shooting for the Beef* depends on a single rifle at the picture's center. It is a natural wedding of content and style. In their late paintings, however, Mount and Bingham would loosen structural rigor, as in Mount's *Catching Crabs,* to achieve a more effulgent merging of light and space.

Despite the social disarray in a painting like Bingham's *The Verdict of the People*, which introduces Election Day with a crawling drunkard, there is a commanding sense of order in the architectonic realism of the figures themselves. Even with such a precedent, however, it is startling to confront the powerful figures of Charles Wimar's Indian paintings, some of them done for a European audience during his years of training at the Düsseldorf Academy. They occupy another world, another landscape, bathed in a strange light, beyond the pale of Mount's Long Island or Bingham's Missouri. They are figments of Germanic Romanticism, perhaps, but they also represent, in their compelling, almost possessed presence, Wimar's intense sympathy for the Native Americans he knew as a young man on the outskirts of St. Louis. By the time he returned from Germany, in 1856, most of them were gone, overwhelmed by the continuing growth of St. Louis as a center of business and transportation.

WILLIAM SIDNEY MOUNT

Catching Crabs. 1865
Oil on canvas. 18 × 24⅜″
The Museums at Stony Brook,
Stony Brook, N.Y.
Gift of Mr. and Mrs. Ward Melville

WILLIAM SIDNEY MOUNT (b. 1807, Setauket, N.Y.–d. 1868, Setauket, N.Y.)

Dance of the Haymakers. 1845
Oil on canvas. 24¼ × 29⅞″
The Museums at Stony Brook, Stony Brook, N.Y.
Gift of Mr. and Mrs. Ward Melville

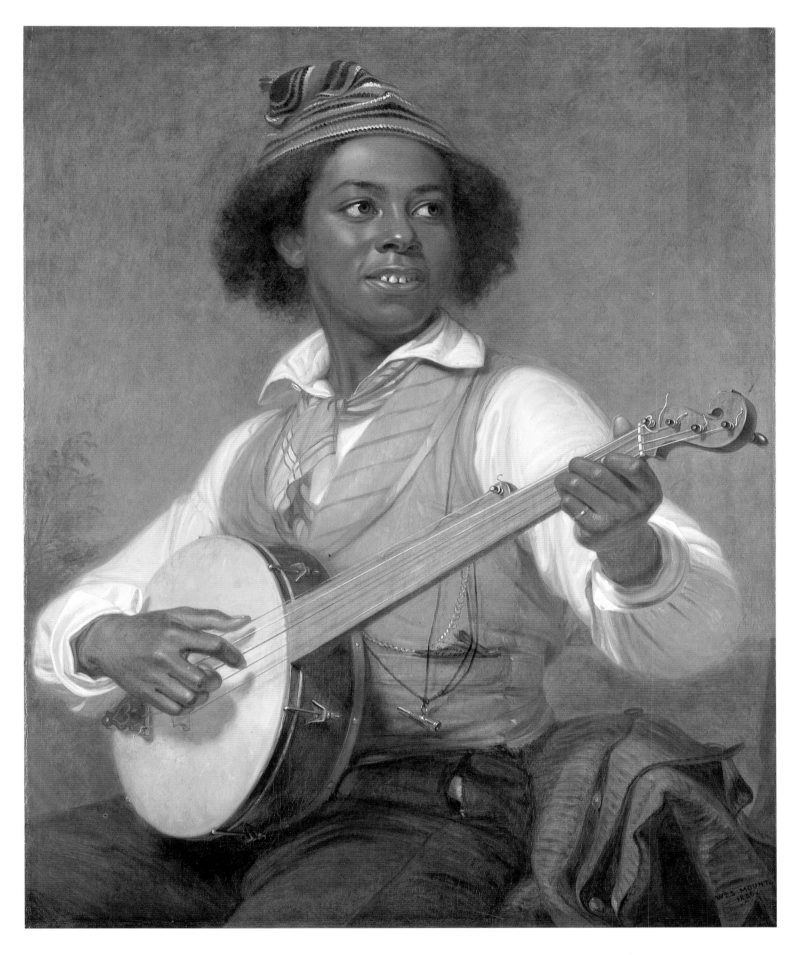

WILLIAM SIDNEY MOUNT

The Banjo Player. 1856
Oil on canvas. 36 × 29″
The Museums at Stony Brook, Stony Brook, N.Y.
Gift of Mr. and Mrs. Ward Melville

OPPOSITE:

GEORGE CALEB BINGHAM

Shooting for the Beef. 1850
Oil on canvas. 33⅝ × 49⅜″
The Brooklyn Museum, New York City
Dick S. Ramsay Fund

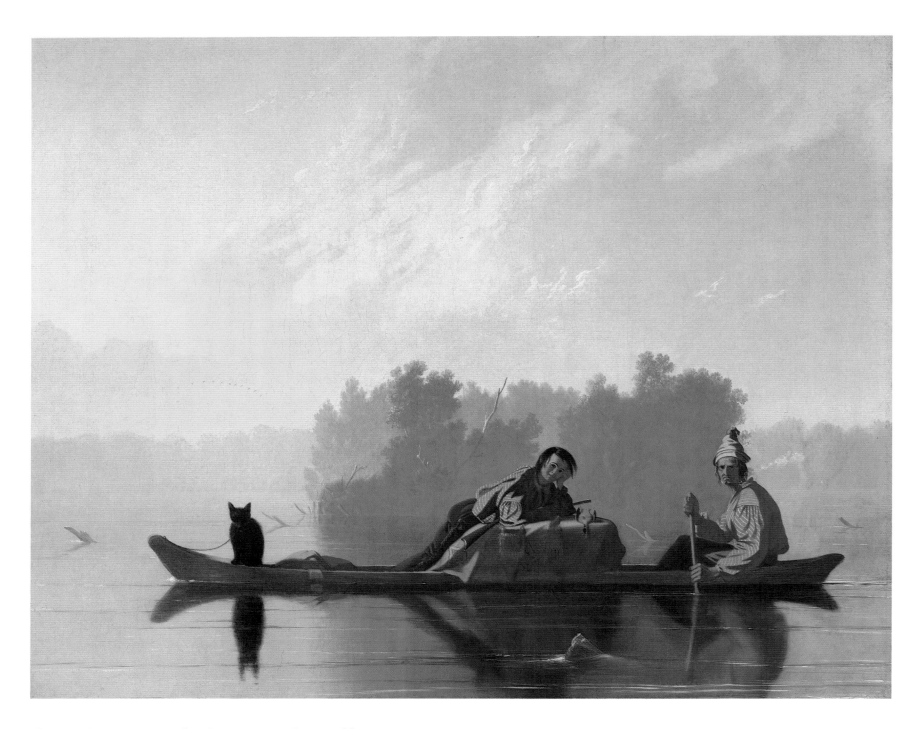

GEORGE CALEB BINGHAM (b. 1811, Augusta County, Va.–
 d. 1879, Kansas City, Mo.)

Fur Traders Descending the Missouri. ca. 1845
Oil on canvas. 29 × 36½″
The Metropolitan Museum of Art, New York, N.Y.
Morris K. Jesup Fund, 1933

OPPOSITE:

GEORGE CALEB BINGHAM

The Verdict of the People. 1854–1855
Oil on canvas. 48 × 66″
Boatman's Bank of St. Louis, St. Louis

CHARLES WIMAR (b. 1828, Siegburg, Germany–d. 1862, St. Louis)

The Captive Charger. 1854
Oil on canvas. 30 × 41"
St. Louis Art Museum, St. Louis
Gift of Miss Lillie B. Randell

9. HOMER AND THE HEROISM

At the end of the Civil War, in the 1865, Winslow Homer completed a prophetic painting. *The Veteran in a New Field* expresses Homer's hope for peace and plenty, reconciliation, a return to normality after the war. It looks back to the idyllic rural world of William Sidney Mount and forward to the hard work not represented there. It seems to predict the agricultural and industrial boom that was about to begin in a country united from New England to California.

But there are other implications here that have meaning for the development of society, art in general, and Homer's art in particular. With his back turned to us, the returned soldier acts as a surrogate for the viewer and the artist. He faces, and we face, an opaque wall of wheat, rather roughly and strangely painted, which joins awkwardly with the sky to create a curtain blocking the view. The action, though essential to life, is one of destruction and even anger, laying waste to a field of wheat.

This is not the world of Mount or Bingham, or that of the idealists Emerson and Thoreau, but one of moral and existential difficulty, reflecting the divisiveness, brutality, and waste of the war itself. As a young correspondent at the front for *Harper's Weekly*, Homer had produced eyewitness sketches of skirmishes and camp life. His work was forever shaped by this experience and by the political and social conscience it awakened. Other artists were also aroused. Abolition moved Eastman Johnson and Thomas Moran, who painted slaves fleeing to freedom, and Moran and others understood, on some level, the injustice of removing Native Americans from their ancestral lands. Later, Johnson painted workers in the cranberry bogs of Nantucket and the maple-sugar camps of Maine. Even the more academic Thomas Hovenden recast John Brown's last moments in a sympathetic melodrama.

The question of women's rights also emerged before the war, but in art it is reflected less directly. Lilly Martin Spencer's parents supported abolition and women's suffrage, and she supported her husband and thirteen children during a long career in New York as a genre and portrait painter. Her views are revealed in homely and often humorous scenes of family life. A deeper and more personal thread of feminine pride runs through an exquisite and poignant portrait of revealed mortality, *We Both Must Fade*.

But it is Homer who introduces self-consciousness and psychological complexity. In the late 1860s and into the 1870s, he painted seashore and country scenes, such as *Long Branch, New Jersey*, in which light, at first, is organized in flat, reflective planes of bright color, perhaps in response to proto-Impressionist painters, such as Eugène Boudin, whom Homer encountered during his ten-month stay in France. Gradually his figures, usually women and children, became more nearly three-dimensional, even columnar, and his compositions more classical in their rhythmic delineation of space. The mother and two children in *Waiting for Dad* are like mourners from an ancient Greek relief. The boys playing in *Snap the Whip* circle into the landscape like a Bacchanalian procession.

Homer's playfulness in these early works is deceptive. His yearning for childhood freedom and motherly protection is filled with unrealized passion. None of his characters looks at another or at us. They turn away, like the veteran, and their faces are shadows or lighted planes that deflect our gaze. Unlike the French Impressionists, who

OF EVERYDAY LIFE

penetrated matter with light, Homer creates surfaces that light makes even more opaque. The brighter things get, the less one is really able to see them. It is interesting, however, that Homer's watercolors, which he began to produce in the 1870s, provided an antidote to this opacity through the rest of his life.

In 1881–82 Homer lived in the English fishing town of Tynemouth, on the North Sea, where he painted women working stoically on the beach, and in 1883 he settled for good, by himself, in his brother's house on the edge of the sea at Prout's Neck, Maine. His palette became much darker, his figures more monumental, heroic in their attachment to the sea, which is almost always present. In the darkling light of storms and night and constant movement, the world is somehow more comprehensible, though no less opaque. Painting is not the answer, but it is the site of a constant and obsessive search, and Homer was the first American artist to understand it that way. The grand themes, which West found in history and Cole in the land, were for Homer in the individual psyche, that which knows life at first hand.

WINSLOW HOMER

Snap the Whip. 1872
Oil on canvas. 12 × 20″
The Metropolitan Museum
of Art, New York City

JONATHAN EASTMAN JOHNSON (b. 1824, Lowell, Me.–d. 1906, New York City)

The Old Stagecoach. 1871
Oil on canvas. 36¼ × 60⅛″
Milwaukee Art Museum, Milwaukee
Gift of Fredrick Layton

JONATHAN EASTMAN JOHNSON

The Cranberry Harvest, Island of Nantucket. 1880
Oil on canvas. 27½ × 54⅝″
Timken Art Gallery, San Diego
Putnam Foundation

OPPOSITE:

LILLY MARTIN SPENCER (b. 1822, Exeter, England–d. 1902, Crum Elbow, N.Y.)

We Both Must Fade (Mrs. Fithian). 1869
Oil on canvas. 71⅝ × 53¾″
National Museum of American Art, Washington, D.C.

WINSLOW HOMER (b. 1836, Boston–d. 1910, Prout's Neck, Me.)

The Veteran in a New Field. 1865
Oil on canvas. 24⅛ × 38⅜"
The Metropolitan Museum of Art, New York City
Bequest of Miss Adelaide Milton de Groot

WINSLOW HOMER

Long Branch, New Jersey. 1869
Oil on canvas. 16 × 21¾″
Museum of Fine Arts, Boston, Mass.
Charles Henry Hayden Fund

WINSLOW HOMER

Breezing Up (A Fair Wind). 1876
Oil on canvas. 24⅛ × 38⅛"
National Gallery of Art, Washington, D.C.
Gift of the W.L. and May T. Mellon Foundation

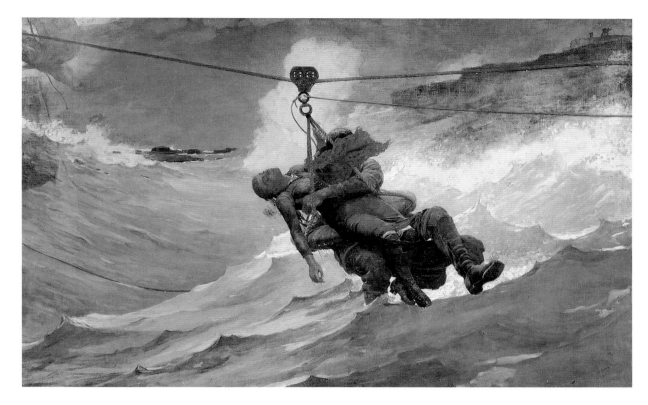

WINSLOW HOMER

The Life Line. 1884
Oil on canvas. 28¾ × 44⅝″
Philadelphia Museum of
Art, Philadelphia
George W. Elkins Collection

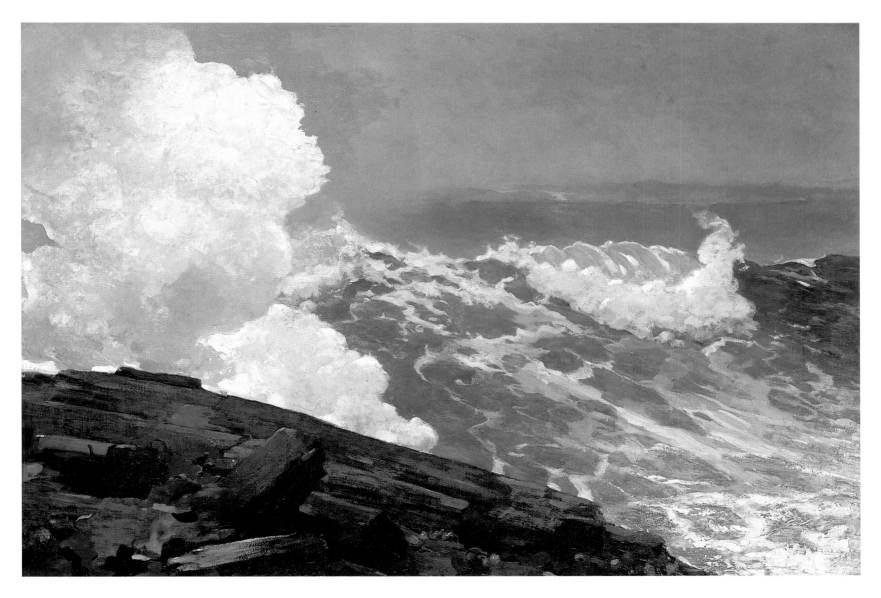

WINSLOW HOMER

Northeaster. 1895
Oil on canvas. 34⅜ × 50¼″
The Metropolitan Museum of Art, New York City
Gift of George A. Hearn

Thomas Moran

Slaves Escaping Through the Swamp. 1862
Oil on canvas. 34 × 44″
Philbrook Museum of Art, Tulsa
Laura A. Clubb Collection

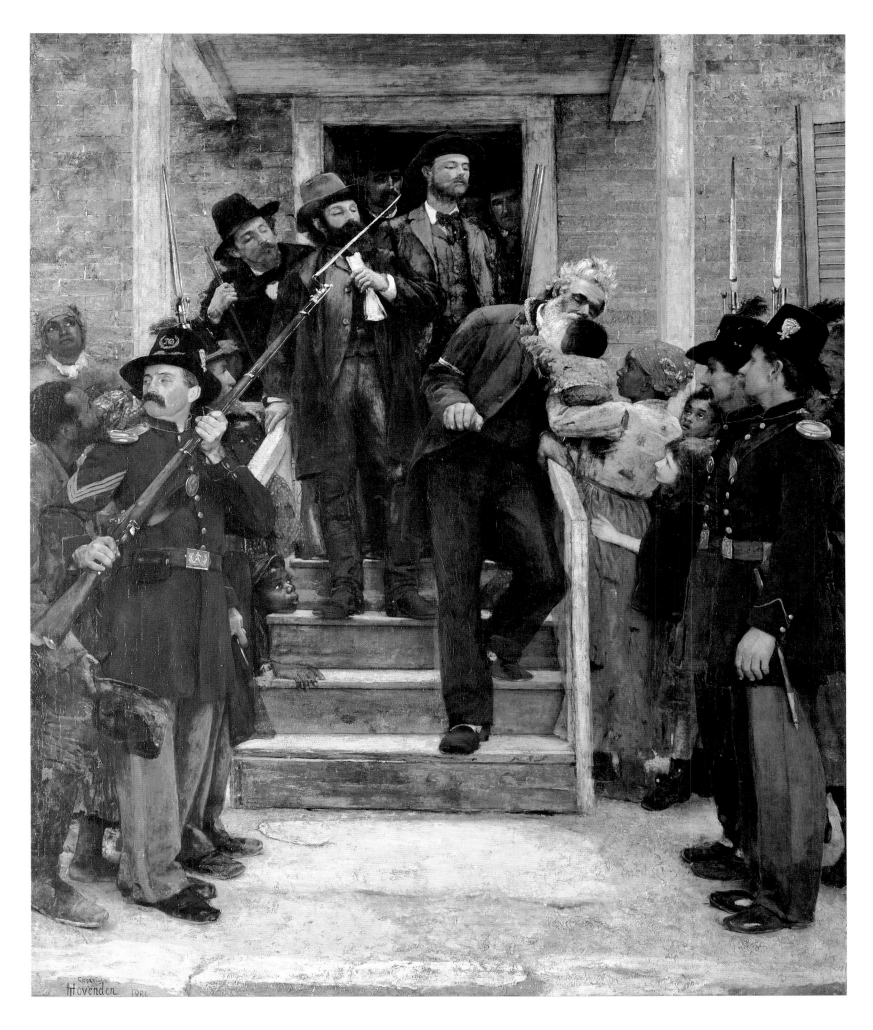

Thomas Hovenden (b. 1840, Dunmanway, Ireland–d. 1895, Philadelphia)

The Last Moments of John Brown. 1884
Oil on canvas. 77⅜ × 63¼″
The Metropolitan Museum of Art, New York City
Gift of Mr. and Mrs. Carl Stoeckel

10. Art for Art's Sake: and Aestheticism

The pressure of moral insight, so evident in the works of Allston, Cole, and the Hudson River School, and in the more ambiguous vision of Winslow Homer, is also felt in various movements toward aestheticism at midcentury. In France, where the idea and ethos of "art for art's sake" emerged in the 1830s, the battle lines were drawn between classicists and Romantics, realists and idealists, academicians and the avant-garde. For artists of the English-speaking world, the battle was perhaps more basic, involving the very existence of art. Art as an ideal in itself became a locus of energy that had been spent elsewhere on various religious, philosophical, and moral ideas.

American aestheticism derived from contacts with French art, though not with the most avant-garde currents of thought. William Morris Hunt's years in France, from 1847 to 1855, were highlighted by his discovery of Jean-Francois Millet and other Barbizon painters, whose painting was hardly done purely for its own sake. For Hunt, who enjoyed considerable attention from 1855 to 1879 as a painter and teacher in Newport and Boston, Millet represented an ideal: the artist at work among humble laborers and peasants. Hunt's own work projects a vaguer kind of Romanticism. He shifted from portraits to landscapes to genre to mythological scenes in styles that also shift, with realism always shrouded by the soft veil of devotion to beauty. Hunt was the avatar of a new attitude that raised art above reality, shifting attention to aesthetic values and the process of art.

Two of Hunt's contemporaries were more focused in this attitude: John La Farge, who studied with him after brief training in Paris (1856–57); and Elihu Vedder, a friend of La Farge and Hunt in Boston before he finally settled in Rome, in 1870. Both La Farge and Vedder were superb users of art, each in his own way, as a stage for the beautiful, mysterious, subtle, and uplifting.

La Farge started modestly, as a painter of exquisitely composed, color-saturated flower pieces and landscapes. Stressing the decorative aspects of art, including the subtle effects of light on color and space, he emerged as an erudite spokesman for the avant-garde in Boston and New York. He accumulated exotic styles and subjects and was one of the first artists to appropriate the vertical spatial patterns of Japanese woodcuts. Out of his later travels, to the South Seas and Japan, he produced such stark and touching scenes as *The Strange Thing Little Kiosai Saw in the River*. His murals and brilliant stained-glass windows for churches and private homes are among the best examples of the contemporary effort to integrate art into larger decorative schemes, ultimately as decorative affirmations of wealth and refinement, and the history of art.

Vedder's aestheticism also involves themes from exotic sources, including such popular ones as *The Arabian Nights* and *The Rubáiyat of Omar Khayyám*, and desert settings that resound with ancient associations. Like La Farge, Vedder is an illustrator, but in narrative rather than decorative terms. Like the Wizard of Oz, he uses special effects to

WHISTLER, ORIENTALISM

make the invisible world visible—the face of Memory hovering over the sea, the Sphinx embodying "the hopelessness of man before the immutable laws of nature." The great questions of life and death are sensuously pictorialized, as in *The Little Venetian Girl*, and art is the final arbiter.

In this literal form, the great questions were irrelevant to James Abbott McNeill Whistler, the most radical of those devoted to art for art's sake. In 1866 he traveled to Chile, to assist, he later said, in the war with Spain. But his paintings of Valparaiso's harbor give little indication of the Spanish bombardment he witnessed. Visual reality was the starting point from which to rearrange the world as art. The tall-masted ships and piers, seen at various times of day and night, provided simple figural elements against the joined ground of sea and sky.

A year later, Whistler specifically renounced the realism of Courbet, who had been a mentor. What interested him was the possibility of realizing painting in its purest form by reducing it to subtle orchestrations of color, gesture, and stroke. This is evident even in paintings he had done during a trip to Trouville with Courbet in 1865. In *Harmony in Blue and Silver: Trouville*, deep space and the landscape's identity are created minimally and almost imperceptibly by the transparent foreground figure and two sailboats. The climax of this seemingly casual but highly evolved kind of evocation was achieved in the Nocturnes and Arrangements of the 1870s, including the portrait of his mother, in which structure and mood are carried by the picture surface itself, the barely measurable thickness of paint. Even more than La Farge, Whistler was influenced by the flat spatial patterning of Japanese painting; the Nocturnes, particularly, are like visual haiku.

Whistler left the United States in 1855 and never returned. He was a product of French and English culture, closely associated with the avant-garde of each country, alternately, until his death. Yet his very unwillingness or inability to consider either country his home made him a sort of expatriate, like many other American artists in the latter half of the nineteenth century. Whatever he was in Europe, indisputably a substantial figure, he remains an American icon.

WILLIAM MORRIS HUNT (b. 1824, Brattleboro, Vt.–
d. 1879, Appledore, Me.)

The Bathers. 1877
Oil on canvas. 24⁵⁄₁₆ × 16⅛″
Worcester Art Museum, Worcester, Mass.

JAMES ABBOTT MCNEILL WHISTLER (b. 1834,
Lowell, Mass.–d. 1903, London)

*The Little White Girl: Symphony in
White, No. 2.* 1864
Oil on canvas. 30 × 20″
Tate Gallery, London

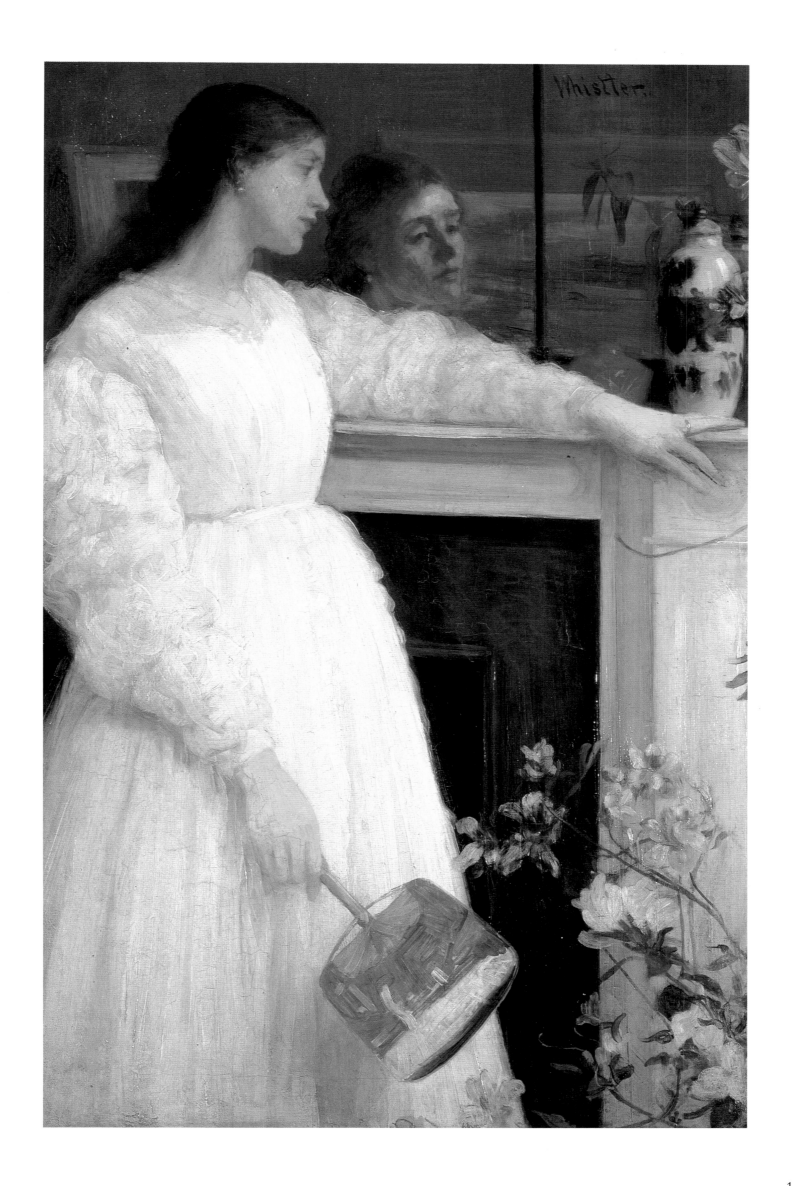

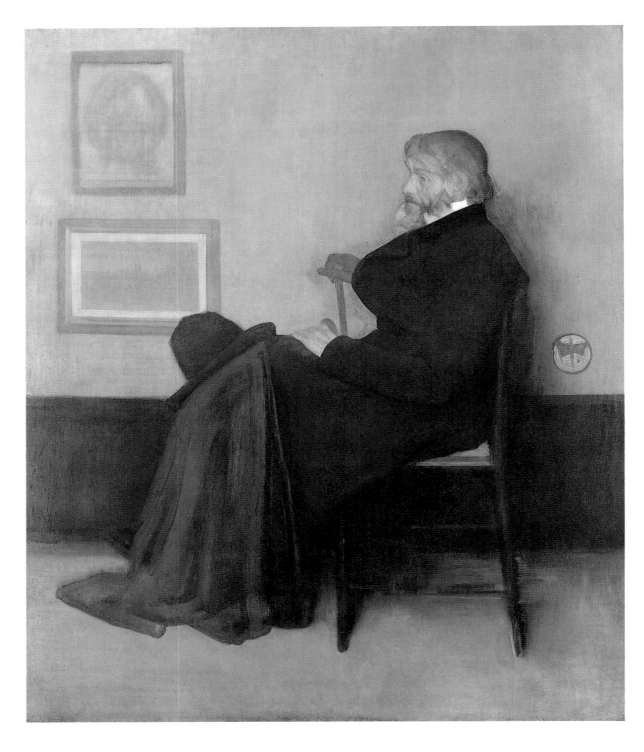

JAMES ABBOTT MCNEILL WHISTLER

Arrangement in Grey and Black, No. 2: Portrait of Thomas Carlyle. 1872–1873
Oil on canvas. 67⅜ × 56½″
Glasgow Art Gallery and Museum, Glasgow, Scotland

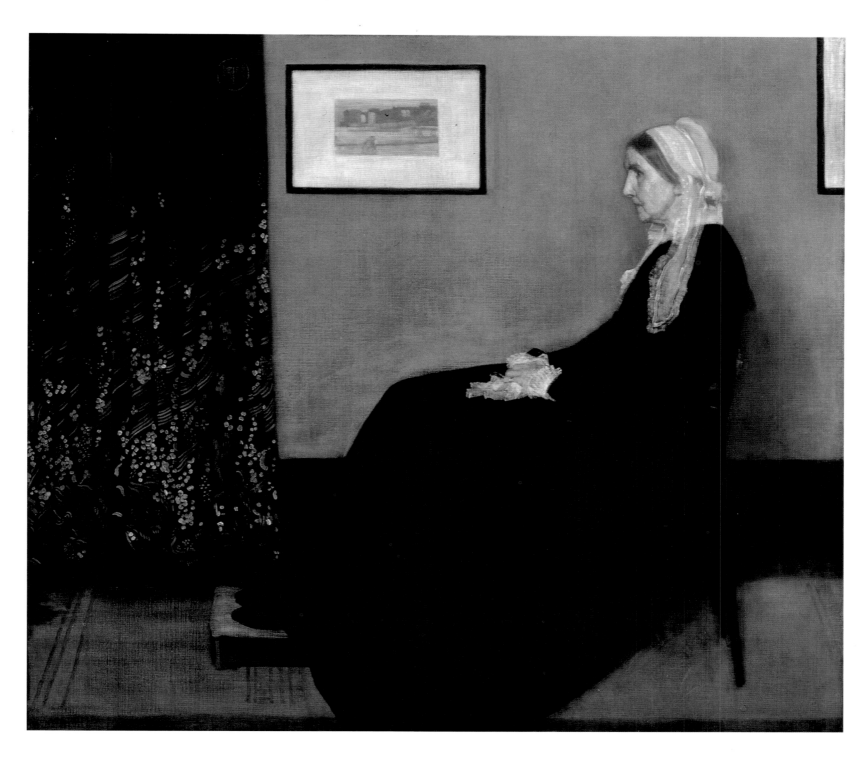

JAMES ABBOTT McNEILL WHISTLER

Arrangement in Grey and Black: Portrait of the Artist's Mother. 1871
Oil on canvas. 56¾ × 64"
Musée du Louvre, Paris

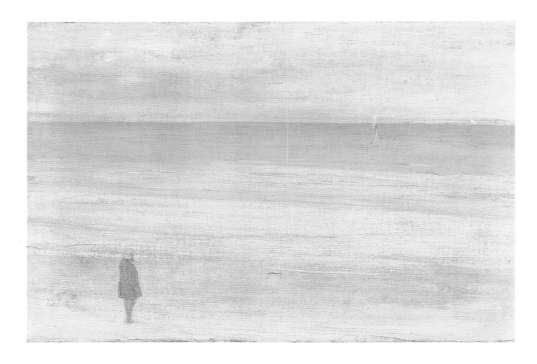

JAMES ABBOTT MCNEILL WHISTLER

Harmony in Blue and Silver, Trouville. ca. 1865
Oil on canvas. 19½ × 24¾"
Isabella Stewart Gardner Museum, Boston

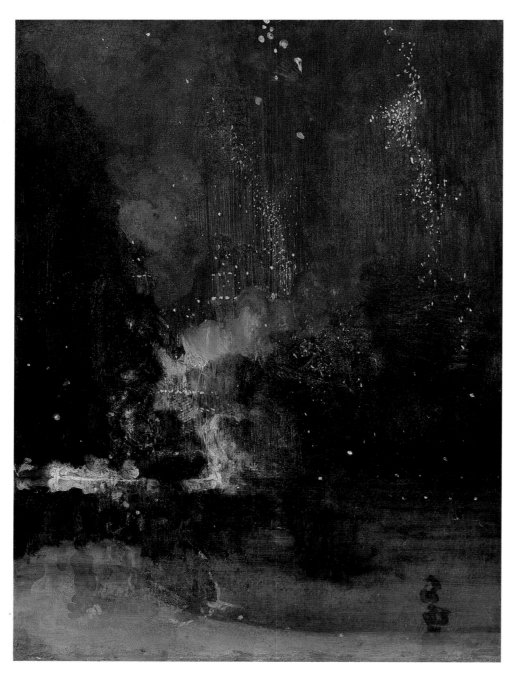

JAMES ABBOTT MCNEILL WHISTLER

*Nocturne in Black and Gold: The
Falling Rocket*. ca. 1875
Oil on oak panel. 23¾ × 18⅜"
Detroit Institute of the Arts, Detroit
Gift of Dexter M. Ferry, Jr.

OPPOSITE:

ELIHU VEDDER (b. 1836, New York City–
 d. 1923, Rome, Italy)

Memory. 1870
Oil on mahogany panel. 20⁵⁄₁₆ × 14¾"
Los Angeles County Museum of Art, Los Angeles.
Mr. and Mrs. William Preston Harrison Collection

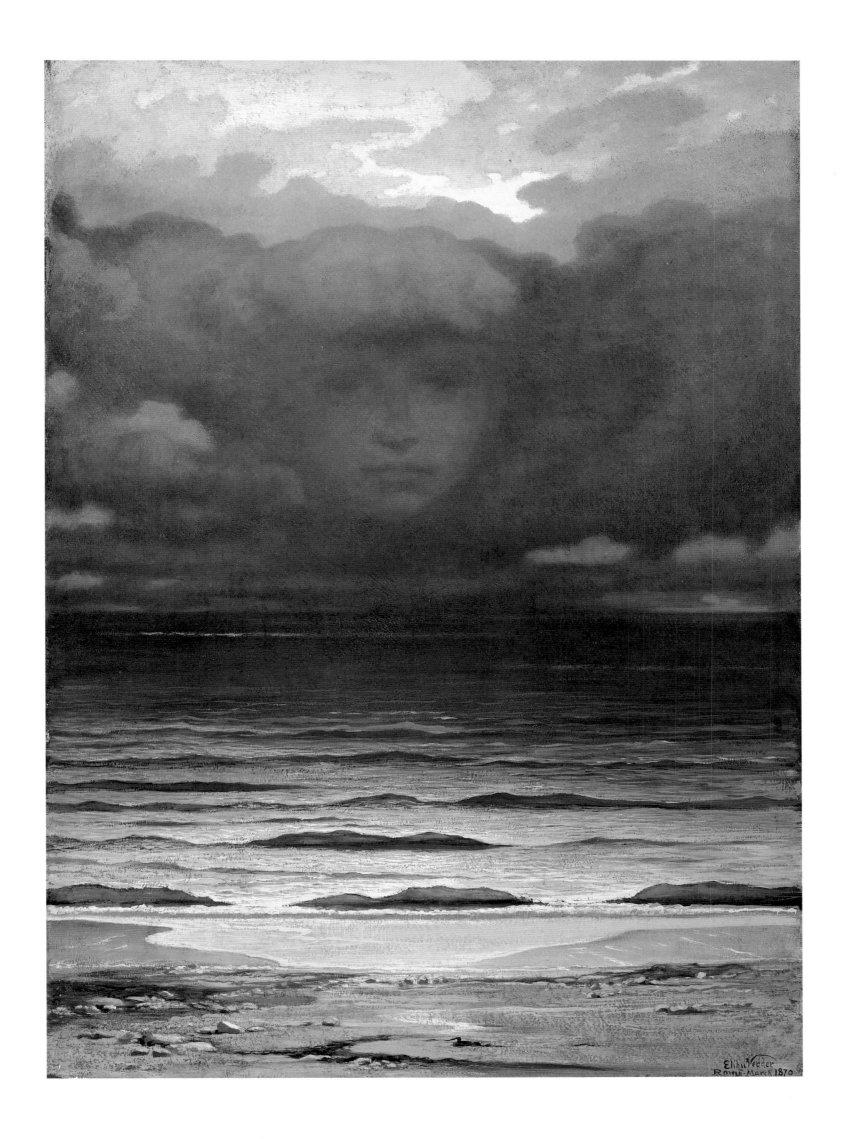

ELIHU VEDDER

The Venetian Model. 1878
Oil on canvas. 18 × 14⅞″
Columbus Museum of Art, Columbus, Ohio
Schumacher Fund

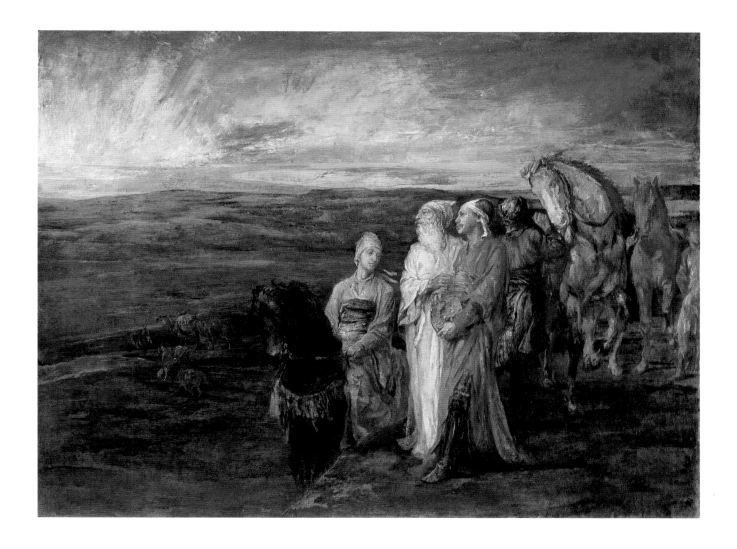

JOHN LA FARGE (b. 1835, New York City–
d. 1910, Providence, R.I.)

Halt of the Wise Men. 1878–1879
Oil on canvas. 32¾ × 42″
Museum of Fine Arts, Boston
Gift of Edward W. Hooper

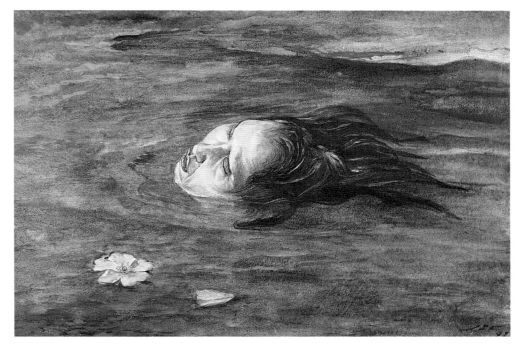

JOHN LA FARGE

The Strange Thing Little Kiosai Saw in the River. 1897
Watercolor on paper. 12¾ × 18½″
The Metropolitan Museum of Art. New York City
Rogers Fund

II. The Humanist Realism

Mary Cassatt and Thomas Eakins were both born in 1844 in Pennsylvania, and both attended the Pennsylvania Academy of the Fine Arts from 1861 to 1865. Both went to Paris in 1866, where they studied with the academic realist Jean-Léon Gérôme, Cassatt for a briefer term than Eakins. Both returned to the United States in 1870, but their lives thereafter diverged. A little more than a year later Cassatt was back in Europe, where she remained for the rest of her life, in France. Eakins stayed put at 1729 Mount Vernon Street, in Philadelphia.

Though Cassatt and Eakins shared many acquaintances early in their careers, there was little contact between the two of them, and each one's art seems as different from the other's as their lives would become. Eakins remained true to the precise realism and traditional dark palette of his academic training, using these tools to create uncompromising portraits of what he saw and knew. Cassatt stopped showing at the official Salon in Paris after 1876 and joined the Impressionists, with whom she exhibited between 1877 and 1886. Like her colleagues, she was a painter of light who never hinted at the darkness and melancholy that characterize Eakins' work throughout.

On major issues, however, Cassatt and Eakins have a great deal in common, in ways that are found nowhere else in American painting. Above all, both were devoted to individual human endeavor and experience, to the physical and emotional lives of real people. They loved to paint the world as it is, Cassatt from her vantage point as a wealthy and comfortable expatriate in Paris and the French countryside; Eakins as an embattled and eventually neglected figure in Philadelphia's art world.

Eakins was immersed in his art as few artists have been. He was often literally part of his own work, as a surgery assistant in *The Gross Clinic*, as the distant oarsman in *Max Schmitt in a Single Scull*, as one of the naked figures in *Swimming Hole*, and as a naked runner and leaper in sequential photographs he used to study the body in motion. He painted only what he directly encountered and exhausted every means he could find to establish the reality of a person or event. This generally meant a close and extremely detailed study of anatomy, perspective, mathematics, and motion, subjects that composed the unusually thorough curriculum he instituted as the director of the Pennsylvania Academy of Fine Arts from 1882 to 1886. He was finally asked to resign his post, partly because his spontaneity—not to say impropriety—in conducting his life classes distinctly inconvenienced the Academy's respectable board of trustees.

Eakins' art is full of apparatus. Art apparatus, including perspective and anatomy, anchors reality in time and space; depicted apparatus—surgical instruments, musical instruments, boats, guns, toys, books—gives those moments a literal as well as an ontological meaning, providing a means to deal with and make sense of the world. In *The Gross Clinic*, the scalpel that Dr. Gross holds in his bloody hand is echoed by a pen that is recording the procedure. Eakins thus places art (writing) in the context of science, with its objective ideals, but also in an arena of suffering and pain that cannot be denied or simply ignored. In *The Concert Singer*, the apparatus is a woman's voice. Eakins took great pains to visually record the moment when the singer, Weda Cook, sang the *e* in the word "rest" from Mendelssohn's "O Rest in the Lord." He also carved the notes of the

OF EAKINS AND CASSATT

song in the picture's frame, restoring the moment in which Mendelssohn's abstraction had existed.

Eakins' moments occur in the middle of events that have, like life itself, a definite beginning and end—a boat race, a prizefight, a song, a chess match, an operation. That is the method of his ultimately tragic, fatalistic vision. In simple, unencumbered portraits— his Walt Whitman, say—an artificial chronological framework is not needed. One sees through the subject's eyes to the past and future. Whitman himself said that "it is not seen all at once—it only dawns on you gradually. . .the more I get to realize it the profounder seems its insight."

Human intimacy is the focus of Cassatt's vision. Portraits of men—her brother, father, and others—appear from time to time throughout her career, but the vast majority of her work is devoted to women, many of whom, too, are family members and friends. For many of the Impressionists, especially her friend Degas, the daily lives of women became an almost obsessive fascination. Cassatt's women, however, achieve an almost iconic status, like certain Madonnas of the Italian Renaissance. Cassatt brings us close to them, insisting on their reality and their humanity. Everything she does emphasizes their absorption in tasks, in relationships—or simply their presence.

Cassatt's methods, like her subjects, are direct and only seemingly simple. *At the Opera* is literally about focusing. It is a tour de force of space, plane, and color composition. Everything draws attention to the act and expression of the young woman—the insertion of her pyramidal black shape in the pattern of yellow and red stripes; the curved sweep of the balcony; even the way the man in the upper left corner turns to focus on her. At the center, a shape formed between the woman's arm and face is an abstract summary of her profile and presence.

In *The Boating Party*, the rowing man's dark silhouette is a foil for emotion from the woman and child in the boat's bow. This is perhaps the only painting by Cassatt in which an inner conflict—in this case, in a woman looking at a man—is apparent. It is also one of the few Cassatts in which a woman and child are nearly obscured within the painting's structure. Yet these two figures are still the focus of attention. If Eakins' moments are about the passage from past to future, Cassatt's are about the fullness of life in the present.

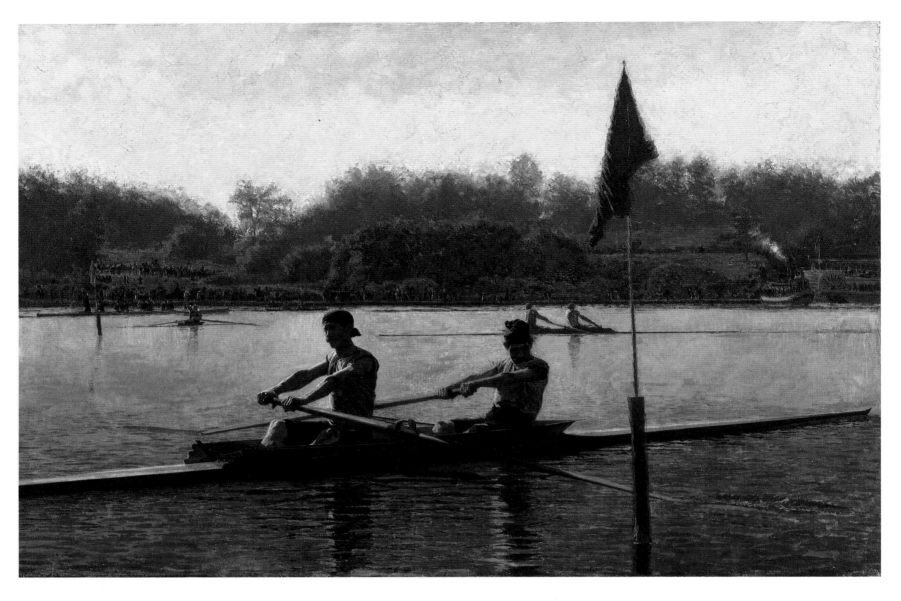

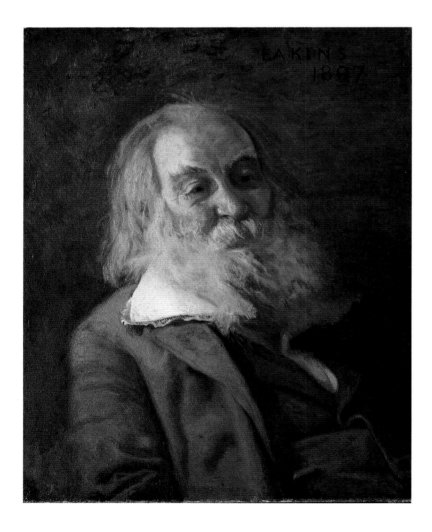

Thomas Eakins (b. 1844, Philadelphia–d. 1916, Philadelphia)

Biglin Brothers Turning the Stake. 1873
Oil on canvas. 40¼ × 60¼"
Cleveland Museum of Art, Cleveland
Hinman B. Hurlbut Collection

Thomas Eakins

Walt Whitman. 1888
Oil on canvas. 30⅛ × 24¼"
Pennsylvania Academy of the Fine Arts, Philadelphia
Philadelphia General Fund

OPPOSITE:

Thomas Eakins

The Concert Singer (Portrait of Weda Cook or Mrs. Stanley Addicks). 1892
Oil on canvas. 75⅜ × 54⅜"
Philadelphia Museum of Art, Philadelphia
Given by Mrs. Thomas Eakins and
Miss Mary Adeline Williams

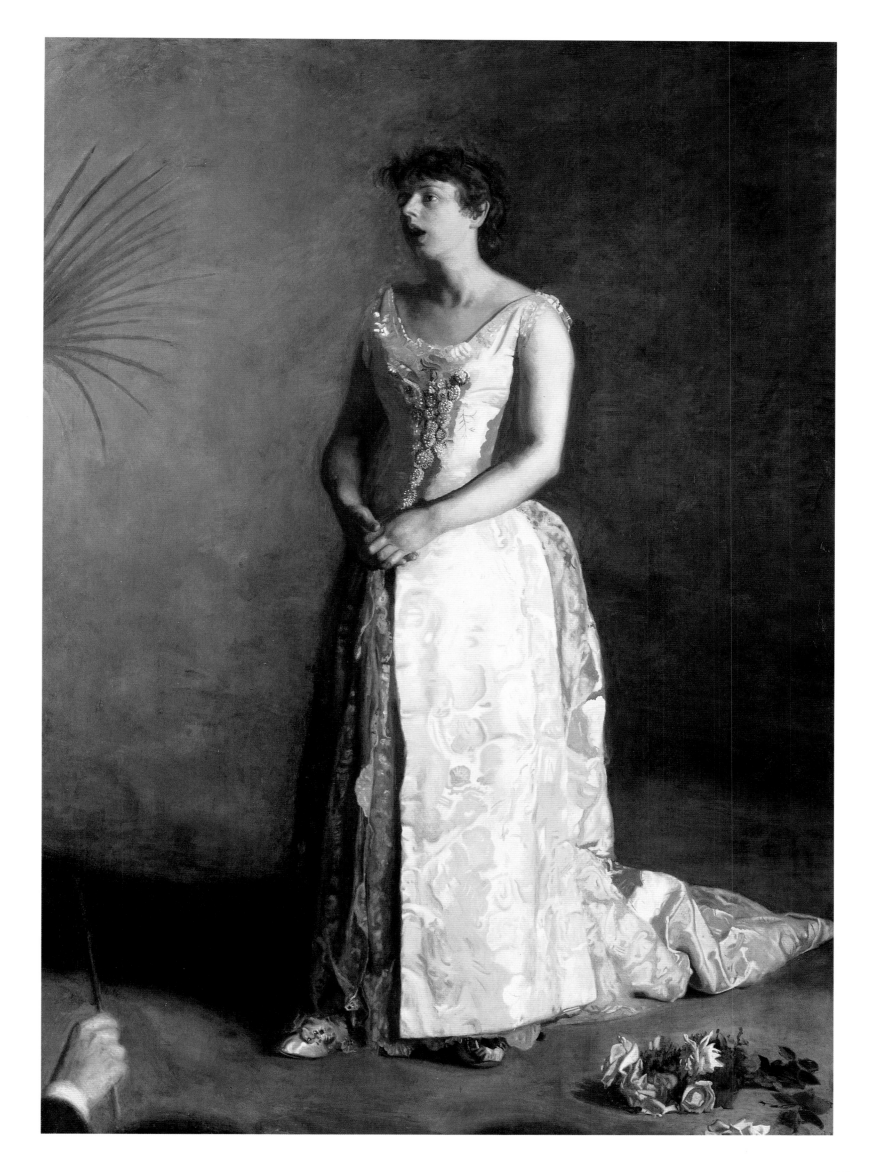

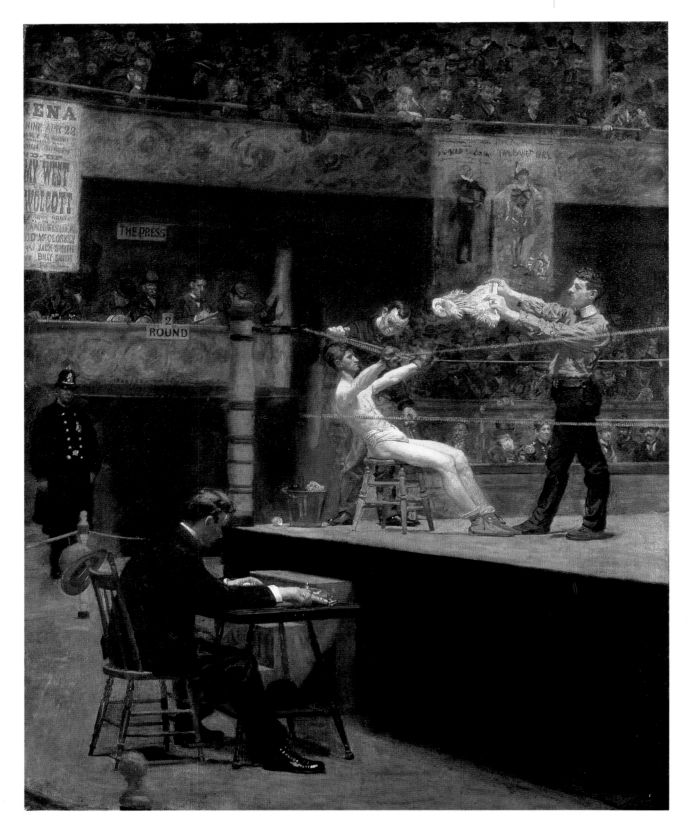

THOMAS EAKINS

Between Rounds. 1899
Oil on canvas. 50¼ × 40″
Philadelphia Museum of Art, Philadelphia
Given by Mrs. Thomas Eakins and Miss Mary Adeline Williams

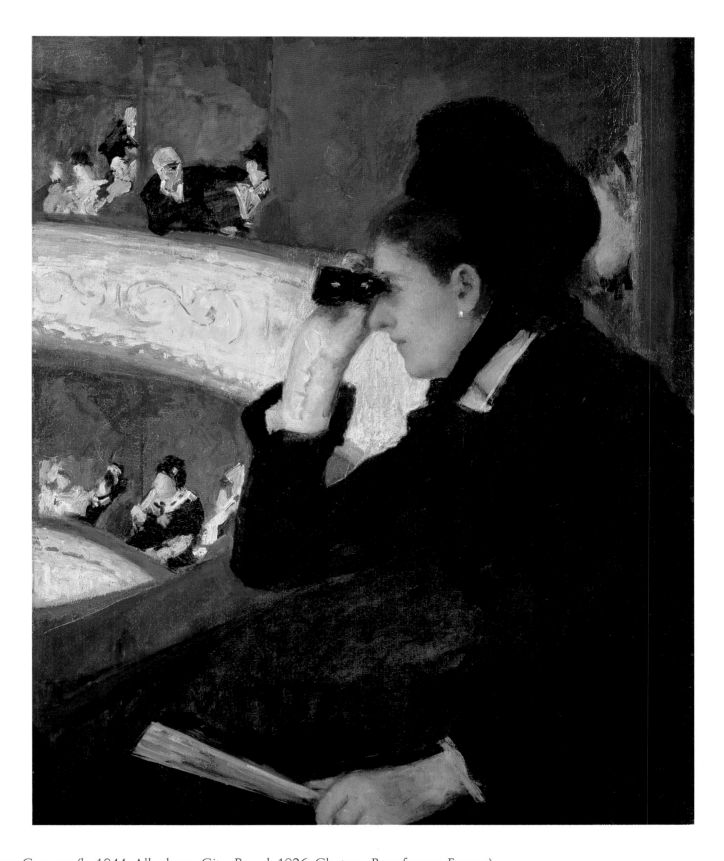

MARY CASSATT (b. 1844, Allegheny City, Pa.–d. 1926, Chateau Beaufresne, France)

At the Opera. 1880
Oil on canvas. 31½ × 25½″
Museum of Fine Arts, Boston
Charles Henry Hayden Fund

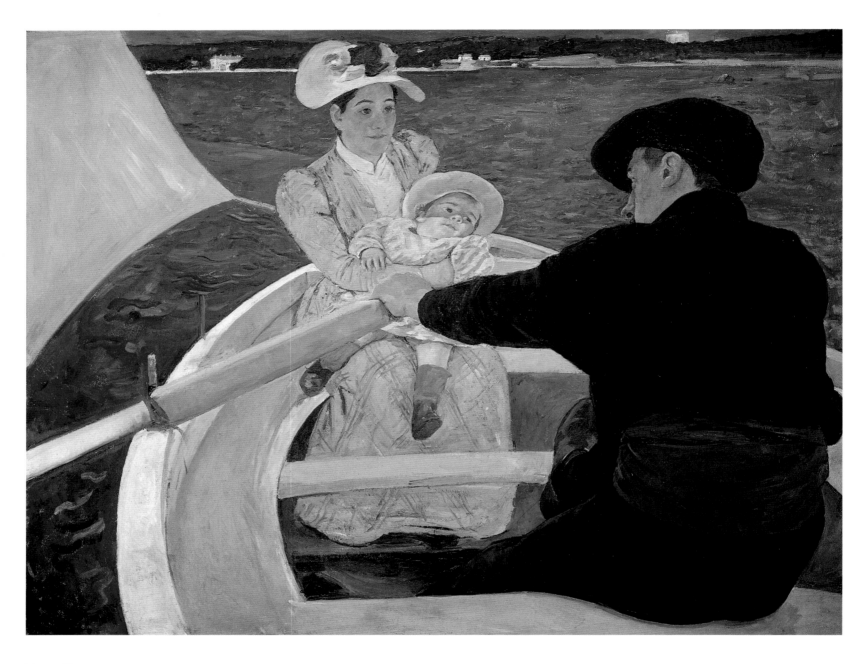

MARY CASSATT

The Boating Party. 1893–1894
Oil on canvas. 35½ × 46⅛″
National Gallery of Art, Washington, D.C.
Chester Dale Collection

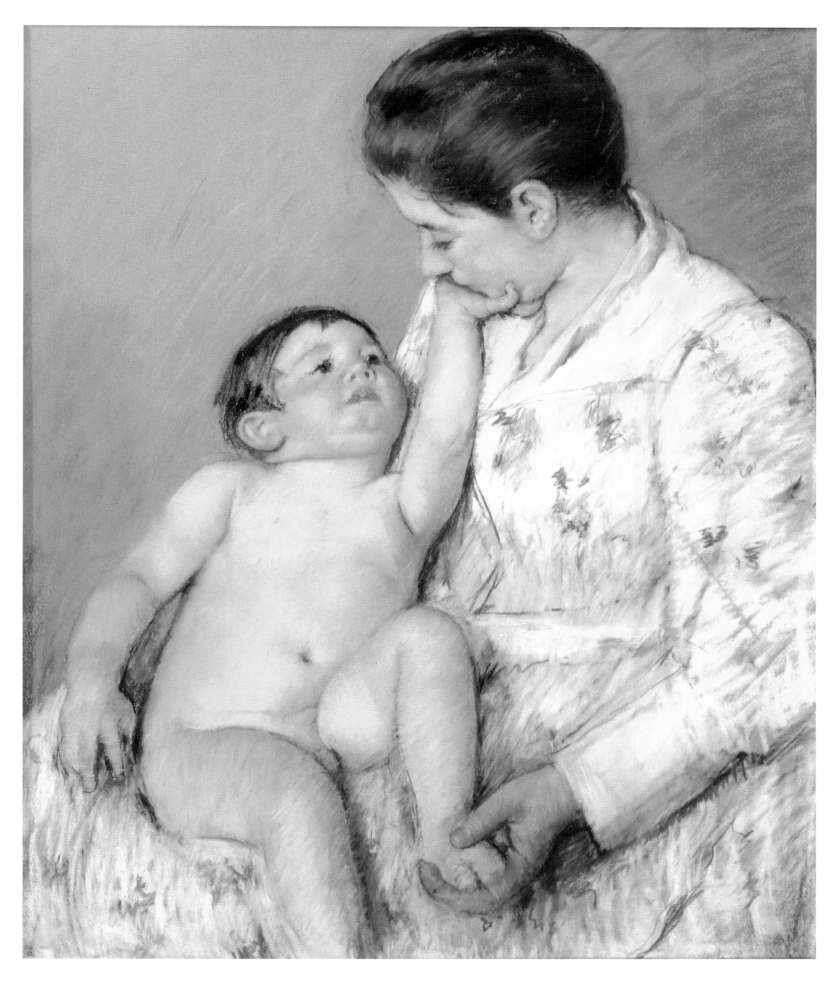

Mary Cassatt

Baby's First Caress. 1891
Pastel on paper. 30 × 24″
New Britain Museum of American Art, New Britain, Conn.
Harriet Russell Stanley Fund

12. Ordinary Objects in the Still life personified

Any subject matter in art is capable of symbolism or allegory, but a still life lends itself particularly well to hidden meanings, and to revelations of the inner self. In his portraits, Copley used still lifes as identifying attributes, pictorial directives, and indications of character or status. The still life in Charles Willson Peale's *Peale Family Group* is actually a signature, with its punning inclusion of peeled fruit. This painting was probably also the starting point for America's first full-fledged still-life painter, Peale's eldest son, Raphaelle.

The hidden meaning in some of Raphaelle's work, as has been suggested, may involve his unhappy relationship with his father. Still life was generally considered a poor substitute for the nobler and more lucrative practice of portraiture, in which other family members had varying degrees of success. But without directly competing with his family, Raphaelle Peale was able to achieve an even purer form of mimesis and aesthetic judgment. His tiny, gemlike paintings, done between 1812 and 1824, are about the perfection of form and relationship, which light, reflection, and organic presence imbue with life. Peaches and lemons and knives and teapots were Raphaelle's living objects, his people. They represent an appreciation of the natural order, and of the mind's ability to perceive, or construct, that order.

Toward midcentury, in the age of national expansion, painters of still lifes and flowers began to emphasize nature's profusion. Severin Roesen, from Germany, introduced a baroque realism of abundance. The Hudson River painters insisted that nature be closely observed. Some artists were encouraged by the British writer John Ruskin, who declared nature to be the only source of beauty. Fidelia Bridges' wildflowers, heroically silhouetted against the sky, and Maria Oakey Dewing's unruly gardens express intense feelings about flowers, one of the few subjects that women, if they insisted on being artists, were encouraged to depict. On the other hand, John La Farge and Julian Alden Weir, nurtured by their experiences in Europe, produced richly brushed still lifes that at times express a dark and elegiac melancholy.

Elegy, or memory, is the natural mode of still life. Fruit, cut flowers, and timeworn objects and surfaces are reminders of life's transience and of things past. In William Harnett's case, as in Raphaelle Peale's, the objects are literally substitutes for living figures. He apparently began painting still lifes because he couldn't afford human models and then found that he possessed a rare talent for rendering objects with uncanny accuracy. Thus an original American school of painting was established.

In the tradition of Charles Willson Peale's fascination with painting that fools the eye (trompe l'oeil), Harnett, John Peto, and others created various kinds of tableaux in which objects on a table or hung from a nail on an old door seem to project into real space. Within a very compressed space, an entire world is laid before the viewer, to be examined in extraordinary detail. Objects measure the absence of people who were once present, through correspondences in time and history, meticulously reproduced

ARTIST'S CREATIVE MIND:

newspaper items, tattered books, playing cards, musical instruments, dead animals, even photographs—almost anything can be included. The final conglomeration is a puzzlement, a collection of clues and relationships that is perhaps symbolic of the mystery of human biography in general. These works, despised by many in the late-nineteenth-century art world as too tricky and concerned with technique, create a plane of ambiguity about life that has also been explored by artists of our own time, most notably Jasper Johns. The examination of literal objective reality serves to manifest its opposite—the mind's subjective indeterminacy.

WILLIAM HARNETT (b. 1848, Clonakilty, Ireland–d. 1892, New York City)

Music and Literature. 1878
Oil on canvas. 24 × 32⅛"
Albright-Knox Art
Gallery, Buffalo, N.Y.
Gift of Seymour H. Knox

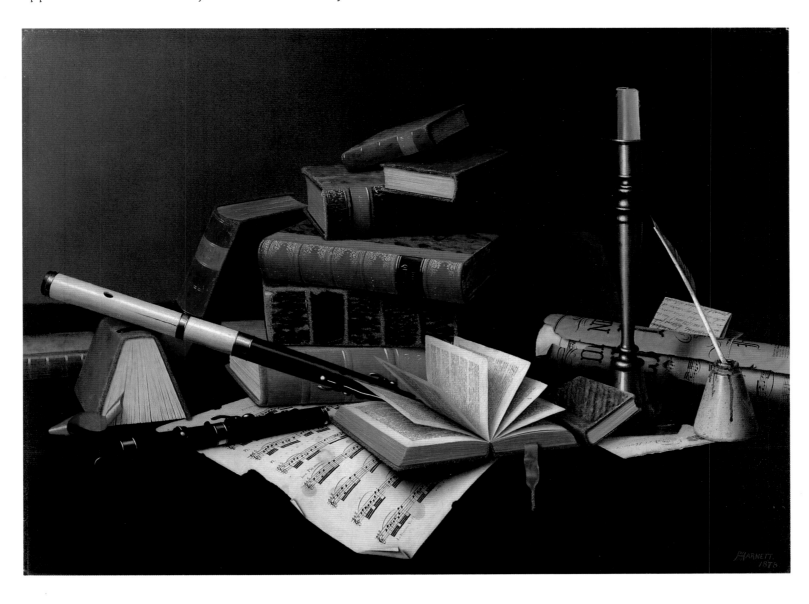

JULIAN ALDEN WEIR (b. 1852, West Point, N.Y.–d. 1919, New York City)

Roses. 1883–1884
Oil on canvas. 35½ × 24¾
Phillips Collection, Washington, D.C.

SEVERIN ROESEN (b. ca. 1815, Cologne, Germany–
d. 1871, Philadelphia, Pa.)

Still Life, Flowers and Fruit. 1848
Oil on canvas. 36 × 26"
Corcoran Gallery of Art, Washington, D.C.
Museum purchase through the
gift of Orme Wilson

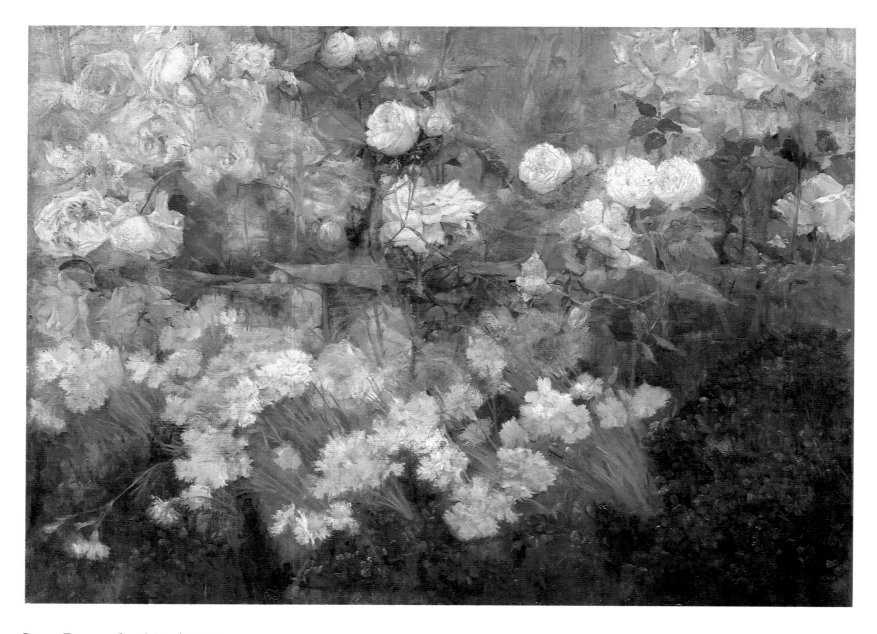

MARIA OAKEY DEWING (b. 1845–d. 1927)

Garden in May. 1895
Oil on canvas. 23⅝ × 32½″
National Museum of American Art, Smithsonian
Institution, Washington, D.C.
Gift of John Gellatly

FIDELIA BRIDGES (b. 1834 Salem, Mass.–
d. 1923, New Canaan, Conn.)

Milkweeds. 1861
Watercolor on paper. 16 × 9½″
Munson-Williams-Proctor Institute,
Museum of Art, Utica, N.Y.

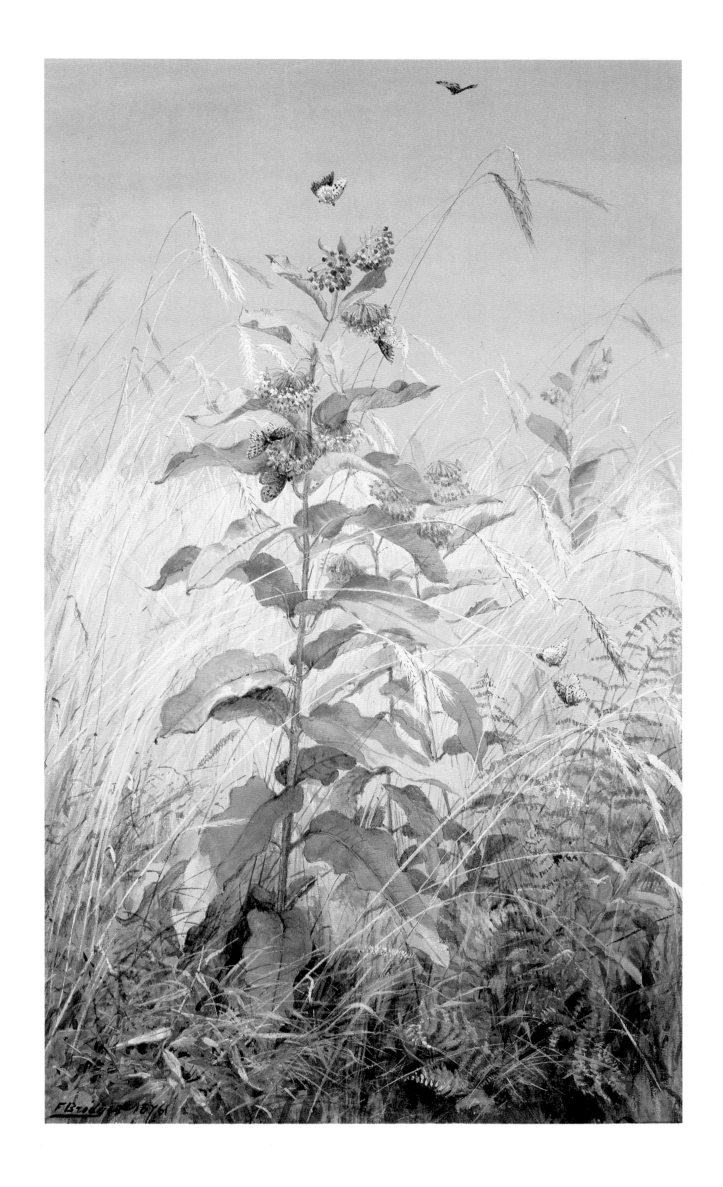

125

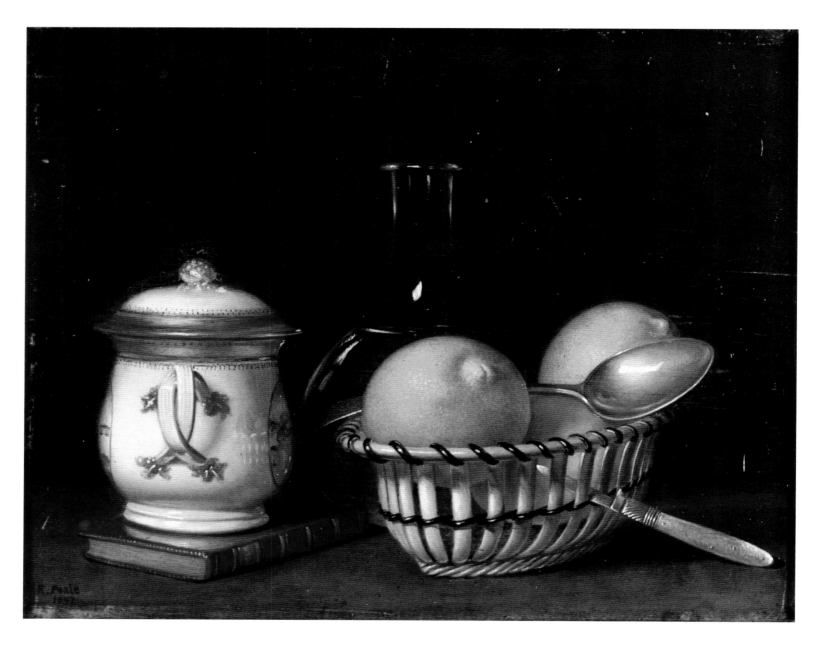

RAPHAELLE PEALE (b. 1774, Annapolis, Md.–d. 1825, Philadelphia)

Lemons and Sugar. ca. 1822
Oil on wood. 12 × 15″
Reading Public Museum and Art Gallery, Reading, Pa.

WILLIAM HARNETT

The Faithful Colt. 1890
Oil on canvas. 22½ × 18½″
Wadsworth Athenaeum, Hartford, Conn.
Ella Gallup Sumner and Mary Catlin
Sumner Collection

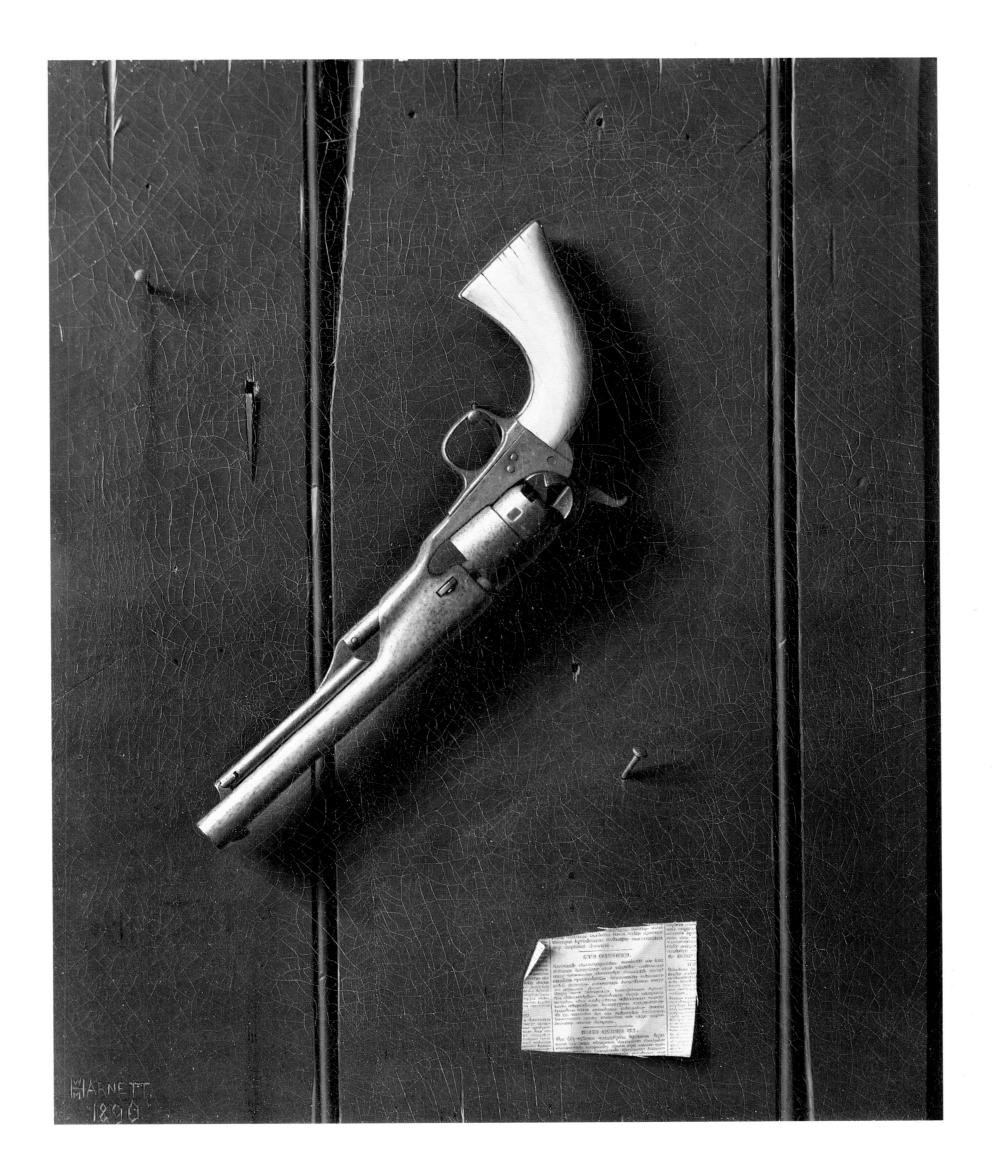

13. Dark Passages: Luminism

No matter how ominously obscured, there is always a sense of universal light in American painting before the Civil War: in the work of the luminists, the Hudson River School, and genre painters alike. The sun or the moon is in its heaven, and everything proceeds from that principle, including the pictorial order and geometry.

After the Civil War that arrangement is not so secure. It is not that light is demoted; quite the contrary for the American Impressionists, who emerged in the 1880s. But it does become a quality rather than a universal principle, a quality that has certain consequences, whether pictorial, coloristic, poetic, or dramatic. It becomes a cathartic agent that brings color or structure to life. Eakins seems to make no assumptions about the way things are; he must constantly test qualities of light as well as of movement and perspective. Even in his early, sun-filled paintings, Homer's raking light has an eerie, blanching effect on solid form. Light is effect, not cause.

Continuity and transition between light and dark are lost, or abandoned. An inexplicable and fathomless gap separates one from the other. Impressionism recognizes the gap by not even attempting the transition: by staying in the field of light. Whistler juxtaposes extremely close values, especially in his white paintings and his Nocturnes, but the gap remains, however imperceptible. For Eakins and Homer, darkness is the given; piercing it is a matter of survival, is the essence of life. Dr. Gross's science illuminates the theater in which he operates and, it is hoped, the experience of those who are obscured by the theater's darkness. A luminous white blanket of snow in Homer's *The Fox Hunt* covers more than half the landscape, yet the prevailing image is of darkness: the blackness of the hovering crows.

It was, in fact, an age of darkness, despite enormous and growing wealth: the darkness of Victorian interiors, of city streets, of the solitary mind. Light was escape, to the countryside, to celebrations, to tamed nature, to the glitter of gilded objects in a gilded age. Counterposed to civilized conviviality were isolation and withdrawal: by Homer to the coast of Maine, by the trompe-l'oeil painters into their objects, by Eakins into neglect, and by a number of other artists—most notably George Inness, Ralph Albert Blakelock, and Albert Pinkham Ryder—into visionary landscapes.

Surprisingly, perhaps, the visionaries, the truth-seekers, were highly respected in the decades around 1900, though only Inness, late in his career, achieved monetary success. At his death, Inness was considered by many the nation's greatest painter, and Ryder was the only older American master to be honored at the Armory Show in 1913, four years before his death. Unconventional and fiercely independent, in their lives as well as their art, all three artists were particularly admired by the avant-garde that was beginning to gain strength in American art.

The admiration is understandable, though their work is in many ways deeply traditional and more redolent of the past than was that of their contemporaries. Inness emerged from the Hudson River School and was later influenced by the pastoral landscapes of the Barbizon painters during a trip to France in 1853. Ryder emulated the dark, glowing tonalities of the old masters and drew on a wide range of European literature for his themes. Blakelock kept before him the image of Native Americans in a primal

REVERSED

landscape that he had seen during youthful travels, from 1869 to 1872, through the wilderness of the West.

But all of them sought to reveal or suggest the reality underlying the visual surface. Slavishly recording what they saw did not interest them at all. "Three solid masses of form and color—sky, foliage, and earth—the world bathed in an atmosphere of golden luminosity": that is how Ryder, early in his career, described what he could capture, with sweeping strokes of the palette knife, creating something that "was better than nature, for it was vibrating with the thrill of a new creation." Inness believed that the intellect must "submit to the fact of the indefinable—that which hides itself that we may see it."

In the last ten years of his life, Inness moved toward this idea as he moved toward greater abstraction. More than ever, the seen world is transformed into an arrangement of color, tone, shape, contour, and over-all structure, not in Whistler's ethereal, reductive manner but in a very material and richly atmospheric mode. Trees are rich bursts of color or dark silhouettes; their trunks are rhythmic accents in the landscape; the sky and land luminesce and darken by turns; and all is brought together with the movement of the brush. There is no consistent, over-all treatment here but an integration of disparate elements in a pattern of nature.

Ryder's dreams were bucolic at first: golden farm scenes and Romantic fantasies that lent themselves at times to paintings on screens, panels, and gilded leather that he provided for a leading furniture-and-decoration firm in New York. Later, he imbued his work with literary themes from Shakespeare, Poe, the Bible, and Greek and German myths, all of them featuring seduction, madness, death, and abandonment in the world. His painted shapes are almost sculptural in their layered thickness. The world is summarized by ineluctable structures of interlocking abstract shapes. The hidden boat in *Moonlight Cove* is as important and meaningful as the distant moon and sky. It is man's real existence in the universe, as is the terrified figure of Jonah in a roiling sea of paint. The paint itself is a visceral reminder of the sea's relentless power.

Blakelock creates a double world. One is of darkness, represented by a foreground screen of trees, which typically contain an Indian camp. The other, beyond the screen, is of golden light. The leap from one to the other is almost unimaginable.

GEORGE INNESS (b. 1824, Newburgh, N.Y.–d. 1894,
Bridge-of-Allan, Scotland)

The Mill Pond. 1889
Oil on canvas. 37¾ × 29¾"
The Art Institute of Chicago, Chicago
Edward B. Butler Collection

ALBERT PINKHAM RYDER (b. 1847, New Bedford, Mass.–
d. 1917, Elmhurst, N.Y.)

The Toilers of the Sea. 1884
Oil on wood. 11½ × 12"
The Metropolitan Museum of Art, New York City
George A. Hearn Fund

ALBERT PINKHAM RYDER

Siegfried and the Rhine Maidens. 1881–1891
Oil on canvas. 19⅞ × 20½"
National Gallery of Art, Washington, D.C.
Andrew W. Mellon Collection

ALBERT PINKHAM RYDER

Jonah. ca. 1885
Oil on canvas. 27¼ × 34⅜″
National Museum of American Art,
Smithsonian Institution,
Washington, D.C.
Gift of John Gellatly

ALBERT PINKHAM RYDER

***The Race Track or Death on a
Pale Horse.*** ca. 1910
Oil on canvas: 28¼ × 35¼″
Cleveland Museum of Art,
Cleveland
Purchase from the J.H. Wade Fund

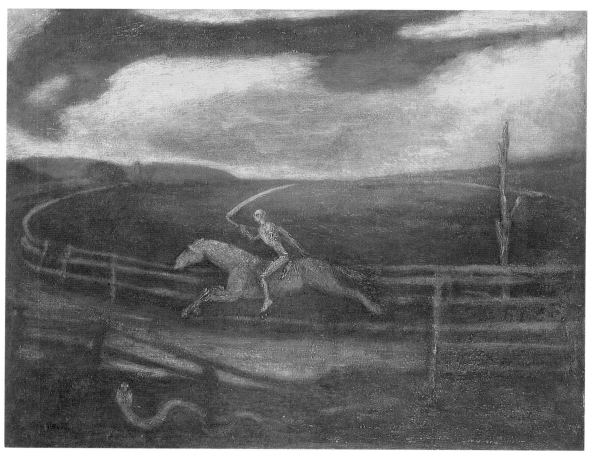

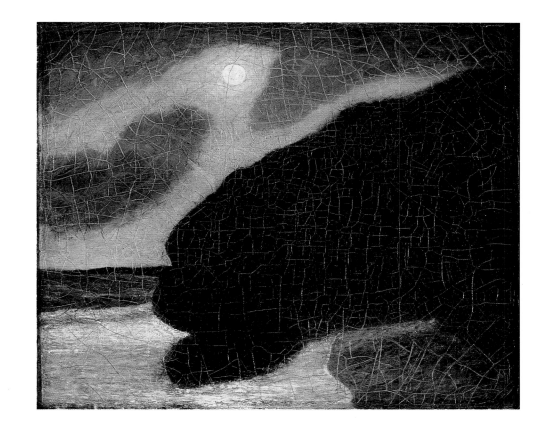

ALBERT PINKHAM RYDER

Moonlit Cove. 1880–1890
Oil on canvas, 14⅛ × 17⅛″
Phillips Collection, Washington, D.C.

RALPH BLAKELOCK (b. 1847, New York City—
 d. 1919, Elizabethtown, N.Y.)

The Poetry of the Moonlight. c. 1880–1890
Oil on canvas. 30 × 25¼″
Heckscher Museum, Huntington, N.Y.
August Heckscher Collection

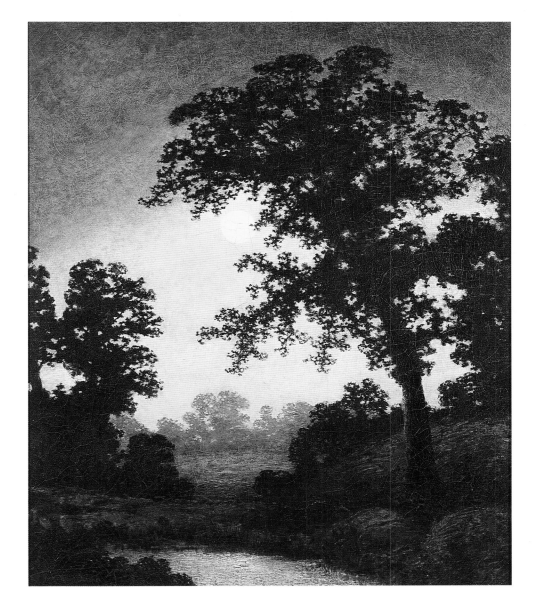

14. LEISURE, LIGHT, AND

With a few exceptions, most American artists in the nineteenth century spent some time and received some training in Europe, usually France or Germany. But from the 1870s onward American painters were overwhelmed by their experience of Europe. Whistler and Cassatt, of course, were already in Europe for good. William Merritt Chase studied in Munich from 1872 to 1878 and, after settling in New York, returned to Europe on numerous occasions until his death in 1916. Theodore Robinson went to Paris in 1876 for three years and returned in 1884 for another eight years, becoming a close working companion of Claude Monet. John Twachtman was in Munich, Venice, Florence, and Paris at various times between 1875 and 1885, guided at first by Frank Duveneck and in touch with both Chase and Whistler. Sargent (though an American citizen) was born in Florence, studied in Paris, moved to England in 1885, and later made twenty trips to the United States, usually to work on portraits and other commissions. In two trips between 1883 and 1889, Childe Hassam toured the Continent and then stayed in Paris. And Cecilia Beaux studied at the Académie Julian, in Paris, in 1889–90.

The effects of this immersion in Europe, even on a native European like Sargent, were curious and various. Except for Whistler, American artists in Europe had never been associated with the avant-garde. They acquired conservative, academic training, as did most European artists, and then continued on their own way. The generation born around the midcentury went through the same process, only more so, and then became aware of the very unconventional art being painted by the Impressionists. This polarity had some interesting consequences.

Americans came to French Impressionism years after its original impulse had passed. The Impressionists themselves were already mature artists. What Americans participated in, then, was not the engendering process, the burst of realizations about painting light and atmosphere and modern life that Monet, Renior, and the others had experienced and thrust upon the Paris art world. Nor did the Americans, with their conservative training, absorb everything that was presented to them. In general, they accepted undifferentiated space that uses perspective to lead the eye around, rather than into, the picture. They accepted the idea of large, empty areas and eccentrically placed figures, as in Chase's *Hide and Seek*, which owes something both to the immediacy of photography and to the lyricism of Japanese design. They adopted a much lighter and brighter palette than they had been used to, and an emphasis on the physical presence of brushstrokes; on the very mechanism of their art and of their ability to render impressions of the world.

But they couldn't, as has often been noted, accept the dissolution of form and color in light. For the Impressionists, any one color was actually composed of many colors, and the composition of color changed as the light changed. Their approach did not represent an absolute visual truth, but it satisfied a desire to analyze the physical world in a way that might reveal an underlying unity. The Americans practiced some of this kind of analysis, but as a consistent principle it was far too abstract. Green is green, blue is blue, each color has its own integrity and its specific and singular function in describing form. A more colorful painting would be one, like Hassam's paintings of flower

IMPRESSIONISM

gardens and flags, in which there are more colored objects, rather than a greater penetration of light.

John Twachtman was no less literal, in a way, but his investigations of color and light and pictorial form, guided in part by Whistler's poetic reductions, were far more intense. Early paintings done in France, such as *Springtime*, indicate his devotion to the fragile but indelible design of nature, rendered in a few tones of gray and green. In later paintings done around his home, in Greenwich, Connecticut, he explores an extraordinary range of color in flowers and plants and in white-on-white snow scenes. Every stroke is part of an over-all aesthetic pattern that is also an organic pattern. The intimacy of his position in nature, his realization of a larger world through the accumulation and organization of individual brushstrokes, each of which seems to carry its own structural information, is reminiscent of Cézanne's grand obsession with his landscape and still-life motifs.

Much more complicated and problematic is the case of John Singer Sargent. He played the piano flawlessly, spoke several languages fluently, painted like a virtuoso, and was generous and self-denigrating to a fault. He learned from the Impressionists but chose not to be one, even declining Mary Cassatt's invitation to exhibit with them early in his career. Cassatt would later say that he had sold out to high society. He painted grand, often flattering portraits of the rich and powerful in England and the United States, and wished that he didn't have to. His works are in such a variety of styles that it is hard to believe that one artist produced them: from charmingly offhand watercolors to stiff mythological murals for the Boston Public Library and other public institutions. He was, in other words, the Benjamin West of his age.

But Sargent at his best was more than simply charming or masterful. He was not, as Monet noted, an Impressionist, though in a way he outdid Impressionism with his sometimes outrageous and sensual mélanges of color. He managed to raise the offhand and casual image, which he captured in his more informal scenes and watercolors, to a principle that weds behavior and art. Like Whistler with his Chelsea storefronts, he was fascinated with (though less rigorous about) unexceptional views: views that fall between here and there, or between day and night, as in *Carnation, Lily, Lily, Rose*, a scene of infinitesimal duration that took two years of posing at twilight to complete. He loved to render figures in a rumpled mess of fabrics and color, as in *The Artist in His Studio*, or to heat a seductive encounter with an odd chemistry of glowing colors, as in *Lady Agnew*. He was, as it were, profoundly superficial, and it is hard to argue with his variation on the realist credo: "I don't dig beneath the surface for things that don't appear before my own eyes."

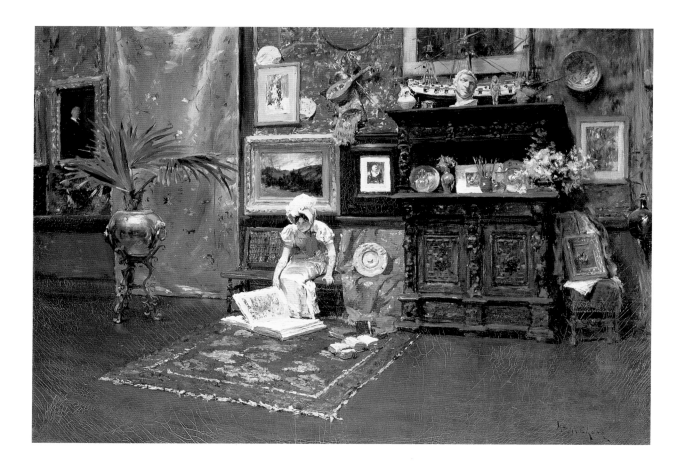

WILLIAM MERRITT CHASE (b. 1849,
 Williamsburg, Ind.–d. 1916,
 New York City)

In the Studio. ca. 1880
Oil on canvas. 10⅙ × 28⅛″
The Brooklyn Museum,
New York City
Gift of Mrs. Carll H. De Silver

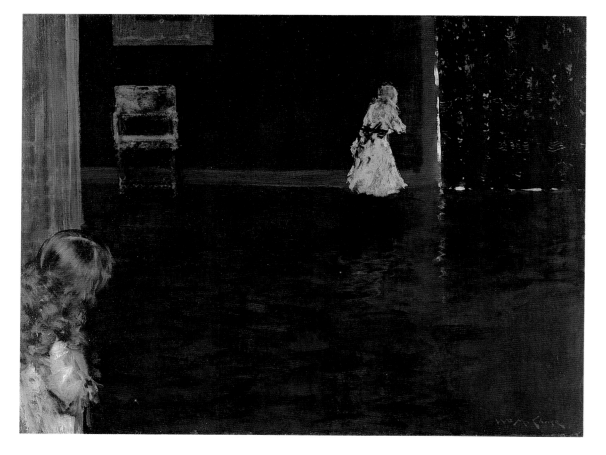

WILLIAM MERRITT CHASE

Hide and Seek. 1888
Oil on canvas. 27⅝ × 35⅞″
Phillips Collection, Washington, D.C.

JOHN TWACHTMAN (b. 1853, Cincinnati–
d. 1902, Gloucester, Mass.)

Springtime. ca. 1884–1885
Oil on canvas. 36⅞ × 50″
Cincinnati Art Museum, Cincinnati
Gift of Frank Duveneck

JOHN TWACHTMAN

Wildflowers. Early 1900s
Oil on canvas. 30¼ × 25¼″
Private collection, Boston
Courtesy Spanierman
Gallery, New York City

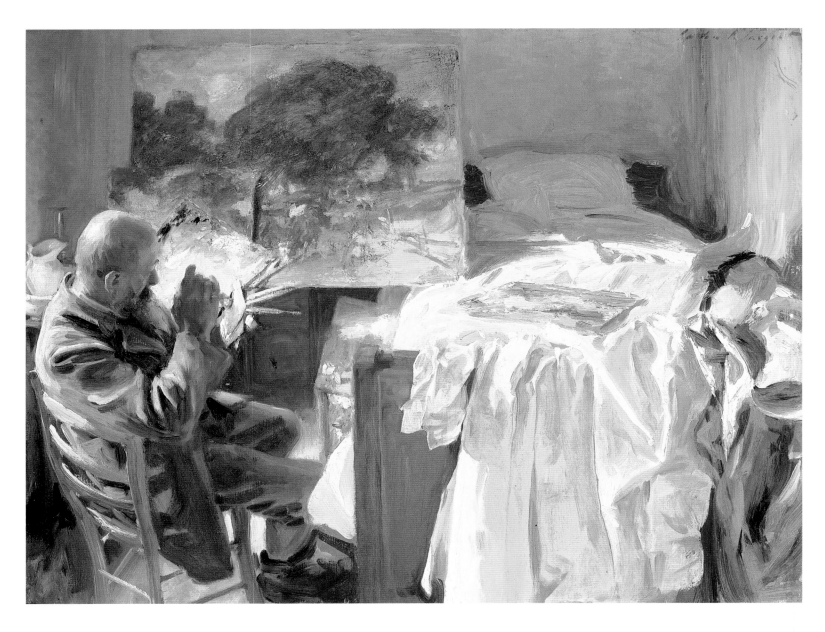

JOHN SINGER SARGENT

An Artist in His Studio. ca. 1903
Oil on canvas. 21½ × 28¼″
Museum of Fine Arts, Boston
Charles Henry Hayden Fund

JOHN SINGER SARGENT (b. 1856, Florence–d. 1925, London)

The Oyster Gatherers of Cancale. 1878
Oil on canvas. 31½ × 48½″
Corcoran Gallery of Art, Washington, D.C.
Museum purchase, Gallery Fund

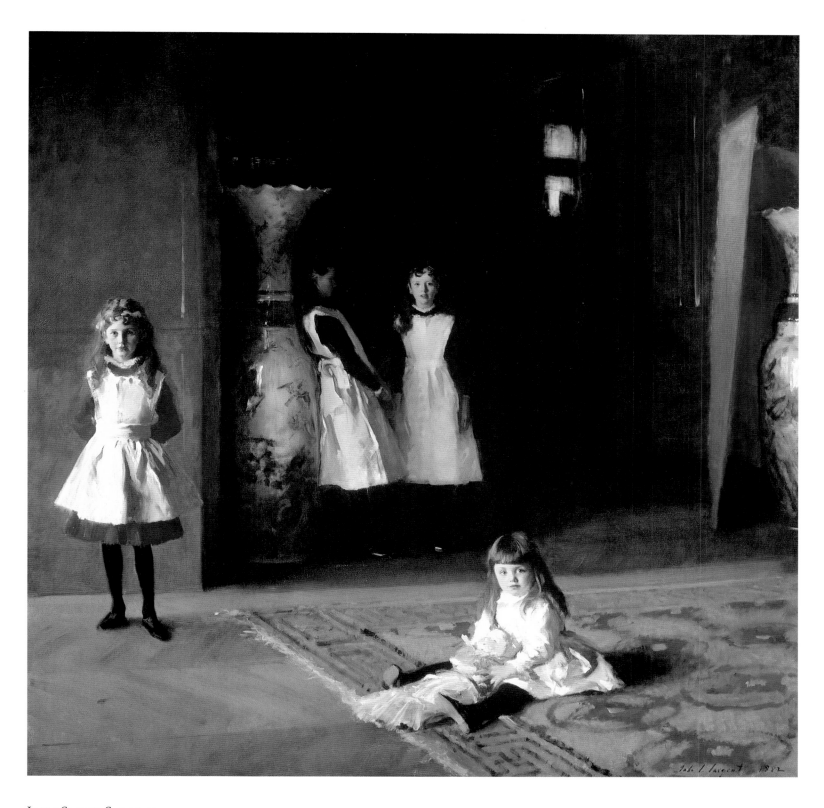

JOHN SINGER SARGENT

The Daughters of Edward Darley Boit. 1882
Oil on canvas. 87 × 87″
Museum of Fine Arts, Boston, Mass.
Gift of Mary Louisa Boit, Florence D. Boit, Jane H.
Boit, and Julia O. Boit, in memory of their father

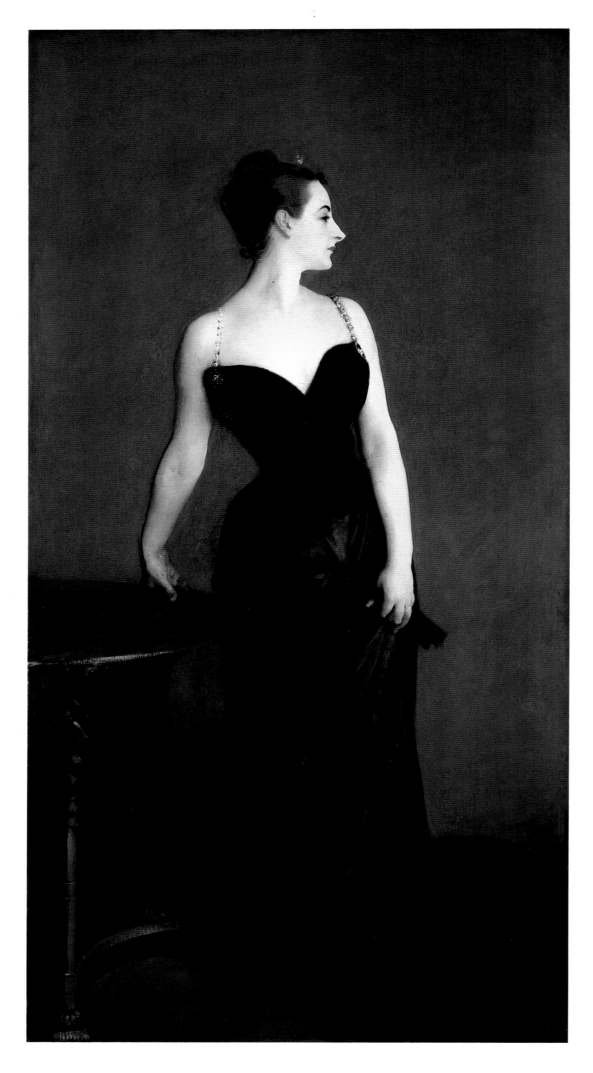

John Singer Sargent

Madame X (Madame Pierre Gautreau). 1884
Oil on canvas. 82¼ × 43¼"
The Metropolitan Museum of Art,
New York City
Arthur Hoppock Hearn Fund

OPPOSITE:

John Singer Sargent

Lady Agnew of Lochnaw. ca. 1892–1893
Oil on canvas. 49½ × 39½"
National Galleries of Scotland, Edinburgh

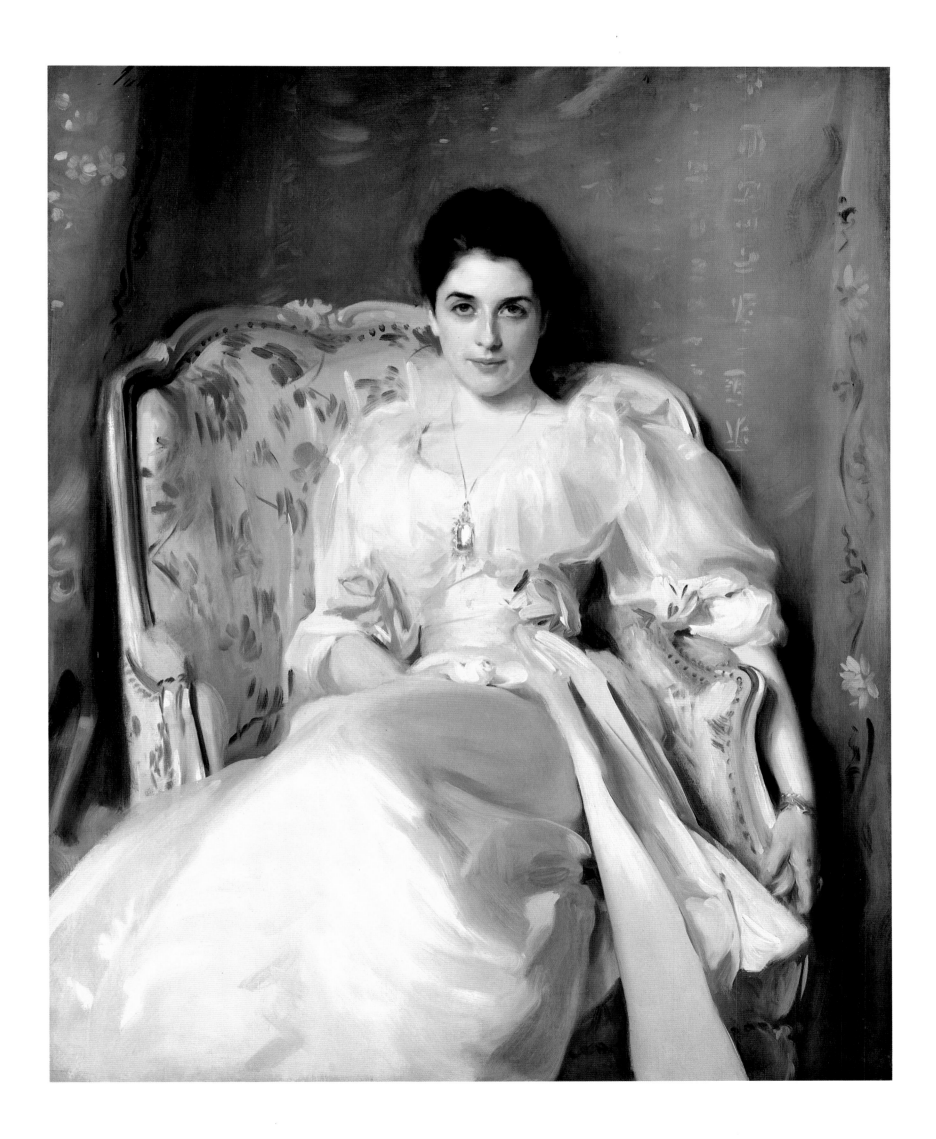

CHILDE HASSAM (b. 1859, Dorchester, Mass.–
 d. 1935, East Hampton, N.Y.)

Boston Common at Twilight. 1885–1886
Oil on canvas. 42 × 60"
Museum of Fine Arts, Boston
Gift of Miss Maud E. Appleton

CHILDE HASSAM

> *The Union Jack, New York, April Morn.* 1918
> Oil on canvas. 36 × 30⅛″
> Hirshhorn Museum and Sculpture Garden, Smithsonian
> Institution, Washington, D.C.
> Gift of Joseph H. Hirshhorn

CHILDE HASSAM

> *Gathering Flowers in a French Garden.* 1888
> Oil on canvas. 28 × 21⅝″
> Worcester Art Museum, Worcester, Mass.
> Theodore T. and Mary G. Ellis Collection

CECILIA BEAUX (b. 1863, Philadelphia–d. 1942, Gloucester, Mass.)

> *Man with Cat (Henry Sturgis Drinker).* 1898
> Oil on canvas. 49 × 34⅝″
> National Museum of American Art, Smithsonian
> Institution, Washington, D.C.
> Bequest of Henry Ward Ranger through
> the National Academy of Design

144

15. BEYOND IMPRESSIONISM

MAURICE PRENDERGAST (b. 1859,
St. John's, Newfoundland–
d. 1924, New York City)

The East River. 1901
Watercolor and pencil on
paper. 13¾ × 19¾"
The Museum of Modern Art,
New York City. Gift of Abby
Aldrich Rockefeller

Since American Impressionism was a late bloomer, it was not followed by the equivalent of post-Impressionism in France. While Gauguin, Van Gogh, Cézanne, Seurat, and Toulouse-Lautrec evolved, out of Impressionism, an emotional, symbolic, abstract use of color, light, and shape, and experimented with the expressive power of line and decorative pattern, few American artists followed this path.

One exception was Maurice Prendergast, who lived in Paris during the early 1890s and was in touch with the Symbolists, the Nabis, and the Neo-Impressionists there. The abstract use of color and shape by Bonnard and Vuillard, among others, appealed to him. Painting scenes of city streets and parks, in Paris and then in Boston and New York, he

moved as close to pure abstraction as anyone else at the time, rendering a face with a single brushstroke rather than detailing its features. Movement, color, light, and gesture are woven into a continuous pattern. A kind of primal energy emanates from his crowds, animals, trees, boats, water, and sky, because it emanates from the brushstrokes themselves. Floral or faunal, animate or inanimate: there is no differentiation among the various elements.

While Prendergast turned his attention to the French Post-Impressionists, a wide variety of American artists of this period were searching for something beyond the matter-of-fact quality of American Impressionism, its assumption that the world is a bright and untroubled family. Young realists in Philadelphia, later known as the Ashcan School, explored the less privileged side of city life. It is worth noting that Prendergast and Arthur B. Davies, neither of whom shared the Ashcan School's gritty manner, later exhibited in New York with this group, as members of The Eight.

A number of American artists were influenced by primitivism and symbolism, tendencies evident in European art at the time—in Gauguin's embrace of peasant and non-European cultures, Arnold Böcklin's Gothic fantasies, and Maurice Denis's religious symbolism—but the American equivalents took some unusual turns. Abstract ideas found expression in a variety of abstract forms.

Thomas Dewing, for instance, who was allied with the New York Impressionists known as The Ten, created strange, indeterminate spaces, indoors and out, in which quietly rapturous young women play music or recite poetry to each other or themselves. Women, the natural world, and the arts are joined in an exquisite round of abstracted relationships and psychological expectancy that owes something to academic classicism as well as to Impressionism.

Dewing, Prendergast, Davies, Louis Eilshemius, and even Henry Ossawa Tanner in his Biblical paintings, continue the Impressionists' and the Victorians' fascination with women in landscapes as capturing some inner truth. Prendergast's city and country scenes are effectively feminine, especially the later, more symbolic work. Davies' women are rhythmic emanations in mythic landscapes. And Eilshemius goes even further, allowing them to fly on the wind in his purposely naive style.

The mythologized landscape, with and without women, continued well into the twentieth century in the work of Maxfield Parrish, whose meticulous paintings after 1930 have the artificiality of a magnificent movie set. Here, finally, ordinary reality is transformed into a celluloid dream.

Thomas Wilmer Dewing (b. 1851, Boston—d. 1938, New York City)

Lady with a Lute. 1886
Oil on wood. 20 × 15″
National Gallery of Art, Washington, D.C.
Gift of Dr. and Mrs. Walter Timme

HENRY OSSAWA TANNER (b. 1859, Pittsburgh—d. 1937, Paris)

The Artist's Mother. 1897
Oil on canvas. 35½ × 45"
Philadelphia Museum of Art, Philadelphia
Private collection

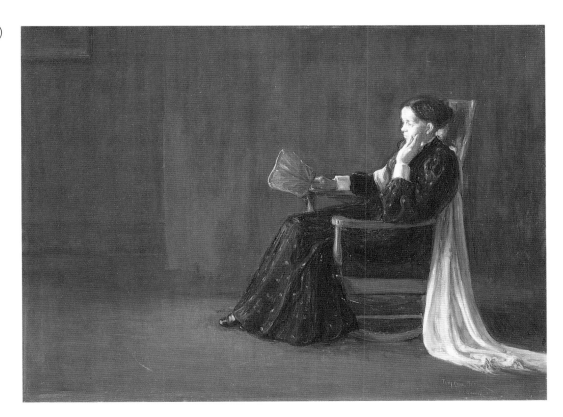

ARTHUR BOWEN DAVIES (b. 1862, Utica, N.Y.—
d. 1928, Florence)

Across the Harbor. 1908
Oil on canvas. 17 × 22"
Indianapolis Museum of Art, Indianapolis
James E. Roberts Fund

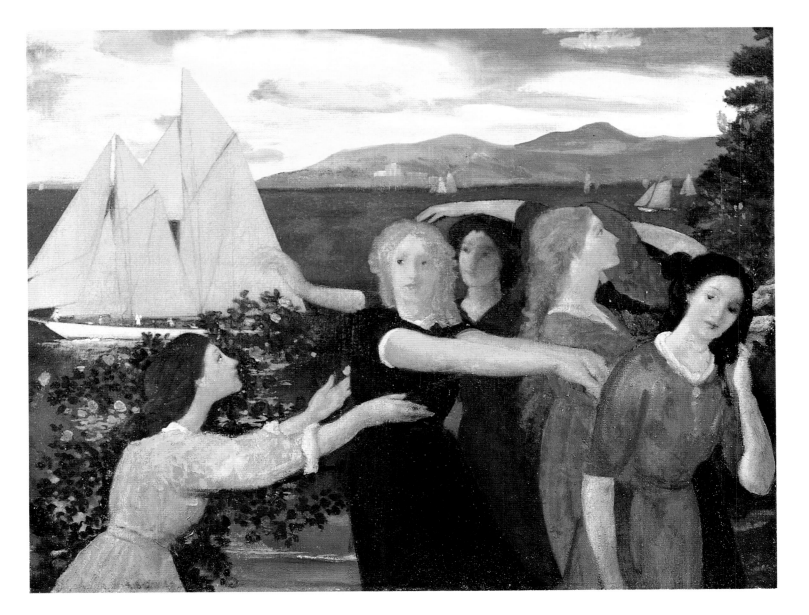

LOUIS EILSHEMIUS (b. 1864, Arlington, N.J.–
 d. 1941, New York City)

Mother Bereft. ca. 1890
Oil on canvas. 20½ × 14½"
Hirshhorn Museum and Sculpture Garden, Smithsonian
Institution, Washington, D.C.
Gift of the Joseph H. Hirshhorn Foundation

LOUIS EILSHEMIUS

Afternoon Wind. 1899
Oil on canvas. 20 × 36"
The Museum of Modern Art, New York City
Given anonymously

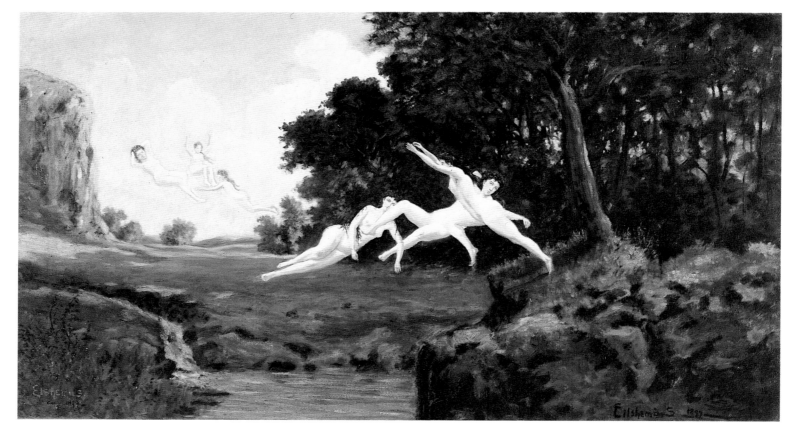

MAXFIELD PARRISH (b. 1870, Philadelphia–d. 1966, Plainfield, N.H.)

The Old Glen Mill. 1950
Oil on masonite. 23 × 18½″
The Anschutz Collection, Denver

16. After the West Was

As an era comes to an end, there is often a scramble to capture it in print or art before it slips away entirely. By the 1880s, the westward movement that had characterized the growth of the Union throughout much of the century was overtaking the frontier. In 1881, on his first trip west, when he was just nineteen, Frederic Remington noted, "I knew the wild riders and the vacant land were about to vanish forever, and the more I considered the subject the bigger Forever loomed."

Filling a need created by the rapid growth of magazine readership after the Civil War, both Remington and Charles Marion Russell were regarded primarily as illustrators. They intended their art to tell stories, and they deliberately set out to capture vignettes of life in the old West for a largely eastern audience. Remington traveled through the West with camera and sketchbook, although he scorned the camera's limitations. "I can beat a Kodac [sic]—that is, get more action and better action," he boasted, "because Kodacs have no brains—no discrimination."

More action and better action is clearly what Remington had in mind in one of his most famous works, *A Dash for the Timber*, which won him critical acclaim at the annual exhibition of the National Academy of Design in 1889. In this large canvas, Remington fuses two themes, of energy and danger in the rugged American countryside, that made up the content of so much of his early work. It was a content that appealed to the general public, who saw in such works the confirmation of their own romantic yearnings for the rapidly disappearing world of adventure that they imagined the untamed West to be.

Remington's background as an illustrator can be seen here in his attention to detail. As a realist—and recalling the West he witnessed as a young man—he took great pains to render the riders' clothing and gear authentically. Likewise, his appreciation of horses is evidenced in the hurtling energy of the dash; the group seems to charge out of the painting right at the viewer. More than one contemporary critic declared Remington's depictions of horses in motion unequalled for their accuracy.

The picture is not perfect. The stiffness of the wounded rider at the apex of the group, especially in his hands, which seem more extended for the sake of drama, betrays a self-conscious straining for effect. Yet the dynamism is undeniable, as is the harsh landscape and the open sky—American space and American color.

The Scout: Friends or Enemies? reveals Remington's theme of man and beast as overwhelmed by and yet dominating nature. The vast, empty space of the painting, with the horizon fading into sky, is overpowered by the colorful solidity of the horse and rider, in the foreground. As he matured, though, his paintings took on a more painterly quality. In 1908, he wrote in his diary, "I have always wanted to be able to paint running horses so you could feel the details instead of seeing them." In *Stampeded by Lightning*, he nearly achieves this, as his brushstrokes convey the frantic energy and chaos of a stampede. His development along these lines was cut short by death in 1909, at the age of forty-eight.

Remington was educated at Yale, lived in and around New York, and usually went west on commissions from *Harper's Weekly* and other magazines. Charles Russell, on the other hand, was an entirely self-taught artist. He was also a cowboy, and he loved the

WON

life and the land that that implied. In *Loops and Swift Horses Are Surer than Lead*, he sets the dramatic capture of a wild bear against a sweeping vista of mountains. The violent and dangerous life of the western wrangler is played out beneath an immense sky and towering peaks. Much of Russell's work lacked polish, and even at their best his paintings smack of the illustration. Westerners, however, could feel at home in his vistas, and they recognized themselves in the roaring, roistering life he portrayed.

For both Remington and Russell, the old West marked a heroic age, if often a cruel and savage one. Remington himself had little sympathy for Native Americans and depicted the wars that tamed the West in all their ferocity. Nevertheless, both artists committed themselves to portraying this age before it fell into a humdrum routine. For this, they still hold a place of high regard among their countrymen, higher perhaps than their purely artistic accomplishments would suggest.

(H.L.W.)

PAGES 154 AND 155:
FREDERIC REMINGTON (b. 1861, Canton, N.Y.–d. 1909, Ridgefield, Conn.)

A Dash for the Timber. 1889
Oil on canvas. 48¼ × 84⅛"
Amon Carter Museum, Fort Worth

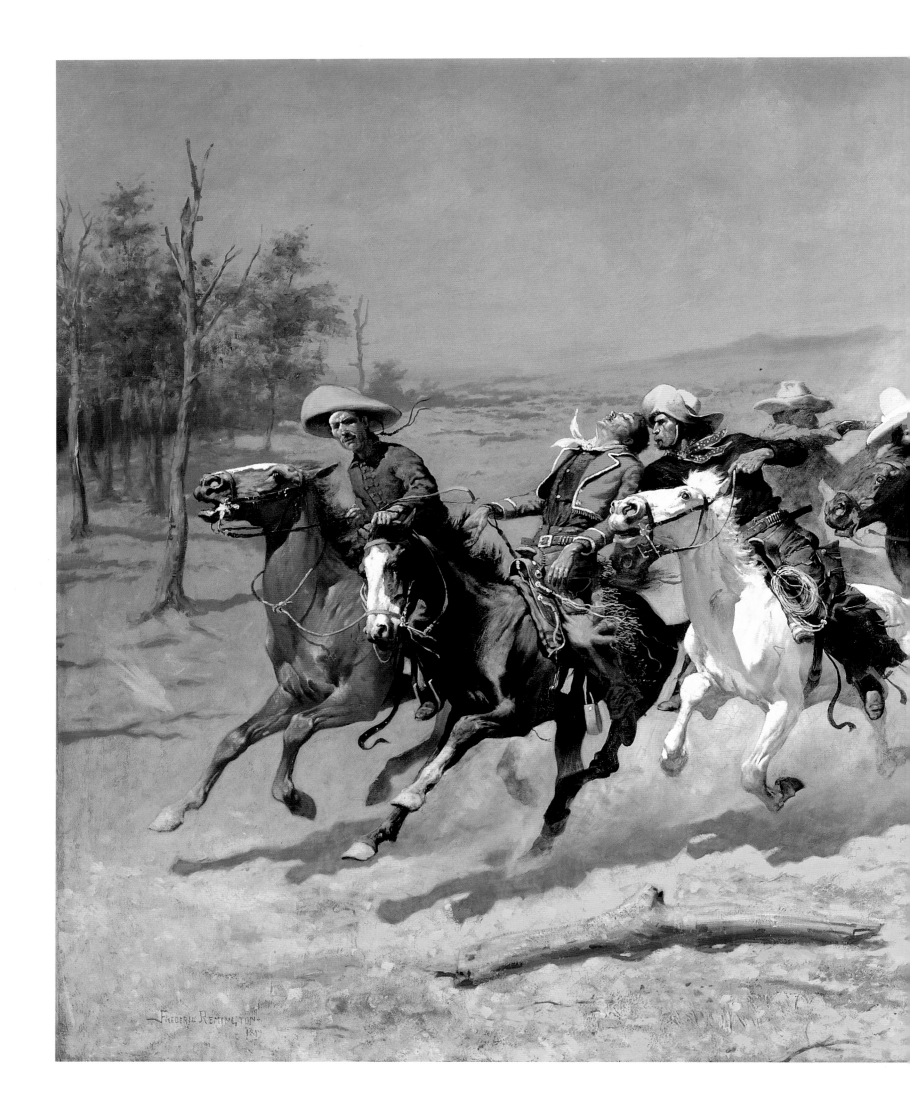

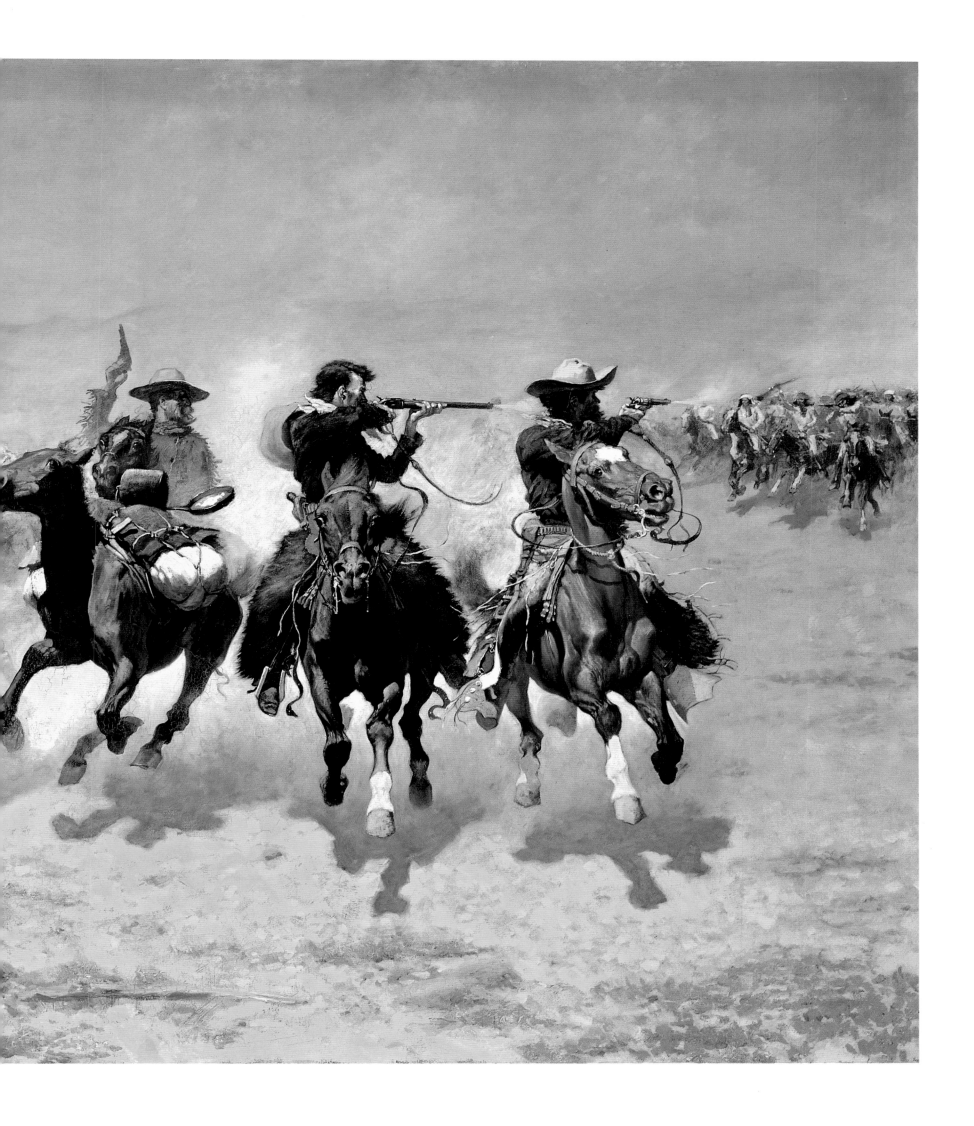

FREDERIC REMINGTON

The Stampede. 1908
Oil on canvas. 27 × 40"
Thomas Gilcrease Institute, Tulsa

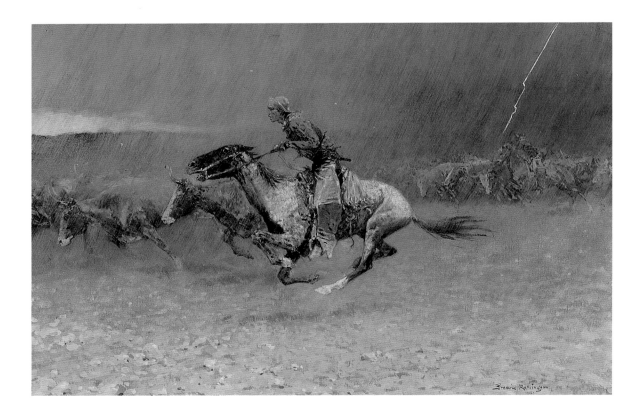

FREDERIC REMINGTON

The Scout: Friends or Foes. ca. 1900–1905
Oil on canvas. 27 × 40"
Clark Art Institute, Williamstown, Mass.

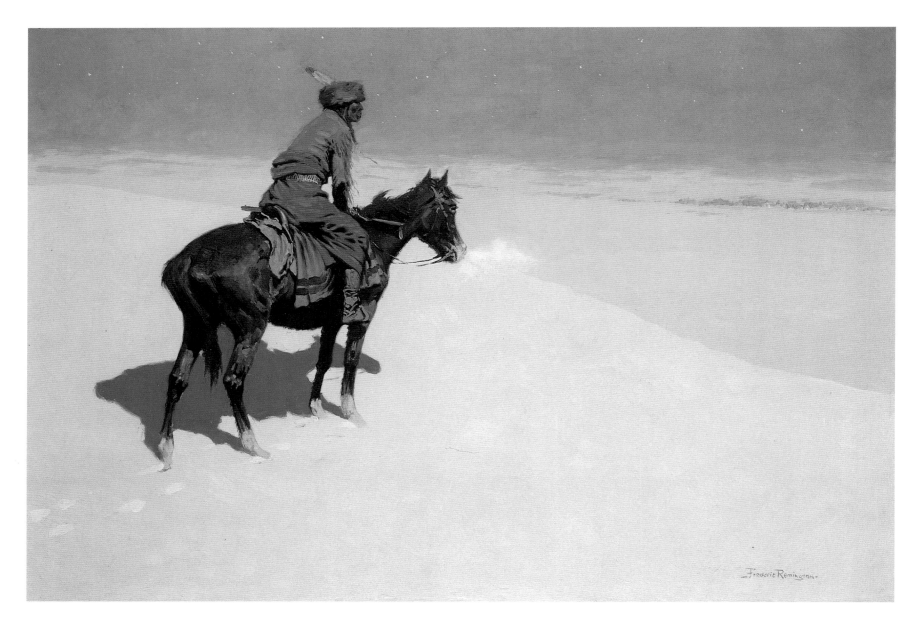

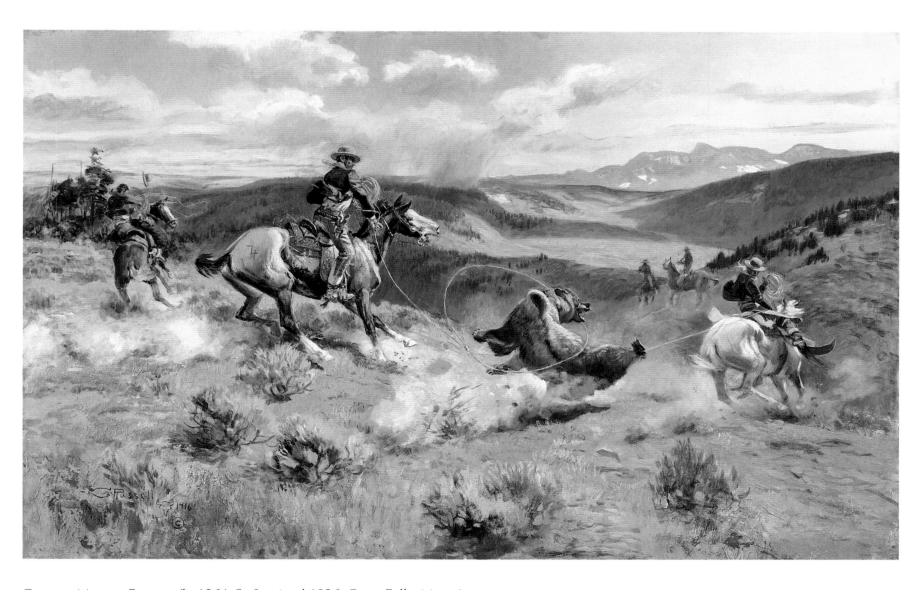

CHARLES MARION RUSSELL (b. 1864, St. Louis–d.1926, Great Falls, Mont.)

Loops and Swift Horses Are Surer than Lead. 1916
Oil on canvas. 30¼ × 48⅛″
Amon Carter Museum, Fort Worth

17. THE ASHCAN SCHOOL

The United States entered the twentieth century as an industrial and urban giant. To capture its transformation artistically required not so much a revolution in technique as a new way of seeing. A group of artists based first in Philadelphia and then in New York pioneered the way to this new vision. They were known variously as New Realists and New York Realists and then, more pejoratively, as Apostles of Ugliness and the Ashcan School. Turning their backs on society portraiture, nature, and art-for-art's-sake they quite literally flung open the windows of their urban studios and looked to the crowded streets below for subject matter and inspiration.

The most influential of the group (though perhaps not the most gifted) was Robert Henri. He studied painting at the Pennsylvania Academy and in Paris, and while abroad he was taken with the early work of Manet, as well as the paintings of Hals and Velázquez. He could make little of the late French Impressionists and was very likely unaware of post-Impressionist painting, but he did develop a sense that real life truthfully portrayed was to be the mission and the salvation of the visual arts in America. Returning to Philadelphia, he gathered around himself a group of artists, illustrators, and journalists who were as determined as he to rescue American art from what they felt was a bloodless aestheticism. The group included George Luks, William Glackens, John Sloan, and Everett Shinn.

Later, they all followed Henri to New York City, where they continued working on their new aesthetic—the frank, unflinching depiction of American urban life. Neither their content nor their style, however, found much favor with the art establishment of the time; in 1907, the National Academy of Design in New York rejected a group of paintings by Luks, Sloan, and Glackens, submitted for exhibition. In protest, Henri withdrew some paintings of his own, and the group decided to hold their own show. The original five plus three others (Ernest Lawson, Arthur B. Davies, and Maurice Prendergast) held a remarkably successful show in 1908 at the Macbeth Gallery. The Eight, as they came to be known, were later instrumental in helping organize the Armory Show of 1913, quite arguably the most important exhibition in the history of American art.

Taking as their point of departure the graphic realism exemplified in Thomas Eakins' *The Gross Clinic*, The Eight set about depicting a life foreign to fashionable society. Henri was a social reformer, as were some others of the group, most notably Luks and Sloan, and the attention these artists paid to the seamier side of life reflected a social purpose as well as an artistic one.

For instance, George Luks' *The Miner* grimly portrays an exhausted, soot-caked miner at the end of a hard day's work. There's nothing romantic about labor here, only a blocky heaviness and a discovering of what, it seems, will never change. The work comprises realistic portraiture and social comment—a combination that prompted many critics to reject the ideas of The Eight out of hand. Such rejection only spurred on the irrepressible Luks. Renowned for his tall tales and macho swaggering, he was the most colorful character of the group. A former coal miner and would-be boxer, he identified with Hals and sought inspiration in the vigorous if crude life of the lower classes.

William Glackens may have been the most worldly and painterly of the group. Like Henri, he had studied in Paris and was influenced by the Impressionists, especially Manet and Renoir. But Glackens was not particularly reform-minded, paying more

attention to formal matters, such as composition and color, than to the subjects or events he painted. He, too, began as an illustrator and covered the Spanish-American War, and his journalist's instinct stood him in good stead as he concentrated on appealing scenes in parks and restaurants full of activity and color.

John Sloan was probably the closest to Henri in temperament and outlook. Henri, in fact, was largely responsible for encouraging him to take up painting seriously. Sloan's approach, however, was more reportorial than confrontational. As Sloan himself noted, he came to view the streets and byways of the city as a "vast stage set where all sorts of lively business was in progress." *Hairdresser's Window* is a case in point. The picture resulted from an actual scene Sloan witnessed as a self-styled "incorrigible window watcher." The vigor and humor of the work recall Hogarth; the characters, though, never rise above caricature. In *The Wake of the Ferry*, Sloan evokes a dark, brooding, romantic atmosphere. The work depicts the ferry ride between Manhattan and Jersey City, and with its somber colors, careful play of light over different surfaces, and solitary, off-center figure, it has a moody power.

When Everett Shinn was connected with The Eight, he painted some bold scenes of city squalor, but he seems much more at home with the world of theatrical illusion. *London Hippodrome* shows Shinn at his colorful best. The circus's excitement and verve obviously appealed to his senses. He did not sustain his interest in realism, however, and after a while he went back to working in theater, as a designer and playwright, and eventually as an art director for the movies—not especially noted for their realistic depiction of the American working class.

Not one of The Eight, George Wesley Bellows was a pupil of Henri, and marched under the banner of New Realism. Rugged and athletic, he saw boxers as modern-day gladiators. *Both Members of this Club* is a violent, stark portrayal of two boxers, one white and one black. Eakins had done realistic boxing scenes earlier, but Bellows seems concerned not so much with accurately depicting the "sweet science" as with provoking a visceral response to the violence. The stance of the boxers is unorthodox, to say the least, and when taxed with that observation Bellows said, "I don't know anything about boxing. I am just painting two men trying to kill each other." The painting's point of view sets the viewer in the midst of the screaming ringside spectators, and the strained posture of the fighters conveys power, motion, and fierce physical contact.

Rockwell Kent, another student of Henri's, represents a different approach altogether. He was not an artist of the Ashcan School but a landscape painter of the American North. It is a tribute to the importance of Henri's ideas and the success of The Eight that a painter like Kent would choose to involve himself with them. However, it was just their striving for truth in painting, their rejection of easy sentimentality in favor of gritty reality, that brought Kent to the group. His *Snow Fields (Winter in the Berkshires)* uses a limited palette to evoke a bare, cold winter landscape. It is a painting that depends on simplicity and stark contrasting shapes to convey a sense that nature can be beautiful and merciless at the same time.

Overall, the achievements of The Eight were remarkable. They found a new and exciting application for traditional realistic art, and they made Americans take another look at America.

(H.L.W.)

GEORGE LUKS (b. 1867, Williamsport, Pa.–d. 1933, New York City)

The Miner. 1925
Oil on canvas. 60¼ × 50⅜″
National Gallery of Art, Washington, D.C.
Chester Dale Collection

160

ROBERT HENRI (b. 1865, Cincinnati–d. 1929, New York City)

Edna. ca. 1910
Oil on canvas. 34 × 28″
Los Angeles County Museum of Art, Los Angeles
Bequest of Dr. Dorothea Moore

WILLIAM GLACKENS (b. 1870, Philadelphia–d. 1938, Westport, Conn.)

Hammerstein's Roof Garden. ca. 1901
Oil on canvas. 30 × 25″
Whitney Museum of American Art, New York City

WILLIAM GLACKENS

The Soda Fountain. 1935
Oil on canvas. 48 × 36″
Pennsylvania Academy of the Fine Arts, Philadelphia
Joseph E. Temple and Henry O. Gilpin Funds

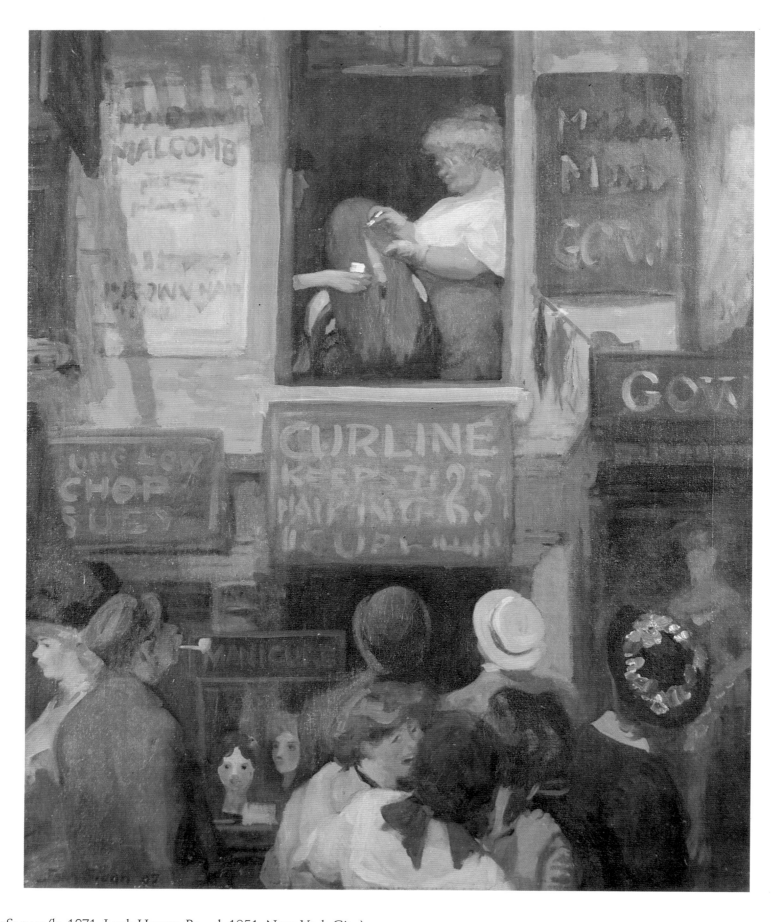

JOHN SLOAN (b. 1871, Lock Haven, Pa.–d. 1951, New York City)

Hairdresser's Window. 1907
Oil on canvas. 31⅞ × 26"
Wadsworth Atheneum, Hartford, Conn.
Ella Gallup Sumner and Mary Catlin Sumner Collection

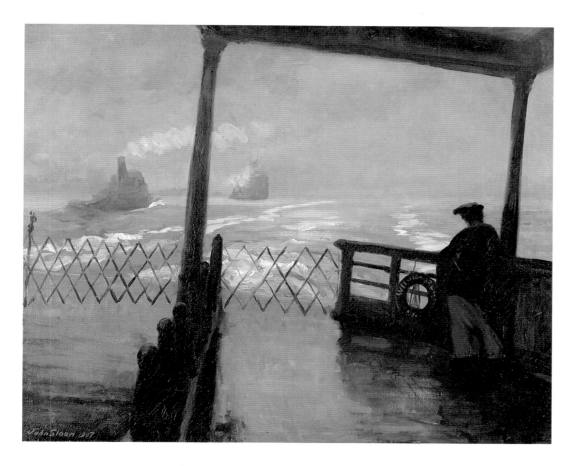

JOHN SLOAN

The Wake of the Ferry II. 1907
Oil on canvas. 26 × 32″
Phillips Collection, Washington, D.C.

JOHN SLOAN

Six O'Clock. ca. 1912
Oil on canvas. 26 × 32″
Phillips Collection, Washington, D.C.

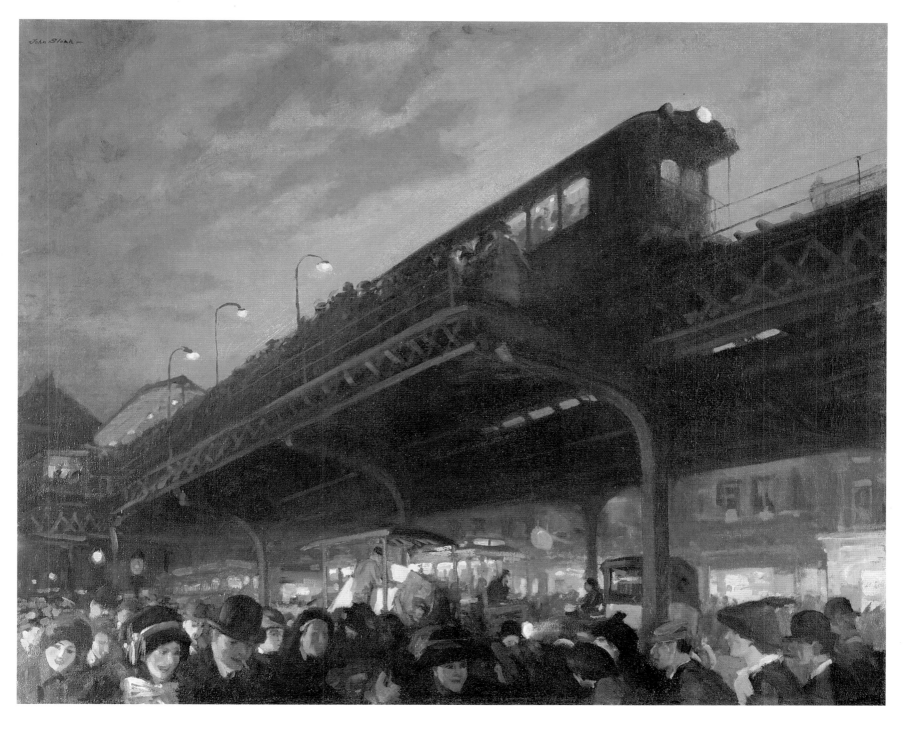

EVERETT SHINN (b. 1876, Woodstown,
 N.J.–d. 1953, New York City)

London Hippodrome. 1902
Oil on canvas. 26⅜ × 35¼″
The Art Institute of
Chicago, Chicago
Friends of American
Art Collection

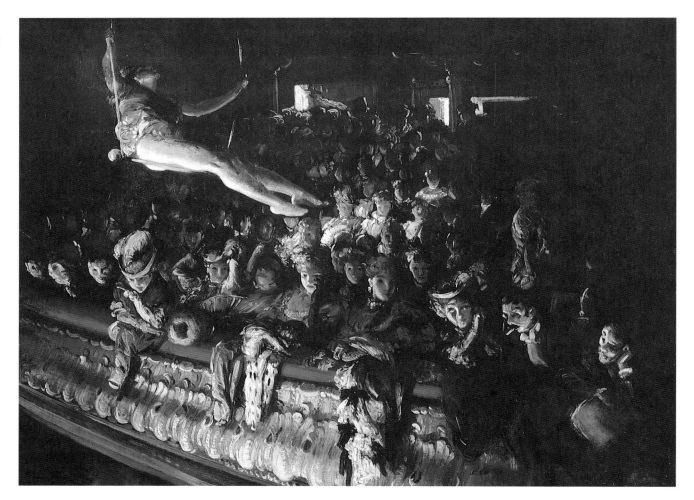

GEORGE BELLOWS (b. 1882, Columbus–
 d. 1925, New York City)

Both Members of This Club.
1909
Oil on canvas. 45¼ × 63⅛″
National Gallery of Art,
Washington, D.C.
Chester Dale Collection

OPPOSITE:
GEORGE BELLOWS

The Sawdust Trail. 1916
Oil on canvas. 63 × 45″
Milwaukee Art Museum,
Milwaukee
Layton Art Collection

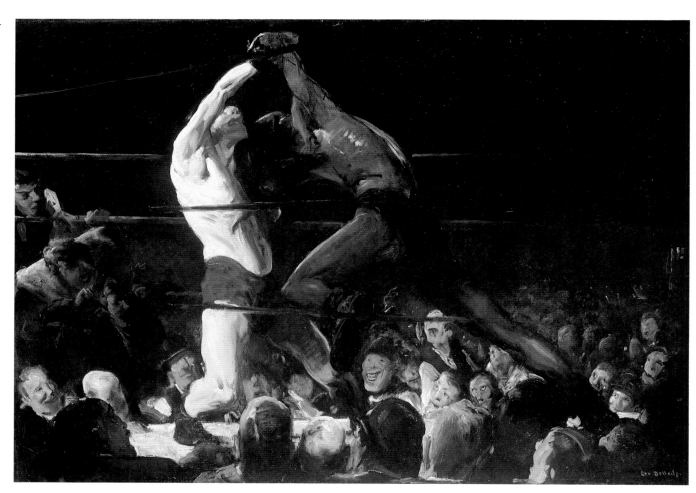

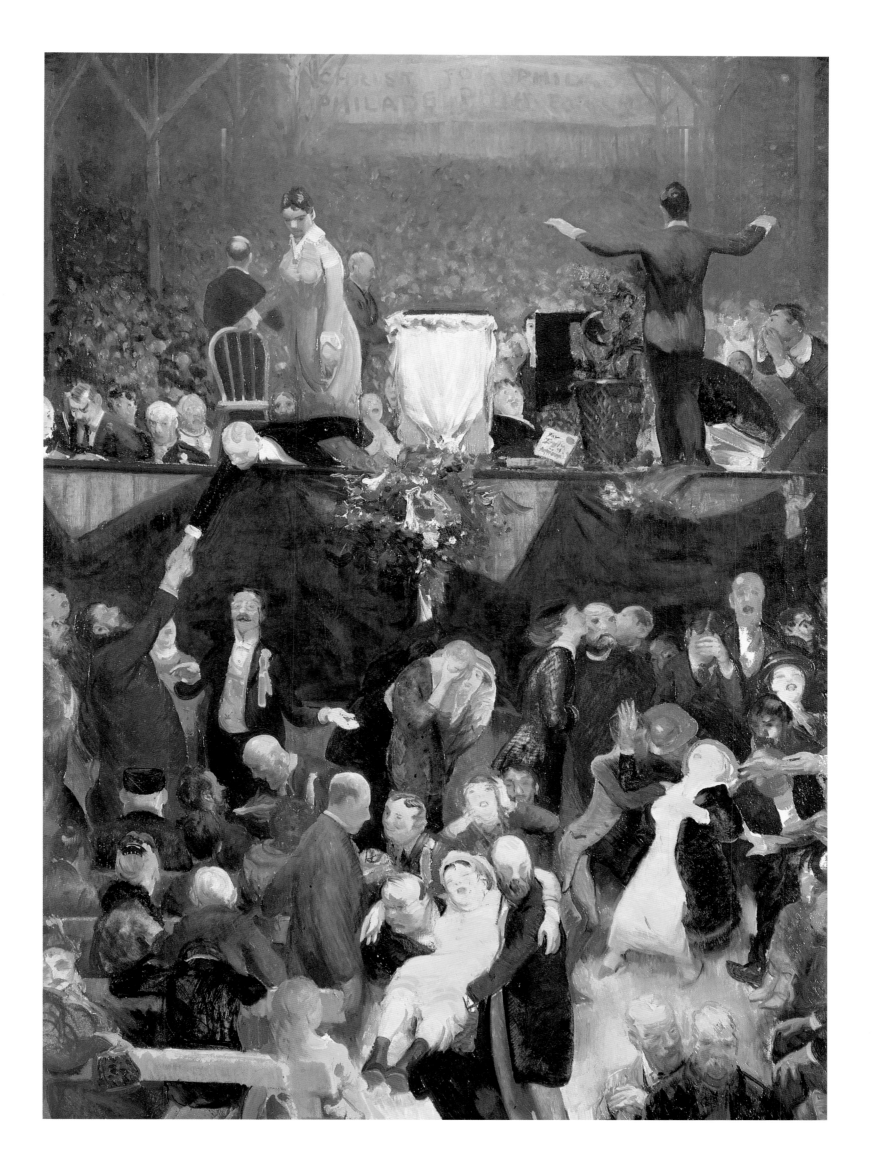

167

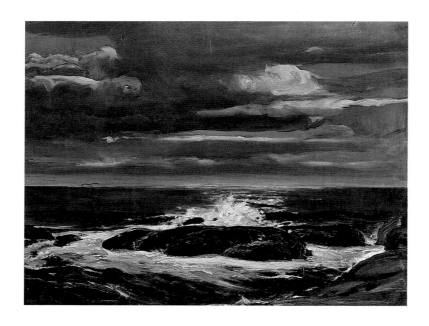

GEORGE BELLOWS

The Sea. 1911
Oil on canvas. 34 × 44⅛"
Hirshhorn Museum and Sculpture Garden, Smithsonian
Institution, Washington, D.C.
Gift of the Joseph H. Hirshhorn Foundation

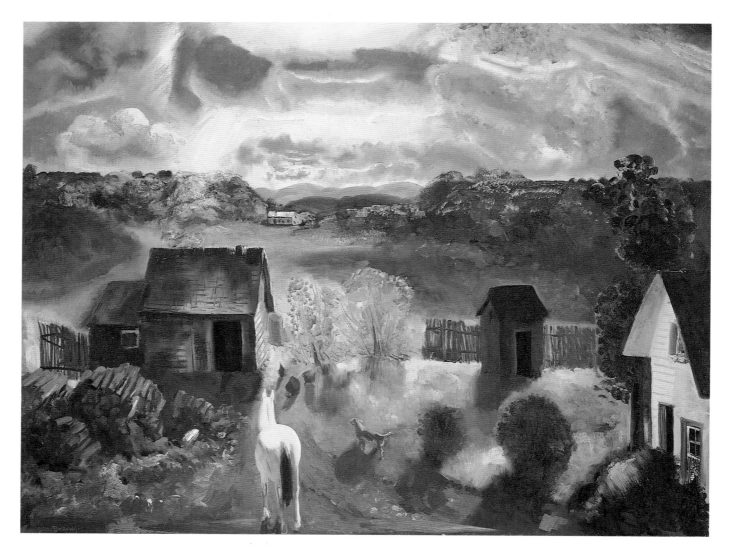

GEORGE BELLOWS

The White Horse. 1922
Oil on canvas. 34⅛ × 44"
Worcester Art Museum, Worcester, Mass.

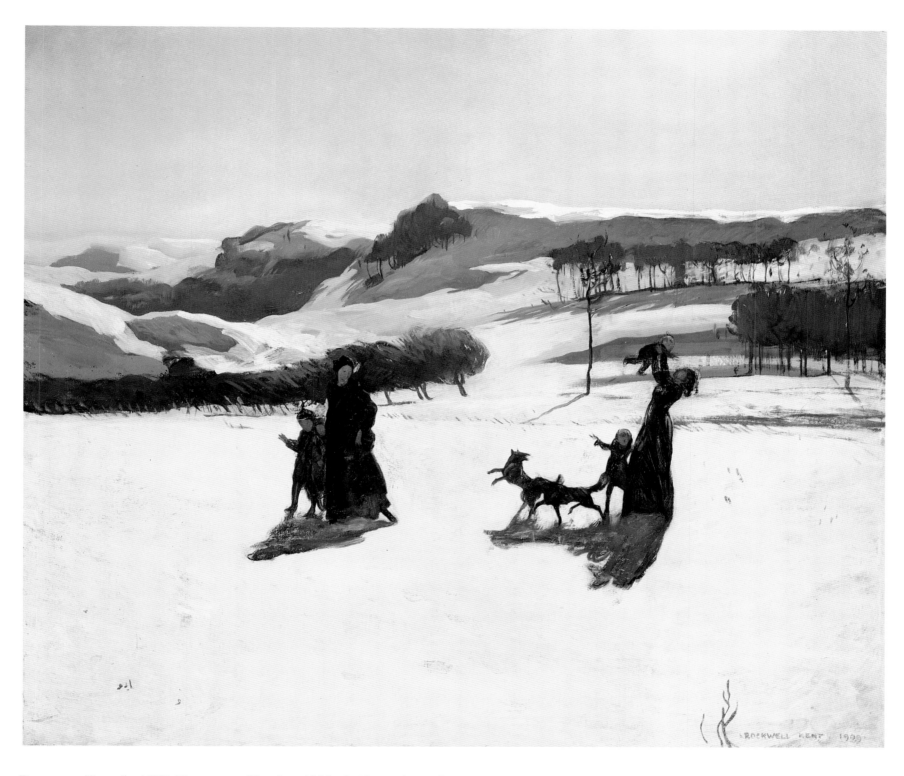

Rockwell Kent (b. 1882, Tarrytown Heights, N.Y.–d. 1971, Champlaine Valley, N.Y.)

Snow Fields (Winter in the Berkshires). 1909
Oil on canvas. 38 × 44"
National Museum of American Art, Smithsonian Institution, Washington, D.C.
Bequest of Henry Ward Ranger through the National Academy of Design

18. Rush Hour New York: OF MODERNISM

Even as the urban realists were reaping success in their shows of 1908 and 1910, the seeds of American modernism were being sown at 291 Fifth Avenue. There, in his Photo-Secessionist Gallery, also called 291, the photographer and art dealer Alfred Stieglitz and his associate Edward Steichen were working to bring the latest European developments in composition to the attention of American painters. 291 was a success, in part because it inspired young American artists to go abroad, especially to Paris, where they witnessed avant-garde developments firsthand.

What they brought back, and what Stieglitz championed, was a mélange of styles— Cubism, Fauvism, Constructivism, Futurism—all of which rejected the means and ends of traditional representational art. Cubism's more mechanical elements would seem ideally suited to the United States in the early twentieth century. The country was in love with mass production as manifested by huge machines. The realistic styles developed in the nineteenth century depicted these machines—dynamos, grain elevators, skyscrapers, factories—as mere components in a picturesque landscape. Even the Ashcan School did not consider factories and office towers an appropriate subject. So when artists such as Joseph Stella joined the Cubist ranks, representations of the city in painting took on radical new forms.

To appreciate just how much Cubism and other twentieth-century styles changed the way artists saw the world, we need only compare Stella's *Brooklyn Bridge* with any of The Eight's city scenes. Stella's bridge is all elemental power and form. Light and color play on its polished metallic surfaces and knit its webs of cables into strict geometric patterns. It is not an illustration of a familiar bridge. Instead, Stella reveals the modes, materials, and modern design that make such a bridge possible. He dissects the architecture and exposes its skeleton.

In a five-panel work, *The Voice of the City of New York Interpreted,* Stella used the same methods to celebrate the dynamism of the city. One of the finest of the first crop of American abstract painters, he later moved into brightly colored mystical works that lack the power of these early paintings.

Max Weber experienced much of the Paris ferment firsthand, and later showed with Stieglitz in 1910 and 1911. Cézanne's work influenced him greatly, but his New York paintings express emotions and energy all his own. *Rush Hour, New York*, at once abstract and volatile, uses Cubist structure and Futurist fragmentation to describe a time and place of violent energy, and even of menace. Weber also used this kaleidoscopic technique to delineate the personality of a place. After a time, he abandoned Cubist composition and turned to a figurative, expressionistic style.

John Marin, too, studied abroad, and he also learned a great deal at 291. He shared with Weber a romantic, dynamic sense of the city; his *Region of Brooklyn Bridge Fantasy* is a good example. As Marin wrote to Stieglitz in 1913, "[T]he whole city is alive; build-

THE AMERICANIZATION

ings, people, all are alive; and the more they move me the more I feel them to be alive." Marin's works are evocative and spontaneous, more concerned with expressing emotional responses than with concocting pictorial renditions. His distinctive style compounded those of Cézanne and Braque with a wonderful sense of color. He said, "Using paint *as* paint is different from using paint to paint a picture," emphasizing the modernist attitude that art should be self-referential rather than representational. As other titles, such as *Off Cape Split*, reveal, he also painted from a love of landscape.

Lyonel Feininger was born in the United States but spent most of his productive years in Germany. His *Church of the Minorites (II)* conveys an atmosphere of contemplation, even of mystery; his Cubist planes describe an ethereal world informed by a private, subjective sensibility.

Alfred Maurer's figure paintings were deeply influenced by Modigliani as well as by Cézanne and Picasso. Later works, such as *Still Life with Doily*, which derive from the Synthetic, collage-like phase of Cubism, represent some of his finest work. In 1909, Stieglitz gave Maurer, Marsden Hartley, and Marin their first one-man shows, at Gallery 291. But everyone else neglected Maurer, and he eventually committed suicide, in 1932.

Marsden Hartley went abroad in 1912 and later fell in with Franz Marc and the German Expressionists; his *Painting No. 5* and his *Portrait of a German Officer*—colorful montages of German military symbols at the beginning of World War I—are good examples of this stage in his career. Later, he backed away from this abstraction, producing a series of stark and forceful landscapes of New Mexico and Maine. Critics have called him inconsistent and sometimes careless; yet at its best his work has intensity and emotional conviction.

For two Paris-trained American painters, Morgan Russell and Stanton Macdonald-Wright, abstraction was a total commitment for a time. Calling the movement they co-founded Synchromy (literally, "colors together"), they employed Cubism's techniques with brilliant colors instead of geometric structures to create rhythmic patterns. Russell's *Cosmic Synchromy* and Macdonald-Wright's *Abstraction on Spectrum (Organization No. 5)* play one color off another, and seem to reach for a universal language of color. They contended that painting, like music, needed no external reference. Both later returned to figurative painting.

Thus the New York art world began to change even before the realists had finished depicting it. After the 1913 Armory Show, it would prove increasingly difficult to deny the new vision, and the new techniques, developing in Europe. Artists everywhere would consider paint as paint, color as color, and form as form. Now the focus would be on how, not what, we see.

(H.L.W.)

ALFRED MAURER (b. 1868, New York
 City–d. 1932, New York City)

Still Life with Doily. ca. 1930
Oil on Upson board. 17⅞ × 21½″
Phillips Collection,
Washington, D.C.

JOHN MARIN (b. 1879, Rutherford,
 N.J.–d. 1953, Cape Split, Me.)

Sunset. 1914
Watercolor on paper. 16½ × 19¼″
Whitney Museum of
 American Art, New York City

JOHN MARIN

Region of the Brooklyn Bridge Fantasy. 1932
Watercolor on paper. 18¾ × 22¼"
Whitney Museum of American Art, New York City

PAGE 174:
MAX WEBER (b. 1881, Bialystok, Russia–d. 1961, Great Neck, N.Y.)

Rush Hour, New York. 1915
Oil on canvas. 36¼ × 30¼"
National Gallery of Art, Washington, D.C.
Gift of the Avalon Foundation

PAGE 175:
JOSEPH STELLA (b. 1877, Muro Lucano, Italy–d. 1946, New York City)

The Bridge. 1922
Oil and tempera on canvas. 88½ × 54"
Newark Museum, Newark, N.J.
Felix Fuld Bequest Fund

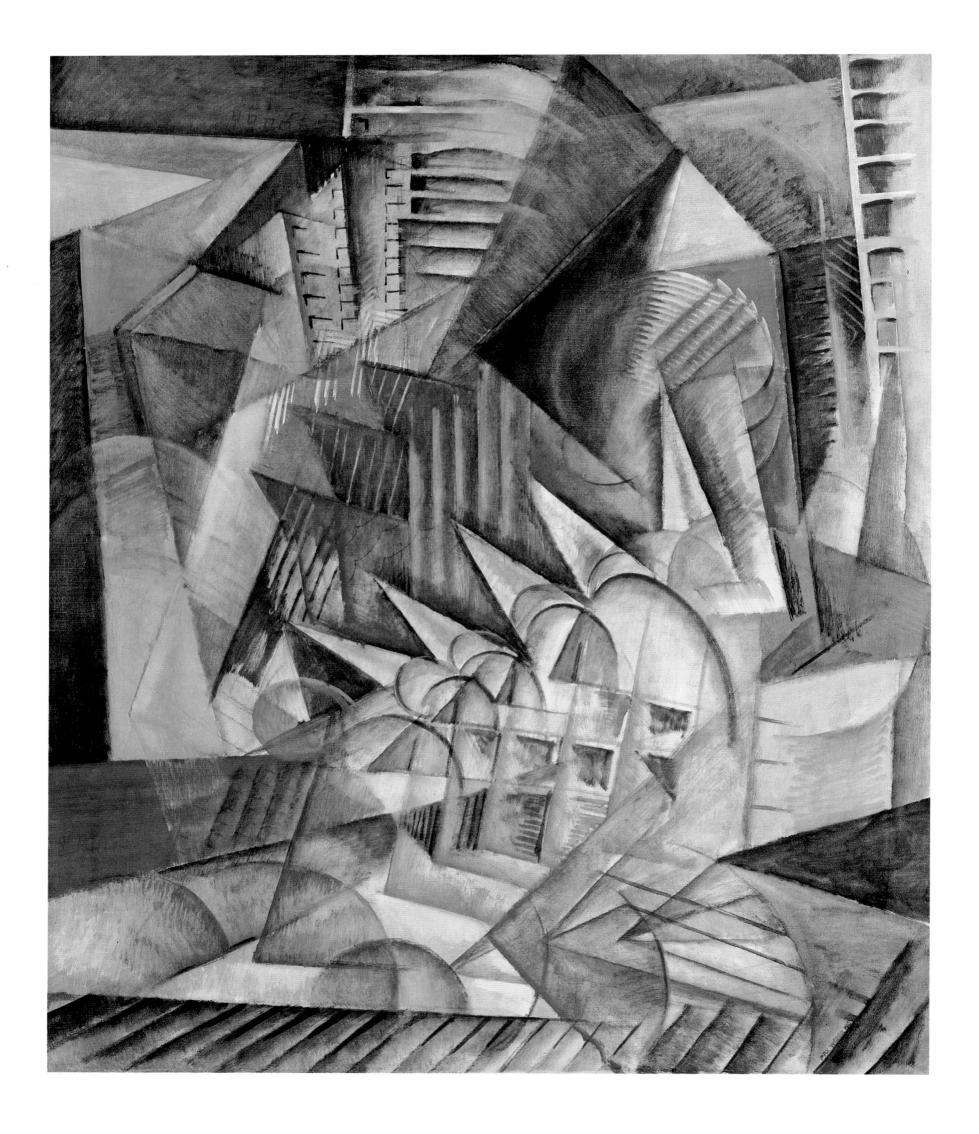

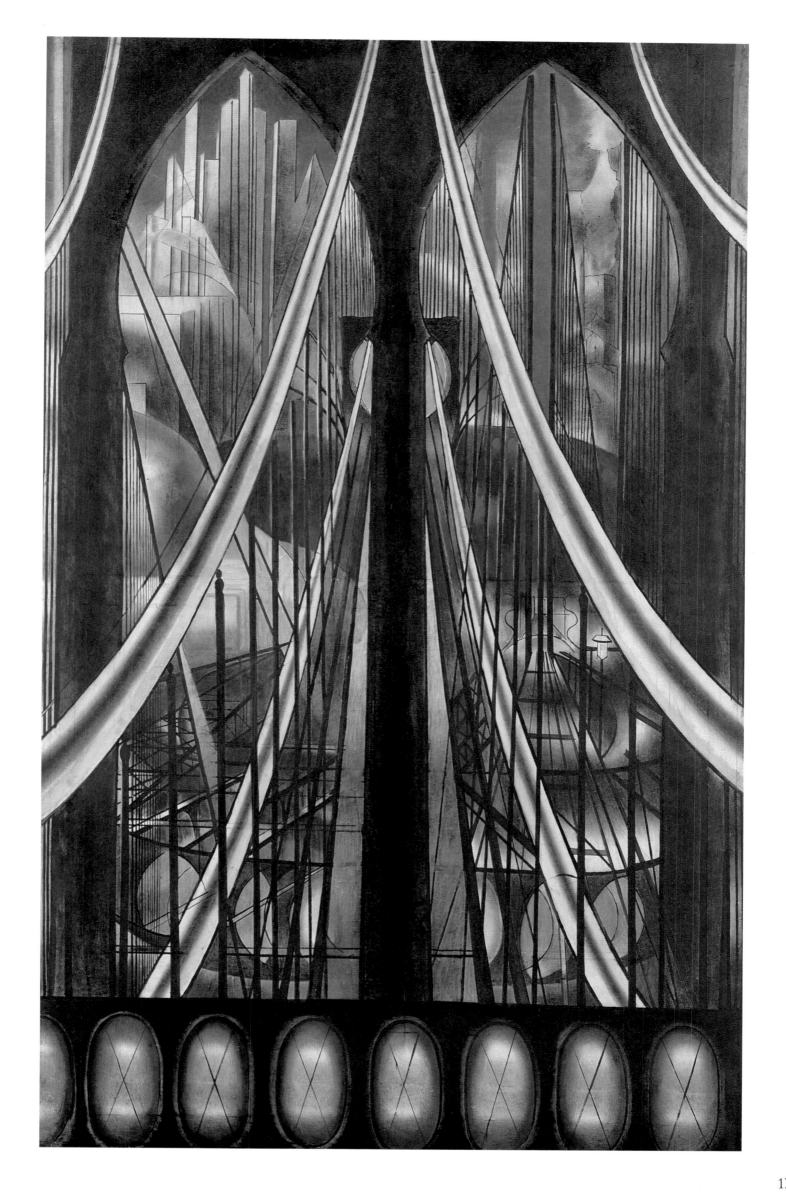

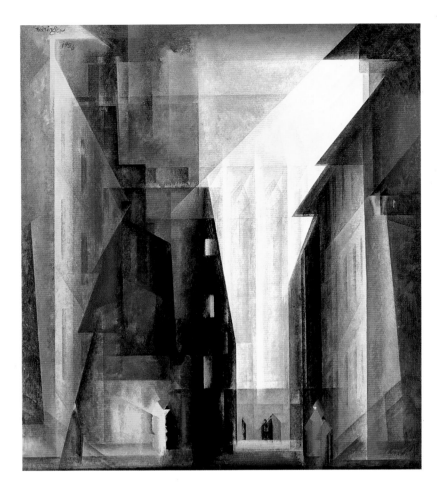

LYONEL FEININGER (b. 1871, New York City–
d. 1956, New York City)

Barfüsserkirche II (Church of the Minorites II). 1926
Oil on canvas. 43⅛ × 37⅜"
Walker Art Center, Minneapolis
Gift of the T.B. Walker Foundation,
Gilbert M. Walker Fund

ABOVE RIGHT:
MORGAN RUSSELL (b. 1886, New York City–
d. 1953, Broomall, Pa.)

Cosmic Synchromy. 1913–1914
Oil on canvas. 16¼ × 13⅛"
Munson-Williams-Proctor Institute
Museum of Art, Utica, N.Y.

RIGHT:
STANTON MACDONALD-WRIGHT (b. 1890,
Charlottesville, Va.–d. 1973, Los Angeles, Ca.)

Abstraction on Spectrum (Organization, 5). ca. 1914–1917
Oil on canvas. 30⅛ × 24³⁄₁₆"
Des Moines Art Center, Des Moines, Iowa
Coffin Fine Arts Trust Fund
Nathan Emory Coffin Collection

OPPOSITE:
MARSDEN HARTLEY (b. 1877, Lewiston, Me.–d. 1943, Ellsworth, Me.)

Painting, Number 5. 1914–1915
Oil on canvas. 39½ × 31¾"
Whitney Museum of American Art, New York City
Anonymous gift

When Marcel Duchamp visited New York for the first time in 1915, he was already a celebrity there. At the Armory Show of 1913, his painting *Nude Descending a Staircase* had been endlessly vilified in the press and intensely admired by a small but determined avant-garde group of artists and intellectuals. On arrival, he immediately became a force in American art, and he has remained so, even since his death in 1968.

The fact that he decided to quit painting in 1918 makes his influence all the more remarkable and distinctive. More than other artists, he opened up the possibilities of painting, first by rejecting its limitations as a strictly optical medium and then by abandoning it altogether. With its curiously literal Cubist rendering of a single figure in motion as multiple figures, *Nude Descending a Staircase* recognizes the limitations of painting. Duchamp then chose to replace representational fiction with his "ready-mades," which blur the distinction between art and reality. Art becomes real in the process of accepting, combining, and altering; it is a functioning world of ideas, language, shapes, and chance. And real objects, in turn, become fictions; a snow shovel, a urinal, or a bicycle wheel is appropriated as a ready-made, and as such loses its original function. This role-reversing process, which might involve photography, machinery, molds, casts, models, found objects, and even paintings or drawings, continues to affect art at the end of the twentieth century.

Duchamp's cohorts during his early years in New York (1915–18 and 1920–21) included Florine Stettheimer, John Covert, and Man Ray, who became Duchamp's closest lifelong friend as well as his artistic colleague. Stettheimer, who lived with her mother and two sisters in refined interdependency, provided a focus of social and intellectual life for writers and artists of the period. Her elegant portraits and group scenes reflect the attenuated brilliance of this milieu. Unlike Duchamp, she remained a painter, but she was quite as dedicated to the realization of a private mythology, encompassing her family, friends, and New York City. Her four "Cathedral" paintings, devoted to Broadway, Fifth Avenue, Wall Street, and Art, done between 1929 and 1942, are visions of vertiginous joy and ebullient satire that make of the great city a kind of private Elysian fields. They glow with an ecstatic light and a breathtaking convergence of deep and shallow space around the central, triumphal motif.

The short, intense career of John Covert, which corresponded roughly to Duchamp's first New York residence, produced several unusual paintings that use odd materials and objects—string, carpet tacks, wooden dowels—to create three-dimensional surfaces that define abstract imagery and spatial illusion. They are paintings on their way to becoming philosophical objects, in which ideational Cubist structure is realized in real, textural form. Unfortunately, Covert, perhaps taking Duchamp's skepticism too seriously, altogether ceased to make art after 1923.

The versatility and playfulness of Duchamp was matched only by Man Ray. When the two artists met, in 1915, Ray was already absorbed in the delusional side of Cubism, the ability of abstract planes to define form and space at the same time. His *The Rope Dancer Accompanies Herself with Her Shadows* matches one abstraction with another, stretching flatness out into large, colorful shapes that are seemingly produced and manipulated by the tiny, abstract figure of the rope dancer. Ray's subtle transformative powers, perhaps encouraged by Duchamp's belief in art as altered reality, were remarkable. He understood the possibility of shifting one image into another, or of combining objects to create an entirely new realm of perception, often through the impersonal but magical

SURREALISM

medium of the machine. When he followed Duchamp to Paris, in 1921, he immediately and naturally fell in with the iconoclastic Dada movement, which promoted art as act more than object, and the Surrealist movement that followed, with its graver attention to the workings of the unconscious mind. Ray's work remained sensual and playful, even in such dramatic images as *Imaginary Portrait of D.A.F. de Sade*, which comments ironically on freedom and society on the eve of the Second World War.

Fascination with the machine as a twentieth-century extension of the mind and body also compelled Joseph Cornell, who did not begin to make art until 1931, after seeing montages by the German Surrealist Max Ernst. The machine Cornell used was the movie camera (he made a number of short, halting films), but what interested him was the ability of film, as medium and mediator, to create another firmament that has its own movement and its own stars. Cornell's desire to enhance reality in this way, or to observe another, more intense level of reality, is not far from Duchamp's investment of art with special powers, Stettheimer's shining theatrical world, and Man Ray's solarized portrait photographs; all of them valued the special aura of stardom. Cornell was not a painter, and yet his boxes resemble paintings expanded into space, rather than sculptures. Like the frames of a film, they concentrate our view on the beauty and sadness of life in time, history, art, and the cosmos. Most of them are habitats or habitations—hotels, trees, nests, cages, landscapes, planets, solar systems—and the figures, whether animal or human, are fatefully fixed by their context. *Rose Castle* presents a microcosm of life into which we cannot see, while *Habitat Group for a Shooting Gallery* allows us to see too much in its carnage: the impossible gap between life (red, yellow, and blue birds) and art (red, yellow, and blue paint splotches).

Cornell's boxes, with their starry skies and constellations, mysterious dark-blue and black tonalities, constantly remind us of his cosmologies. Duchamp, who knew Cornell quite well, had made Cubism metaphysical. This aspect of modern art, stirred as well by Surrealism, was taken in other directions by Mark Tobey, Morris Graves, and Alfred Jensen, away from Duchamp's mechanical and linguistic universe. Tobey even specifically repudiates the Machine Age and its hold on humankind in his painting *The Void Devouring the Gadget Era*, of 1942. More concerned with the oneness of humanity, he brought to his art a profound mixture of religious thought (through the Bahai faith), Eastern philosophy, and scientific perception. Interestingly, he evolved much as Jackson Pollock would later: from dense figural scenes to calligraphic abstractions. His motives, however, were social, political, and spiritual rather than psychological; they involved the acceptance of a higher reality, based in nature and the cosmos, which might heal the fragmentation of human society. Tobey's student Morris Graves moves even deeper into nature, away from civilization, evoking the continuity of animal life with universal forces.

For Alfred Jensen, cosmologies are palpable systems encompassing ideas about how the universe works. He weaves an extraordinary fabric of numbers, colors, shapes, and relationships, derived from Goethe's Theory of Colors, the mathematics of Greek architecture, the Mayan calendar, the oracular *I Ching* of China, Pythagorean concepts of odd and even numbers, and modern optical theories, to unlock the secrets of light, optics, universal movement, and growth. In contrast with Duchamp's transparent and shifting realm, Jensen's paintings are remarkably opaque, material embodiments of the universe's dynamic and infinitely complex certainties.

FLORINE STETTHEIMER (b. 1871, New York City–
 d. 1944, Rochester, N.Y.)

The Cathedrals of Broadway. 1929
Oil on canvas. 60⅛ × 50⅛″
The Metropolitan Museum of Art, New York City
Gift of Ettie Stettheimer

JOHN COVERT (b. 1882, Pittsburgh–d. 1960, New York City)

Brass Band. 1919
Oil and string on composition board. 26 × 24″
Yale University Art Gallery, New Haven, Conn.
Gift of Collection Société Anonyme

The Rope Dancer Accompanies Herself With Her Shadows

MAN RAY (b. 1890, Philadelphia–d. 1976, Paris)

The Rope Dancer Accompanies Herself
with Her Shadows. 1916
Oil on canvas. 52 × 73⅜″
The Museum of Modern Art, New York City
Gift of G. David Thompson

MAN RAY

Imaginary Portrait of D.A.F. de Sade. 1938
Oil on canvas with painted wood panel.
24¼ × 18⅜″
Menil Collection, Houston, Tex.

MARK TOBEY (b. 1890, Centerville, Wisc.–
d. 1976, Basel, Switzerland)

Edge of August. 1953
Casein on composition board. 48 × 28″
The Museum of Modern Art,
New York City

Morris Graves (b. 1910, Fox Valley, Ore.)

Sea, Fish, and Constellation. 1943
Tempera on paper. 19 × 53½"
Seattle Art Museum, Seattle
Gift of Mrs. Thomas D. Stimson

Joseph Cornell (b. 1903, Nyack, N.Y.–
d. 1972, New York City)

Habitat Group for a Shooting Gallery. 1943
Mixed-media box construction;
wood, paper, glass. 15½ × 11⅛"
Des Moines Art Center, Des Moines, Iowa
Coffin Fine Arts Trust Fund: Nathan Emory Coffin
Collection

Joseph Cornell

Rose Castle. 1945
Wood, paper, paint, mirror, tree twigs,
and tinsel dust. 11½ × 14⅞"
Whitney Museum of American Art,
New York City
Kay Sage Tanguy Bequest

Alfred Jensen (b. 1903, Guatemala City,
Guatemala–d. 1981, Glen Ridge, N.J.)

Let There Be Light. 1978
Oil on canvas. 81 × 60"
Museum of Contemporary Art, Chicago
Promised Gift of Douglas and Carol Cohen

There was neither night nor day. Then God arose by commanding, "Let there be light".

Then blackness as # one remained,
The light broke and # two became.

20. NATURE AND SYMBOL

Arthur Dove, Georgia O'Keeffe, and Marsden Hartley are often linked because all three were early abstractionists who found inspiration in America's natural landscape. All three were friends of Alfred Stieglitz and exhibited their paintings at his "291," Intimate, and American Place galleries in New York City, the showplaces for avant-garde art where all three saw the European experiments with Cubism, Futurism, and Expressionism firsthand. Moreover, all three were steeped in the ideas of the New England Transcendentalists and the turn-of-the-century Theosophists, whose philosophies celebrated both the beauty of nature and the oneness of humanity and the cosmos.

Arthur Dove's work was informed by a deep and lasting love of nature. In France in 1909, unlike most of the expatriates Dove spurned Paris for the south, where dazzling sunshine lightened his palette. In 1912, after Dove's return to New York, Alfred Stieglitz gave him a one-man show in which were exhibited ten pastels that came to be known as the Ten Commandments—probably the earliest abstractions in America.

Dove's lifelong working procedure thereafter was to sketch out of doors with watercolor only. Later in the studio he would select those sketches he would expand into large paintings. Inspired by nature, Dove abstracted forms to reveal "their certain condition of light, which establishes them to the eye, to each other and to understanding." He also felt that each object had a specific configuration that captured its inner essence, and he concentrated on showing how it intuitively *felt*, not how it actually struck the eye. In his visions of nature, to portray the intuited idea he often produced distortions in color and form; plants become fleshy pinwheels and the wind floats in comma shapes over the surface in paintings like *Nature Symbolized, no. 2* of 1914.

From 1910, Dove lived on farms in Connecticut and Long Island. His views of fields of grain and livestock in paintings like *Fields of Grain as Seen from Train*, with its energetic arc of abstract wheat and extremely nonrepresentational rendering of a cow, reflect this aspect of his life. Never imprisoned by doctrinaire schools of art, Dove was influenced by Kurt Schwitters and Dadaism during the twenties, producing collages of found objects. The thirties and forties saw him again focused on nature. The tightly compressed views of his early work gave way to radiant sunrises and moonrises often set in large landscapes.

Even when it was difficult for Americans to gain exposure to the principles of modern art, and in spite of being female, Georgia O'Keeffe made a substantial place for herself in the avant-garde art world. Critics have often portrayed her as an untutored original, but, in fact, she received extensive training at the Art Institute of Chicago and the Art Students League in New York. O'Keeffe later studied at Columbia University with Arthur W. Dow, whose adherence to Paul Gauguin's philosophy of basing drawing on abstract design principles was a central influence on O'Keeffe's later abstraction.

In response to the vast landscape in Texas, where she went to teach, O'Keeffe began to do abstractions in which she distilled nature to its essence in a few lines. O'Keeffe sent these powerful, minimalist drawings to her friend Anita Pollitzer, who showed them to Alfred Stieglitz. Deeply impressed, Stieglitz mounted a show of them without even consulting O'Keeffe. That was the beginning of their lifetime partnership—and a modern marriage. It was in New York, where she had embarked on cityscapes—and on making sales with them—that she began to pursue a more "feminine" subject matter: close-up depictions of flowers that often emphasized their vagina-like inner

forms. These paintings struck a responsive chord in the public, and the sale of a suite of six calla lily paintings for $25,000 in the mid-twenties made her the family breadwinner. Probably because of the taboos against overt feminine sexuality at the time, O'Keeffe denied that her intense examination of natural forms was intended to express a woman's experience of her body.

In 1929, O'Keeffe went to New Mexico for the first time and was immediately enchanted by the light and landscape. She began to collect the bleached bones of animals—a skull, a horn, a pelvis—and adopt them as motifs in her work. In her works of the thirties O'Keeffe often gave these bones a surrealistic dimension. Interestingly, O'Keeffe's work began to be regarded as part of American Scene painting; her rose-bedecked cow's skull looming against the sky (red, white, and blue are the colors, of course) came to be seen as American as the stars and stripes. But her flower-adorned skulls and repeated motif of a cow's pelvis forming a window through which we see the sky recall the ancient symbol of Eros and Thanatos, or love and death, presented with a Dali-like poetry.

Throughout his career, Marsden Hartley was a nomad. While drawn to the excitement of big cities, he found little to paint there. When he visited the bleak landscapes that were his principal inspiration, he immediately missed the urban bustle and complained of loneliness. Working in Europe at the outbreak of World War I, Hartley returned to America. His subsequent travels through the early 1920s took him to Provincetown, Bermuda, Oqunquit, New Mexico, and Gloucester, with sojourns in New York in between. Removed from Europe and the inspirations of his earlier mysticism and interest in Cubism and Expressionism, he turned to a more representational approach and matured into a masterful painter whose loose brushstrokes enriched his still lifes and landscapes. To Hartley, excellence in painting grew out of spontaneity, passion, and rapid execution in fluid brushstrokes.

After an unusual and very successful auction of his works organized by Stieglitz in 1921, Hartley was again able to return to Europe, principally to Paris and Berlin, where he felt more at ease. He remained there until financial difficulties in 1930 forced him home. During the thirties and early forties Hartley again found an emotionally charged subject in the American landscape, especially the craggy coasts of Maine with which his work ultimately became most identified. These dark, heavily impastoed landscapes were partially influenced by Alfred Pinkham Ryder. Both men found that abstraction and simplification added to the magic and emotional intensity of their paintings. Hartley's brooding scenes of rock masses and waves arguably mirrored the national psyche at a time when the Great Depression was having profound emotional effects on the population. Yet in all his years of traveling Hartley sought out bleak landscapes with a need to express his own loneliness. He said shortly before he died, "I can't tell you how I suffered since I came back here—nothing but rocks—the ocean—sea gulls. I just hated to leave the beautiful scene of Broadway at night . . . knowing it was the last I should see of its white splendor until next spring and summer." Yet leave he did, and his ghostly gulls and fish gleaming against the dark backgrounds of his last paintings have a transcendent radiance that speaks of sorrow and joy at once.

(A. S. W.)

Marsden Hartley

Landscape, New Mexico. 1919–1920
Oil on canvas. 28 × 36″
Whitney Museum of American Art,
New York City
Purchased with funds from
Frances and Sydney Lewis

Marsden Hartley

Eight Bells Folly: Memorial to Hart Crane. 1933
Oil on canvas. 30⅝ × 39⅜″
University Art Museum, University of
Minnesota, Minneapolis
Gift of Lone and Hudson Walker

MARSDEN HARTLEY

Madawaska-Acadian Light-Heavy. 1940
Oil on hardboard. 40 × 30″
The Art Institute of Chicago, Chicago
Bequest of A. James Speyer

OPPOSITE:
ARTHUR DOVE (b. 1880, Canandaigua, N.Y.–
d. 1946, Centerport, N.Y.)

Fields of Grain as Seen from Train. 1931
Oil on canvas. 24 × 34⅛″
Albright-Knox Art Gallery, Buffalo, N.Y.
Gift of Seymour H. Knox

OPPOSITE:
ARTHUR DOVE

Me and the Moon. 1937
Wax emulsion on canvas. 18 × 26″
Phillips Collection, Washington, D.C.

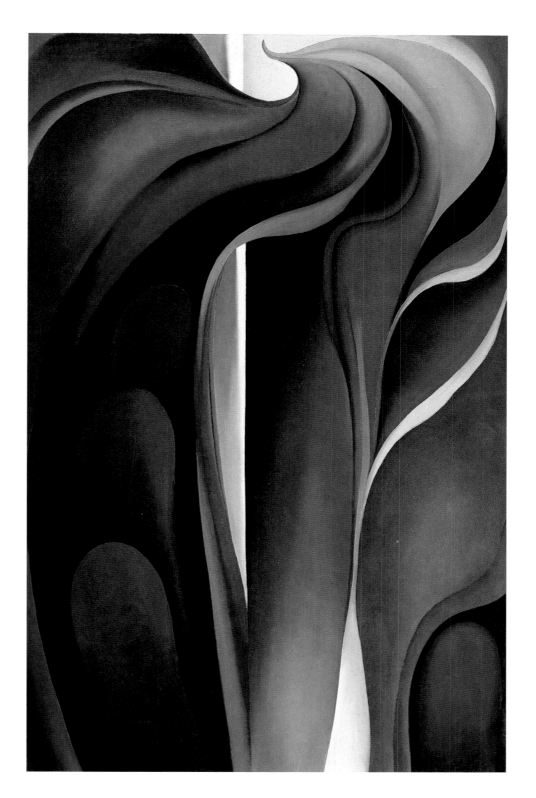

GEORGIA O'KEEFFE (b. 1887, Sun Prairie, Wisc.–d. 1986, Abiquiu, N.M.)

Jack-in-the-Pulpit No. V. 1930
Oil on canvas. 48 × 30″
National Gallery of Art, Washington, D.C.
Alfred Stieglitz Collection, Bequest of Georgia O'Keeffe

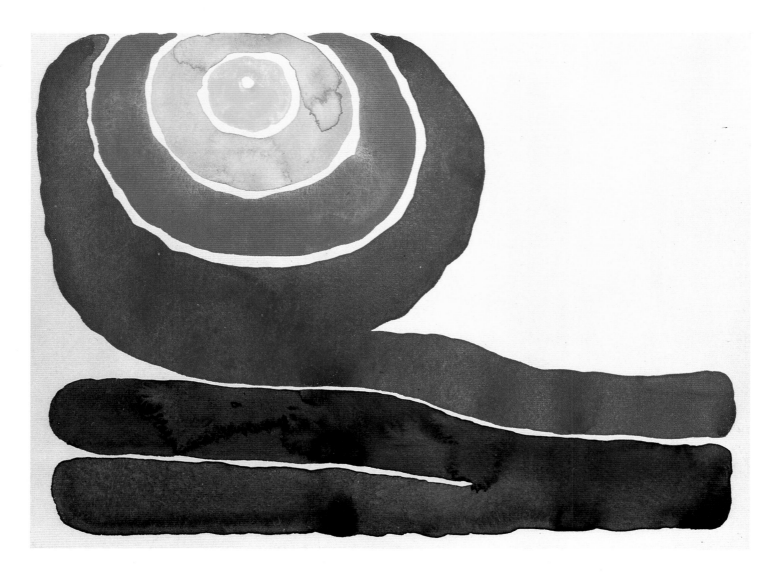

GEORGIA O'KEEFFE

Evening Star, III. 1917
Watercolor. 9 × 11″
The Museum of Modern Art, New York City
Mr. and Mrs. Donald B. Straus Fund

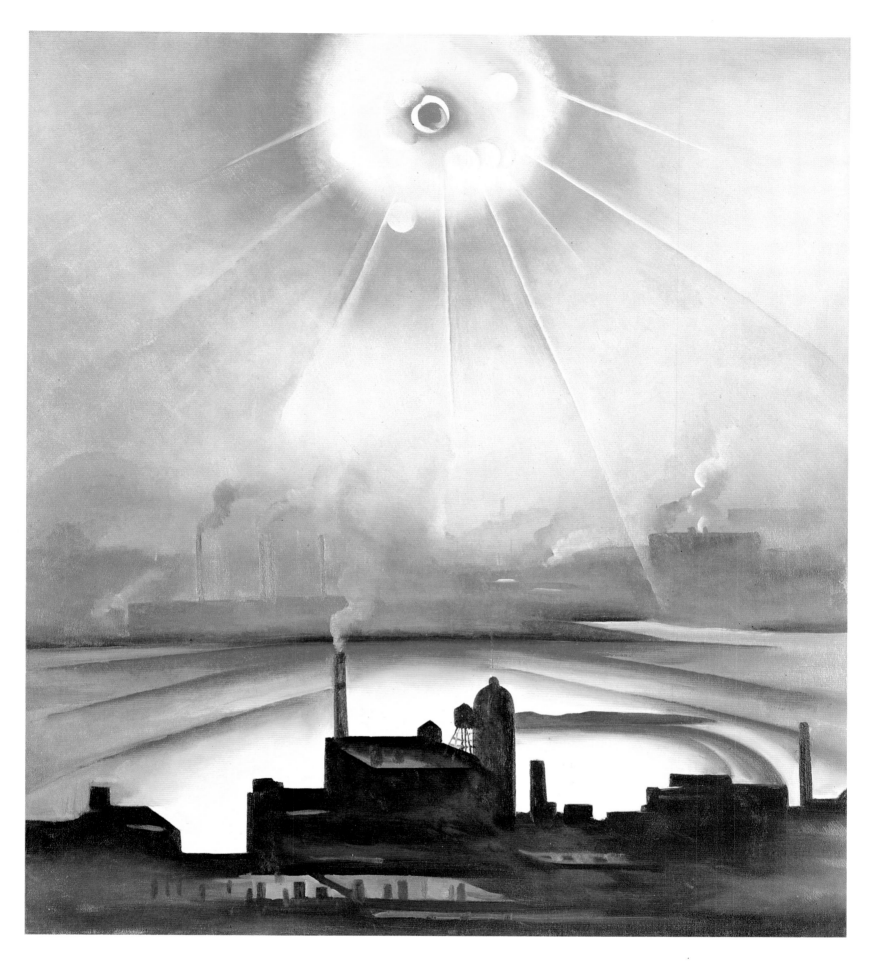

GEORGIA O'KEEFFE

East River from the Shelton. 1927–1928
Oil on canvas. 27¹⁄₁₆ × 21¹⁵⁄₁₆"
New Jersey State Museum Collection, Trenton
Purchased by the Association for the Arts of the
New Jersey State Museum with a Gift from Mary Lea Johnson

193

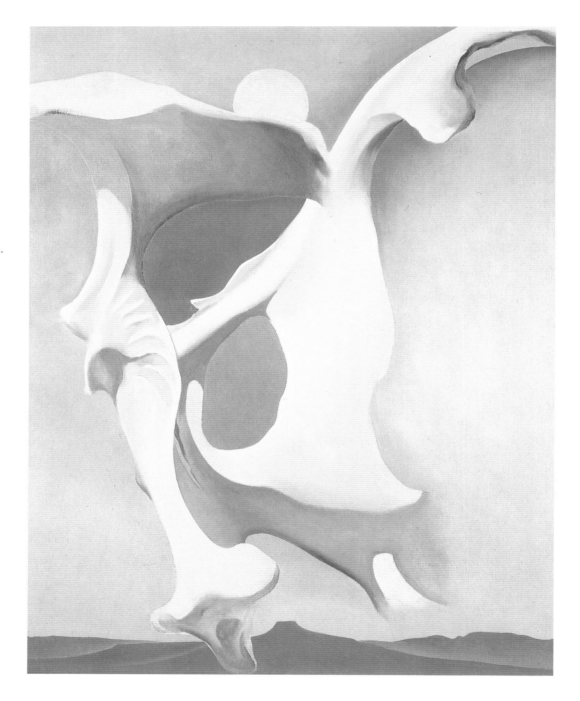

Georgia O'Keeffe

Pelvis with Moon. 1943
Oil on canvas. 30 × 24″
Norton Gallery of Art, West Palm Beach, Fla.

GEORGIA O'KEEFFE

Cow's Skull: Red, White, and Blue. 1931
Oil on canvas. 39⅞ × 35⅞"
The Metropolitan Museum of Art, New York City
Alfred Stieglitz Collection

21. INCENSE OF A NEW

IN THE JAZZ AGE

One branch of American modernism known as Precisionism used Cubist geometry to strip urban and industrial subjects of extraneous detail and to present the clean, linear results dispassionately. Charles Demuth and Charles Sheeler, both born in 1883, were closely identified with this movement in the 1920s, but they approached it from different directions.

Demuth was first known for his delicate watercolor still lifes and landscapes. From 1917 to 1919 (having paid Europe two visits, in 1907 and 1912), he worked on an ambitious set of watercolors depicting vaudeville and nightclub performers.

Turning to larger, architectural subjects, though, he demonstrated a different sensibility. Unlike the Cubists, he uses planes and lines to create an austere precision, as in his ironically titled rendering of grain silos, *My Egypt*. In *Incense of a New Church*, he departs from this strict style, allowing himself a more extravagant reaction to form. *I Saw the Figure 5 in Gold* takes as its title the first line of a poem by Demuth's friend William Carlos Williams, about a fire engine racing to answer an alarm. The gold "5" receding into a red background is a clever sort of mimicry. In addition, Demuth added two nice allusions: "Bill" and "Art Co."

Charles Sheeler's depictions of America's urban and industrial landscapes owe much to the clear-focus photography that he and Paul Strand experimented with from 1917 though the 1920s. The curiously realistic, coldly formal results are quite unlike the volatile, Cubist- and Futurist-inspired realism of Stella. Sheeler's *Church Street El* and *Upper Deck* exemplify this photographic approach.

It was Sheeler's *River Rouge Plant* that popularized the notion of American industry as a monumental subject—a worthy aspect of landscape painting. Where Demuth is poetic and ironic, Sheeler is naturalistic and precise. The very precision of these works, devoid of a human presence, lends them an eerie, abstract sheen. The bright tones of *City Interior*, for instance, have this effect. But later works, such as *Architectural Cadences* and *Two Against the White* (both from the 1950s), return to a more complex, abstract use of Cubist forms.

Stuart Davis was a student of Robert Henri, and for a time he worked as an illustrator for the left-wing magazine *The Masses*. By the 1920s he had broken with Henri's school of realism, though he was still interested in portraying urban reality.

Lucky Strike shows Davis in a humorous mood, adopting the Cubist collage style. Cubism's attention to the decorative aspect of household objects is apparent in an abstract series that includes *Eggbeater No. 4*; an electric fan and a rubber glove are also represented. Jazz inspired Davis to use bright, dynamic color combinations, as in his *Swing Landscape*, to convey the music's vitality. Here, outlines flatten Cubist forms; any sense of depth is conveyed by the juxtaposition of contrasting colors. A two-panel work,

CHURCH: CUBIST REALISM

House and Street, uses flat planes and strong colors to a different effect; it suggests two frames of a filmstrip. Even in his late work, such as *Something on the Eight Ball,* Davis is still trying new ways to describe city life.

While the painters discussed here have been loosely grouped together, it is clear that they all painted very differently. Each took what he needed where he found it. Each mixed and matched schools, techniques, and materials to convey his own vision, and each changed, adapted, and invented as he went along. Assigning these artists to this or that school or camp is an exercise in futility. As Davis put it, "The act of painting is not a duplication of experience, but the extension of experience on the plane of formal invention."

(H.L.W.)

CHARLES DEMUTH (b. 1883, Lancaster, Pa.–d. 1935, Lancaster, Pa.)

Incense of a New Church. 1921
Oil on canvas. 26 × 20⅛″
Columbus Museum of Art, Columbus, Ohio
Gift of Ferdinand Howald

CHARLES DEMUTH

I Saw the Figure 5 in Gold. 1928
Oil on composition board. 36 × 29¾″
The Metropolitan Museum of Art, New York City
Alfred Stieglitz Collection

OPPOSITE:

CHARLES SHEELER (b. 1883, Philadelphia–
d. 1965, New York City)

Upper Deck. 1929
Oil on canvas. 29⅛ × 22⅛″
Fogg Art Museum, Harvard University,
Cambridge, Mass.
Louise E. Bettens Fund

CHARLES SHEELER

Church Street El. 1920
Oil on canvas. 16⅛ × 19⅛″
Cleveland Museum of Art, Cleveland
Mr. and Mrs. William H. Marlatt Fund

CHARLES SHEELER

Two Against the White. 1957
Oil on canvas. 14⅞ × 18″
Hallmark Fine Art Collection, Kansas City, Mo.

STUART DAVIS (b. 1894, Philadelphia–
d. 1965, New York City)

Lucky Strike. 1924
Oil on paperboard. 18 × 24″
Hirshhorn Museum and
Sculpture Garden, Smithsonian
Institution, Washington, D.C.

STUART DAVIS

Eggbeater No. 4. 1927
Oil on canvas. 27 × 38¼″
Phillips Collection, Washington, D.C.

STUART DAVIS

Something on the Eight Ball. 1953–1954
Oil on canvas. 56 × 45″
Philadelphia Museum of Art, Philadelphia
Adele Haas Turner and Beatrice Pastorius Turner Memorial Fund

S<small>TUART</small> D<small>AVIS</small>

Swing Landscape. 1938
Oil on canvas. 87$^{15}/_{16}$ × 172$^{15}/_{16}$″
Indiana University Art Museum, Bloomington

22. AMERICAN MAIN

Everyone smiles at the sight of one of the colorful, busy, naive paintings by Grandma Moses (Anna Mary Robertson). The reaction, as much nostalgic as aesthetic, seems almost instinctive. *A Beautiful World* stirs our memory of a time when that was how we saw the world. Barns and farmyards, maple trees, covered bridges, quilting bees: we all long to return to a time when the world was at once simple and busy with such happy details. Perhaps we have grown jaded, but her vision is irresistible, conjuring up as it does an America we may have visited only in our childhood dreams.

Edward Hopper, on the other hand, presents us with an American scene that is both familiar and haunting. We know Hopper's world, and there's nothing grandmotherly about it. Trained by Robert Henri in the manner of the Ashcan School, he worked for a number of years as an illustrator. Even so, a painting like *New York Restaurant* is carefully crafted to carry a heavy freight of heightened reality.

Hopper's trademark is light that one critic said "illuminates but never warms." In this painting, for instance, it reveals a scene of apparent conviviality to be one of actual isolation. We have his own word for it that this disturbing effect was deliberate: "In a specific and concrete sense," he said, "the idea was to attempt to make visual the crowded glamour of a New York restaurant during the noon hour. I am hoping that ideas less easy to define have, perhaps, crept in also."

It is in his concern with intangibles that Hopper goes beyond realism and naturalism. A master at rendering the solitary moment, he creates a world of solitary people who seem to be waiting, but who also seem to have lost hope. *New York Movie* and *Nighthawks*, intense studies of the alienation of modern life, are made all the more haunting by their understated literalness. Hopper does not tell a story in these city scenes, but his images evoke a sense of profound isolation.

The Lighthouse at Two Lights combines two more of Hopper's favorite subjects, the sea and architecture. Again, his paradoxical light makes the structure seem both sturdy and inaccessible. In *Carolina Morning* he manages to counterbalance the brilliant red of the woman's dress with the clear light of wide open space. Artfully understated, Hopper's people, and the rooms, houses, stores, bridges, and street fronts they haunt, anticipate the world of "Waiting for Godot."

Norman Rockwell may be America's best-known illustrator. A whole generation grew up with his *Saturday Evening Post* covers, and reproductions of his storytelling portraits of American life decorate many a parlor, kitchen, and waiting room. If *Marriage License* is too cloying for some tastes, its masterly composition—with the light glowing in the window of the dark office of the Justice of the Peace—is undeniable. Rockwell's stock American types are little more than caricatures, but there is charm in their sense of well-being.

In Rockwell's *Freedom of Speech*, a collage of heads conveys the strength of a country committed to such a fundamental right, while in *Southern Justice* he indulges in a rare moment of social criticism. *Shuffleton's Barbershop* and his humorous *Triple Self-Portrait* confirm Rockwell to be a skillful illustrator; when he resists sentimentality and cuteness, he can be an astute observer of the American scene.

Andrew Wyeth and *Christina's World* may be America's favorite painter and America's favorite painting. Critics still debate the painting's meaning: Is it a study in desolation, even madness, or is it simply a melodramatic illustration in a naturalistic style? Christina, crippled by polio, seems to yearn to reach the farm buildings on the horizon.

STREET

Yet Wyeth undermines the intensity of her pose by his overscrupulous attention to the landscape. The grass, for instance, is a tour de force; one critic called it a "tracery of abstract writing." The viewer may conclude that the whole composition is too mannered, too contrived, to be persuasive.

Wyeth's love for the land is sincere; consider *Soaring*, a bird's-eye view of a landscape. If his human figures tend to suffer from a Rockwell-like superficiality, his landscapes and interiors show great sensitivity.

(H.L.W.)

NORMAN ROCKWELL (b. 1894, New York City–d. 1978, Stockbridge, Mass.)

Freedom of Speech. 1943
Oil on canvas. 45¾×35½"
Norman Rockwell Museum
at Stockbridge, Mass.
Printed by permission of the
Estate of Norman Rockwell

GRANDMA MOSES (Anna Mary Robertson) (b. 1860,
 Greenwich, N.Y.–d. 1961, Hoosick Falls, N.Y.)

A Beautiful World. 1948
Oil on pressed wood. 20 × 24″
Grandma Moses Properties Co., New York City

EDWARD HOPPER (b. 1882, Nyack, N.Y.–d. 1967, New York City)

South Carolina Morning. 1955
Oil on canvas. 30 × 40″
Whitney Museum of American Art, New York City
Given in memory of Otto L. Spaeth by his family

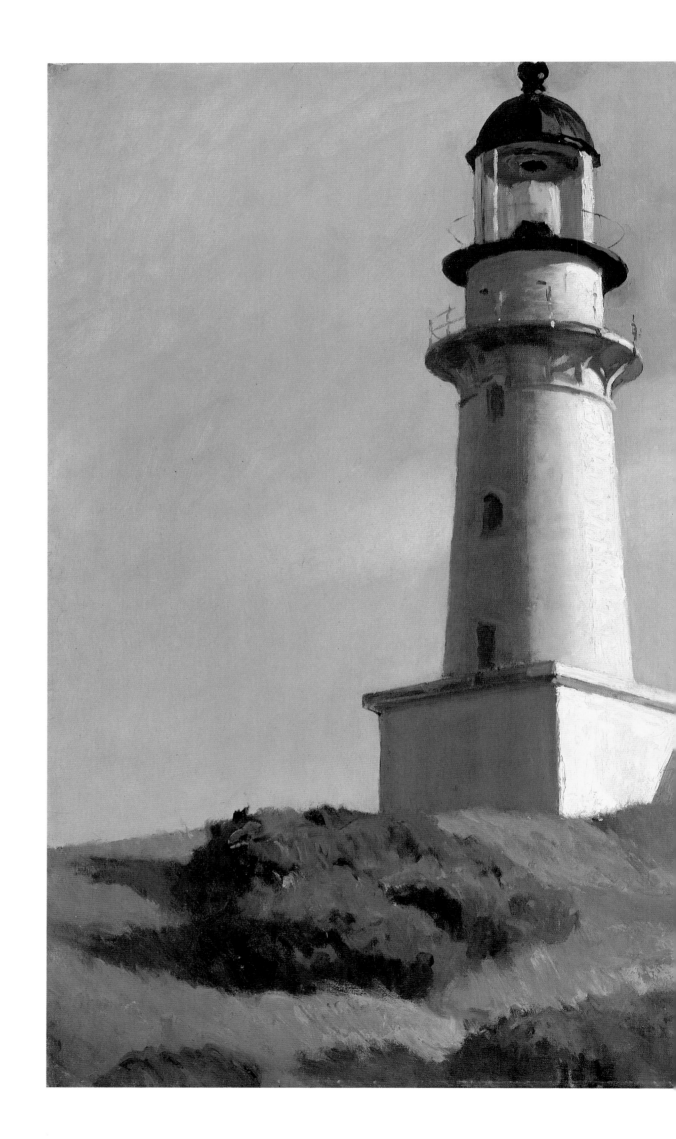

EDWARD HOPPER

The Lighthouse at Two Lights. 1929
Oil on canvas. 29½ × 43¼"
The Metropolitan Museum of Art,
New York City
Hugo Kastor Fund

210

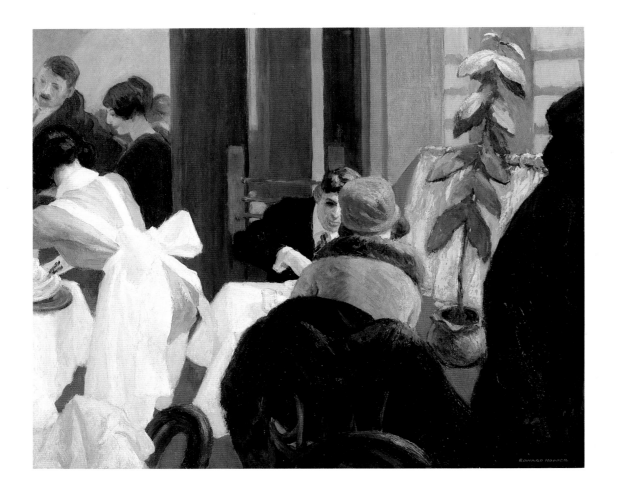

EDWARD HOPPER

New York Restaurant. ca. 1922
Oil on canvas. 24 × 30″
Muskegon Museum of Art, Muskegon, Mich.

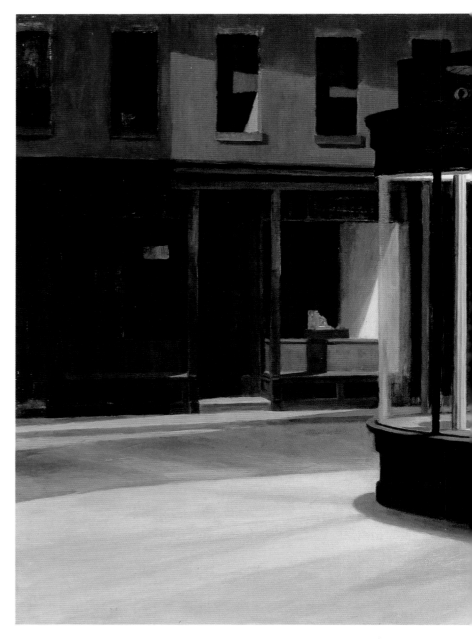

EDWARD HOPPER

Nighthawks. 1942
Oil on canvas. 30 × 56¹¹⁄₁₆″
The Art Institute of Chicago, Chicago
Friends of American Art Collection

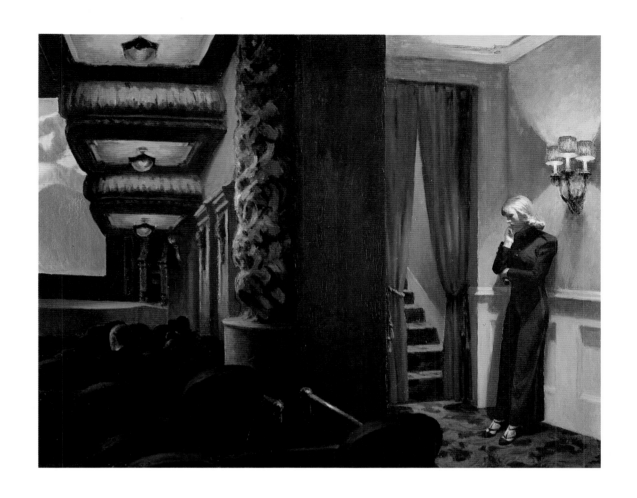

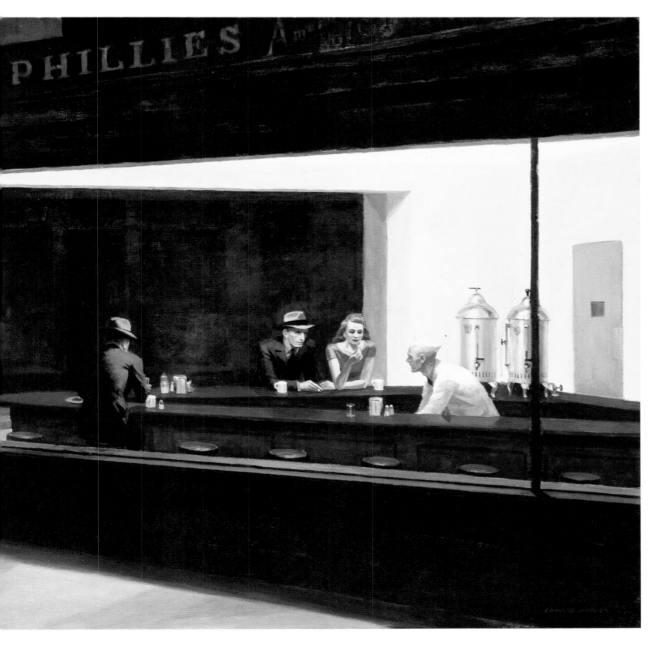

EDWARD HOPPER

New York Movie. 1939
Oil on canvas. 32¼ × 42⅛"
The Museum of Modern Art,
New York City
Given anonymously

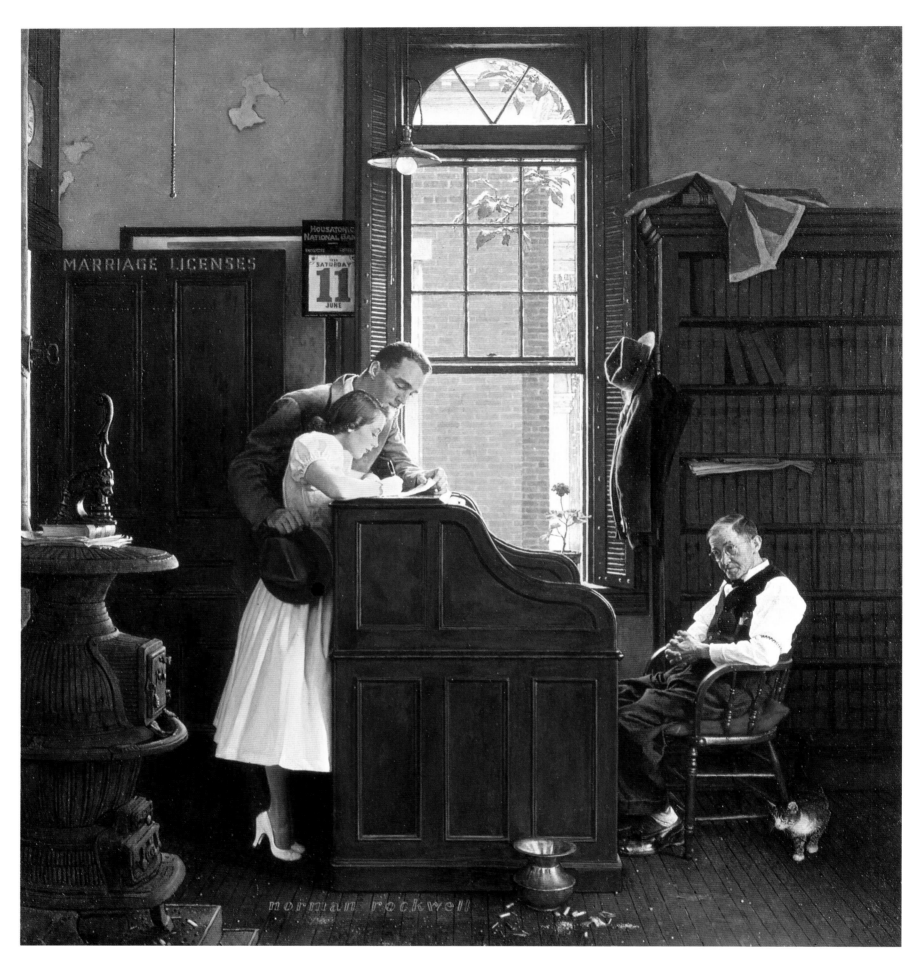

Norman Rockwell

Marriage License. 1955
Oil on canvas. 45½ × 42½″
Norman Rockwell Museum at Stockbridge, Mass.

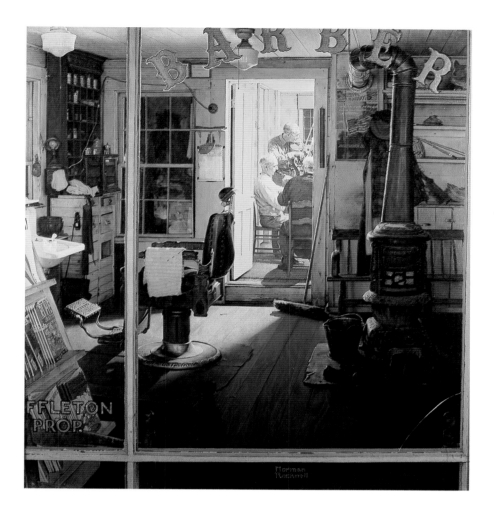

NORMAN ROCKWELL

Shuffleton's Barbershop.
Saturday Evening Post cover, 1950
Oil on canvas. 46¼ × 43″
Berkshire Museum, Pittsfield, Mass.
Printed by permission of the
Estate of Norman Rockwell

NORMAN ROCKWELL

Triple Self-Portrait. Saturday
Evening Post cover, 1960
Oil on canvas. 44½ × 34⅜″
Norman Rockwell Museum at
Stockbridge, Mass.
Printed by permission of the
Estate of Norman Rockwell.

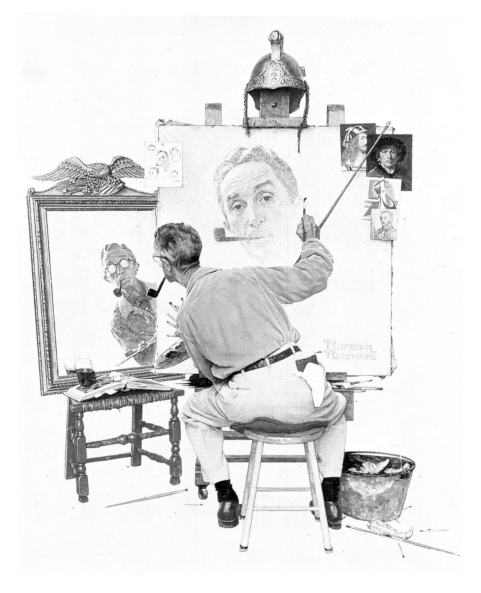

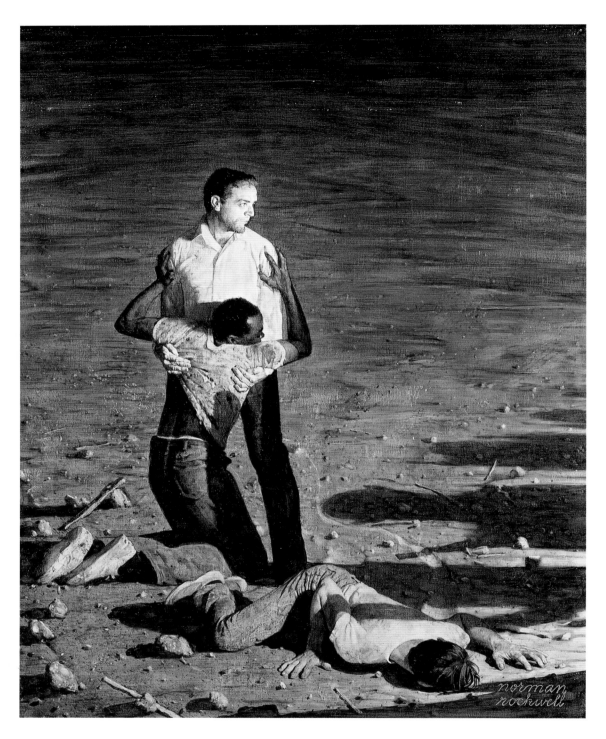

ANDREW WYETH (b. 1917, Chadd's Ford, Pa.)

Christina's World. 1948
Tempera on gessoed panel. 32¼ × 47¾"
The Museum of Modern Art, New York City

ANDREW WYETH

Soaring. 1950
Tempera on masonite. 48 × 87"
Shelburne Museum, Shelburne, Vt.

NORMAN ROCKWELL

Southern Justice (Murder in Mississippi),
unpublished final painting. 1965
Oil on canvas. 53 × 42"
Norman Rockwell Museum at
Stockbridge, Mass.
Printed by permission of the
Estate of Norman Rockwell

23. Time and the Land

American Gothic, painted by Grant Wood in 1930, at the beginning of the Great Depression, has become the best-known example of the movement, termed regionalism, that rejected European modernism in favor of a realistic style that suited a new purpose: celebrating the American scene. Wood's timing was perfect. The enduring of hardships in the Depression made Americans feel both proud and protective of their nation. Wood and Thomas Hart Benton soon emerged as the leading practitioners of two realistic styles that idealize the common man and assure the viewer that all is well in the nation's heartland. Though the two artists shared a positive vision of the American ideal, they made dramatically different choices when it came to particular themes and styles. Wood's portraits of stiff, pinched neo-Puritans are a far cry from Benton's energetic, animated scenes.

During the late 1920s, Wood took a trip to Europe and came home with a fond regard for sixteenth-century Flemish painters, such as the van Eyck brothers, whose meticulous attention accorded well with the style of the American Arts and Crafts Movement, in which he had been trained. Wood combined these sources to create a hard-edged, pristine primitivism. His schematized landscapes—plowed fields reduced to neatly curving oval planes, tree branches to circular patterns, and harvested crops to pyramids in rows—are all about continuity, and about Wood's own love of the values such a scene symbolizes. His 1932 *Daughters of Revolution* works a witty twist on his austere and subdued representations. The pinched-faced, tight-lipped trio toasting the father of their country contrast prissily and smugly with the expressive painting *George Washington Crossing the Delaware*, by Emanuel Leutze, behind them.

Benton's elongated figures and kinetic landscapes are infused with the spirit of one of his favorite eras in art: the seventeenth-century baroque. *People of Chilmark (Figure Composition)* (1922) prefigures Benton's mature style. Sweeping spirals of motion and emotion underscore his epic vision, rooted in American folklore. In his *Ballad of the Jealous Lover of Lone Green Valley* (1934), Benton translates the rhythm and images of a popular song into the rhythmic contours of the land and the cast of five characters. His strong diagonals are a visual corollary of the melodramatic song.

It is not surprising that Charles Burchfield has been identified as a regionalist; he took his hometown, of Salem, Ohio, for his subject. The poignant *Ice Glare* (1933) is typical of Burchfield. His rickety houses, empty streets, leafless trees—sights so common that they go unnoticed—describe an abiding inner spirit rather than any one neighborhood. Burchfield's watercolor technique is fluent, a matter of small strokes layered to compose solid forms. From the 1940s until his death in 1967, as he became increasingly introverted, he developed a haunting, dreamlike manner associated less with the regionalists than with Arthur Dove, who in turn anticipated Abstract Expressionism.

Regionalism was short-lived. By 1942, the year Wood died, it was already in decline. Benton continued to paint his modern versions of classical myths and Biblical scenes until his death in 1975. The Second World War demanded a less parochial art. In September 1930, Jackson Pollock was a student in a class taught by Benton at the Art

Students League, in New York City. Benton remained Pollock's mentor, but by 1942 Pollock had turned his attention to European modernism and was well on his way to Abstract Expressionism. After only one decade, regionalism had been superseded. Of all the regionalist canvases, only Grant Wood's *American Gothic* has been kept in the public's consciousness; but the variations worked on it, in cartoons, posters, and advertisements, convert the faces the artist saw as the epitome of traditional American ideals into pop symbols.

(B.C.)

THOMAS HART BENTON (b. 1889, Neosho, Mo.–
d. 1975, Kansas City, Mo.)

People of Chilmark (Figure composition). 1920
Oil on canvas. 65⅝ × 77⅝″
Hirshhorn Museum and Sculpture Garden, Smithsonian
Institute, Washington, D.C.
Gift of the Joseph H . Hirshhorn Foundation

THOMAS HART BENTON

The Ballad of the Jealous Lover of Lone Green Valley. 1934
Oil and tempera on canvas. 42¼ × 53¼″
Spencer Museum of Art, University of Kansas, Lawrence
Elizabeth M. Watkins Fund

OPPOSITE:
THOMAS HART BENTON

July Hay. 1943
Oil and egg tempera on composition board. 38 × 26¾″
The Metropolitan Museum of Art, New York City
George A. Hearn Fund

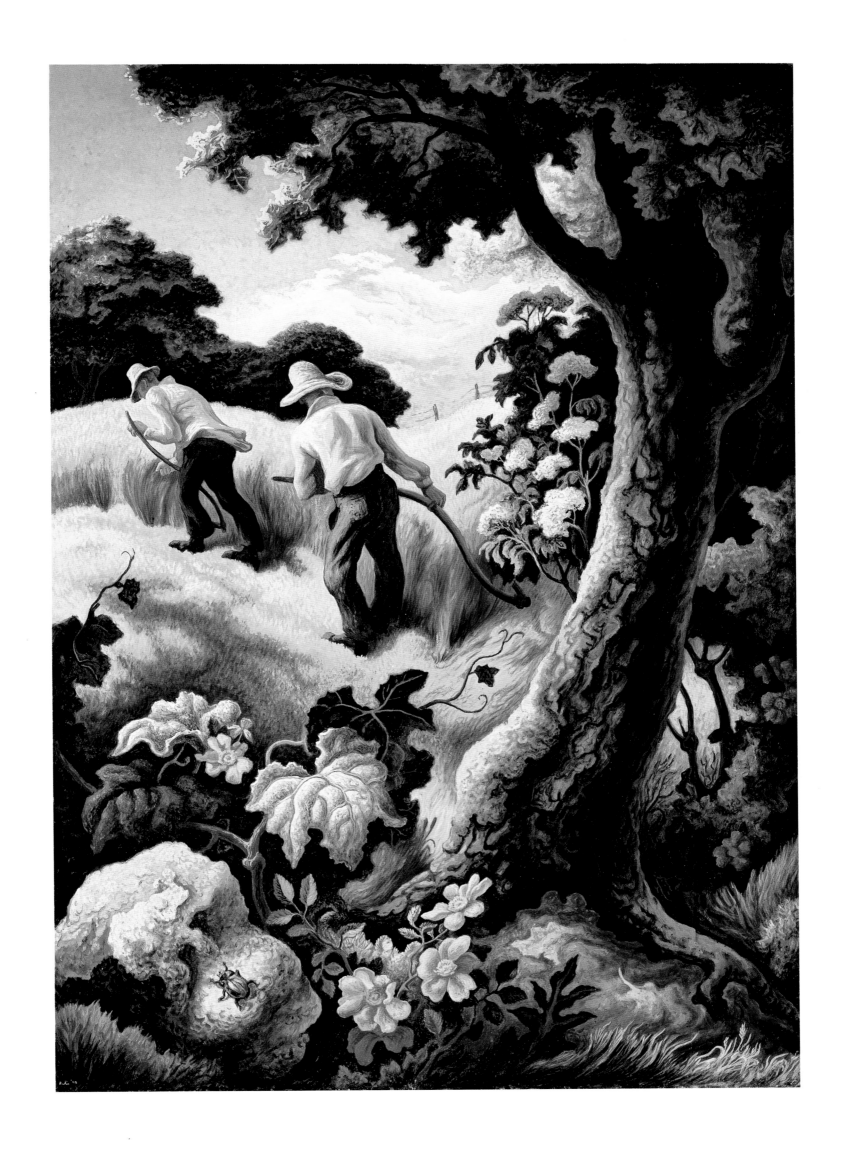

GRANT WOOD (b. 1892, Anamosa, Iowa–
 d. 1942, Iowa City, Iowa)

Daughters of Revolution. 1932
Oil on canvas. 21⁹⁄₁₆″ × 101⁵⁄₈
Cincinnati Art Museum, Cincinnati
Edwin and Virginia Irwin Memorial

GRANT WOOD

American Gothic. 1930
Oil on beaver board. 29¹⁵⁄₁₆ × 24¹⁵⁄₁₆″
The Art Institute of Chicago, Chicago
Friends of American Art Collection

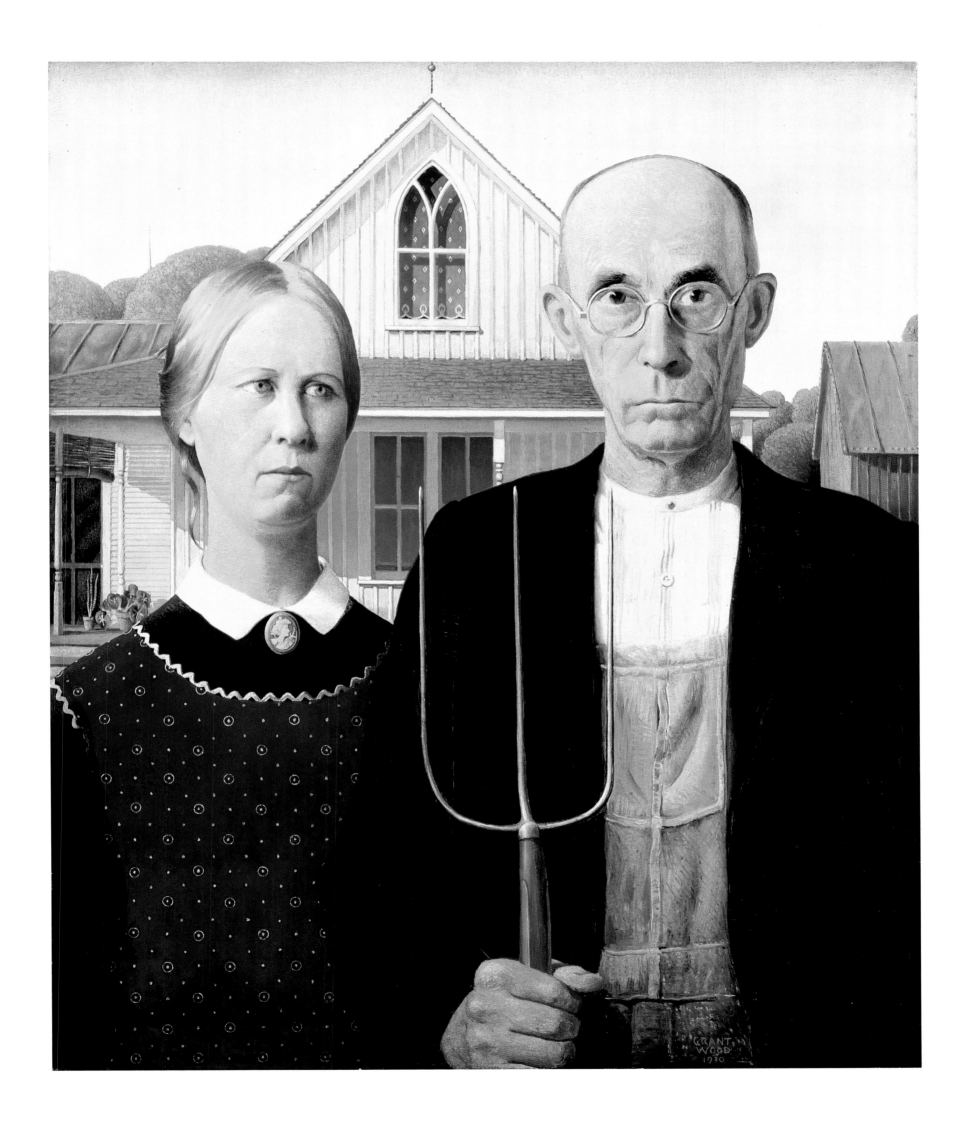

CHARLES BURCHFIELD (b. 1893, Ashtabula, Ohio—
 d. 1967, Gardenville, N.Y.)

Childhood's Garden. 1917
Watercolor. $27 \times 18^{15}/_{16}''$
Munson-Williams-Proctor Institute
Museum of Art, Utica, N.Y.

CHARLES BURCHFIELD

Ice Glare. 1933
Watercolor on paper. $30^{3}/_{4} \times 24^{3}/_{4}''$
Whitney Museum of American
Art, New York City

24. SOCIAL ART IN AN AGE OF ABSTRACTION

Throughout the twentieth century, diverse styles and types of content have coexisted in art, though one variety usually gets singled out for attention during any particular period. During the 1930s, American painting included many groups and individuals working in varied ways; the Stieglitz group, abstract artists, regionalists, social realists, and Expressionists were active. A number of artists were making socially conscious art that has been described by various labels, and many of these practitioners persisted over several subsequent decades. The Great Depression brought with it an urgent need for response from writers, visual artists, and other intellectuals; the political, social, and personal struggles that ensued motivated many artists to document and dramatize the issues and the conditions of life, particularly in the cities.

Reginald Marsh and Isabel Bishop have been termed "American Scene" painters and "urban realists." Both depict scenes from life in and around New York City, and both eschew modernism, instead employing traditional techniques of representation. Marsh's exuberant, baroque scenes of the characters in New York's dance halls, burlesque houses, and honky-tonks, along with his bustling crowds at Coney Island, are complex, energy-filled compositions that convey the hustle and bustle, and often the seedier side, of the city. His oeuvre owes as much to his early work as an illustrator for magazines and for the *Daily News* as it does to his studies with John Sloan and George Luks, leading painters of the earlier Ashcan School of American realism. Bishop is more introspective; she used her considerable technical skills and powers of observation to capture more intimate and ephemeral aspects of the ordinary people she observed from her studio, overlooking Union Square, in Manhattan. She painted there for over forty years, from 1934 to 1978, producing an array of poetic representations of the local street scene: people walking, rushing, dozing, reading newspapers, and sitting at lunch counters, on the subway, or on park benches.

In marked contrast with the art of Marsh and Bishop, Horace Pippin's primitive, unschooled depictions of the places and events from his own experience, and sometimes from events that he did not see but that were of personal import to him, are from the other end of the stylistic spectrum. Pippin memorialized occurrences from the twenty-two months he spent as a soldier in a black regiment during World War I with directness and emotive force, even as he recorded his imagined version of John Brown's last raid, trial, and death at Harpers Ferry.

Ivan Albright is one of the major artists who practiced in a manner termed "Magic Realism." His is an eerie, pessimistic view, personally derived, of the corrosive entropy incurred by the passage of time, simultaneously evocative of the decay and darkness that exists in human nature. His harsh, raking light and incredible detail visualize every minute flaw in people and things alike, and the horror of all his art makes the works almost overwhelmingly repulsive to confront.

Ben Shahn and Alice Neel exemplify types of painting that are directly involved in social commentary of a critical nature: Neel in intimate portraits and in scenes of Spanish Harlem, where she lived for many years; Shahn in powerful, often satirical, depictions of the harrowing plight and often hopeless struggles of political victims and the

urban poor. In a manner that recalls the German Expressionists Otto Dix and George Grosz, Shahn characterizes the cruelties and inequalities suffered by society's persecuted or forgotten. In his paintings, posters, and murals, he uses his incisive abilities as draftsman and characterizer, formulating works of biting, effective social propaganda that are visual protests against the grim indignities humans perpetrate against their fellow-humans in an age of social upheaval and injustice. His series about the trial and imprisonment of Sacco and Vanzetti are among his most powerful pieces, communicating with expressive abstract lines and planes the tragedy of political victimization. Neel also spares nothing in her candid, tough portraits, which reveal the individual psychologies of her sitters through bold, expressionistic brushstrokes and truth to an unidealized reality. Her pictures of famous personalities, labor leaders, friends, and family all share the extremely rugged directness of an art that, in her own words, was a "revolt against everything decent."

These six American artists are exemplary of those whose penchant for realism took on many distinctive forms, from the poetic to the political, beginning in the socially, economically, and politically jolting era of the Depression. Pippin died in 1946, Marsh in 1954, and Shahn in 1969. Albright, Neel, and Bishop all lived into the 1980s. While major prominence came to those artists who took the path to abstraction blazed by their modernist predecessors, these six and numerous other artists continued to develop the concerns they had established early on, making their contributions to the pluralism that has existed in American art of the past half century.

(B.C.)

HORACE PIPPIN (b. 1888, West Chester, Pa.–d. 1946, West Chester, Pa.)

John Brown Going to His Hanging. 1942.
Oil on canvas. 24⅛ × 30¼"
Pennsylvania Academy of the Fine Arts, Philadelphia
John Lambert Fund

ISABEL BISHOP (b. 1902, Cincinnati–d. 1988, New York City)

Two Girls. 1935
Oil and tempera on composition board. 20 × 24″
The Metropolitan Museum of Art, New York City
Arthur Hoppock Hearn Fund

ISABEL BISHOP

Nude No. 2. 1954
Mixed media on masonite. 31¾ × 21½″
Des Moines Art Center, Des Moines, Iowa
Rose F. Rosenfield Purchase Fund

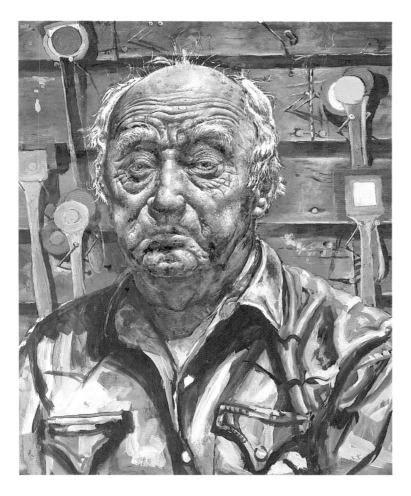

IVAN ALBRIGHT (b. 1897, North Harvey, Ill.–d. 1983, Woodstock, Vt.)

Self-Portrait in Georgia. 1967–1968
Oil on canvas. 20 × 16"
Butler Institute of American Art, Youngstown, Ohio

REGINALD MARSH (b. 1898, Paris–d. 1954, New York City)

Twenty-Cent Movie. 1936
Egg tempera on composition board. 30 × 40"
Whitney Museum of American Art, New York City

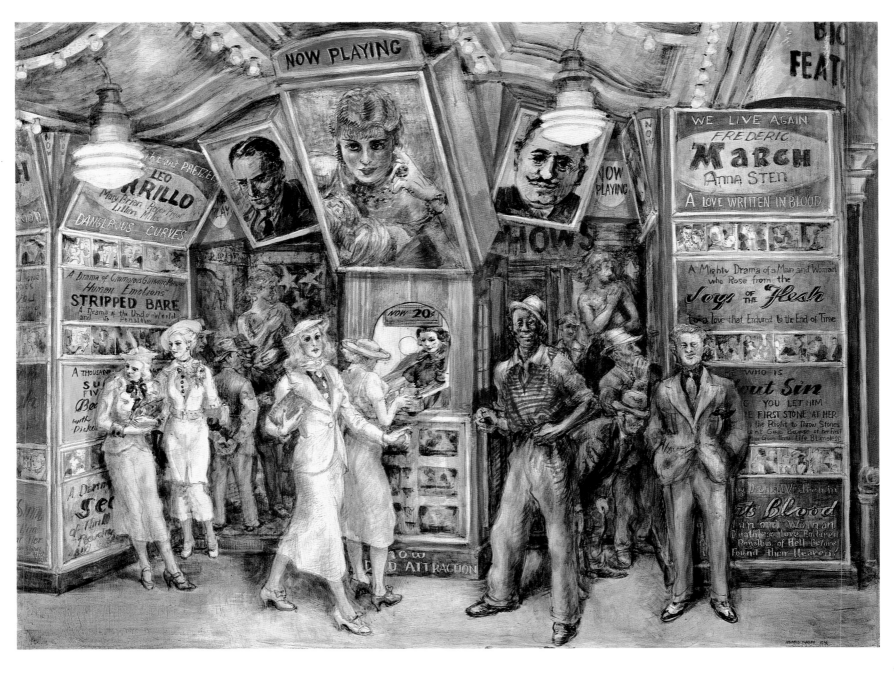

BEN SHAHN (b. 1898, Kaunas, Lithuania–
d. 1969, Roosevelt, N.J.)

The Passion of Sacco and Vanzetti.
1931–1932
Tempera on canvas. 84¼ × 48″
Whitney Museum of American
Art, New York City
Gift of Mr. and Mrs. Milton
Lowenthal in memory
of Juliana Force

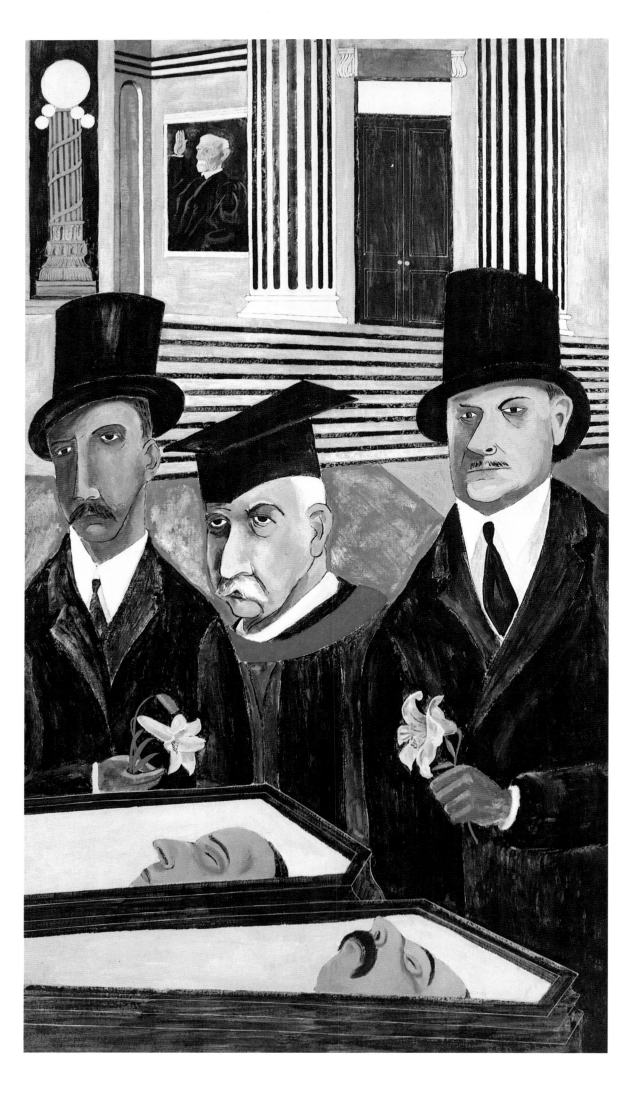

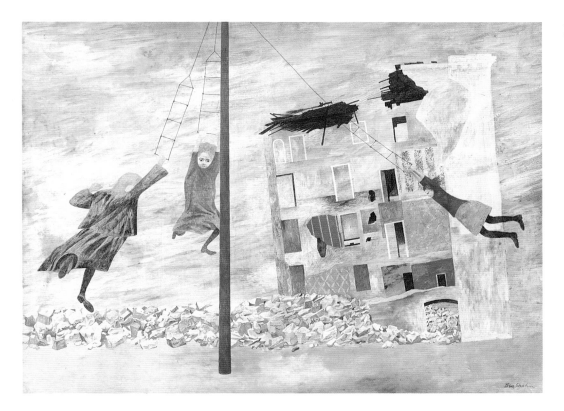

BEN SHAHN

Liberation. 1945
Tempera on cardboard, mounted on
composition board. 29¾ × 40″
The Museum of Modern Art, New York City
James Thrall Soby Bequest

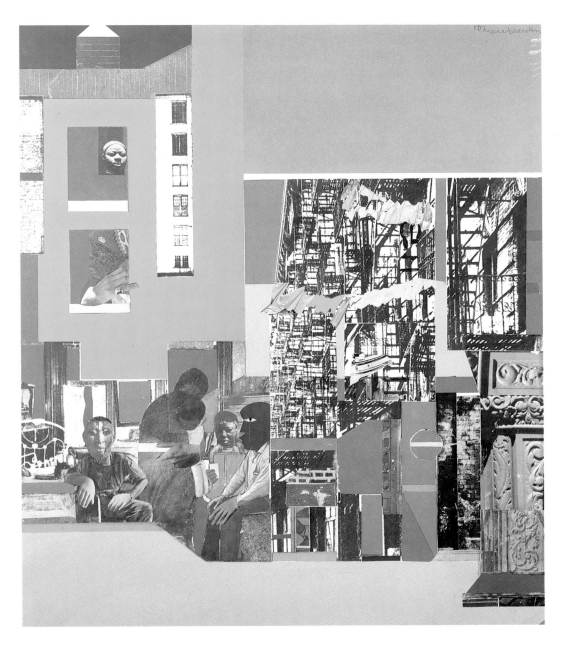

ROMARE BEARDEN (b. 1914, Charlotte, N.C.–
d. 1988, New York City)

Black Manhattan. 1969
Collage on board. 25⅞ × 21″
Schomburg Center, Art and Artifacts Division,
The New York Public Library, New York City
Astor, Lenox, and Tilden Foundations

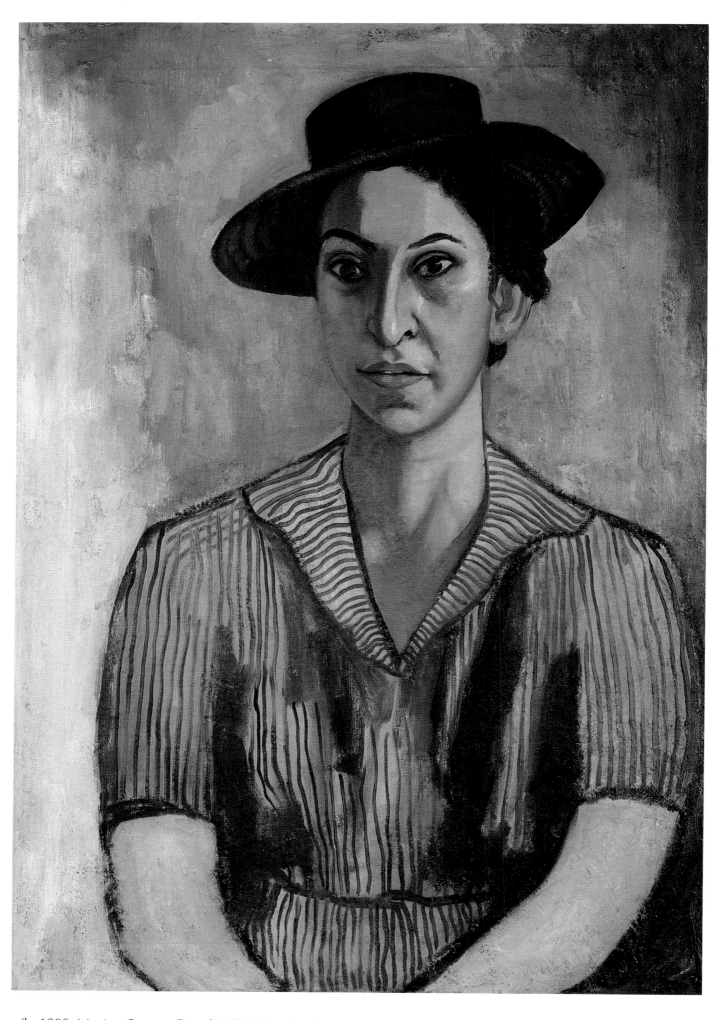

ALICE NEEL (b. 1900, Merion Square, Pa.–d. 1984, New York City)

Woman with Blue Hat. 1934
Oil on canvas. 32 × 22″
Robert Miller Gallery, New York City

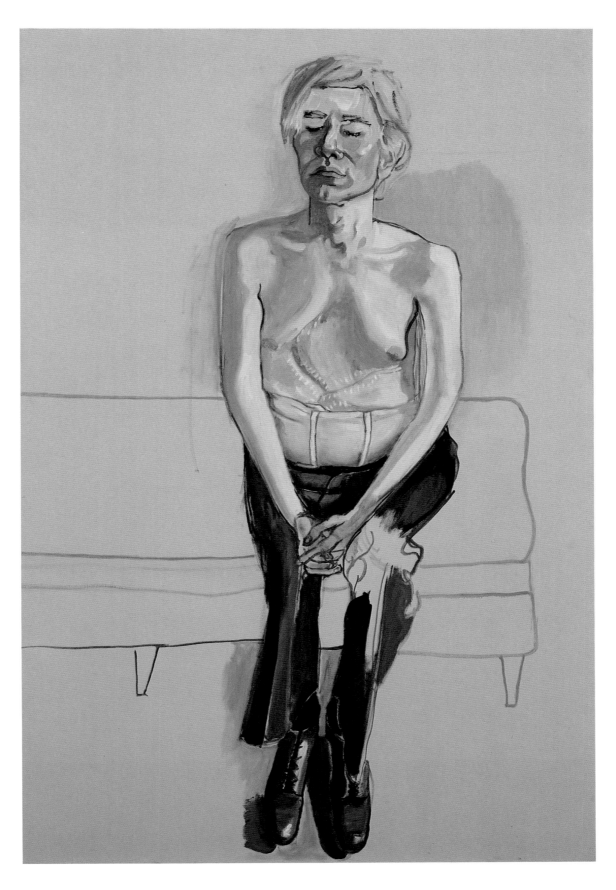

ALICE NEEL

Andy Warhol. 1970
Oil on canvas. $60 \times 40''$
Whitney Museum of American Art, New York City
Gift of Timothy Collins

25. STARTING OVER

Recalling the origins of the Abstract Expressionist movement, Barnett Newman declared in 1967:

> Twenty years ago we felt the moral crisis of a world in shambles . . . devastated by a great depression and a fierce World War, and it was impossible . . . to paint the kind of painting that we were doing—flowers, reclining nudes. . . . this was our moral crisis in relation to what to paint. So that we actually began . . . from scratch . . . as if painting had never existed.

Newman's belief in an absolute break with tradition and a rejuvenated subject matter was shared by Mark Rothko, one of the founders of The Subjects of the Artist, a new art school. Named by Newman, who later joined the faculty, this school opened at 35 East Eighth Street near many artists' studios in the fall of 1948. Although this informal New York institution had to close in the spring of 1949, its curriculum and the activities of its successors in the 1950s—known as Studio 35 and the Club—reflected the broader interests of the Abstract Expressionists.

During World War II, New York had become the capital of the art world with an influx of such European Surrealist emigrés as Max Ernst, André Masson, and Yves Tanguy, as well as the Chilean painter Roberto Matta. The Surrealists' concept of automatism was crucial for the Abstract Expressionists, who were exploring the capacity of art to serve as a direct vehicle for primal, unfettered emotional expression. By the late 1940s, the Americans were using the unpremeditated (yet deliberate) markings and shapes of automatism to create a bold, nonobjective unity of colors, lines, and forms, rather than the refined arrangement of abstracted symbolic images of the European school.

Deeply impressed with the paintings of Matisse, Milton Avery evolved a lyrical style of subtle, translucent colors and simplified, flattened forms for his serene seascapes and idyllic depictions of family and friends. As mentor to Rothko and Newman, whom he met in 1928 and 1931, Avery played a major role in transmitting Matisse's approach as a colorist to the younger generation. Avery's economy of color, form, and composition resulted in paintings with a childlike innocence which suggested new poetic possibilities for the unifying of form and content.

Seeking to express "basic human emotions—tragedy, ecstasy, doom," Rothko employed expressionistic figures in the 1930s and primitive, mythic, surrealistic imagery in the 1940s before arriving at his signature style. *Slow Swirl by the Edge of the Sea* (1944) is a major painting from Rothko's Surrealist period that was nurtured by his studies of the natural sciences at Yale University as well as of the ideas of Carl Jung and Friedrich Nietzsche. Here, two primeval creatures, suggesting the aquatic origins of existence (and interpreted by some as symbolic of Rothko, on the left, and his future wife Mary Alice Beistle, on the right), evoke ritualistic dance, the rotation of planets, and the life cycle. By 1949, in paintings such as *Number 22*, Rothko had moved toward what he called "the simple expression of the complex thought." Wishing to remove barriers between the painter, the viewer, and the ideas embodied in his pictures, Rothko evolved a new pictorial unity based on stacked horizontal fields of pure, luminous color pushing to the

edges of the canvas. Seemingly pulsating and floating, these translucent bands have frayed edges as well as related hues and values which unify them with the surrounding color space. The large, heroic scale of these paintings of the 1950s and 1960s reflects Rothko's conceiving of the work of art as engulfing both himself and the viewer in a transcendental communion.

Issuing declarations of independence from any European movements or influences, restricting his exhibitions, and denying that his works refer to anything, Clyfford Still has inhibited interpretation. A characteristic painting such as the vast *Untitled* (1957) has a rich impasto surface evoking bark or slate and jagged interlocking forms suggesting stalactites. Although he spurned the tendency of commentators to find elements of landscape in his paintings, Still asserted the importance of fusing color, texture, and shapes "into a living spirit." Still did not frame his paintings: " To be stopped by a frame's edge was intolerable; a Euclidian prison, it had to be annihilated, its authoritarian implications repudiated," he declared.

Similarly, Barnett Newman pronounced his belief in an "assertion of freedom" and a "denial of dogmatic principles." Influenced by Still, Newman rejected the geometry of much European picture-making as dividing the world into finite relations—as he proclaimed in his *Death of Euclid* of 1947. Newman created during this period a series of pictures with circular images related to the emergence of the universe from chaos: *Genesis—The Break* (1946), *The Beginning* (1946), and *Genetic Moment* (1947). By 1949 Newman had moved beyond Surrealist-inspired biomorphic images to such nonobjective paintings as the monumental *Day One* of 1951–52, in which the stark expanse of unbroken red evokes the void at the beginning of creation. Suggesting the elements of earth and fire, the enveloping red-orange field was also the subject of Newman's *Vir Heroicus Sublimis* (1950–51). By means of a note attached to the wall when this vast painting was exhibited in 1951, Newman encouraged the viewer to stand close to the work in order to experience the sensation of a boundless, sublime color-space activated (but not divided) by the intuitive placement of vertical "zips."

Ad Reinhardt created an art of value contrasts—contrasts of light and dark—with roots in Cubist and Constructivist geometry. Although Reinhardt in 1953 began to create "total image" paintings based on variations of blue, red, and black, he rejected his colleagues' interest in transcendent subject matter. By 1961 Reinhardt had arrived at his uniform, nonreferential black paintings based on the symmetrical, directionless, neutral motif of the cross and the negation of color. Fascinated with Oriental art and Zen mysticism, his goal was to create timeless, contentless work. In appreciating Reinhardt's subtle pictures (which are actually a rich, nonreflective gray as a result of beginning with colors and painting them out), the viewer is prompted to withdraw from the world into a meditative gaze that has been compared to Eastern methods of attaining higher states of consciousness. Stating that he was creating "the last paintings which anyone can make," Reinhardt continued the ambitions of his colleagues Still, Newman, and Rothko, breaking with tradition in order to create an ultimate unity of form and content which solicits the viewer's intimacy and focused attention.

(G.S.)

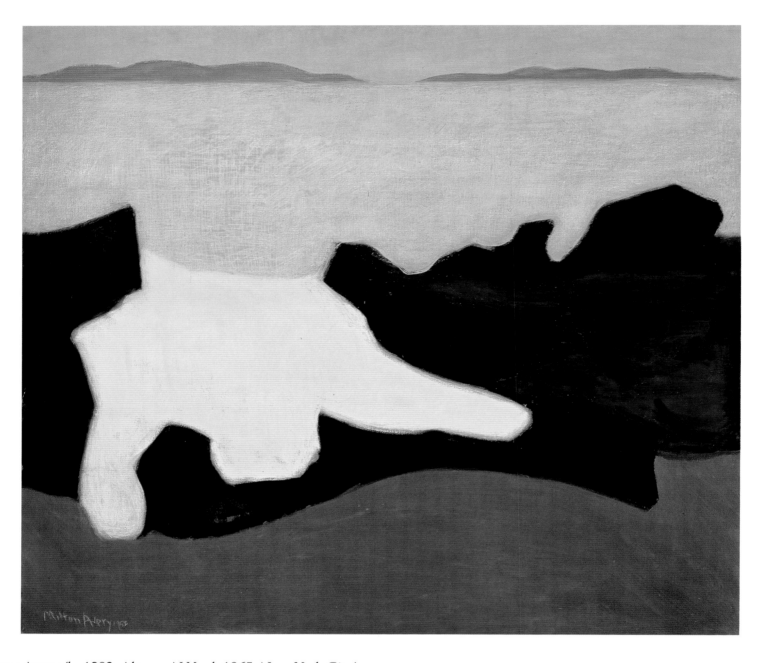

Milton Avery (b. 1893, Altmar, N.Y.–d. 1965, New York City)

Sunset. 1952
Oil on canvas. 42¼ × 48⅛″
The Brooklyn Museum, New York City
Gift of Roy R. and Marie S. Neuberger Foundation, Inc.

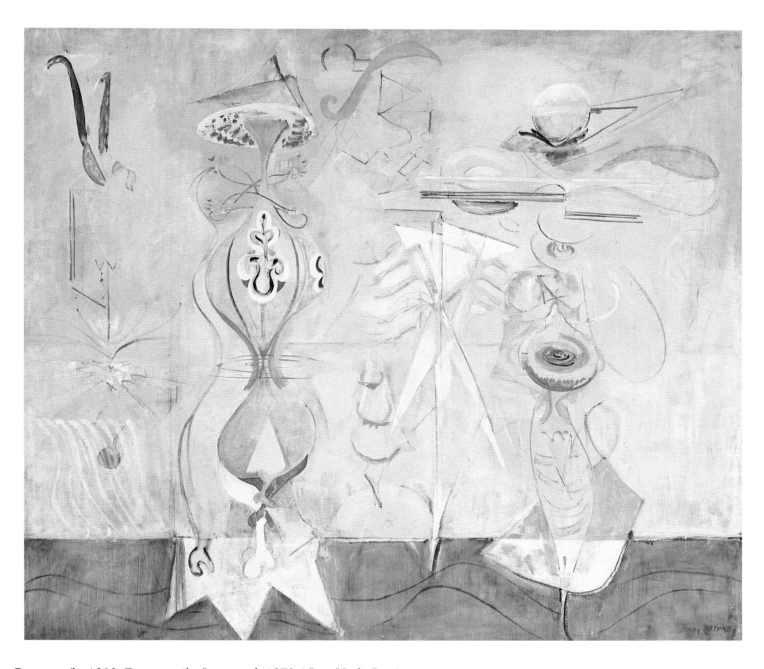

MARK ROTHKO (b. 1903, Daugavpils, Latvia–d. 1970, New York City)

Slow Swirl by the Edge of the Sea. 1944
Oil on canvas. 75³⁄₈ × 84³⁄₄″
The Museum of Modern Art, New York City
Bequest of Mrs. Mark Rothko through
the Mark Rothko Foundation, Inc.

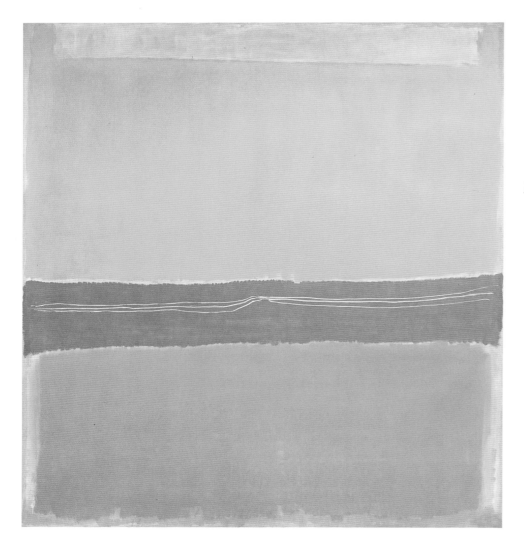

MARK ROTHKO

Number 22. 1949
Oil on canvas. $117 \times 107\frac{1}{8}''$
The Museum of Modern Art,
New York City
Gift of the artist

MARK ROTHKO

Orange, Red, and Red. 1962
Oil on canvas. $93 \times 80''$
Dallas Museum of Art, Dallas
Gift of Mr. and Mrs. Algur H. Meadows
and the Meadows Foundation Inc.

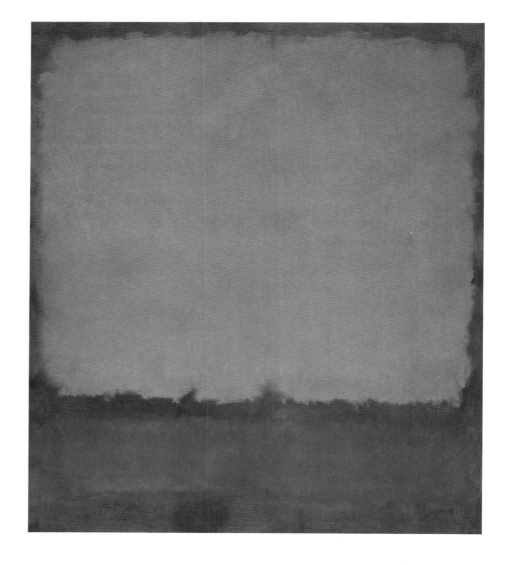

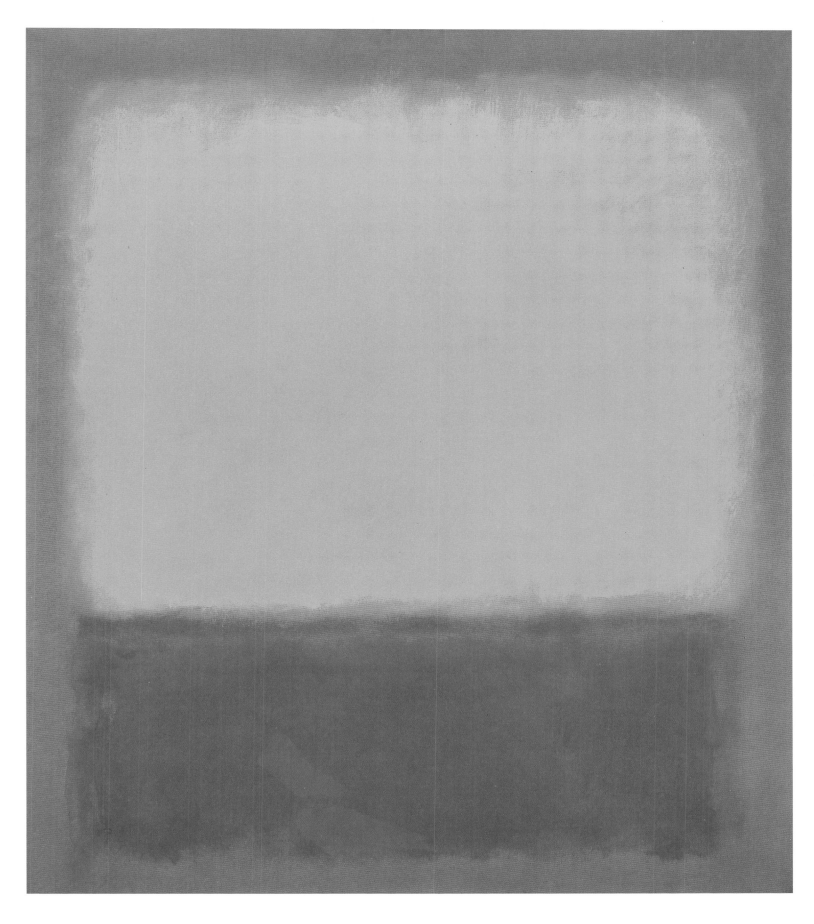

MARK ROTHKO

Yellow over Purple. 1956
Oil on canvas. 69½ × 59¼"
Morton G. Neumann Family
Collection, New York City

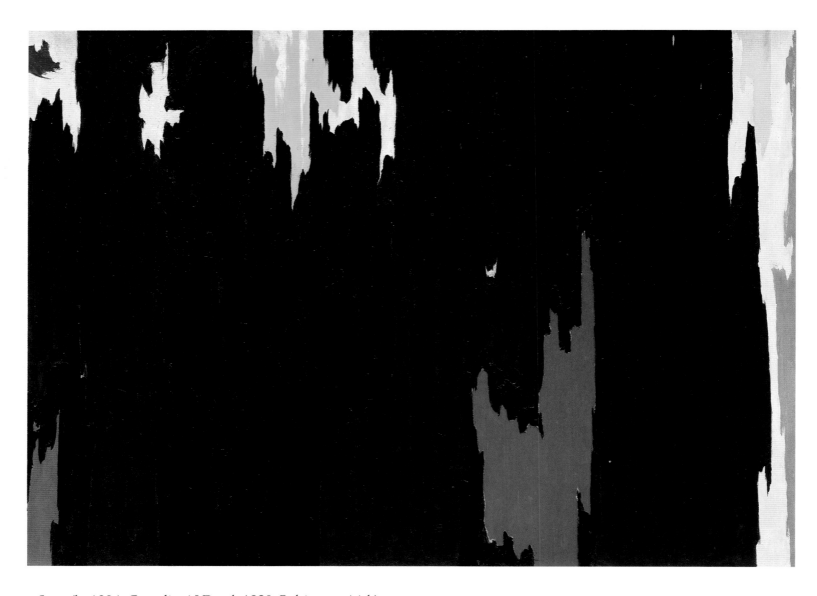

CLYFFORD STILL (b. 1904, Grandin, N.D.–d. 1980, Baltimore, Md.)

Untitled. 1957
Oil on canvas. 112 × 154"
Whitney Museum of American Art, New York City
Purchased with Funds from Friends of
Whitney Museum of American Art

<small>Barnett Newman (b. 1905, New York City–

d. 1971, New York City)</small>

Day One. 1951–1952

Oil on canvas. 132 × 50¼"

Whitney Museum of American

Art, New York City

<small>Ad Reinhardt (b. 1913, Buffalo, N.Y.–

d. 1967, New York City)</small>

Black Painting No. 34. 1964

Oil on canvas. 60¼ × 60⅛"

National Gallery of Art, Washington, D.C.

Gift of Mr. and Mrs. Burton Tremaine

26. FIGURATIVE, NON-FIGURATIVE

The Surrealism that influenced American abstract painting was not that of the colorful, almost photographic dream images of Salvador Dali and René Magritte, but was the earlier and more radical form that developed during the twenties: its use of automatism, coiling lines, and biomorphic abstraction (incorporating ambiguous and hybrid organic forms) celebrates, above all, the power and validity of the dream state—the mythology and archaic memories that compose the Jungian collective unconscious. In his 1924 Surrealist Manifesto, André Breton defined Surrealism: "Noun, masculine. Pure psychic automatism, by which one intends to express verbally, in writing or by any other method, the real functioning of the mind. Dictation by thought, in the absence of any control exercised by reason. . . . Surrealism is based on the belief in the superior reality of certain forms of association heretofore neglected, in the omnipotence of dreams, in the undirected play of thought."

Most of the major Abstract Expressionists, including Jackson Pollock, Mark Rothko, Franz Kline, Clyfford Still, Adolph Gottlieb, and William Baziotes, found Surrealist principles and content central to the development of their final, signature form of abstraction. Arshile Gorky was profoundly influenced by Surrealism both through such secondhand sources as magazines, during the thirties, and through his personal friendships with the Surrealists, after they came to America. Its impact is apparent in his mature work: his use of biomorphic abstraction, his acceptance of accident and chance, his fortuitous grouping of images, and his use of color washes.

Born Vosdanig Manoog Adoian, he took the name Arshile Gorky in 1930, not in homage to the Russian writer Maxim Gorky but because it means "the bitter one," reflecting the difficulties he experienced as an artist in America. In 1918, Gorky's mother had died, and he and his younger sister came to America; their two older sisters had preceded them. After working briefly in the Hood Rubber plant, making soles for shoes (he was dismissed for drawing on the job), Gorky began to pursue a career as an artist. Yet although he studied at various art schools, and was an art instructor from 1925 to 1931, he was largely self-taught. His painting prior to 1925 was in the Post-Impressionist idiom. He began to question this direction of art, and set out to discover the next modern phase. He was never without a monograph in his pocket, with reproductions of works by Uccello, Ingres, or Tintoretto, which he would often hold at arm's length and examine upside down, to isolate form, and to experience it divorced from content. In this way he studied Cézanne and, later, Picasso, Léger, Miró, Kandinsky, Matta, and others.

During the thirties, Gorky worked on many of the problems Picasso had posed, and the closest he came to geometric abstraction was in a number of paintings based on Picasso's studio interiors of 1927–28. An unusual example of Gorky's post-Cubist style is his self-portrait as a boy with his mother, which he based on an old, faded photograph. Gorky was preoccupied with versions of this portrait from 1926 to 1935. Using grids, he enlarged pencil drawings of the subject until this souvenir of a lost moment took on an eternal monumentality in a painting reminiscent of Picasso's neoclassical period.

During the late thirties, Gorky went beyond Picasso in a series, based on Surrealist principles, in which biomorphic abstractions were knit together with dripping, veil-like washes of color. Gorky spent the summer of 1942 in Connecticut, and the following one on a Virginia farm, drawing closeup views of flowers, grasses, and other organisms. Back in the studio in the winter, he worked on large paintings based on these sketches. According to his friend Elaine de Kooning, herself a painter, Gorky "found in the contours of weeds and foliage a fantastic terrain pitted with bright craters of color which he let swim isolated on the white paper while a labyrinthine pencil line, never stopping, created dizzy, tilted perspectives that catapulted the horizons to the top of the page . . . staring down into the hearts of flowers, to come up with magnified stamens and pistils, as aggressive as weapons, with petals like arching claws, leaves like pointed teeth, and stems like spears." Freely interpreting nature to reflect his own psychological states, Gorky became the immediate precursor to Abstract Expressionism. His rich, painterly surface transforms the initial shapes into something more abstract and immediate.

Willem de Kooning was born in Rotterdam in 1904. He studied both fine and applied arts and came into contact with revolutionary art movements such as De Stijl before coming to America, in 1926. He began to experiment with abstraction in the late twenties, at about the time he met Arshile Gorky. The two men became close friends and shared a studio in New York in the late thirties. During the thirties, de Kooning painted in several styles, but most important to his development was a series of muted abstractions of biomorphic or geometric shapes and sensitive portraits of friends.

Of the major artists of his generation, de Kooning was the only one to choose the human figure, first male and then female, as his principal theme. In the changes of the image of the woman from the gentle and lyrical *Queen of Hearts*, of the early forties, to the fragmented and violated women of the early fifties, in which slashing, heavily impastoed brushstrokes of paint bind these noisy, big-busted, toothy monsters to the canvas, one can trace both the pictorial and psychological development of the theme. Increasingly, anatomical forms become fragmented, and there is no clear statement as to where the figure exists in space. When first shown, in 1953, the monumental females were attacked by some critics as "vulgar, monstrous, perverse, infantile and horrible and shamefully revealing." Others, who admired them, tended to dismiss the subject matter and concentrated on the paintings' formal properties, especially de Kooning's virtuoso brushwork and his ability to create a picture that looked like it was in the process of being painted. De Kooning disagreed, saying, "The *Women* had to do with the female painted through all ages, all those idols, and maybe I was stuck to a certain extent; I couldn't go on. It did one thing for me: it eliminated composition, arrangements, light—all this silly talk about line, color, form—because that (the women) was the thing I wanted to get hold of."

To some extent, de Kooning's paintings are a direct response to the restless, messy, violent backdrop of the urban environment in which his pictures germinated. De Kooning's paintings describe a state of flux and decay; he described the American city as a "no-environment" in which the human being becomes a "no-figure." This theory partially explains the ease with which his slashing brushstrokes perform radical surgery on the human figure in his paintings.

Beginning with his first one-man exhibition, in 1948, de Kooning gained critical acceptance, and his paintings began to be exhibited at major museums. In the fifties, the slipping planes and open contours of paintings like *Excavation* gave way to denser and more crowded works, in which charged brushstrokes smashed against one another. Rejecting geometric structure, de Kooning announced that "nothing is less clear than geometry." His works consequently became more unstructured. In the late fifties, his wild, colliding strokes, which bear a resemblance to those of Franz Kline, seemed to describe the broad planes of landscape. From these, in the early sixties, de Kooning turned back to figure painting—women, once more, with a delicacy transcending that of his earlier works.

(A.-S.W.)

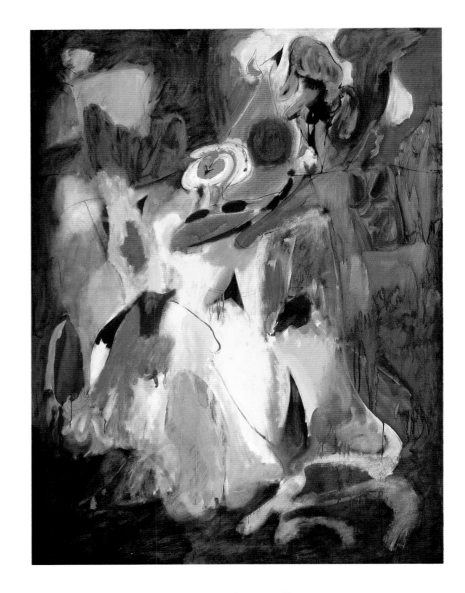

ARSHILE GORKY (b. 1904, Tiflis, Georgia, Russia—
 d. 1948, Sherman, Conn.)

The Artist and His Mother. ca. 1929–1936
Oil on canvas. 60 × 50″
National Gallery of Art, Washington, D.C.
Ailsa Mellon Bruce Fund

ARSHILE GORKY

Waterfall. 1943
Oil on canvas. 60½ × 44½″
Tate Gallery, London

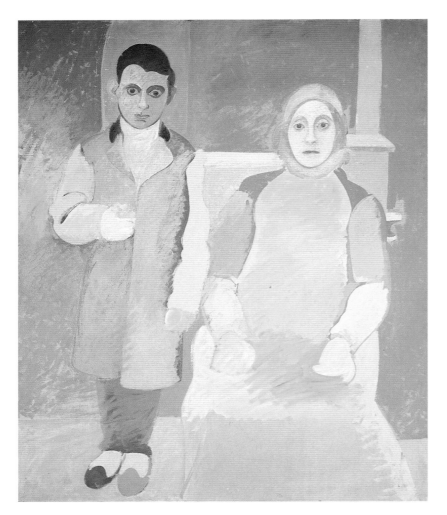

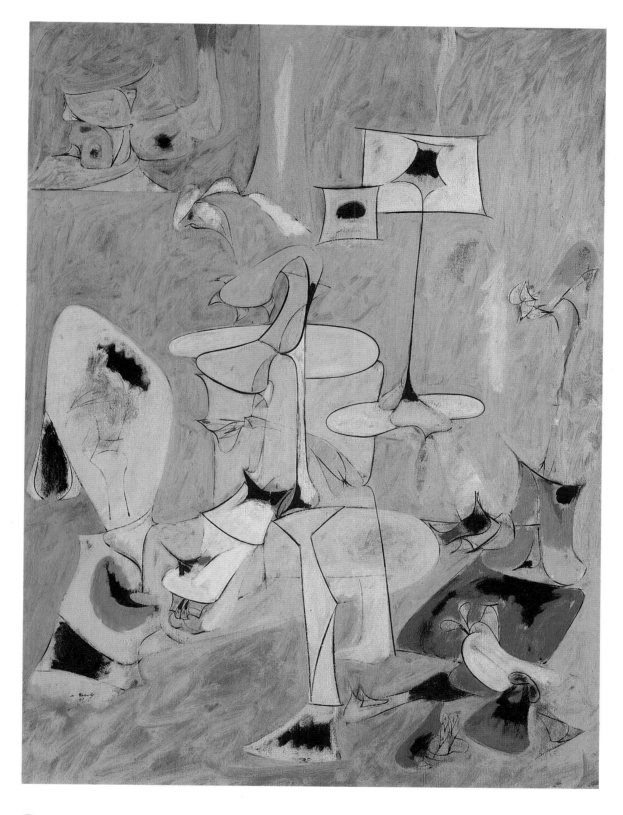

ARSHILE GORKY

The Betrothal, II. 1947
Oil on canvas. 50¾ × 38″
Whitney Museum of American Art, New York City

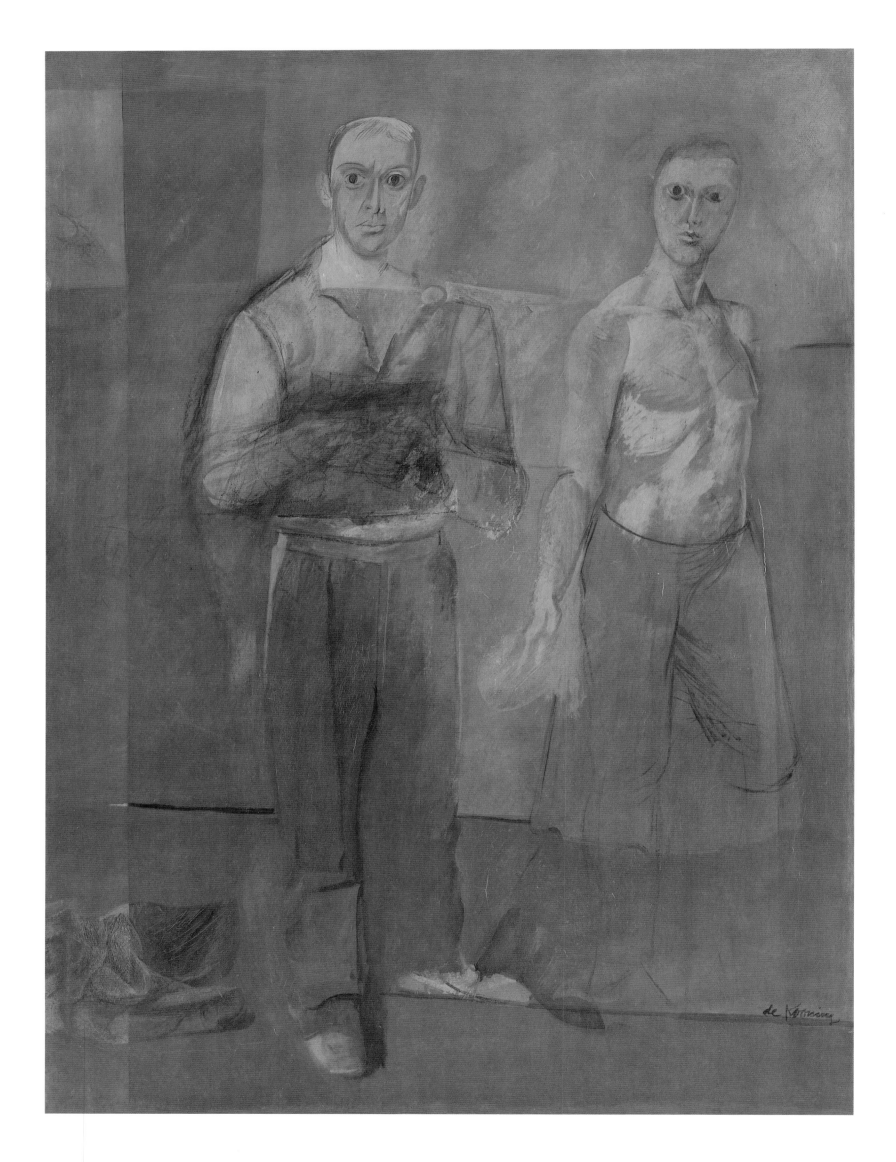

246

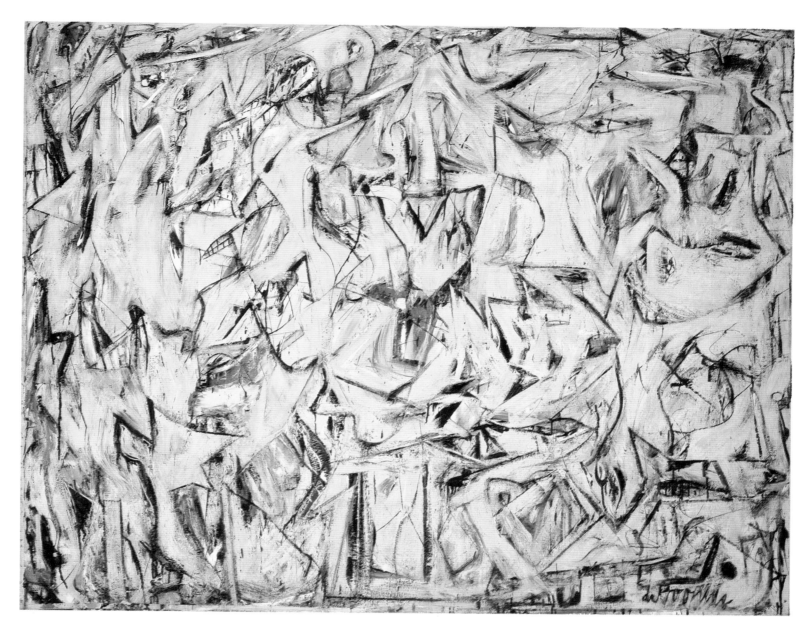

WILLEM DE KOONING

Excavation. 1950
Oil on canvas. 80 × 100″
The Art Institute of Chicago, Chicago
Mr. and Mrs. Frank G. Logan Purchase Prize,
Gift of Mr. and Mrs. Noah Goldowsky
and Edgar Kaufmann, Jr.

WILLEM DE KOONING (b. 1904, Rotterdam, The Netherlands)

Two Men Standing. 1938
Oil on canvas. 61 × 45″
The Metropolitan Museum of Art, New York City
From the Collection of Thomas B. Hess;
Rogers, Louis V. Bell, and Harris Brisbane Dick
Funds and Joseph Pulitzer Bequest

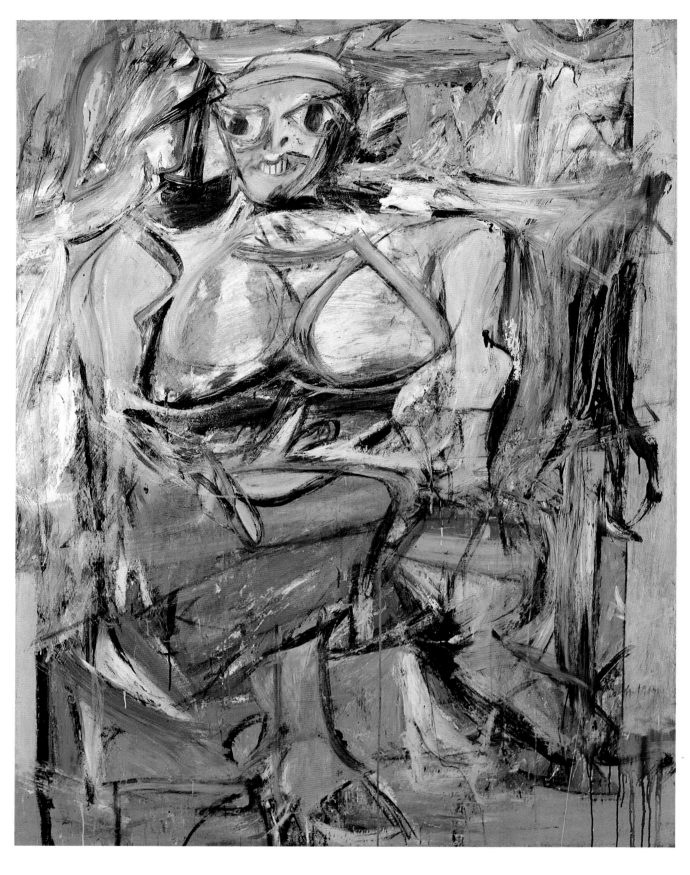

WILLEM DE KOONING

Woman I. 1950–1952
Oil on canvas. 75⅞ × 58″
The Museum of Modern Art, New York City

WILLEM DE KOONING

Untitled III. 1981
Oil on canvas. 88 × 77 1/16"
Hirshhorn Museum and Sculpture Garden,
Smithsonian Institution, Washington, D.C.
Partial gift of Joseph H. Hirshhorn by
Exchange and Museum Purchase

27. Out of the Web: Pollock and Gesture

Sometime during the 1930s, it became an almost sacred principle in American abstract painting to maintain the integrity of the plane, or as critic Clement Greenberg put it, "the constructed, re-created flatness of the surface." Naturalism and illusions of depth were things of the past. Based on the earlier development in Europe of Synthetic Cubism, paintings were organized as units of a flat pattern or grid anchored to the frame. Toward the end of the decade the concept underwent a dramatic metamorphosis in the work of some artists: shapes were replaced by forces, the plane by the field.

In Irene Rice Pereira's *Green Mass* there is no interlocking of planes, yet everything is in the plane, including depth. Various textures are used to dematerialize shapes, giving them the appearance of circuits, terminals, or smaller fields within the larger field. They relate to each other and to the whole, not strictly across the surface as in Synthetic Cubism, but in ways that are impossible to describe, just as the field itself is impossible to describe as a spatial entity. The field is a self-contained unit portraying particular forces. Rather then making the frame its perimeter, Pereira leaves the edges of the painting blank, as though what lies outside this universe were unknowable or at least undefined. Her paintings, like those of the Russian and Bauhaus Constructivists of the 1920s, are metaphors of modern scientific ideas about the physical world, increasingly in the service of metaphysics.

The other way out of the planar trap was, in a sense, psychological, encouraged by the general interest in psychoanalytic theory and aspects of Surrealism and Expressionism introduced in the late 1930s by refugees from Nazism in Europe and by the cult of Picasso. Jackson Pollock was the first perhaps to grasp the possibilities. He began his career with a dour version of rural genre in the manner of his teacher, Thomas Hart Benton. Rapidly he evolved a violent, swirling style, with figures clutching one another in a desperate dance or combat. He seems to have a horror of empty spaces, constantly filling in with shapes and automatic writing and numbers and eyes peering out of the mélange of rhythmic movements. His drawings of this period, known as the "psychoanalytic drawings" because they were done in conjunction with his Jungian analysis, record an interminable repertoire of archetypal grotesques, many in the style of Picasso's *Guernica*, which had arrived in New York in 1939. In a sense, he was already creating fields of energy, their specific meanings obscure but their general meaning about the relationship of the unconscious, particularly Pollock's, to art and creativity obvious. Lines to the "real world" are cut; the planar dimension becomes an increasingly abstract psychological landscape in which spatiality has a different, ungeometric, uncompositional aspect. In these, as in Pereira's theoretical structures and Pollock's later abstractions, activity is clustered within the frame, not tied to it. It exists within an unknown field or, rather, the field of the painting.

Pollock's grotesques and double figures, such as *Male and Female*, developed into multiple, continuous abstract figures in seemingly endless arabesques and then into pure energy in his drip paintings of 1947–50. These seminal works, known as much for their method of execution as for their final appearance, seemingly allowed Pollock to relinquish his demons, attenuating them in layered skeins of paint that represent the

AND FIELD

larger rhythms of nature, its textures, sounds, and smells. Even the titles indicate a change: *Shimmering Substance* is from the "Sounds in the Grass" series leading up to the drip paintings; *Full Fathom Five, Cathedral, Sea Change,* and *Autumn Rhythm* follow, as well as numbered works. In *Out of the Web,* abstract figures reintroduced as cutouts in the canvas are much freer and less tortured in their movements than the early figures. But the web of paint, Pollock's universe, is also a veil or mask, and in 1950 he returned to the figure, in paintings like *The Portrait and the Dream,* more troubled and tragic than ever. The few all-over paintings he did in the half-dozen years before his death in 1956 are equally disturbing in their references to drowning (*Ocean Grayness* and *The Deep*), blinding *(Grayed Rainbow* and *White Light*), and being lost (*Scent* and *Search*).

Lee Krasner arrived at a similar kind of field painting in the same year, 1946, as Pollock, her friend and husband (they were married in 1942). Her paintings are much smaller than Pollock's, and she used a traditional brush rather than his drip method. She is also more concerned with the language and texture of nature (*Continuum*) and culture (the "Hieroglyph" series) than with an expanding psychic field. Even her later, larger paintings (*Vernal Yellow*) still structure the plane in a Cubist way, but they also achieve an extraordinary density of shapes and emotional energy on the surface.

Uniquely among the Abstract Expressionists, neither Krasner nor Franz Kline went through a Surrealist phase. Krasner came out of the studio figural and still-life tradition, and Kline worked in a charming reportorial vein of representation. When Kline moved to abstraction in the late 1940s, it was abruptly and completely—to black and white rather than color, to a structure without drawing, totally composed of oversized, slashing brushstrokes. His abstract imagery is environmental: brawny, industrial, urban. When large enough to be ambient, his paintings are environments indeed. Like the cosmic vistas of Rothko, Newman, and Still, the tangled webs of Pollock, and the figural abstractions of de Kooning and Gorky, Kline's bold abstractions are landscapes, the continuing expression of a tradition that began with Thomas Cole and the Hudson River painters.

IRENE RICE PEREIRA (b. 1907, Boston—
 d. 1971, Marbella, Spain)

Green Mass. 1950
Oil on canvas. 40⅛ × 50″
National Gallery of Art, Washington, D.C.
Gift of Leslie Bokor and Leslie Dame

LEE KRASNER (b. 1908, Brooklyn, N.Y.–
d. 1984, New York City)

Continuum. 1947–1949
Oil and enamel on canvas. 53 × 42″
Alfonso Ossorio Collection
Courtesy of the Robert Miller
Gallery, New York City

LEE KRASNER

Vernal Yellow. 1980
Oil on canvas. 59 × 70″
Museum Ludwig, Cologne,
West Germany

Franz Kline (b. 1910, Wilkes-Barre, Pa.–d. 1962, New York City)

Mahoning. 1956
Oil on canvas. 80 × 100″
Whitney Museum of American Art, New York City

JACKSON POLLOCK (b. 1912, Cody, Wyo.–
 d. 1956, East Hampton, N.Y.)

Male and Female. 1942
Oil on canvas. 73¼ × 49″
Philadelphia Museum of Art, Philadelphia
Gift of Mrs. and Mr. H. Gates Lloyd

JACKSON POLLOCK

*Shimmering Substance (from the Sounds
in the Grass series)*. 1946
Oil on canvas. 30⅛ × 24¼″
The Museum of Modern Art,
New York City
 Mr. and Mrs. Albert Lewin and
 Mrs. Sam A. Lewisohn Funds

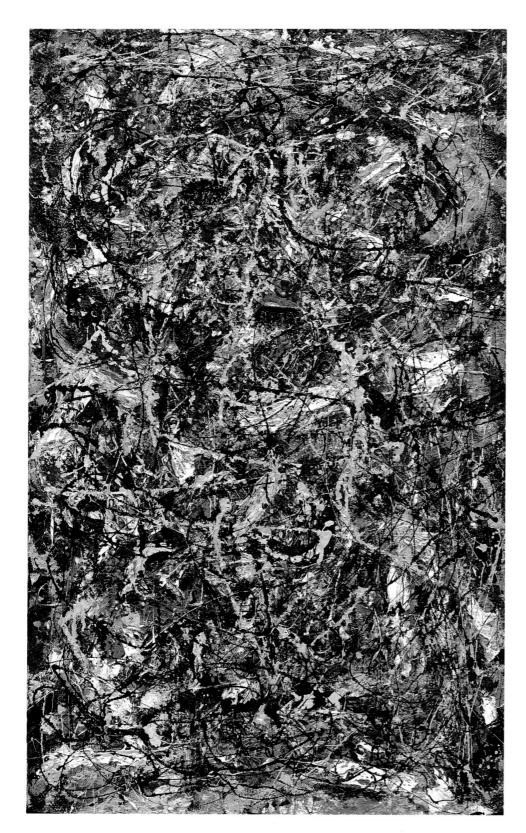

JACKSON POLLOCK

Out of the Web: Number 7. 1949
Oil on canvas. 47¹³⁄₁₆ × 96¹⁄₁₆″
Staatsgalerie, Stuttgart,
West Germany

JACKSON POLLOCK

Portrait and a Dream. 1953
Enamel on canvas. 58⅛ × 134¼″
Dallas Museum of Art, Dallas
Gift of Mr. and Mrs. Algur H.
Meadows Foundation Inc.

JACKSON POLLOCK

Full Fathom Five. 1947
Oil on canvas with nails, tacks,
key, coins, etc. 50⅞ × 30⅛″
The Museum of Modern Art,
New York City
Gift of Peggy Guggenheim

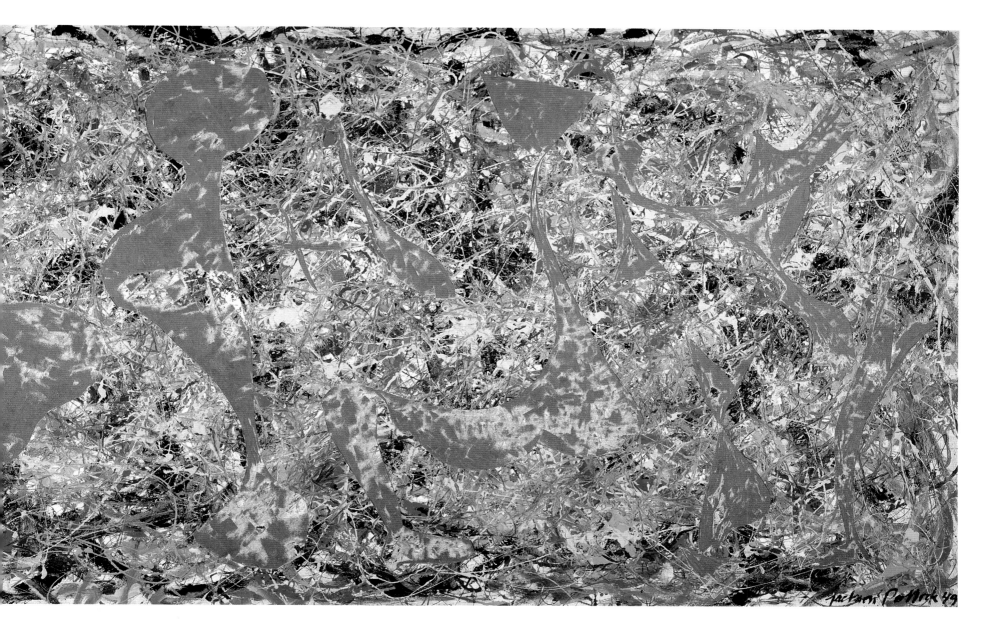

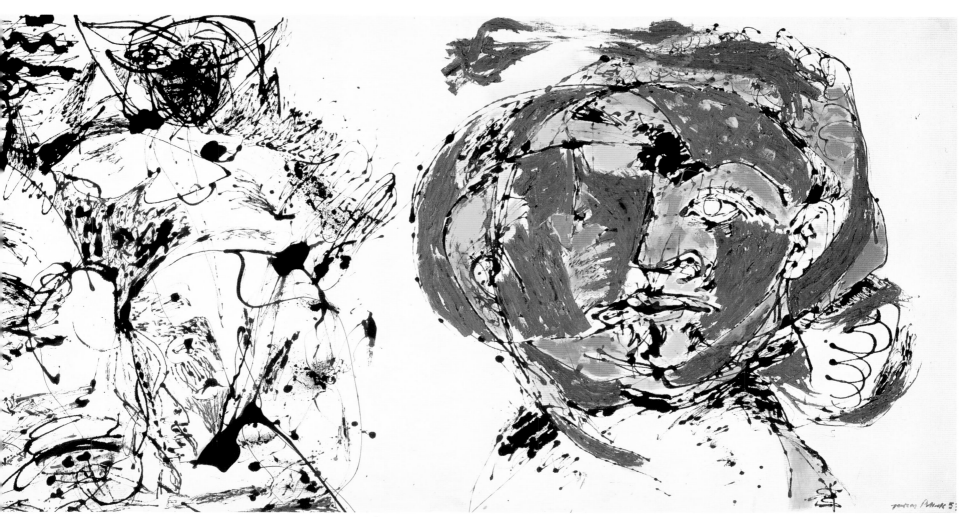

28. REFIGURING ABSTRACT

The emergence of Abstract Expressionism after the Second World War had an unprecedented impact on American art. Despite public derision, many considered the New York School—including Willem de Kooning, Arshile Gorky, Jackson Pollock, Mark Rothko, Barnett Newman, Franz Kline, Clyfford Still, Robert Motherwell, and Adolph Gottlieb—the first original American art movement. Their work seemed to reflect the country's outsize ambition and energy. With growing support from dealers, collectors, museums, and even government agencies during the 1950s, these Abstract Expressionists ushered in American leadership in art, centered in New York City.

It was a great, extended moment, difficult for some to get beyond, as such moments tend to be. But of course, the specifics of Abstract Expressionism—its bigness, its emphasis on the plane of the picture and all-over surfaces, its spontaneous brushwork and galactic spatiality (microcosm and macrocosm)—were either rejected or channeled to new uses almost as soon as the next generation, and in some cases the same or an earlier generation, began to think for itself.

The direction was toward a new kind of serenity and abstract order, as is particularly evident in the work of Agnes Martin, Ellsworth Kelly, Helen Frankenthaler, Joan Mitchell, and Al Held in New York, and Morris Louis, Kenneth Noland, Gene Davis, and Alma Thomas in Washington, D.C. Instead of taking on the entire universe, or even the human psyche, these artists focus on particular processes, patterns, anomalies, nuances of color and shape, and rhythmic energies. Unwilling to be overwhelmed, their work is immersed in nature, alluding to flora and fauna, landscapes, and light.

Martin replaces painterly incident with the perfecting mechanism of the grid, which equalizes relationships and allows meditation to flow without disruption, or which may be the inherent principle of order in the color field. While Martin's grids dissolve the physical, Thomas's emphasize it in patterns that seem visual correlatives of physical laws of motion. Her paintings resemble the surface of a stream, a sky, a group of people: a field that seems both random and inevitable, like the constant flutter of leaves in the wind. Both artists achieve distinctive visions of the interplay between multiplicity and oneness.

Frankenthaler and Mitchell, too, are rooted in the physical world. Both are abstract artists, and yet their paintings seem to represent real places of light, mass, movement, and time rather than worlds within or beyond. Frankenthaler extends the spontaneity of Abstract Expressionism by allowing the paint to act in a way that suggests the mutual fluidity of sky, sea, and land. In her early *Mountains and Sea*, which had an immediate impact on Louis and Noland and then on other painters as well, she used thin washes of color for the first time, allowing the thinned-out colors to create their own perimeters as they soaked into the canvas. Louis and Noland would soon subject this technique to more rigid controls, while Frankenthaler continued to exploit the chance effects and random flowing energies in brilliant conjunctions and layers of both opaque and transparent color forms.

Brushstrokes define Mitchell's paintings the way they do the nineteenth-century landscapes of John Twachtman. Emerging from a white background as though its light

EXPRESSIONISM

had engendered them, these brushstrokes absorb, reflect, or conceal, according to their "moment"—the way they happened, and happen to look. In this respect, they are very much about things that come to pass in time and place, about the intrusion on one's sensibility of every possibility of joy and sorrow.

Al Held began by containing Abstract Expressionism's energy in massive forms: huge letters, for instance, that seemed to strain the picture frame. Later, he introduced interlocking geometric figures, defining space in terms of contradictory illusions. Space is both finite and endless, as it was fathomless in the work of Pollock; Held's geometry emphasizes the contradiction and offers control, and, in 1978, more playfully after he began to use bright and unmistakably artificial colors.

In the work of other artists, refiguring meant an actual return to the human figure. Jan Muller felt that abstraction was no longer enough, and Lester Johnson that action painting had become a cliché. Larry Rivers felt the need as a student to draw the nude model, to record the reality. All three artists fused figuration and abstraction in a way that allowed them to emphasize the timelessness of the latter. Rivers was determined to register those people, events, and relationships that were most powerful in his own life and not to abandon them to the oblivion of nonobjectivity. Incorporating commercial packaging and labels, he was also a precursor of Pop Art. Muller in the last four years of his short life, and Bob Thompson in the last six of his, created mythological landscapes in which there is a strong folk art fatefulness about the way figures are woven into a rhythmic pattern of colored shapes and movements.

A more complete return to figuration and human ethology occurred in the work of Harry Jackson and Alfred Leslie. In his early abstract paintings in New York, Jackson's thought evolved gradually toward archetypal themes, culminating in *The Family* of 1953, which is already essentially a figural landscape. But even after the total transformation to figuration, particularly in *The Italian Bar*, the spirit and dynamics of Abstract Expressionism remained, not only in the panoramic intersection of depth and lateral movement, but also in the powerful integration of figures with each other and their surroundings, suggesting the bonds of social and cultural encoding. In Jackson's later paintings and sculptures, reflecting his long association with the American West, figures and landscapes seem to be infused with an abstract energy and are part of a larger circle that turns through various trials and awakenings between birth and death, sometimes in a single gesture of a horse or its rider.

Leslie's figures emerge into light with unusual clarity and intensity. Like Jackson, Leslie draws on the past, particularly the dramatic lighting and compositions of the baroque and the lucid realism of Copley, but clean outlines, bold modeling, and generalized shapes give his figures and forms an abstract presence that is startling and poignant. They appear in landscapes that are likewise vivid but ghostly; *A View of Sunderland from Mount Sugarloaf*, for instance, seems to exist at an eerie juncture of past and present. The viewer's eye moves back and forth between the picture-postcard view and the ambiguous foreground figure with her empty baby carrier. There is in its focal sense of time and place something that overwhelms the viewer, surprising and hypnotic in its thrust.

ALMA THOMAS (b. 1891, Columbus, Ga.–
d. 1978, Washington, D.C.)

Light Blue Nursery. 1968
Acrylic on canvas. 50 × 48″
National Museum of American Art,
Smithsonian Institution, Washington, D.C.
Gift of Alma W. Thomas

AGNES MARTIN (b. 1912, Maklin, Canada)

Untitled #11. 1977
Graphite and gesso on canvas. 6 × 6′
Whitney Museum of American
Art, New York City
Gift of the American Art Foundation

AL HELD (b. 1928, Brooklyn, N.Y.)

B-G-3. 1978
Acrylic on canvas. 84 × 84″
Virginia Museum of Fine Arts, Richmond
Gift of Sydney and Frances Lewis

LARRY RIVERS (b. 1923, New York City)

The Accident. 1957
Oil on canvas. 82 × 90⅜"
Collection of Joseph E. Seagram
and Sons, Inc., New York City

ALFRED LESLIE (b. 1927, New York City)

A View of Sunderland from Mt. Sugarloaf. 1973
Oil on canvas. 108³⁄₁₆ × 71⅞"
Courtesy of the Claude Bernard
Gallery, New York City

HARRY JACKSON (b. 1924, Chicago)

The Italian Bar. 1956
Oil on canvas. 84½ × 104″
Wyoming Foundry Studios, Cody, Wyo.

HARRY JACKSON

The Family. 1953
Oil on canvas. 89½ × 130″
Wyoming Foundry Studios, Cody, Wyo.

HELEN FRANKENTHALER

HELEN FRANKENTHALER (b. 1928, New York City)

Mountains and Sea. 1952
Oil on canvas. 86⅞ × 117″
Private collection
On loan to the National Gallery of
Art, Washington, D.C.

Nature Abhors a Vacuum. 1973
Acrylic on canvas. 103½ × 112½″
Private Collection
Courtesy of the Andre Emmerich
Gallery, New York City

JOAN MITCHELL (b. 1926, Chicago)

Stretch. 1989
Oil on canvas. Diptych: 94½ × 157½″
Courtesy of the Robert Miller Gallery,
New York City

JAN MULLER (b. 1922, Hamburg, Germany–
 d. 1958, New York City)

Jacob's Ladder. 1958
Oil on canvas. 83½ × 115″
Solomon R. Guggenheim Museum, New York City

Bob Thompson (b. 1937, Louisville, Ky.–d. 1965, Rome)

An Allegory. 1964
Oil on canvas. 48 × 48"
Whitney Museum of American Art, New York City
Gift of Thomas Bellinger

29. California's Other

Almost as soon as Abstract Expressionism became entrenched in the vibrant art scene of San Francisco during the late 1940s, it was opposed by painters who had been among its principal young practitioners. David Park, the oldest of them, was the first to turn from what he felt was the rhetorical egocentricity of the movement. His bold figurative paintings of 1950 were at first ridiculed by those who had already established an orthodoxy of abstraction. But gradually others joined him, notably Elmer Bischoff in 1952 and Richard Diebenkorn in 1955. Their work and teaching formed the foundation for Bay Area Figurative Painting, though none of them used the term.

For Park, Bischoff, and Diebenkorn, Abstract Expressionism had become an empty style, with undefined and unattainable goals. Bischoff expressed it as a loss of faith: "If one has cooled off with the Abstract Expressionist idea, meaning that one no longer believes in it as a language, then no one any longer believes in its communicative potential." But there was also a positive need to embrace objective reality—figures, interiors, landscapes, still lifes—without abandoning the spontaneity and primal energy of Abstract Expressionism. The monologue was replaced by a dialogue in which the abstract emotive power of the earlier movement was applied to perceptions of the physical world.

The departure from Abstract Expressionism is apparent in the treatment of light. The inner visions of Rothko, Newman, Pollock, and other New York artists evoke a generalized, unifying light that seems to come from another realm. In the paintings of Park, Bischoff, and Diebenkorn, the light is natural, though it also imbues color with a preternatural intensity. These are not scenes that exist somewhere between dream and reality, mind and body; they are totally of this world. Yet in their abstraction, distortion, and materiality, they just as obviously belong to the world of paint. Park remarked that in his representational works he was making pictures rather than paintings, but in fact he was doing both.

All the Bay Area painters turned to what was around them—figures on the beach, still lifes, suburban interiors, and a variety of landscapes—typical California scenes filled with California light. Their aim was to create universal figures and spaces, free of regional identification, but a sense of location is unmistakable—even in Bischoff's and Diebenkorn's work from the late 1960s on, which essentially returns to pure abstraction.

Despite their lack of specificity, human figures are powerfully present in the work of both Park and Bischoff. Rudely brushed nudes, like human totems, increasingly dominate Park's paintings of the late 1950s. Bischoff's work involves a greater degree of integration and interaction. Figures are catalysts for forces within the landscape. The nude woman at the center of *Two Figures at the Seashore* is split down the middle by a shadow that defines the painting's asymmetry. In her powerful and mysterious countenance, she focuses the maelstrom of colors, shapes, and brushstrokes around her. The space is charged with shimmering surfaces and contrasts of dark and light, hot and cool, contour and field. Later landscapes, interiors, and abstractions would become even more integrated as coloristic and gestural dramas, reminiscent of John La Farge's subtle landscapes a century earlier and of the intense expressionism of the Norwegian painter Edvard Munch.

LIGHT

Human figures play a less expressionistic, more architectural role in Diebenkorn's paintings of this period. Like some of Edward Hopper's figures, they appear to be ciphers in the overall structure of the picture space, just as the houses, streets, shadows, and plots of ground in *Cityscape (Landscape No. 2)* are elements in a scheme that otherwise seems quite abstract. Diebenkorn would carry the vertical plotting of this work into the abstract "Ocean Park" series of paintings and drawings that has occupied him since 1967, when he moved to Los Angeles.

Paradoxically, from the moment Diebenkorn returned to figurative painting in 1955, he began working toward the abstract idea of painting as a balanced arrangement of color planes, arrived at intuitively. His most consistent and compelling model in this was not Hopper but the French master Henri Matisse, to whom Diebenkorn's work pays homage in numerous ways. Visual reality provided a general outline or pattern, as it did in the more celebratory and sensual art of Matisse, but beyond that the picture is a matter of refinement and adjustment on the canvas. Ultimately, Diebenkorn's variety of views—of still lifes, interiors, landscapes—became a single view through the window of his Santa Monica studio, on which the variations of the "Ocean Park" series are based.

While Park, Bischoff, and Diebenkorn were establishing distinctive new directions in the 1950s, Wayne Thiebaud, working in San Jose and Sacramento, was just beginning to paint at the age of thirty, after several years as a cartoonist, illustrator, and designer. Though not part of the early Bay Area group, Thiebaud was profoundly influenced by Diebenkorn's structural refinement and mundane subject matter. Unlike Diebenkorn, however, Thiebaud is fascinated with the objects and figures that make up the composition, with how everyday things look that have never before and will never again exist—cakes, ties, shoes, and ice cream cones. For this reason he has been associated with and cited as a precursor of Pop Art in New York. But his interest is less in the cultural meaning of such objects than in their beauty, in the possibility of describing them in paint. Thiebaud recreates them as almost sculptural forms in thick impastos of paint that describe their essential shapes and subtle patterns of color in light. In later works, he expands his vision to landscapes, particularly the vertiginous hills of San Francisco, which in many respects resemble Diebenkorn's vertical views. But, as in all of Thiebaud's work, there is a sense of surprise and animation that contrasts sharply with Diebenkorn's more ordered and less revealing universe.

271

ELMER BISCHOFF (b. 1916, Berkeley, Calif.)

Two Figures at the Seashore. 1957
Oil on canvas. 56 × 56¾″
Newport Harbor Art Museum, Newport Beach, Calif.
Purchased by the Acquisition Council with a Matching
Grant from the National Endowment for the Arts

WAYNE THIEBAUD (b. 1920, Mesa, Ariz.)

Delicatessen Counter. 1962
Oil on canvas. 30¼ × 36¼″
Menil Collection, Houston, Tex.

WAYNE THIEBAUD

Corner Apartments (Down 18th Street). 1980
Oil and charcoal on canvas. 48 × 35⅞″
Hirshhorn Museum and Sculpture Garden, Smithsonian
Institution, Washington, D.C.
Museum purchase with funds donated
by Edward R. Downe, Jr., 1980

RICHARD DIEBENKORN (b. 1922, Portland, Or.)

Cityscape I (formerly Landscape I). 1963
Oil on canvas. 60¼ × 50½″
San Francisco Museum of Modern Art, San Francisco
Purchased with funds from trustees and friends
in memory of Hector Escobosa,
Brayton Wilbur, and J.D. Zellerbach

30. Facts and Ambiguity

Abstraction abruptly assumes the shape of reality in the works of Robert Rauschenberg, Cy Twombly, and Jasper Johns. Rothko's transcendent clouds of color become Rauschenberg's *Bed*, Pollock's shimmering depths become Johns's flags and targets, and the spontaneous brushwork of Abstract Expressionism (or perhaps Surrealist automism) becomes Twombly's handwriting. Grand vistas are replaced by opaque surfaces, grand subjects by mundane objects. It is much easier to comprehend, much more difficult to understand.

An intense form of transference takes place. What the artist knows he puts into his work. But for what one knows there is already an existing language of words, signs, symbols, shapes, formulas, whole treatises, whole poems, whole paintings, whole bodies of belief and knowledge that can, presumably, describe and penetrate anything and everything. Yet the artist is forced to recognize that the systems that enable him to form a picture and to think coherently cannot define how he himself uniquely thinks or feels or even how he pictures himself and everything outside himself. There is an ambiguity. What gets put into the art is the process of knowing, or the idea, the difficulty, the hope, the futility of knowing.

Twombly is perhaps clearest, if that word applies, about the process. His inspiration, usually classical literature, art, or mythology, would seem further from his expressionistic style than any other cultural source, but it was the ancient Greeks who formulated the notion of Chaos, the confusion of matter out of which all life arises. And the classical world exists in the present world: Rome, where Twombly has lived since 1957, is a city of layers whose surfaces have been scratched and worn for thousands of years. What remains of the earlier world are voices that pierce veils of accumulated human knowledge and experience.

Twombly's paintings and drawings are acts of criticism beyond analysis, depiction, or re-creation. The story of Leda and the Swan, Raphael's *The School of Athens*, Keats's *Hyperion*, the figure of the Latin poet Virgil, or a tree or a mountain already exist: they are givens we use to make sense of the world. They contain mistakes, contradictions, anomalies, inconsistencies, exaggerations, and bursts of energy that, in fact, cannot be accounted for. Twombly makes equivalents that begin to duplicate. He introduces grids, words, numbers, and shapes, but soon veers into elusiveness and complex shifting. What remains is the signature of the artist, his handwriting, which also cannot be duplicated, and serves as witness to the formation of consciousness.

Jasper Johns is also "interested in things which suggest things which *are* rather than in judgments." But in his work they are "pre-formed, conventional, de-personalized, factual, exterior elements"—the American flag, targets, numbers, names of colors, utensils, and other disinflected objects. He, too, is concerned with the wholeness of a thing, remaining within the boundaries of knowledge, yet his enterprise is about what is not known. His number paintings are entirely self-contained in both their grid-system and telescoped versions. The four panels of *Untitled* (1972) seem to be variations of the same pattern with different images, and some sequential paintings end at the right edge where the left edge begins. Instead of space he presents absolutely opaque surfaces—

the flag, the target covering, false masonry walls, cross-hatch patterns, the skin of the body. Images are cast into and hidden in the skin as though to hold them in the immediacy of the surface. There are references to looking for what lies beneath the surface—mirrors, flashlights, doors, and drawers that open in the painting—and warnings about doing so, for instance, the Swiss avalanche sign with death's head in *Racing Thoughts*.

For one who stresses depersonalization, Johns is the most personal of artists. The more elusive his preoccupations, the greater one feels their presence. His nonillusionary space is completely his own, and one feels its enclosure. Johns's method is seductive. The flags, targets, and other single-focus early paintings elicit an almost involuntary response: a salute to the flag, a shot at the target, and other actions by the viewer. Beautiful and sensual encaustic surfaces (Abstract Expressionism tamed) and collaged newspapers under the surface invite closer contact with the work, immersion in its secrets. Later, the ambiguous presence of the artist becomes more evident—in body parts, profiles, a souvenir plate, and whole environments, for instance, his studio, imprinted on the canvas. *Racing Thoughts* places artist and viewer in the intimacy of Johns's bathtub, surveying images of brooding peril puzzled together on the facing wall above the faucet. The painting has become an opaque reflecting device of the mind.

Robert Rauschenberg is the ultimate incorporator of "fact." He was the first to use imprints of real things in his work: a nude female figure on photographic paper, a tire track (done with the composer John Cage). Then he reversed the process of collage and used whole large objects as surfaces for his paint, rather than small fragments to enliven a painting. *Bed* was done on his own quilt, sheets, and pillowcase around the time his friend Johns was painting his first flags and targets. A long series of "combines" followed, in which he used photographs, postcards, suitcases, street signs, ironing boards, window frames, and a variety of stuffed animals, including an Angora goat and an eagle. Everything is life-size and assertively in the viewer's space, both as art and as evidence of a larger reality. Paint is applied in expressionistic slashes that pull together disparate and unredeemed objects with a furious energy.

Later, he silk-screened on various surfaces photographs he himself took in the city or appropriated from newspapers, magazines, and books. This enabled him to pull even more sources into the work. Unlike Johns, who strives to conceal and reveal things at the same time, Rauschenberg wants to show everything, to have an impact, to bring everything into the process, to create a sense of merger and possibility. Art becomes the site of struggle, politics, disaster, human achievement, international communication. He overwhelms ambiguity with his recitations of unambiguous facts.

ROBERT RAUSCHENBERG (b. 1925, Port Arthur, Tex.)

Bed. 1955
Combine painting; oil and
pencil on pillow, quilt, sheet, on
wood supports. 75¼ × 31½ × 8″
The Museum of Modern Art, New York City
Fractional gift of Leo Castelli in
honor of Alfred H. Barr, Jr.

Robert Rauschenberg

Soundings. 1968
Silk-screen on Plexiglas with electronic equipment.
36′ long
Museum Ludwig, Cologne, West Germany

CY TWOMBLY (b. 1929, Lexington, Va.)

The Italians. 1961
Oil, pencil, and
crayon on canvas.
78⅝ × 102¼″
The Museum of Modern Art,
New York City
Blanchette Rockefeller Fund

JASPER JOHNS (b. 1930, Augusta, Ga.)

Flag. 1954–1955
Encaustic, oil, and collage
on fabric mounted on
plywood. 42¼ × 60⅝″
The Museum of Modern Art,
New York City
Gift of Philip Johnson in
honor of Alfred H. Barr, Jr.

OPPOSITE:
JASPER JOHNS

Target with Plaster Casts. 1955
Encaustic on canvas with
plaster cast objects.
51 × 44 × 3½″
Courtesy of Leo Castelli
Gallery, New York City
Collection of Mr. Leo Castelli,
New York City

JASPER JOHNS

Untitled. 1972
Oil encaustic and collage on canvas. 72 × 192″
Museum Ludwig, Cologne, West Germany

JASPER JOHNS

Racing Thoughts. 1983
Encaustic and collage on canvas. 48 × 75⅛″
Whitney Museum of American Art, New York City
Purchase, with funds from the Burroughs Wellcome
Purchase Fund, Leo Castelli, the Wilfred P. and
Rose J. Cohen Purchase Fund, the Julia B. Engel
Purchase Fund, the Equitable Life Assurance Society of
the United States Purchase Fund, the Sondra and
Charles Gilman, Jr. Foundation, Inc., S. Sidney Kahn,
The Lauder Foundation, Leonard and Evelyn Lauder
Fund, the Sara Roby Foundation, and the Painting
and Sculpture Committee

31. Pop and Media Art

In the 1960s, a number of American artists began to admit images from the commercial culture and mass media into their work. Pop Art had already been proclaimed in London, during the late 1950s, by the painter Richard Hamilton and others, but it was in the United States that Pop flourished, perhaps because mass-produced images so dominate everyday American life. Pop is neither abstract nor realistic; its practitioners play with the formal elements of twentieth-century modernism, but with images that are unavoidably familiar. They coopt popular culture's images, recoding them within a fine-art format to both undercut and multiply their meanings. Pop is not merely an art of imitation or quotation. By lifting symbols of consumption out of their conventional context, Pop artists make us think about the very nature of information and communication—about everything from commercials and comic strips to soup cans and assassinations—in our mass communications–saturated society.

Andy Warhol's silk-screened images of Marilyn Monroe and Mao have become as famous as Monroe and Mao themselves. Warhol perfected the use of repetition and variation. In his huge Mao, the icon-like image is twice-removed from the original: the picture manipulates the photo of the historic human being—a gigantic photo that was used with great impact upon masses of people. Often Warhol's choices involve some tragedy made public because of the glamour of the person involved. We see Marilyn Monroe over and over—as if to say *ad infinitum*—thus mythologized by Warhol just as she had been continually mythologized over the years by the mass media. He gives us Jacqueline Kennedy, wearing a pink pillbox hat, in the news photo that became the banal repicturing of her grief. It hints of the unreality of our culture, as we are presented with what is larger than life, but through an incessant repetition that makes the woman's grief, the public's capacity to share in it, and, accordingly, our culture's true value system ambiguous or questionable.

Roy Lichtenstein's favored emblems of banality are comic strips and fine art translated into magnified Benday dots, the dots that are part of the mechanical process of reproducing pictures in newspapers and magazines and of filling in the colors of comic strips. Lichtenstein is commenting on the nature of invention even as he makes us consider the implications of a system that treats Mickey Mouse and Picasso as equals.

James Rosenquist's mature techniques derive from his early work painting billboards. In flat, large areas of bright color, he fractures his images, warping their scale, creating vertiginous transitions. A pair of lips as big as a tire, a tube of lipstick as big as a rocket: by upsetting our sense of scale, Rosenquist dramatizes the distortion of images—and, by extension, of values—in which we passively participate.

Both Jim Dine and Tom Wesselman construct assemblages that make us think twice about our industrial world. Dine affixes workbench-variety tools to painted

surfaces and juxtaposes a painting of a robe with a genuine axe. In Wesselman's mixed-media compositions with flatly painted nudes, especially the "Great American Nudes" series, fragmented and impersonal figures reside in mass-produced designer-color interiors, often stocked with Coca-Cola or Ballantine beer.

Pop Art's pioneers, in the early 1960s, had a common purpose: to raise our perception of the impact of signs and messages that we have come to take for granted. Defying the attitude that high art cannot concern itself with modern mass culture, they observed the crossover with a wit that is both deadpan and outrageous.

(B.C.)

ROY LICHTENSTEIN (b. 1923, New York City)

Drowning Girl. 1963
Oil and synthetic polymer paint
on canvas. $67\frac{5}{8} \times 66\frac{3}{4}$"
The Museum of Modern
Art, New York City
Philip Johnson Fund and gift of
Mr. and Mrs. Bagley Wright

ROY LICHTENSTEIN

Preparedness. 1969
Oil and magna on canvas. $10 \times 18'$
Courtesy of the Leo Castelli Gallery,
New York City

ROY LICHTENSTEIN

Reflections: Nurse. 1988
Oil and magna on canvas. 57¼ × 57¼"
Courtesy of the Leo Castelli Gallery, New York City

ANDY WARHOL (b. 1930, Philadelphia–d. 1987, New York City)

Big Torn Campbell's Soup Can (Vegetable Beef). 1962
Acrylic silk-screen on canvas. 72 × 59 ¹⁵⁄₁₆″
Kunsthaus Zurich, Switzerland

ANDY WARHOL

Red Disaster. 1963
Silk-screen on linen. 93 × 80¼″
Museum of Fine Arts, Boston
Charles H. Bayley Picture and Painting Fund

ANDY WARHOL

Marilyn Monroe Diptych. 1962
Oil on canvas. 82 × 114″
Private collection
Courtesy of the Leo Castelli Gallery, New York City

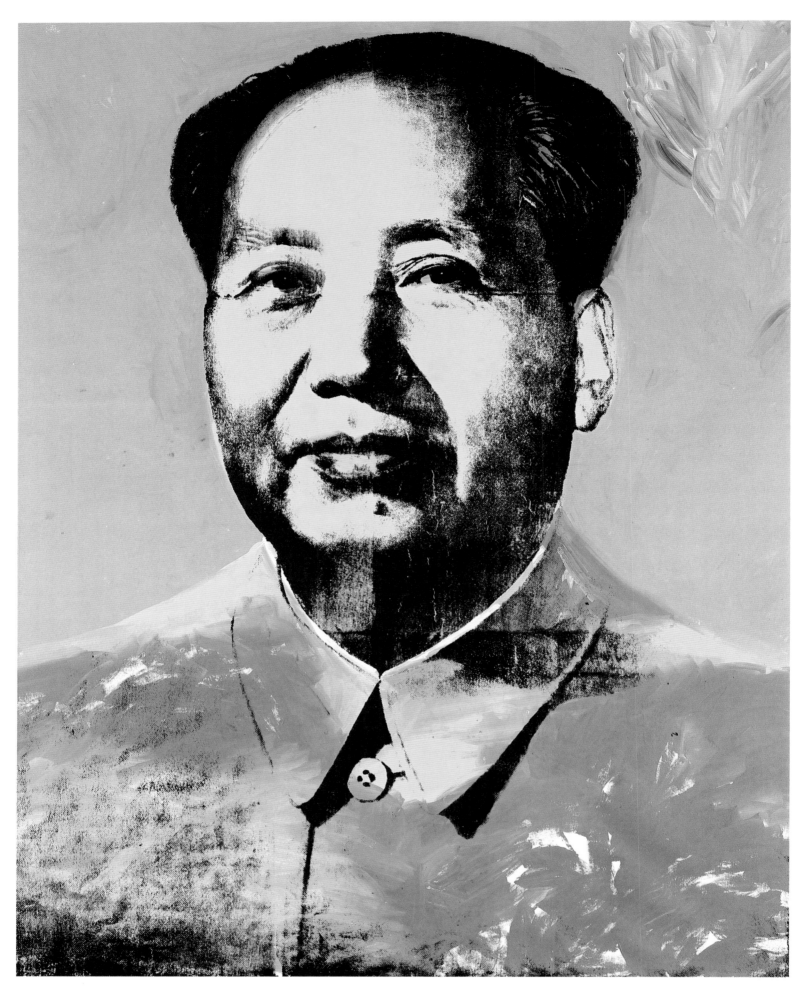

ANDY WARHOL

Mao. 1973
Acrylic and silk-screen on canvas. 16 × 8′
The Metropolitan Museum of Art, New York City
Gift of Sandra Brandt

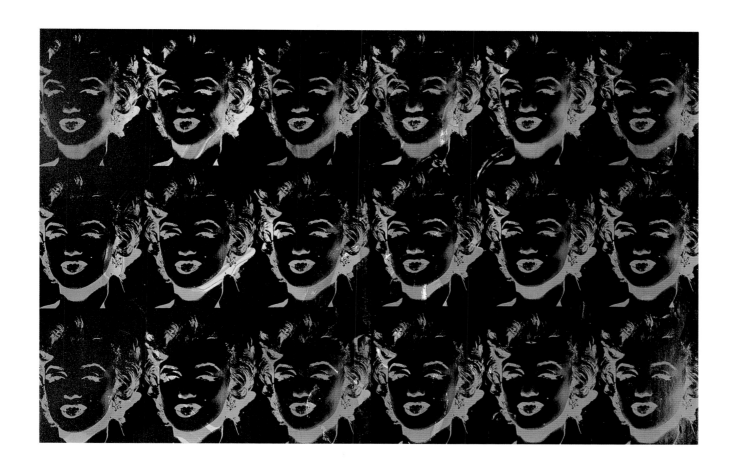

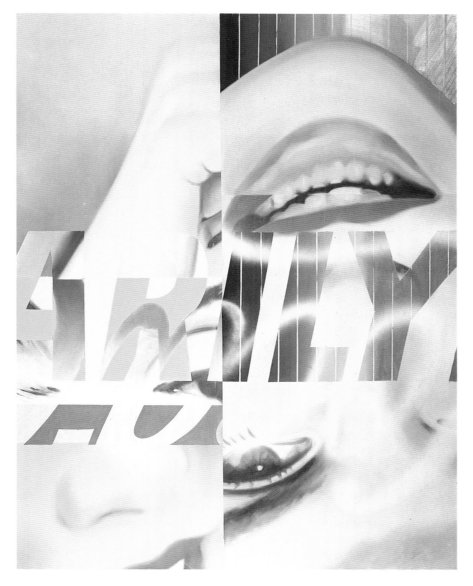

ANDY WARHOL

18 Multicolored Marilyns (Renewal Series). 1979–1986
Acrylic and silk-screen on canvas. 54½ × 82¹¹⁄₁₆″
Courtesy of Bruno Bischofberger, Zurich, Switzerland
Private collection

JAMES ROSENQUIST (b. 1933, Grand Forks, N.D.)

Marilyn Monroe I. 1962
Oil and spray enamel on canvas. 93 × 72¼″
The Museum of Modern Art, New York City
Sidney and Harriet Janis Collection

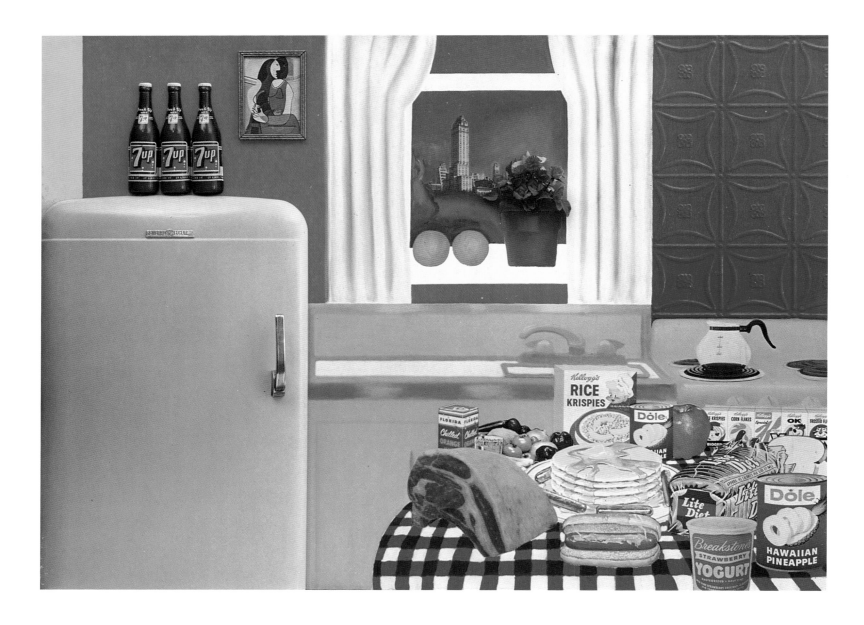

TOM WESSELMAN (b. 1931, Cincinnati, Ohio)

Still-Life Painting, 30. 1963
Assemblage: oil, enamel, and synthetic
polymer paint on composition board with
collage of printed advertisements, plastic artificial
flowers, refrigerator door, plastic replicas of
"7-Up" bottles, glazed and framed color
reproduction, and stamped metal. $48\frac{1}{2} \times 66 \times 4''$
The Museum of Modern Art, New York City
Gift of Philip Johnson

JIM DINE (b. 1935, Cincinnati, Ohio)

Five Feet of Colorful Tools. 1962
Oil on unprimed canvas surmounted by a board
on which thirty-two painted tools hang on hooks.
Overall, $55\frac{5}{8} \times 60\frac{1}{4} \times 4\frac{3}{8}''$
The Museum of Modern Art, New York City
Sidney and Harriet Janis Collection

JIM DINE

Cardinal. 1976
Oil on canvas. 108 × 72″
Sydney and Frances Lewis Collection, Richmond, Va.

32. REALISMS AND

Something like the convergences of Luminism more than a century earlier, a number of artists in the 1960s arrived, by various routes and for various reasons, at a realism of great clarity and detailed surface. In the wake of Abstract Expressionism, many who had been trained as abstract painters duly sought other paths. They had several models. Many had never abandoned figuration, and others—including Larry Rivers, Harry Jackson, and Alfred Leslie—had already returned. Jasper Johns and Robert Rauschenberg used figurative elements, and Pop artists introduced a new iconography using images from the mass media and consumer objects. The spell of abstract painting, in other words, had already been broken.

But why the extraordinary devotion to precision in rendering the material world? Why did these painters return to the given in such an extreme way? Perhaps they carried realism to the nth degree because Abstract Expressionism had gone so far in the opposite direction. In the 1920s, Charles Sheeler and the other Precisionists, taking their cue from Cubism, emphasized the formal, planar construction of the painting as an analog of modern industrial architecture. The new realists, like the Abstract Expressionists before them, conceived of the painting as a unified field carrying as much information as possible on its surface—objective information, rather than subjective, though the result may be profoundly personal or as profoundly impersonal. The intermediary in most cases is the photograph, which picks up, on a flat surface, what it is exposed to, providing a comprehensible contemporary version of reality, one that gives an all-inclusive order to the world.

The methods and results of work in this vein couldn't be more different. Malcolm Morley almost always paints pleasant, colorful, sometimes exotic views based on postcards, snapshots, and travel posters. In his early work he renders picture-perfect scenes of civilized life and culture—ocean liners, sporting events, Old Master paintings—but copying them upside down in some cases, to ensure his impartiality, his dedication to simply making a painting. Eventually, the thin veneer of this placid world and the restrained, workmanlike approach are subverted in a series of disaster paintings whose vigorous brushwork and distortion belong to expressionism at the opposite end of the spectrum.

In his huge portrait heads, Chuck Close translates the photograph of a human face onto a grid, working square by square. The sum total of the marks across the canvas amounts to a portrait, but, like a computer printout, remains an abstract pattern, a mathematically derived approximation of the human face. The very essence of a finite image, it also represents a collision between or the merging of subject and artist, whose genetic imprint is carried in each mark.

Human figures in Richard Estes' paintings are only suggested: in *Central Savings*, for instance, they are mere reflections in the bank's window. Though a city is partly defined by the density of its population, one hardly notices the absence of human beings, possibly out of the urban habit of ignoring them. Estes presents the city as a complex structure of solid and reflective façades that simultaneously plunge into space and refer back to the surface of the painting. Like other Super-realists, he also uses photographs but

Unrealisms

alters images to create intricate designs that confound the viewer's sense of space.

Audrey Flack's paintings are saturated with color, form, time, history, and feminine sensuality. Unlike most realists of the period, she is committed to the emotional, historic, and symbolic content of photographs as a source. Her early paintings are based on photos, such as one of John F. Kennedy in the Dallas motorcade minutes before he was shot. Her later still lifes, such as *Queen*, are set up in dense groupings, photographed, and then translated on canvas. Objects are boldly brought together in a shallow plane extending in front of and behind a neutral gray border. Their redolent colors and shapes—a rose, photos of mother and daughter, a watch, a mirror, a playing card—reverberate in a pattern of intense emotional association.

Janet Fish's still lifes similarly reverberate. Colors reflect from one object to another, linked in a highly charged field of light. Through color, objects relate, like people in intimate conversation. They are both in the world and part of something larger; indeed, Fish's early groupings of reflective glasses were followed by more complex arrangements of vases, flowers, books, and other objects that also open out into landscapes and family tableaux. The still life is the still center of life.

Gregory Gillespie's realism transforms things—walls, fruits, bodies, faces, trees, the paint itself—into textures, figures, objects, and various specters that live in the substance of the painting's space. In many works, photographs are collaged into the surface and then painted over as an almost talismanic way of incorporating and exposing the image's and the subject's spirit, its repressed inner life. In *Still Life with Watermelon*, the watermelon becomes a human organ—a brain or a placenta, perhaps, and thus a center of consciousness (or unconsciousness) that holds images that are either threatening or reassuring. Since the early 1960s, Gillespie has treated reality as a window that looks both inward and outward.

AUDREY FLACK (b. 1931, New York City)

Queen. 1976
Acrylic on canvas. 80 × 80″
Courtesy Louis K. Meisel Gallery,
New York City

MALCOLM MORLEY (b. 1931, London)

*SS Amsterdam in Front
of Rotterdam*. 1966
Acrylic on canvas. 62 × 84″
Courtesy of the Saatchi
Collection, London

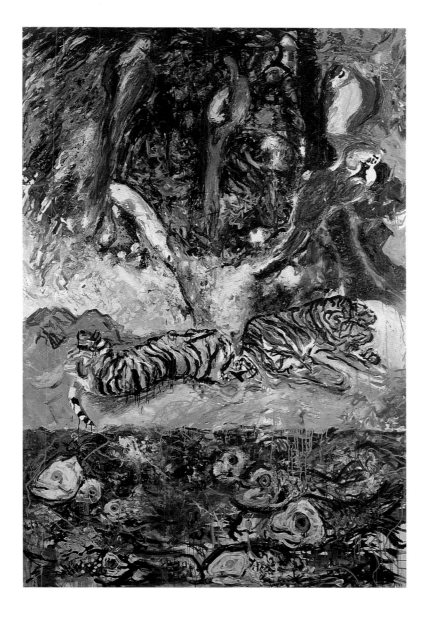

MALCOLM MORLEY

Macaws, Bengals, with Mullet. 1982
Oil on canvas. 120 × 80″
Courtesy of the Saatchi Collection, London

GREGORY GILLESPIE (b. 1936, Roselle Park, N.J.)

Still Life with Watermelon. 1986–1987
Mixed media. 84 × 57″
La Jolla Museum of Contemporary Art, La Jolla, Calif.
Courtesy of the Forum Gallery, New York City

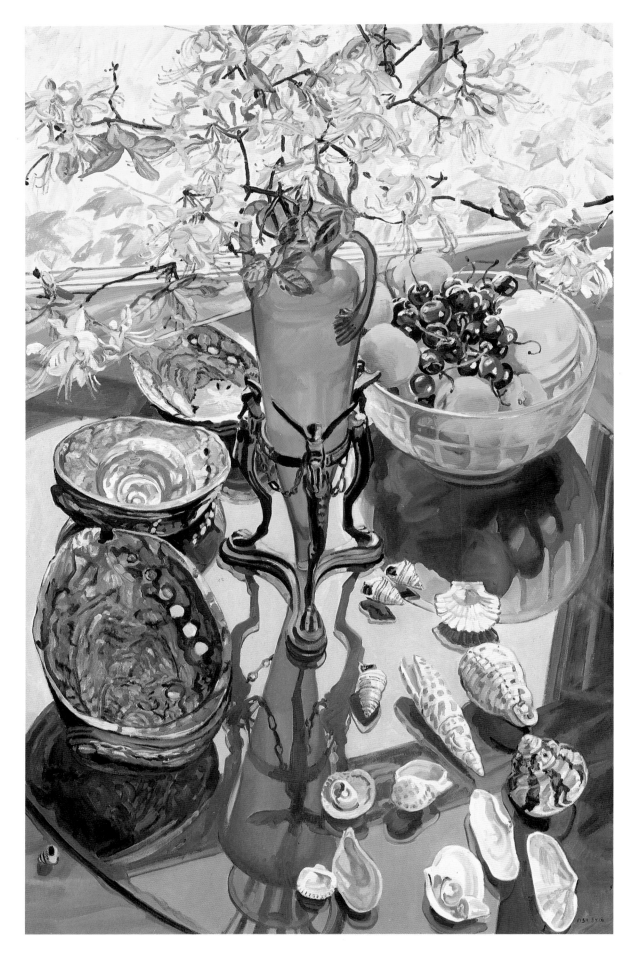

JANET FISH (b. 1938, Boston)

Hunt's Vase. 1984
Oil on canvas. 58 × 36″
Courtesy of the Robert Miller Gallery, New York City

RICHARD ESTES (b. 1936, Evanston, Ill.)

Central Savings. 1975
Oil on canvas. 36 × 48″
Nelson-Atkins Museum of Art, Kansas City, Mo.
Gift of the Friends of Art

CHUCK CLOSE (b. 1940, Monroe, Wash.)

Lucas. 1986–1987
Oil and pencil on canvas. 100 × 84″
The Metropolitan Museum of Art, New York City
Purchase, Lila Acheson Wallace Gift and Gift of
Arnold and Melly Glimcher, 1987

33. THE PLANE OF SPACE, SELF, AND BEING

The plane of the painting has always been a real place where the ideational and perceptual worlds intersect to form illusion (window or mirror), icon (image), and space idea (structure), and where the artist, and therefore the viewer, projects through to another reality. Looking at a picture, one must accept its reality not simply as a picture, as representation, but as randomness imagining coherence.

Duchamp redirected aesthetic experience beyond the predominantly visual, creating the picture plane literally as a window in *The Large Glass*, as a door in *Etant donnés*, as a box to be opened in several works. Jackson Pollock made himself part of the picture by standing within it to scatter paint, and indeed footprints, cigarette butts, and other incidental objects sometimes remained part of the picture; evidence of the artist's emotional and conceptual energy is thus embedded in layers of gesture and space. Rauschenberg's *Bed* is an actual embedment, a placement of the whole person in the picture, and Jasper Johns traps signs and systems from the gray indeterminacy of the past in abstract fields or walls.

In retrospect, Frank Stella's early "pinstripe" paintings, with their regular white lines on a black field, cleared the circuitry, eliminating all incident so that the boundaries and viability of the field could be explored and established. Each successive series of paintings added something new, extending but also creating additional boundaries. The series after the early stripe paintings, including *Gran Cairo*, introduced color in striped test patterns. Later series added intersecting geometric shapes, protractor shapes, hot colors, earth colors, gestural brushstrokes, French curves, a variety of materials, and surfaces, optical cones—a phenomenological dictionary of motifs and techniques that seems to encompass all the possibilities of abstract painting. Titles are also in series (New Hampshire towns, Polish synagogues destroyed in the 1930s and 1940s, Brazilian place names, exotic birds, etc.), suggesting a parallel, without making the connection, between Stella's abstract universe and the living world.

The early minimalism of Arakawa was also a starting point, but to open up the plane rather than restrict it to known quantities. In an extraordinary conflation of text and space, the basic image is that of a book, at first in the form of an empty spread of "pages" defined only by corner registration marks. The possibilities of knowing lie within the marks within the frame, between one mark overlying or underlying another, and beyond all of this. Everything is written on the plane, all questions, conjectures, commands, charts, diagrams, pictures, and objects. But whereas a normal book stirs imagined spatiality, the "book" created by Arakawa and Madeline Gins is itself spatial and perhaps endless. By turning the page, moving to another painting, one moves to another angle of vision, of feeling, or meaning, of logic. Anything is possible in terms of the mind's, or the whole organism's, action on a given situation, but specific stated conditions have the contradictory effects of focusing and confusing—and therefore expanding—the issue.

In the series of floor and wall works of 1987–89 to which *The Process in Question* and *Beneath Untitled No. 3* belong, the viewer ascends on grids of recognizable, increasingly

arcane images toward arrangements of lines on white fields. Though physically part of the grid, the viewer actually identifies more with the vertical plane, the field of perception.

Like Arakawa, Pat Steir uses the picture plane to collate disparate phenomena. In her paintings of the 1970s, images from nature, personal lists, grids, childlike drawings, color charts, and other devices are revealed and obscured in turn. This uncertainty transmits a febrile intensity across the picture plane, a sensitivity to the connectedness and disconnectedness of events. Later, Steir harnessed uncertainty by reinterpreting the styles of historic and contemporary artists and equating them with forces of nature.

Form is gesture in the work of Hannah Wilke. Pollock and others painted abstract gestural fields. Wilke creates individual presences that seem to carry within them a universal law of formation: clay or chewing gum transformed from two to three dimensions in a single folding gesture; self-portraits created with layered strokes of color; movements of the body that communicate, unfold, and expose. These forms belong to a species, class, or order, a process of life. They are products of the singular body-mind. Her most radical forms, evolved from a feminist iconography begun in the early 1960s, are single-folded gestures in chewing gum that she once described as "my pyramids." In their simplicity they encompass an enormous range of expression and idea. Shaped in a moment from inert matter, they are three-dimensional organisms derived from two-dimensional planes (rectangular gum strips), infinite curves describing small universes. They are both sustenance as food and products of the body, softened and molded by spit and chewing. In photographs and performances they are beautification marks and emotional scars, sexual forms and symbols of the origins of life, created instantaneously and as easily discarded.

For Wilke, art is a continuation of life, a transfiguration through which the paradox of beauty and tragedy can be confronted. Her watercolor self-portraits of 1986–89, done before and after she was aware of her own illness, are pure color, created, like her ceramic and gum sculptures, with a few gestures. The calligraphic layers merge to form singular, evanescent human presences, dematerialized sculptural volumes that suffuse the air around them with color, like Veronica's veils or holographic images. As in all of Wilke's work, they insist on self-exposure, rather than withdrawal behind the mask of art, as an act of aesthetic faith.

A 1965 work by Lucas Samaras places a human skull against a star-filled sky; the entire field is stuck with pins in a regular pattern. The image is one of terror, of death associated with the void. And yet the skull forms something like a land mass on a map, a place that exists in the universe. A year later, in 1966, Samaras created the first of five rooms or spaces in which every surface is covered with mirrors. The effect is to undermine solidity, to make familiar surroundings and furniture spatial, part of fractured, cubistic depth. A totally mirrored space seems to extend forever in all directions, but it is repetitiously finite, a controlled environment in which those who enter are woven into the faceted pattern.

These patterns appear over and over again in a variety of obsessive surfaces. Boxes, paintings, entire scenes are adorned with printed fabrics, pins, colored stones, fake flowers, gilding—like some precious religious object. Overlapping strips of fabric in the "Reconstructions" of 1976–80 create dazzling deep spaces, like the mirrored rooms, that are also ultimately finite. In several series of Polaroid photographs, the nude figures of Samaras and then his friends are bathed in lurid light that serves not only to intensify the drama of their public exposure, but to enclose them in the artist's and the viewer's private fantasy.

For none of these artists is "painting" in the traditional sense enough. Wilke and Samaras are equally involved in sculpture, photography, and other media. Arakawa is concerned not with painting, but with "models of thought," "perceiving fields," "thinking environments." Even Stella breaks out of the plane in order to emphasize it all the more. Each of them evokes a dimensional presence that seems to have power or knowledge beyond the picture, in history, in life, in nature. They expand the definition of painting.

LUCAS SAMARAS (b. 1936, Kastoria, Macedonia, Greece)

Reconstruction #28. 1977
Sewn fabrics. 104×77"
Albright-Knox Art Gallery, Buffalo, N.Y.
Charles Clifton & Edmund Hayes Funds, 1979

FRANK STELLA (b. 1936, Malden, Mass.)

Gran Cairo. 1962
Synthetic polymer on canvas. 85¼×85½"
Whitney Museum of American Art, New York City
Purchased with funds from the Friends of the Whitney
Museum of American Art

OPPOSITE, TOP:

ARAKAWA (b. 1936, Tokyo)

*The Process in Question (triptych/eight
floor panels)*. 1987–1988
Acrylic on canvas, photo enlargements.
126¹¹/₁₆×270"/100×192¹⁵/₁₆"
Collection of the artist

OPPOSITE, BOTTOM:

ARAKAWA

*Beneath Untitled no. 3 (diptych/six
floor panels)*. 1988
Acrylic on canvas, photo enlargements.
126×180"/96⁷/₁₆×144¹¹/₁₆"
Collection of the artist

FRANK STELLA

Silverstone. 1981
Mixed media on aluminum and fiberglass.
105½ × 122 × 22″
Whitney Museum of American Art, New York City
Purchase, with funds from the Louis and Bessie Adler
Foundation, Inc., Seymour M. Klein, President,
the Sondra and Charles Gilman, Jr. Foundation, Inc., Mr. and Mrs.
Robert M. Meltzer and the Painting and Sculpture Committee

PAT STEIR (b. 1938, Newark, N.J.)

Line Lima. 1973
Oil and graphite on canvas. 84 × 84″
Whitney Museum of American Art,
New York City
Gift of an anonymous donor

HANNAH WILKE (b. 1940, New York City)

B.C. Series: Self-Portrait, April 19, 1988
Watercolor on arches paper. 72 × 52″
Courtesy of Ronald Feldman
Fine Arts, New York City

34. ECOLOGY AND ECONOMY: CONDITIONS OF BEING

The contemporary world, in its own peculiar way, offers the possibility of an art life, the illusion that artists are actually part of society, like doctors, lawyers, stockbrokers, and rock musicians, though the part is rather small and specialized. Art has values and is traded vigorously, if manipulatively. The most favored is treated as investment. A powerful network of collectors, dealers, museums, government agencies, publishers, auction houses, and banks supports the art enterprise, while the artists themselves lend colorful enigma to the affairs of the community.

In this economy, which flourished throughout the 1980s, it is fitting (perhaps too fitting, at times) that art should be ecological, concerned with natural, political, cultural, social, economic, and psychological conditions at the end of the twentieth century. The basic mood, however, even for those who are most successful in the system, is discomfiture, ranging from vague disorientation and cynicism to outrage and a sense of loss. Racial and sexual discrimination, political oppression, and harm to the biosphere are still powerful issues, but so are despair, confusion, and detachment.

The ecological mode might be said to have originated in certain aspects of Pop Art, such as Claes Oldenburg's urban environments of the early 1960s. But contextually it is most clearly projected in the early work of several California artists, including Ed Ruscha. Although counted as a Pop artist, Ruscha focuses more on the strange conjunction of mental and visual space in a consumerist, media-dominated society than on the phenomenology of objects and images. He portrays in elegant and meditative delineations where we actually live and what we actually see in modern America, photographing or painting the ordinary gas stations of California, for example, as Constructivist monuments, with an air of wonderment at their iconic stature. He writes messages in the sky as though even the heavens were cooperating in the banal desires of everyday life—or directing them. But in later works, such as *Plots*, the cheerful demeanor is gone; only a pattern of lights seen from the air remains, exquisitely describing what had been a perfectly nice society.

In the late 1960s and early 1970s, artists like Vija Celmins, Nancy Graves, Jennifer Bartlett, and Agnes Denes turned to nature as a subject, perhaps in reaction to the artificiality of Pop Art and the authoritarian coldness of Minimalism. Theirs is a nature seen through conceptual eyes—but compelling nonetheless. Denes turned from painting altogether and explored more deeply than anyone the underlying physical processes, often in relation to human inertia and invention. Celmins used graphite drawings and sculpture to replicate galaxies and oceans and rocks with eerie, mathematical precision. Graves constructed life-size camels, painted abstract topographical maps of the Pacific Ocean floor, the moon, and Antarctica, and rearranged nature in garden sculptures.

The idea of mimicking nature is oddly unsettling in the work of Celmins and Graves. Nature itself is unsettling in the work of Bartlett, despite the enormous control she exercises in works like the 153-foot-long painting *Rhapsody*, with its 988 enameled metal plates encompassing every imaginable modern stylistic variation on the themes

of "tree," "house," "mountain," and "ocean." Like the others, Bartlett adopts a distanced view, almost that of an alien creature, from under the sea, for instance, in *The Island.* Evidences of humanity —blind little houses and boats—are overwhelmed by nature.

Neil Jenney simplifies relations: a painting is something with a subject, a title, brushstrokes, and a frame. In his paintings of the early 1970s these are emphasized with a childlike directness and assurance about simple causality. Later, in works like *North America Abstracted*, brushstrokes all but disappear into illusion, and the frame becomes even more elaborate: in some, a sliver of landscape is seen, overwhelmed by the framing device; in others, an illusion of brilliant, corrosive light glows in the rectangle, eliminating the landscape altogether, much as the actual landscape is disappearing or being brought under control. Once again, cause and effect are inescapable.

Whereas the political edge in Jenney's work is elegiac, Sue Coe directly attacks western political and social systems by relentlessly detailing oppression: episodes of apartheid in South Africa, the murder of Malcolm X, the calculated brutality of the meat industry—the specifics that most of us would rather submerge in a generalized admission of human cruelty. She is interested, not in the banality of evil, but in its actuality and persistence—and its demise. Following in a tradition that extends back to Goya, Coe considers art a political act, part of a larger effort to effect change.

The politics of survival fill the art of Vitaly Komar and Alexander Melamid. Born and raised in the Soviet Union, they invented their own artistic freedom, using the official Socialist Realist style in which they were trained, by subversively embracing the concatenation of history and everyday life. They wanted—and still want—to know how things got to be the way they are, how the artists themselves got to be the way they are. It fascinates them that while they were being shaped by Soviet society, quite different things were going on elsewhere—American art, for instance, which they now produce. So they crossed boundaries to forge a continuous chain of historical and personal events and styles that is both comic and tragic. *The Blue Cup* makes Lenin an accomplice of American Abstract Expressionism; the cup he drops in the right panel becomes a splash of blue paint on the rumpled canvas in the left panel. The connection, in fact, is not so farfetched: Abstract Expressionism would probably not have happened without the Russian Revolution. It is impossible to escape, in any case, the cataclysmic effect of the act.

David Salle also collapses history, though in a more abstract way. Disparate images from past and present, most of them borrowed from photographs and other works of art, are juxtaposed and overlapped. Salle's appropriation of images and his illustrational style emphasize the representational mode, in which the drama of simultaneous, totemic presentation tempts, then thwarts interpretation. The images occupy a kind of psychological limbo, an area of existential nausea. Ubiquitous, darkly shadowed women, most of them naked and provocatively posed, serve as demiurges, sexual avatars of both dislocation and creative unity. One series of four paintings half hides the letters C, U, N, and T, but the effort to get beneath the surface seems to create new surfaces.

Incantatory sexuality pervades the work of Eric Fischl, as well. In the hushed reverence of his suburban scenes, sex becomes a religious experience of guilt and expiation, and of revelation. The mass of human flesh in *The Old Man's Boat and the Old Man's Dog* is surrounded by the moral sea of Winslow Homer. Both Salle and Fischl drive deep into the heart of middle-class America.

It's a long trip from the Los Angeles of Ed Ruscha to the New York City of Jean Michel Basquiat, over territory that covers the Pacific Ocean, the moon, the political power structure, big city slums, North American forests, Moscow, and the suburbs. Basquiat encompasses all of this in a welter of names and associations. With the wit, intelligence, and force of street language and images, his paintings, like a textbook or a dictionary, redefine and reconstitute the world, down to the parts of the body and the basic chemical elements. The powerfully drawn, sometimes kaleidoscopic figures of black men and grinning skulls are uncompromising assertions of human consciousness and conscience. They remind us how vibrant and enduring the human spirit can be.

NANCY GRAVES (b. 1940, Pittsfield, Mass.)

Pacific Ocean Floor, 150 Miles Out. 1971
Acrylic on canvas. 90 × 72"
University Art Museum, University
of California at Berkeley
Gift of Mr. and Mrs. Harry W. Anderson

ED RUSCHA (b. 1937, Omaha, Neb.)

Plots. 1986
Acrylic on canvas. 72 × 72"
Courtesy of the Leo Castelli Gallery,
New York City

JENNIFER BARTLETT (b. 1941, Long Beach, Calif.)

The Island. 1984
Oil on canvas. 108 × 156"
Saatchi Collection, London
Courtesy Paula Cooper Gallery, New York City

Jennifer Bartlett

Rhapsody (Detail). 1975–1976
Enamel, silk-screen, baked enamel on steel plate. Each unit is 12 × 12″
Courtesy Paula Cooper Gallery, New York City
Collection of Mr. Sidney Singer, New York

SUE COE (b. 1946, Tamworth, England)

Greed. 1984
Mixed media. 7′ × 5′
Courtesy Galerie St. Etienne, New York City

JEAN MICHEL BASQUIAT (b. 1960, Brooklyn, N.Y.–
 d. 1987, New York City)

Carbon/Oxygen. 1984
Acrylic on canvas. 88 × 77″
Courtesy of the Robert Miller Gallery, New York City

OPPOSITE, TOP:

VITALY KOMAR (b. 1942, Moscow, U.S.S.R.) and
ALEXANDER MELAMID (b. 1943, Moscow, U.S.S.R.)

The Blue Cup. 1985–1986
Mixed media. Two panels. 60 × 72″
Courtesy of the Ronald Feldman Gallery, New York City
Private collection

OPPOSITE, BOTTOM:

NEIL JENNEY (b. 1945, Torrington, Conn.)

North America Abstracted. 1978–1980
Oil on wood. 38 × 85¼ × 5¼″
Whitney Museum of American Art, New York City

ERIC FISCHL (b. 1948, New York City)

The Old Man's Boat and the Old Man's Dog. 1982
Oil on canvas. 84 × 84"
Saatchi Collection, London

DAVID SALLE (b. 1952, Norman, Okla.)

Dual Aspects Picture. 1986
Oil and acrylic on canvas. 156 × 117"
Museum Ludwig, Cologne,
West Germany

315

INDEX

Page numbers in *italic* refer to illustrations.

CREDITS